Cybernetics of Art

First published in 1983, *Cybernetics of Art* uses the methodology and concepts of cybernetics to explore art and the creative process. Part I surveys the domain that includes both science and the arts, attempting to understand their differing viewpoints- and the basis of conflicts between them. Art is approached as a method of knowledge aimed at knowledge of experience per se (as distinct from knowledge derived through experience).

Part II poses the problem of notionally constructing an authorship machine and develops the technical argument by exploring the question of the kind of machine it would need to be. Part III examines the products of such a machine with a view to finding criteria for distinguishing those that might be called art. An extended, non-technical commentary accompanies the text throughout, with the dual aim of comparing the book's technical conclusions with ideas expressed by critiques and practicing artists and assisting readers unfamiliar with the information sciences in following the argument. In a world dominated by artificial intelligence, this inter-disciplinary book will be useful for scholars and researchers of cybernetics, art, and humanities and social sciences in general.

Cybernetics of Art

Reason and the Rainbow

M. J. Rosenberg

Routledge
Taylor & Francis Group

First published in 1983
by Gordon and Breach, Science Publishers, Inc.

This edition first published in 2024 by Routledge
4 Park Square, Milton Park, Abingdon, Oxon, OX14 4RN

and by Routledge
605 Third Avenue, New York, NY 10017

Routledge is an imprint of the Taylor & Francis Group, an informa business

Publisher's Note
The publisher has gone to great lengths to ensure the quality of this reprint but points out that some imperfections in the original copies may be apparent.

Disclaimer
The publisher has made every effort to trace copyright holders and welcomes correspondence from those they have been unable to contact.

A Library of Congress record exists under ISBN: 0677059701

ISBN: 978-1-032-79931-5 (hbk)
ISBN: 978-1-003-49457-7 (ebk)
ISBN: 978-1-032-79932-2 (pbk)

Book DOI 10.4324/9781003494577

The Cybernetics of Art
REASON AND THE RAINBOW

M. J. Rosenberg

There was an awful rainbow once in heaven:
We know her woof, her texture; she is given
In the dull catalogue of common things.
Philosophy will clip an Angel's wings,
Conquer all mysteries by rule and line,
Empty the haunted air, and gnomed mine —
Unweave a rainbow . . .

JOHN KEATS

GORDON AND BREACH SCIENCE PUBLISHERS
New York London Paris

Gordon and Breach, Science Publishers, Inc.
One Park Avenue
New York, NY 10016

Gordon and Breach Science Publishers Ltd.
42 William IV Street
London WC2N 4DE

Gordon and Breach
58, rue Lhomond
75005 Paris

Library of Congress Cataloguing in Publication Data

Rosenberg, M.J., 1933–
 The cybernetics of art.

 (Studies in cybernetics; v. 4)
 Includes bibliographical references.
 1. Art and technology. 2. Cybernetics. I. Title.
II. Series.
N72.T4R67 700'.1'05 82-3012
ISBN 0-677-05970-1 AACR2

Set in 10 point IBM Press Roman by ⫪\ Tek-Art, Croydon, Surrey, England. Printed
in Great Britain by Billing & Sons Ltd., Worcester, England.

To Thelma Philip

*a wonderful teacher
in lasting gratitude*

Systems which aspire to the explanation of the universe cannot be analysed at all clearly by any discourse. Words are not appropriate to ideas of this kind, and the result is that, in order to make them serve, one spreads over all things the darkness that preceded creation, but not the light which followed.

<div align="right">MME DE STAEL</div>

Contents

PART THREE Authorship's Products

Acknowledgements

For permission to reproduce certain material I should like to thank authors and publishers as follows: 'The Story of the Cape' is reprinted by permission of Schoken Books Inc. from *Tales of the Hasidim: Early Masters* by Martin Buber. Copyright © 1947, 1975 by Schoken Books Inc. *In a Station of the Metro* is reprinted by permission of New Directions Publishing Corp. and Faber and Faber from *Collected Shorter Poems* by Ezra Pound. Figure 6.4.1 is reproduced from *Perceptrons* by M. Minsky and S. Papert by permission of MIT Press, and Figures 8.2.1 to 8.3.4 inclusive from *Artificial Intelligence,* by the same authors, by permission of the MIT Artificial Intelligence Laboratory.

Introduction to the Series

Cybernetics, the science of systems of control and communications, is a rapidly growing subject and there now exists a vast amount of information on all aspects of this broad-based discipline. To call cybernetics 'broad-based' is to imply that its viewpoint is nearly identical with all the approaches taken to artificial intelligence. Furthermore, systems analysis, systems theory and operational research often have a great deal in common with cybernetics – and, in fact, are not always discernibly different from it, so far as this series is concerned. Computer science, too, is usually closely linked.

The fields of application are virtually unlimited and applications can occur in investigating or modelling any complex system. The most obvious applications have been to construct artificially intelligent systems to simulate the brain and nervous system, and social economic systems.

The range of applications today have gone so far from its starting point that it now includes such subjects as aesthetics, history and architecture. The immediate modelling can be carried out by computer programs, special purpose models (analog, mathematical, statistical, etc.), and automata of various kinds, including especially neural nets. All that is required of the system to be studied is that it is complex, dynamic, capable of 'learning' and has feedback or feedforward or both.

This is an international series. It includes translations in English from originals in other languages.

FRANK GEORGE

Preface

Among a variety of objects prompting the present enterprize has been the hope of exploring the sharp distinction, deeply embedded in thought and conduct, that is commonly drawn between the affective and the intellectual aspects of mental life. Approaching art, with its affective associations, as a method of knowledge − commonly regarded as intellectual − provides what appears to be suitable ground for such an undertaking, while the information sciences suggest a way to proceed. Yet the treatment of art as a method of knowledge will not commend itself to everyone. To approach literature, music and the fine arts as ways of knowing, directed moreover at an understanding of the same reality − if in another aspect − as that at which all knowledge, including scientific knowledge, aims, is a departure from more traditional practice that will strike many people, humanists and scientists alike, as at best ill-conceived.

The hope is to define and justify the view taken by applying to the arts the kind of understanding that the information sciences have successfully brought to a number of complex questions, a view that aims, without relaxing its rigour, to grasp the detail out of which complexity is built, in a way classical science does not readily permit, while using the methods of these new scientific fields, so peculiarly suited to it, to escape the vagueness, muddle, grandiloquence and other vices to which much that is written about − especially the theory of − art has so often shown itself susceptible. Joined with this hope has been also the object of finding a means of empirically testing a rigorous− a 'scientific' − theory of art, a way less at variance with art's objects and spirit than traditional science offers, and so better able perhaps to escape the distortions and constraints that result from the inappropriateness of traditional methods.

In their short history, the sciences of information, communication and control (which form the major part of the subject matter of cybernetics) have greatly enriched the understanding of human learning and intelligence, and there seems on the face of it, therefore, no reason why their elucidation should not extend also to art. The reader should understand 'cybernetics' as a shorthand to denote the information sciences generally, and forget as far as possible the more sensational and scurrilous connotations to which it has in some measure unfortunately become attached. Outside these new areas of science, concepts

useful for discussing the arts are exiguous: philosophy, where it touches art, has concerned itself principally with aesthetics and questions of art's ontological status, neither of which interests falls properly within the scope of the present exploration. Psychology has shown similar inclinations. Even approaches such as Arnheim's in the field of the visual arts, which attempt to combine notions of entropy with *gestaltist* views, are largely irrelevant to the present work. Closest to its theoretical domain, though still with a quite different outlook from the one adopted here, is Moles' approach to the arts by way of information theory. Almost no previous work, however, directly attempts to approach art as a method of knowledge, a way of knowing the world, whose understanding the broader aspects of the information sciences may advance.

This lack of previous work has made it necessary to proceed piecemeal in attempting to draw together a coherent whole from available useful concepts, with consequences, I am afraid, often all too obvious. Inevitably, it has led to numbers of rather rough and ready results, while also, in the absence of an established literature, leaving extremely vague at whom to direct this kind of book. To those in the world of the arts who might be interested in its conclusions its technicality may make it seem inaccessible and forbidding, while the technically versed may well be uninterested in its subject. There is, moreover, a lack of sympathy for, a mistrust of what to many humanists may appear a 'mechanistic' approach to art and aesthetics. And this is a further difficulty, not that the approach *is* mechanistic, but that its origins, alien to the humanist tradition, should so readily offer occasion for the emergence of such deep-seated intellectual xenophobia with its attendant dreads and prejudices. Moreover, though the familiarity of the conclusions that emerge from thinking so removed from traditional ideas surrounding the arts may appeal to the rationalist as their vindication, rational corroborations will not in general reciprocally engage non-rational sympathies – the lofty flights of creative fancy soaring forever high about the otiose confirmations or denials of mere reason.

With all this in mind, I have tried to take what steps I could to widen both the interest and accessibility of the book wherever possible. Part One should serve to lower the non-technical reader gently into the argument. Chapter 1 sets out to chart broadly a single domain encompassing both science and the arts, attempting to understand the different viewpoints of both and the basis of the conflicts between them. Chapter 2 raises some of the problems surrounding thinking about the arts and offers the methodology of effective procedures developed by the information sciences as a way of confronting them. Part Two takes up the argument in greater detail, more or less rigorously from first principles. Chapter 4, which shows how purpose emerges inescapably from order and organization as order from purpose, is in a sense at the bottom of the whole argument.

The basic notions of information science are incorporated as and where they are needed, with general concepts supplemented by specific results where relevant.

Mostly, presentation makes little attempt to cover the traces marking the paths of reasoning that have led to conclusions, the rather hackneyed object of displaying the scaffolding along with the finished structure being pursued in a genuine belief in its particular helpfulness in the present case towards gaining a fuller grasp of the argument and its aims. Also, with the object of clarity, Parts Two and Three, as well as each chapter, begin with a general synopsis and outline of objectives.

The argument proper – Parts Two and Three – restricts itself as far as possible to a more or less rigorous consideration of abstract systems. However, in referring to the entities denoted by the names 'A', 'W' etc. it sometimes makes the meaning of the text plainer to allude to them as if they were persons rather than things. These entities are therefore not always designated as 'it', but may be personified as 'he' where this makes for clarity. Usage follows no particular rule. The reader may understand 'it' wherever 'he' refers to an abstract entity. Many readers, however, may still be put off by the use of letters to signify ordinary words, the very freedom from meaning's constraints that such symbolising aims at, rendering its results baffling or incomprehensible, and so making much of the argument appear far harder than it really is. Those who feel this to be a difficulty may find it helpful to think of the symbols used simply as if they were abbreviations for more usual kinds of names. A glossary of the six mainly-used symbols follows, and readers who dislike symbols may find it helpful to look at it before reading Part Two.

Applications to the real world of the arts of the views and conclusions of the argument, along with other empirical considerations, and also some of the more speculative notions that arise are dealt with in commentary interpolated throughout – visually distinguished from the theoretical argument by a smaller typeface. The attempt has been to counterpose to each successive theoretical step its empirical correlative. Confirmation for conclusions reached by way of the abstract arguments from first principles, which are the wherewithal of the theory as it is developed, is looked for less in direct application to the arts than in the views of practising artists that echo or corroborate them. That such different approaches from such widely separated starting points should be found, in important cases, to arrive at so closely similar conclusions seems an empirical justification of the theory developed that well exceeds what might have been hoped for at the outset. To some extent the commentary may be read independently of the theoretical discussion, so that the non-technical reader who prefers to skip some part of the abstract argument should still often be able to follow its empirical conclusions by pursuing it in the commentary.

Cross references in the text are by chapter and section number; for example, 7.3 refers to Section 3 of Chapter 7. Presentation of references is according to the Harvard system. Where reference throughout is always to the same work of a particular author, the year of the publication referred to follows only the first

citation. Reference to citations re-cited is by cross reference to the first citation.

It remains for me most gratefully to acknowledge the valuable suggestions and critical guidance of Dr David Stewart whose assistance did such a lot to direct into fruitful paths and free from confusion much of the work that led to the present study, and to express my deep appreciation to Professor F.H. George for his never-failing helpfulness, encouragement and kindness at all stages of the enterprize. Failure to reflect this generous and extensive help I have received must, I am sorry to say, be attributed wholly to my own dullness.

M.J. ROSENBERG

Glossary of Symbols

The following are the six most commonly used symbols in the book. There are others, but I have thought it better to restrict the glossary to these rather than risk making the symbols look even more threatening than they may do already by providing a complete glossary of all of them.

A — Author: one who originates something, which may be either something permanent or something transitory.

E — Environment: the world in which individuals — things and people — exist, (an individual's world is not the world itself, but that part of it that affects him); generally, the author's surroundings — in a broad sense — in which he forms his view of his world and in which he does his originating; where he produces a product or work, W; also the surroundings of the work itself, the world in which it is publicly observable, in which its audience views it.

O — Observer: in the case of the arts, the audience, reader, spectator, etc., of the work, W.

W — Work: the *product* of an author, the thing he originates; this may be a painting, a poem, an invention, the proof of a theorem, a scientific theory, a move in a game of chess, a tennis stroke, etc.

AW — The productive or, as it is often thought of in the case of the arts, the 'creative' process: the scientist performing an experiment, the tennis player playing tennis, the artist at work making his painting, poem, or whatever.

WOA — Work of Art: painting, poem, musical composition; or performance — on the stage, etc.

The above are all objective, publicly observable 'things'. Where any of these things are subjective, occurring 'in the mind', of an observer or an author, say, the symbol that represents them is followed by an asterisk, as in E^*, for instance, which could be the author's or the observer's model, his view, the way he sees, his conception of, his surroundings.

Reason and Experience

1

Life and Abstraction

1.1 Expropriation

The opposition between the belief in reason and its rejection in favour of non-rational alternatives represents the basis of one of the most important differences that has divided men's aims and efforts, distinguishing among the many forms of human enterprize the humanities, especially the arts, from the concerns of rationality and science. Mistrust of reason and the sense of its inadequacy and inappropriateness as a method of human knowledge and apprehension is probably as old as reason itself. Among alternatives to it that have been proposed in the search for understanding and explanation of the world are mysticism, faith and the transcendent truths of revelation, prescription, tradition, history, blood, race and soil, innocence of heart and the exercize of will. This diversity is united often in little more than a turning away from the 'unnaturalness' of reason — the plodding, earth-bound, cumbrousness of its contrivances, its abstractions and its theories — and in sharing sometimes also a belief in a drawing closer to life and living as it actually occurs or has occurred in the past, a preference for intuition and the soaring flight of imagination, as the best if not the only source of understanding and truth. This divided outlook is uncertain ground upon which to build a unified account of both methods of knowledge, providing instead views and theories that tend to appeal exclusively either to those who look to science as the only true method of knowledge or to those drawn to the arts, seldom furnishing a standpoint from which to recognize the similarities as well as the differences of both together.

It has been traditional to associate with the humanities, and particularly the arts, such capacities as words like 'creativity', 'imagination', 'intuition' and 'aesthetic value' denote, usually combining in some degree connotations of emotion; and with reason and science, faculties of intelligence, an inclination towards deduction and the pursuit of logical argument. Ironically, it has been left to the study of 'artificial' intelligence to discover the arbitrariness of the distinctions that these various terms imply, and to reveal in a practical way an inescapable intimacy uniting the different elements they signify in intelligent behaviour. Works of art are not non-intelligent undertakings; indeed one of the

difficulties of defining what is meant by art is simply an aspect of the wider problem of deciding what qualities characterize intelligence.

The traditional distinction between art and the capabilities needed for it, and intelligence and its characterizing capacities, has been facilitated by the view that both sets of faculties, if characteristic, are still distinct aspects of the all-embracing faculty of mind, taken to be the defining principle of *homo sapiens*. But mind itself has shown peculiar resistance to attempts to capture its quality by succinct definition, principally because such efforts have usually set out with tacit or even explicit assumptions of its incorporeality. Such assumptions are not disinterested. They underpin the claim to a quality that sets men apart from the rest of the universe, which results from a conviction that is probably among the most deeply rooted in cultural history.

To the belief in such uniqueness, reason is inimical. Science's successive advances have brought men down from their place of god-like pre-eminence in a world created especially for them, the crowning achievement of the divine purpose, to a standing as common subjects of the same universal laws as the rest of nature, and sharing many if not all their once-supposed unique capacities with the most primitive creatures. Successive seemingly impregnable strongholds of human exclusiveness have had to be abandoned, mystery and magic to make way, as Keats laments, for the world of 'common things'. Beginning with the dislodgement of men from the cosmic throne at the universe's centre that was the effect of Copernicus's discoveries in the first half of the sixteenth century, science has proceeded to enhance its prestige at the expense of human self-esteem, stripping it, in a long succession of painful defeats, of one after another of the comforting mysteries that have clothed it. From the seventeenth century, incursions upon the human domain succeeded with gathering momentum. Kepler showed planetary orbits to be, not circles centred on the sun, not the perfect creations of the divine hand they had been supposed, but 'distorted' into ellipses, with the sun away at one of the foci. Harvey used a simple pump as a model for the blood's circulation, an elementary machine to represent the body's greatest mystery, symbol of love, kinship, race, honour. Newton unwove Keats's rainbow and imprisoned Blake's robin redbreast, nature herself, in a cage of physical laws. Evolutionary theory proposed men's cousinhood with the apes and familial bonds extending back almost without limit to primitive life forms; and, in psychology, Freud's arguments for the existence of 'unconscious' motivation appeared finally to deprive men of what had already long been under attack by philosophers, their free will. The whittling away has continued to our own time, when men have had to contend with machines for the very character hitherto supposed the unique and defining human quality, intelligence, the faculty of mind itself.

So advancing science, the spread of technology, the emergence of machines, faster, stronger and surer than men, to do the work of men's hands and muscles,

reason's great conquests of understanding, explanation and invention, drove the distinctively human prerogatives before them in headlong retreat. Not surprisingly, the search for shelter from this onslaught of hard materiality, of measurements and machines, led directly to the age-old haven, seemingly invulnerable, of incorporeality. The final flight was bound to be to the natural redoubt of dualism, the idea of the separation of mind and body, ground prepared by centuries of thought, richly represented in language and the world of everyday experience.

Whatever the philosophical or psychological standing of dualism, the sense of it remained intuitively irresistible. It is the way things feel, however they may be in fact − just as it feels as if the sun revolves around the earth − a feeling held with a strength that explanations of mind or consciousness proposed by psychologists and physiologists does little to weaken, a last defensible position for the distinctively human faculties against the offensives of hostile and materialistic science.

And what then is the characterizing feature of the exclusively human side of man's dual nature? It is the power to create. This is the power that gives to mind its godlike quality; reason, as we have long known, is a quite mechanical business. So the machine that plays chess or proves theorems is *merely* reasoning; the poet, the painter the composer, perhaps even, as a courtesy, in some lesser way, the inventor, is creating. What scientists, reasoners, do is of small significance. This much is quite in accordance with the received orthodoxies and prejudices of the nineteenth century and earlier; of the romaticism and aestheticism of the literary world even in rationalist France, as well as in Britain and Germany; with the views of Byron and Shelley, Baudelaire, Mallarmé and Flaubert; indeed, it was the view in which scientists themselves acquiesced and it remains very much the belief to the present: 'The novel is a great discovery: far greater than Galileo's telescope or somebody else's wireless', D.H. Lawrence says; (cited by Leavis, 1967, p. 11) Toynbee's (1959) 'Seventeen "great men"', from Xenophon to Lenin, includes no scientists. It is, however, a difficult belief to maintain when it confronts the question: if reason and imagination, creation and criticism, are all functions of mind, in what respects do they differ? How does mind behave, what does it do, when it is reasoning or imagining that makes it mechanical in one case, but spiritual in the other? How indeed does mind work at all?

These were among the issues that had begun to be raised in different forms by the philosophers of the seventeenth century, whose thought led directly to questions about the workings of mind. The materialism of Descartes and Leibniz, the associationism of Locke and J.S. Mill, the subjectivism of Kant laid much of the foundation for questions later taken up by Wundt, Helmholtz, Fechner and the materialist and subjectivist schools in modern psychology, many of which simply restate the problem of reason and imagination, whether mind is plodding and mechanical or airy and swift, corporeal and earth-bound or

spiritual and ubiquitous, offering sureness in a known sphere or opening up or indeed bringing into existence new realms. 'Analytical' machines — the fore-runners, though based upon mechanical rather than electronic components, of modern computers — were bound, when they appeared, to be associated with the processess of reason. The effect, rather than enhancing the standing of machines, which retained the image — well vindicated by the reality of the time — of being manifestly slow, clumsy and brutal, was to detract from reason's prestige. 'The analytical Engine', wrote Byron's daughter, the Countess of Love-lace of Babbage's machine, 'had no pretensions whatever to originate anything. It can do whatever we *know how to order it* to perform. It can *follow* analysis; but it has no power of *anticipating* any analytical relations or truths' (Cited by Bowden, 1957, p. 398). The dichotomy is between following and originating. The machine cannot be author of anything; it can do only what it is told. Science was content to be modest, leaving the world of intuition, imagination, of authority, to mind. Yet, as the humanities withdrew further towards spirit, the emotions, inner life, a human fastness that seemed secure against the incur-sions of mechanism and measurement, science and reason began an attack on spirit itself by claiming and seeking to demonstrate that mind was capable of nothing that might not, in theory at any rate, be accomplished — however slowly and clumsily, but accomplished nonetheless — by the simplest of machines; and still more than this, that what such machines could not do could not be done at all!

Turing's (1936) paper on computability advanced what amounted to just such a claim. Reflecting a view that had been taking shape among mathematicians and those working in the field of formal logic from the time of Frege, Turing proposed that a procedure would be effective in solving a problem, if it laid down in a clear and unambiguous way a set of instructions to be followed step by step until the solution was reached. Furnishing such a procedure presents three problems: first, framing the instructions in such a way that they will be clear and unambiguous; secondly, making sure of their completeness, know-ing, that is to say, that there will be instructions for what to do at every occasion that may possibly arise during the course of the solution; and thirdly, knowing that a solution will eventually be reached, that the instructions lead along a path that eventually comes to an end and not one that goes round in circles or con-tinues for ever. On the question of ambiguity, the meaning of an instruction depends, in varying degrees, upon who interprets it, his mental capacities, back-ground, education, culture and so forth. Someone of too limited intelligence may fail to understand what he is told to do, while someone 'too' intelligent may discover in an instruction some consistent though unintended interpretation. A procedure that could be brought to a successful conclusion by a very simple mechanism whose workings were obvious and fully and easily comprehended would avoid the difficulty, while also meeting the other criteria of effectiveness.

Provided the machine were simple enough, problems of its interpretation of instructions would not arise; and provided the procedure reached a solution after a finite number of steps, it would have all the attributes required of it.

When Turing published his paper there was, of course, nothing new about mechanistic explanations of the workings of the human body. Determinism of various orders had been a commonplace since the seventeenth century. Descartes, the Encyclopaedists, Diderot, d'Alembert, had all entertained conceptions of the sort. In *l'Homme Machine*, La Mettrie had achieved notoriety by developing the idea of mechanism to encompass mind, suggesting that the mind had 'thought' muscles just as the legs had 'walk' muscles. But, reducing the stark implausibility of such explanations had been a tacit underlying assumption that the complexity of the human machine was a necessary adjunct of the complex things that men could do; that no simple mechanism could be expected to carry out complicated tasks or solve complex problems such as those associated with mind's peculiar powers: if mind were mechanical, it was so only in some remote, hypothetical way. This reservation helped to hold mechanistic explanations of mind at arm's length, to invest them with powerful metaphoric overtones, so rendering them relatively harmless.

Turing showed that such assumptions of complexity were unnecessary; that, in place of qualitative increases in complexity, it was sufficient to provide simple, quantitative increases in memory; and this could be easily arranged by the simple device of increasing the length of paper tape on which the machine writes and erases the symbols of its alphabet in a string whose length is limited only by the supply of paper available. It followed that there was no limit to the complexity of the problems that Turing's simple machine might undertake effectively. But there was even more than this to Turing's claim. Not only was it the case that a procedure a simple machine could carry out could be regarded as effective but, conversely, any procedure that could be regarded as effective could be carried out by a simple machine; or, what a simple machine could not do could not effectively be done at all; problems that could not be solved effectively were insoluble.

This startling view naturally invited attack. Any claim that nothing that could effectively be done by minds could not equally, however much more cumbrously, be accomplished by the simplest of machines may easily be represented as so manifestly absurd as scarcely to call for refutation. Jefferson (1949) for example, takes up the argument against machines where Lady Lovelace has left it:

> Not until a machine can write a sonnet or compose a concerto because of thoughts or emotions felt, and not by the chance fall of symbols, could we agree that machine equals brain – that is, not only write it but know that it had written it. No mechanism could feel (and not merely artificially signal, an easy contrivance) pleasure at its success, grief when its valves fuse, be warmed by flattery, be made miserable by its mistakes, be charmed by sex, be angry or depressed when it cannot get what it wants.

The dogmatic tone, the ostentatious concern with human prerogatives, the implied high moral outlook are taken to be quite sufficient to grant exemption from the rigours of rational argument. Bowden (1957) recalls Turing's (1950) question as to how one would know what the machine felt other than from the evidence of what it produced. From a point of view such as Jefferson's, however, this is a mere quibble; indeed arguing at all makes too great concessions to absurdity. But there is, of course, nothing so simple-minded about Turing's claim. Moreover, the view he proposed, besides having antecedents in earlier ideas about mechanism, did not differ as radically as at first appeared from beliefs about reason held since the eighteenth century, and tacitly taken to be the case for far longer.

1.2 Rational and Non-rational

These are the ideas that have their origins in the belief, which extends, in implied or even explicit form as far back as the Old Testament, that reason is the fundamental principle of the universe, that a definite and fixed order governs nature and human affairs. According to this outlook events follow a grand design, which is absolute, perfect, timeless, just, (whether or not its workings are comprehensible to the human mind) governed by fixed causal laws that bind their Creator Himself; and not as the outcome of inescapable chance or divine caprice. In Greek thought too, a similar belief in a rational universe is already fully formed in the doctrines of the pre-Socratic period. The Ionian philosophers share a view of the unity of nature and the existence of a few simple principles according to which it is governed. They ask what the world consists of and what its basic design is, questions that point to the implicit assumption that its essential elements are static and unchanging, that it is a world in which real and historical variations are insignificant, mere surface changes, compared to the fixed persistence of reality; assumptions that grow into a vision of a universe in which careful observation and the patient application of human reason may be expected to yield rational answers to men's questions, answers that will be the same irrespective of where, when, or by whom the questions are asked. It is this belief in the comprehensibility, the underlying rationality of things, and the hope of explaining and understanding them by means of reason that reached its high point in the ideas of the French Enlightenment, which proclaimed the autonomy of reason, particularly the methods of mathematics and the natural sciences, as the sole reliable method of knowledge, to be applied with equal rigour in the fields of history and human affairs as in the world of inanimate objects.

Sure knowledge derived from reason would lead to a view stripped of fantasy and dogma and their attendant fanaticism and cruelty, and provide men with clear and certain understanding of the world, of history, human relationships and social arrangements, as much as of nature. Such knowledge would be timeless, universal and absolute (and so, incidentally, allowing of no differences of opinion) having equal force for all men, everywhere, always. From unbroken progress in the unfolding comprehension of nature and the understanding of human values would emerge an unmistakable vision making plainly apparent how to attain those ends towards which normal human beings everywhere and at all times naturally directed their efforts, so bringing them freely to choose those paths that led to the condition of virtue, wisdom and happiness natural to men, which only ignorance perverts to vice and misery. Inexorably from this harmonious state would flow justice and rational government, freeing men permanently from exploitation, oppression and tyranny, and creating at last that condition of rationality in which alone the human mind and spirit could flourish and grow to their proper dimensions.

From Galileo, Copernicus and Newton, Descartes and Leibniz, Bacon and Locke it had been the belief in reason that had steadily been gathering support until, by the time of the Enlightenment, of Hume, Diderot, Voltaire it had finally come to dominate entirely all the progressive thought of the time. Not surprisingly then, reacting against this outlook − the more so on account of the immense authority that accrued to it from the prestige science had acquired by its achievements in the seventeenth and eighteenth centuries − the altogether different sentiment arose that advanced belief − still by means of rational argument − in the non-rational and anti-rational. This outlook was not new. At its most extreme it represents a view that expresses belief in the fundamental irrationality of the world itself, the unpredictability, as part of their character, of history and the events governing men's lives and fortunes. This was the view underlying the beliefs of Greek religion, of a world and men's lives ruled by gods, as frail, capricious and irrational as men themselves, whose actions, like men's, could be governed by jealousy, hatred and folly, as much as nobility, generosity and love; of a nature at best indifferent to human aspirations and actions; rewards and punishments, good fortune or bad that neither reason nor justice, but chance or a malevolent fate determined. This was the view of Homer, of Aeschylus and Sophocles. It finds a philosophical echo in the metaphysics of Heraclitus, in which the idea of a stable, unchanging reality is rejected, and 'Everything is in a state of flux'; the very laws that govern events are subject to change. It is an outlook that finds expression in the scepticism of the sophists towards the revelatory powers of reason in matters of human affairs and in the relativist views of society to which the scepticism led. It is belief of a kind that underlies the thought of St Augustine, for whom God's choice of His elect is made without motive, or in Calvin's view that damnation and salvation equally

reflect God's goodness: damnation His justice, salvation His mercy; and it contains elements of the older anti-rationalism of the mediaeval period — a reliance upon received wisdom, authority, faith, revelation.

But, in its reaction against the dominant rationalism of the Englightenment, anti-rationalism made a new departure, or at least placed a new emphasis of its own: a tendency that appeared as a common element among the various forms it took to stress the predominant importance, in events, actions, and human affairs and their description and comprehension, of experience; of life and living. The emphasis was itself the result of a new relativism, particularly in the view taken of human affairs that grew out of the widening horizons of knowledge of the world, of foreign customs, exotic races and new lands that exploration and travel had provided, as well as the new, critical attitudes to the study of history and human society that were part of the rationalist, scientific spirit. These brought with them an awareness of the uniqueness of the conditions determined by the particular place and time, of the influence of geography and climate on customs and institutions, and of the need, in the evaluation of historical questions, to consider human behaviour and values in relation to the demands and circumstances from which they had sprung. The world's variety and changeability, the particularity of conditions, were what was of overriding importance in shaping opinions and the matters that depended upon them, not the artificial constructions of reason. In particular, moral values and notions of justice, questions of political and social order, human institutions, were less dependent upon permanent, fixed laws of nature than upon traditions and conventions that were themselves changing and transitory. The unforeseeable and ungovernable quality of living, the uncertainty of what would be from day to day or moment to moment, the irrationality of the human mind, disqualified reason from revealing, especially in matters involving value judgements, any truths whatever of universal significance.

For, in the eighteenth century, a new awareness had begun to grow up of the variety of human societies and civilizations. Those books about exploration and travel that began to appear from the time of the seventeenth century increased knowledge of the breadth of variation of human practices and customs and institutions in newly discovered lands, and of the influences upon them of their histories and especially of the natural environment, the quality of soil, the vegetation, of whether a place were mountainous or flat, watered or dry, cold or hot. The existence of such variety and the interplay of natural and social factors clearly placed formidable obstacles in the way of discovering any such simple, absolute formulae as rationalism looked for, principles likely to apply equally to all societies at all times. Not simply the regard given to reason and the claims made for it by the Enlightenment, nor just the hope of discovery was now questioned, it was the very existence of such permanent, universal truth that appeared in doubt. In the reaction against rationalism, the variety that was so much the

character of human affairs, appeared not merely as an obstacle to the discovery of simple, universal explanations, but as the clearest evidence that such explanations did not exist at all. If human values and the organization of human affairs represented a response to natural and historical differences, how could it be expected that some simple, absolute principle, that applied as much and in the same way as it applied to inanimate nature, could be used to explain human behaviour, history and social organization in all its richness and variety?

At the high tide of its authority, this unquestioned element of rationalist doctrine came under attack. In human affairs, there was not one truth, but many. What appeared barbarous to an eighteenth-century Frenchman might be both appropriate and valid for a Homeric hero. Reason was inadequate not just as an explanatory principle, but as a method of understanding. It offered a form of knowledge that was, certainly in respect to human values, by its very nature, false, lacking as it did all character of what shaped such values, the character of life in a real world. Life took place in the midst of real events, connected with particular beliefs, individual attachments, loyalties, aspirations, feelings, frailties; participating with family, tribe, race, in traditions, customs, history, territory; sharing distinctive geography, climate, language, social institutions. It had the character, that is to say, of being in a real place at a real time. Far from being reality's nature, as the rationalists believed, reason was no more than a method; one, indeed both inadequate and misleading.

To the proponents of these views in their more extreme forms it seemed that experience, with emphasis upon one or other of its aspects, personal or social or historical, alone offered whatever hope there might be of true knowledge. And experience was, by its nature, inaccessible to reason. Experience was neither orderly nor controllable. Sensations, memories, feelings, moods, beliefs, desires, along with the unpredictable and uncontrollable events of the world, washed all sensible beings in a continuous tide. Consciousness was multi-faceted and holistic, the simultaneous occurrence of its innumerable elements, the immediacy and compresence of these sensations with those feelings and memories and that mood, in this place, at that time, the essence of its character. Reason could work only at second-hand, removed from the source of its data, selecting, generalizing, abstracting, taking events one at a time, in isolation; breaking the bonds of simultaneity, occurrence, inventing, distorting and destroying its data and offering *ficta* in their place. This was the tenor of the views that developed as the romantic, irrationalist reaction against the French Enlightenment among the romantic poets in England and in the German movement that came to be known as the *Sturm und Drang,* and that has grown into the wide, modern, irrationalist movements in the present day.

1.3 Rationalism, Non-rationalism and Individual Taste

The dichotomy between the two views, that supposing a basic rationality in all things, human values and social arrangements as much as nature and the physical world, and the preference for reason as a method of knowledge, and, opposed to it, a relativistic attitude to truth is of course neither clear-cut nor unchanging, not to be taken as absolute. Indeed, at different times, in the thought of different men, similar arguments have been brought to the support of both outlooks. What at one period, from one viewpoint, may be interpreted as belonging to or furthering one argument, in another may appear as evidence for its opposite. But what is constant, what runs as a distinction between thinkers, whichever way belief turns, is the existence of a division of approach or emphasis or spirit that identifies what have perhaps always been distinguishably different fields of human inclination or effort, those that lean towards the analytic and deductive, and those that place a higher value upon experience and life.

Both Voltaire and Rousseau share the dominant belief of their time, that all human beings everywhere, always, once freed from what clouds their understanding, will desire, and therefore freely choose what is natural to them as part of the harmonious order – and identical in all cases – those paths that clarity reveals that lead to happiness, wisdom, virtue, justice and liberty. Yet, what to Voltaire appears the value of reason as a civilizing force leading men away from the ignorance, superstition and barbarism that perverts their vision, and delivering them to their natural goals, to Rousseau presents itself as the source of men's doubts, the civilized confusions that are the corruption of natural man and the major obstacle to a life of purity, justice and harmony with others.

The difference between these views, as between belief in reason and the deeper forms of irrationalism, reflects a difference of perspective among their respective proponents; a preference for knowledge acquired by description and analysis or for that received by means of the immediate acquaintance of the senses; for what is public, objective and criticizable, or what is personal, private and not open to question; for the general or the particular; uniformity or variety; for the absolute and eternal, or the passing moment; for absolutism or relativity in human and social values; for interest in the mass, or in the individuals that comprize it; for emphasis of the universal and unchanging qualities of human nature, or concern with the differences between individuals and societies in different periods and places and circumstances. The difference of preference is all-pervasive, dividing human interest and objectives. Among the men who have inclined to one side or the other, the division reflects a distinction of affinity, a difference of taste or of temperament; the separation of the philosopher and the poet, of sense and sensibility. Those to whom reason appears the sole reliable source of knowledge place value upon detachment, a drawing back from reality, a standing aside from events, a choice of objective contemplation and reflection

over engagement and action. Those who have doubted reason's powers have sought experience, life itself in some form, action, sensation, feeling, memory and the fullness of the interplay between them; or a world of myth, faith, devotion; of art and creative power, as the only true ways to knowledge.

Among workers in the humanities, and especially the arts, writers, whose work by its nature demands a distance from events but whose concern is with experience itself, have been led to inner conflict and unhappiness. Byron, Baudelaire, Rimbaud, George Sand, Flaubert, Tolstoy; in our own time, Maurois, Orwell, Hemingway — the list is a long one — show evidence in their lives of ambiguous feelings, often destructive, directed against themselves and their work, arising out of the inaction dictated by its discipline and, opposing it, the desire for direct influence upon or participation in the events and experience that are its subject. For a commitment to and belief in the pre-eminent importance of the immediacy and directness of experience calls for an immersion in life and living, a need for continuous, intimate contact with the world and with people, a running together with the ever-changing, uncontrollable, unpredictable richness of sensation and feeling, the here and now. Experience is immediate, particular and concrete. Every instant consists of a particular combination, a compresence of innumerable elements, unique and unrepeatable. It makes up a single whole that cannot be dissected into its parts without destroying its vital element any more than if it were a living creature. If it is not to be lost beyond recall, it must be attended to with absolute awareness, the total participation of the whole being. The orderly, formal, obedient, timeless spaces of reason, of analysis, deduction, experiment, classification, the unawareness of present happening that generalization and abstraction or the sameness and habit of repetition breeds, are an avoidance of the suffering and so a denial of the never-ending, never-repeating flux of sensation, emotion, memory; an illusion, a numbness in which life seeps away in easeful unconsciousness.

These extreme positions share little common ground. To take up reason is to abandon life; to enter life, to seek experience, to find moral impulsion in faith, belief unsupported by argument, is to put reason out of reach. To those immersed in being, living, feeling, the achievements of science, utilitarianism, common sense appear shallow, dreary, unimportant; concern with practical problems, calculation, commonplace and vulgar; restraint, doubt, prudence, suspicion, narrow and pusillanimous. To the rationalists, the protagonists of intuition, imagination, genius, flashes of insight, inspiration are not to be trusted; the appeal to authority, tradition, faith, mysticism; to myths of tribe, race, blood, language, seem reckless, dangerous, barbarous. To the adherents of each side the other's method and objectives appear misguided and insignificant, its criticisms irrelevant, its propositions untrustworthy. Within its self-defined boundaries, each side is unassailable by the other. It is the peculiar virtue of irrationalism, myth, mysticism, in the view of its exponents, the German anti-rationalists, or

the early romantics in England, for Blake or for Keats, that it is not objective and rational, not representative of nor dependent upon reality; for this makes it share with direct experience the quality of absolute mental being, not open to question or refutation or others' doubts. It is because of, not in spite of this immunity of irrationalism that it offers a spring for action, a source for creative power. Ancient, tried, resistant to the weakening corrosiveness, the deadening undermining of the heroic spirit represented by analytical intellectualism, it remains an inspiration to moral strength, vitality and courage.

And as reason cannot touch irrationalism, so irrationalism's own urgings can make no impression upon reason. For the rationalist it is the major strength, the defining character of analytical method that it is able to dissect experience, to break it down into its component parts, to freeze it, making it possible to reflect upon it after it has passed, in calm contemplation, to dismember, abstract, deduce, generalize. It is its virtue that it does not reach its conclusions from raw data alone but tests its hypotheses to destruction or else increases their plausibility by failing to destroy them; that it seeks constantly, as its ultimate criterion of truth, to match its conclusions with objective and publicly observable reality.

1.4 The Roles of Science and the Humanities

Since the Enlightenment, the two separate domains, reason and experience, have come, by a wide consensus, to be seen as represented respectively by science and the humanities. To science are supposed to belong pre-eminence in deduction, observation and critical analysis; while to the humanities is allowed much of the credit for the exercize of the imaginative faculty, the powers of original thought, of invention and creation. Within this widely accepted view, science appears the purest, the most developed, the most refined expression of rational method; going beyond the requirements of common sense or the approximate certainties of *le bon sens* of Voltaire – the imperfect, though for life's purposes sufficient, tempered answerability to reality that good sense calls for – to a demand for rigour in inference and generalization, precision of agreement with observable facts, the sceptical evaluation of conclusions, and a ceaseless criticism and testing of hypotheses by continuous, hard-headed questioning and search for error, pressing probabilities always closer to certainty, approximations to greater exactitude.

This activity, however – so is the widely received impression – has little to do with creative originality, which remains the preserve of the issues, aims and methods of those who work in the humanities, particularly the arts. Art, from this outlook, owes nothing to the empirical answerability demanded by science, to deductive rigour or critical scepticism. Its offerings, it is supposed, are entities in their own right, needing no reference to a reality outside themselves to give them legitimacy. They are concerned with experience, with feeling and sensation

that represents truth *per se*. This is the view of art developed by the romantics following, and in reaction against the rise of science's authority and the rationalism of the Enlightenment, when the rift first properly appeared between science and the humanities the lines of whose divisions still dominate the classification of human intellectual activity. Whatever imaginative elements scientific thought may require, scientific method fetters imagination and art remains the imaginative exploit *par excellence*. Moreover, any creative content in science represents imagination's contribution grafted onto or superimposed upon the reason that is its true preserve. Closest familiarity with reason's workings is the possession of science whose pre-eminent understanding of reason's proper nature and use are not enjoyed by those less intimately connected with it.

It was in the seventeenth and eighteenth centuries that science came of age. Its achievements appeared profound and permanent. They were demonstrable and often spectacular. Its prestige grew and with it its sense of certainty. Nowhere else in the history of ideas was it possible to point to such an evident progression of achievement, with new understandings building one upon another in a sure and seemingly inexorable advance towards ever more comprehensive knowledge such as not even the Renaissance could match. With science's achievements grew the belief that reason was the skeleton key to knowledge and understanding of all kinds, not simply of nature, but of human affairs as well. Human beings were part of nature, and so the method that had made such strides towards the understanding of the physical world was bound to work as well when it came to human relationships and activities, and the values, customs, laws and other social arrangements to which they gave rise. The application of reason made steady progress possible in the whole field of human knowledge, whether of physical nature, of psychological or social questions, legal systems, history or the arts. To reason, particularly in its scientific form, the world presented itself as so many problems or questions, solutions and answers to which reason's application would, at least in theory, be able to discover or show non-existent. In either case reason's findings were absolute. They did not vary with place, time, custom or history, but remained the same for all men everywhere, at all times; universal and eternal truths enjoying an existence apart, independent of the flux and change of life and the world.

This outlook, with little modification, has persisted. It was the view of the positivists, of J.S. Mill, of Russell and Wells, and has remained the widely held belief of men working in the field of modern science, of J.Z. Young and T. Dobzhansky and Jacques Monod and P.B. Medawar. In the eighteenth century, the view of reason as the sole reliable method of understanding and knowledge, of the steady unfolding of truth through its method, was held not only by philosophers and scientists, but also by those engaged in the humanities, with history, legal systems, social questions, psychology and the arts. In matters of human achievement the idea of steady progress, rather like the progress widely

supposed to characterize the advance of science, became accepted. Even Wordsworth still believed that the Poet could bind together 'the vast empire of human society as it spread over the whole earth and over all time', a view which, however differently from science's way the task was to be accomplished, still owed its general outlook to the feeling of rationalist optimism of the Enlightenment. In the spirit of the time, science and the humanities still appeared much as part of a single enterprize as they had in previous times. Leonardo, or Dante in the *Paradiso*, are unaware of any sharp division between art and science, and for Pope a century and a half later, science and art still denote something similar: 'One science only will one genius fit;/ So vast is art, so narrow human wit'. Both are skills to be acquired; art somewhat wider, more encompassing, science more restricted and specific. Even for Shelley, in his *Defence of Poetry*, there is not yet a sense of separateness either between art and science or reason and imagination. Voltaire, who speaks for the Enlightenment more than any other figure, saw the technical procedures of scientific argument, science's axioms and inference rules, as applicable in everyday life, if with some relaxation of science's exacting rigour. *Le bon sens* was reason's translation into the everyday world, a form at once more elevated and more rational than what is associated with common sense, while at the same time less demanding than the pure reason of science, the precision and rigour that goes beyond the needs or the capabilities of reasonable men in ordinary human affairs.

Science's achievements had given its followers great prestige. Cultivated gentlemen and ladies interested themselves as much in science as in poetry, music, art, or architecture; and they might try their hands at all of them. In the last quarter of the eighteenth century it became fashionable to perform scientific experiments using the splendidly made instruments of brass and mahogany so beautifully conceived by the makers of the period. Joseph Wright's narrative painting, *Experiment with an Air Pump*, a scientific experiment conducted in a drawing room (involving the death of a cockatoo induced by/depriving it of air) illustrates the place that science had come to occupy, its intrinsic interest and novelty as well as the awe it could command. The scientists and philosophers of the time were part of the cultivated world. Hume was a favourite of the Paris *salons,* which were the meeting places of the Encyclopaedists, of d'Alembert and Diderot. Through the prose of Steele, Swift and Addison and the heroic couplets of Pope, in the paintings of Reynolds and Gainsborough in England, of Chardin in France, the current of reason flows with calm and assurance. And even among the neo-classical painters, from whose work the unheated serenity of the earlier period is beginning to disappear, David is still able to assert that 'the genius of the arts can have no other guide than the torch of reason'. Ridicule, satire, the heroic couplet and the mock heroic form are peculiarly at one with the detachment of reason, and the propositions of Cartesian geometry with the good manners of the *salon.*

Perhaps inevitably with the growth of such prestige, doubt was bound to retreat, certainty turn to absolutism, and a tendency appear for opinion to move to prescription. Science and reason were no longer simply lamps to light the way to truth, but truth itself – single, absolute, unchanging, possessing indeed those very attributes that their advance had so rationally stripped from the Creator, deciding, judging and legislating about every part of life, conduct and belief. The reaction had been bound to occur, and when it came it forced a schism between science and the humanities that has remained unbridgeable ever since. The seeds of the schism had long been germinating, and the reason why a rift had not occurred earlier was perhaps that science had never before been clearly enough identifiable as something different and distinct from the humanities, nor successful enough – as its spectacular advances had now made it – to induce reacting humanism to seek to separate itself as a kind of protection against it. Science had to come of age, to assert its own distinctive identity, acquire a separate *persona*, before it could be seen as fit to react against.

The reaction, when it came, was both profound and far-reaching. For Blake, by 1820, Bacon and Newton appeared as iron scourges over Albion, reasonings like vast serpents; heaven raged over the imprisonment of nature in a cage of scientific laws, laws that had unwoven Keats' rainbow and turned the awful into dull and common things. What moved the Poet was not knowledge, whose objects were those of a cold observation that deliberately turned aside from vital qualities, it was passion; *Tintern Abbey's*

> ... sense sublime
> Of something far more deeply interfused,
> ... and in the mind of man;
> A motion and a spirit that impels
> All thinking things, all objects of all thought,
> And rolls through all things.

Experience is no simple matter of cold observation. It is interfused with memory and feeling and the inner life of the mind; and the motion and the spirit of the vast, unceasing interplay of everything that is, the 'presences of Nature' that

> ... make
> The surface of the universal earth
> With triumph and delight, with hope and fear,
> Work like a sea.

It is in this spirit, which permeates their thought, that the romantic poets in England reacted against the whole-hearted acceptance given to scientific ideas by the previous century. The antagonism against cold reason is not intellectual or moral. It is a revulsion of feeling against a view of the world that appears, as

Whitehead (1925) puts it, to leave out everything that is most important. By deliberately eliminating experience from its observations, by avoiding feelings and beliefs and memories, by concerning itself with the general and the abstract while standing aloof from the concrete, the particular, the non-repetitive, the restless sea of changing sensation, science confines itself to a mechanical world of absurd simplicity and quite loses touch with the compresent flux of real life, the very heart of things. 'To generalize is to be an idiot. To particularize is the alone distinction of merit,' Blake says, with an Olympian sweep from which the most generalizing men of science would shrink in alarm.

It is true that science in the seventeenth and eighteenth centuries was peculiarly of a kind to justify such a view. It moved in a confined sphere, principally of inanimate nature, a rarefied world of idealized objects and phenomena, of dimensionless particles, frictionless motion, prudently restricting its endeavours to such contrived and limited problems as promised success to the methods available to it. When the wonder had passed, the fascination at the power of its techniques to provide revelations about nature's workings, attention was bound to shift to what had been revealed, and people begin to wonder whether it touched the real world at all, the world in which men actually lived their lives; or whether the knowledge it provided, when measured against the infinitude of human ignorance, justified the great confidence, the optimistic vision of progress, and the prescriptive authority it commanded – just as the onlookers in Joseph Wright's painting may have wondered at the end of the demonstration what they had really learned from it, from watching the cockatoo suffocate.

1.5 Reason and Imagination – Two Methods, Two Realities

In this spirit of reaction to rationalism's high authority a new distinction came to be drawn between science and the humanities, in particular the arts, according to which art, especially poetry, and to a diminishing degree, according to their closeness to it, the other elements of humanistic concern, depended upon imagination, science upon reason. This difference reflected a view that received wide support from workers both in science and the humanities, though the value each placed upon the two faculties differed. To those concerned with the arts, imagination appeared a capacity altogether superior to reason, revealing a deeper, more exalted kind of truth, quite as different from that reason identified as the world in which it operated differed from reason's; not simply uncomplementary, but positively antagonistic. To science reason appeared more objective and reliable, less given to flights of fancy that bore its conclusions away from the objective, physical world of nature. It was less likely to distort understanding with desires

and beliefs about how reality should be, attempts to make it conform to some imagined ideal; better fitted than imagination for steady progress towards certain knowledge that would free men's minds from fanciful superstitions, prejudice and dogma, of which imagination was the very potent source. Moreover, despite their differences, by the nineteenth century the view of the creative superiority of imagination had come to be shared by rationalists and humanists, scientists and artists alike, and remains the view that has persisted to the present day.

It was believed by Wordsworth, Coleridge, Keats and Shelley. On the side of reason, among those who, in accordance with the official policy of The Royal Society, had renounced the florid luxuries of metaphor and rhetoric in favour of austere precision and plainness of language. It was a view held equally by Bacon, Locke, Hobbes, Mill and Bentham, by Voltaire and the Encyclopaedists, by Racine and Molière, Swift and Pope. For all these, to imagination belongs the creative faculty, along with all artistic and humanist concern; while reason and the method of science are seen as aspects of a single, though quite separate, form and pursuit. Where flashes of insight mark the leaps and bounds of imagination's progress, reason is to be found, with painstaking deliberation, piecing together its indestructible chains of clear and distinct ideas, joining facts and events with its links of rational inference, moving with inexorable and dogged certainty from (trivial) premises to (banal) conclusions. And if from time to time reason should employ imagination, as it must if it is to escape at all from the wholly commonplace, the constraints it places upon imagination are so severe that they quite deprive it of its power.

The difference between imagination or intuition, and reason is not so much qualitative as it is a difference of modes of operation. What intuition accomplishes by the virtually instantaneous rapidity that is the quality of mind or spirit, reason must achieve by means of a laborious and plodding 'calculus of discovery'. The great power that its vastly superior speed bestows upon it enables intuition to defeat mere reason, fleeting ahead — and this is the characteristic quality of imagination as it is seen to exist in the arts — beyond the reach of merely rational critics. Imagination's products can, indeed must, be taken on trust, first because imagination's vision and movement is transparent and unerring, and secondly because the workings of the critical faculty are altogether too slow, too ponderous to keep up with it. To bridle imagination is to deny it its greatest strength, its true character; to clip its wings, to cripple its soaring flight and hold it earthbound. To carp at its freedom, to doubt its insights, is to show a cold cautiousness, a meanness of spirit, a narrow, unadventurous prudence and lack of daring, a hum-drum mediocrity. 'If the sun and moon should doubt, /They'd immediately go out' (William Blake, *Auguries of Innocence*). Imagination, Coleridge asserts, 'is the repetition in the finite mind of the eternal act of creation in the infinite I AM' (*Biographia Literaria*).

Ironically, this view of imagination and reason and the differences between

them became current at about the moment that science's own understanding was leading to a greater recognition of the part that the imagination played in the rational process, as well as to a deeper appreciation of reason's limits. A profound change had taken place in science since its seventeenth-century beginnings. The biological sciences were supplanting the physical at the centre of the stage. And, in the face of the new complexity confronting it, it appeared that reason lacked not simply the ability to penetrate experience that Berkeley and Hume had shown, but was limited even as a tool of understanding and explanation. Imaginative speculation was coming to be seen as the medium of discovery. Discovery was an art; it did not obey fixed rules. W. Whewell, in 1840, had recognized difficulties in the concept of induction, whereby scientists are supposed to discover 'laws' of nature by extracting them in some way from numerous instances of their operation. W.S. Jevons, some thirty years later, was able to assert that induction, in this sense, did not occur. The notion grew up instead of a progress that comes about as a series of conjectured hypotheses, guesses at how things work, imaginative jumps, intuitive and creative — and probably differing little in character from the inspirational flights of the poet — modified as necessary by further guesses to match observed reality. The guesses go ahead of established facts and observation, which in turn offer tests of their accuracy. Error, if not the mother, is at any rate the midwife of invention. Today, scientists who have confronted the question seriously would generally tend to believe neither in reason's sufficiency for scientific discovery (though leaving discovery's answerability to reason unchallenged) nor perhaps even in its capacity to provide a complete account of the world — if resisting allowing a fuller account to any other faculty. Yet such concessions have proved insufficient to satisfy reason's detractors.

For despite the concurrence between their respective proponents concerning the characters of reason and imagination, there is little agreement between them about the values to be attached to each. If it took the emergence of science as enterprize in its own right to lead to open schism between it and the humanities, the antagonisms that underlie the break had been present at least as far back as Plato. Art is to be banished from the Republic: it offers 'no knowledge of value'. Indeed, as mere imitation, it positively misleads, interposing a screen of deception between mind and the reality and truth that should be its objects. Its effect is the very reverse of philosophy, which reveals truth by a process just the opposite of imitation, that of stripping away what lies between the objects of awareness as they present themselves to the senses, and the reality — the Ideas, of which sense objects are themselves no more than imperfect copies — that lies beneath. But this is not to be taken to detract from art's powers. On the contrary, art is to be prohibited precisely because of its plausibility, its 'magic charm', which gives it such a dangerous capacity to subvert and seduce the mind from the contemplation of Truth that is its highest calling. In one form, this represents

the belief in 'hard' facts. What really counts is the hard, material world and truths about it, not the isolated, conscious experiences of individual minds. The inferiority of literature to science, and so, *a fortiori*, of painting, music and other forms of artistic expression, is that it relaxes the requirement of conformity to physical reality that science accepts as its very basis. All that is demanded of literature is a kind of internal consistency, a quality of being 'believable-in', as Medawar (1972) puts it, which is no more than the minimum requirement for any 'structure of imaginative thought'. In this view, the divergence of poetic from factual truthfulness is not a matter of poetry's inadequacy, nor of its inability to represent reality, but of its failure even to attempt to do so. Science is alone in taking upon itself the burden of factual conformity, the need to pass the test of presenting what is actually the case. The content of science's ideas is more real than the behaviour of a character in a play or a novel, or for that matter a history; it may be verified by means of precise, objective criteria, securely tied to a world of publicly observable things; and, conversely, what cannot be bound in this way, what is not objectively verifiable, is not simply less tractable, but less real. It is here that the argument acquires its dogmatic, its moral tone: by severing its links with 'hard' facts, art is seen to become a deceiver.

The moral outlook of the tenth book of the *Republic* recurs in successive periods, down to the present, wherever particular circumstances and temperaments combine to call up echoes of Plato's thought or originate it afresh. The association of art and what is connected with imaginative enterprize with the morally frivolous asserts itself repeatedly; art is a mortal danger to men's minds and souls. This belief underlies the asceticism of Judaism and Islam; it dominates the thinking of the middle ages in Europe, appears in the midst of the Renaissance in the doctrines of Savonarola – born in the same year as Leonardo – and returns in the beliefs of the Reformation in Germany, of Calvin and his followers, and of the Commonwealth in England. For Francis Bacon, poesy 'filleth the imagination, and yet is but the shadow of a lie'; in *Emile*, Rousseau calls for fiction to be withheld from children because of its deceptiveness. Art is morally suspect. It is at once misleading, frivolous, trivial, impure, and potent, turning men aside from truth, irrespective of whether truth is thought of as belonging to religion or to reason or to the authority of government or the collective will of the majority. It is a belief commonly professed by those who have sought to dominate men's minds and actions, whether as rational philosophers or political or religious leaders; and is opposed by those others who have prized individual freedom and the autonomy of the individual mind above all public or collective concerns – German anti-rationalists, the romantics of nineteenth-century French and English literature, the *samizdat* writers of Eastern Europe. But, whether favouring or opposed to the imaginative faculty and its works, its force is inwardly acknowledged. Plato's injunction that 'poetry is not to be taken seriously' indicates the ambiguity of art's opponents, forced at once to take

poetry seriously enough to wish it out of the way, prohibited, and to dismiss it as of no account. It is an ambiguity not peculiar to the *Republic*, but familiar wherever, declining from the higher reaches of philosophical abstraction, states seek to bend their subjects' minds to particular ideologies or ways of belief. Irving Kristol (1979) mentions that Brecht, asked how he reconciled his loyalty to communism with the banning of his plays in the USSR, while he had become rich on his royalties in the West, replied, 'Well, there at least they take me seriously!' Art and opposition to it carry a powerful moral charge.

Rationalism and imagination lie outside each other's realms, beyond the reach of each other's arguments; and it is this perhaps that has forced both away from their own respective, central positions, to confront one another on the mutually accessible, neutral ground of morality. In the case of rationalism, it is this that has intensified the ambiguity of feeling associated with rational opposition to imagination. The ambiguity is seen at its sharpest in Freud's attitude to the arts, to which he is not simply attracted but where he acknowledges a persistent and continuing indebtedness. Literature is of profound importance in the formation of his thoughts: as Lionel Trilling (1950) says, 'the effect of Freud upon literature has been no greater than the effect of literature upon Freud'. And the former has been considerable; in Auden's (1979) words, 'the importance of Freud to art is greater than his language, technique or the truth of theoretical details. He is the most typical . . . representative of a certain attitude to life and living relationships'. Freud says of himself that he resorts to literature often before clinical evidence. Psychoanalysts are only repeating scientifically what writers and artists have always said. Yet the praise of artists' and writers' insights turns to dismissiveness when serious questions come up. 'Art does not seek to be anything else but an illusion . . . it never dares to make an attack on the realm of reality' (Freud, 1933, p. 205). Enjoyment of works of art is simply 'satisfaction through fantasy' (Freud, 1966, P. 80); literature merely an intermediate stage of the mind on the route to rationality (Freud, 1960a). Successful psychoanalysis, by rendering him rational, will destroy the artist's creative urge. Rationality, in short, transcends art.

Indeed, such a view is a natural extension of rationalist thought. In a rational society, Marx believed, art would vanish. Art is marginal. By implication, at any rate, it is a second-best to reason. Explicitly, this is the view of positivism, which looks forward not only to unifying all science, but to its own subsuming of all human knowledge within a single perfected language, capable of dealing equally with all categories of expression of the human mind. Poetry and art, according to Von Mises (1951), are makeshift arrangements for communicating experience of 'states of consciousness . . . in areas of life not sufficiently explored by science'. Poetry, as C.K. Ogden and I.A. Richards (1923) have held, is not, like science, concerned with knowledge, but is to be associated more with 'evocative language'. Where science makes statements poetry makes pseudo-statements

(Richards, 1976). Poetry admits of a kind of simulation of experience by means of linguistic forms that have been created for that special purpose, a method inferior to the description that would be possible with a more adequate, unambiguous, non-metaphoric, logically perfect, universal linguistic tool such as was looked forward to by Leibniz and by Russell. This was something akin to the language of the propositional calculus, or what emerges in our own time in the ideas, like those of the developmental psychology of Piaget and his followers, deeply embedded in the European positivist tradition, of pure mind – mind operating upon mind, far from the world of feeling and sensation – as the highest form of mental development. At best art is a stop gap, a temporary expedient awaiting rationality's inexorable advance, in the form of science, to make it obsolete. At worst it is a seducer, a corruptor, an opiate, more pernicious perhaps than religion itself for the cultivated mind, to unfocus the reason and distort the judgement, to obscure men's moral interests and turn them aside from truth. 'I love poetry and am moved by it,' B.F. Skinner (1981) claims, 'but it is basically a kind of fraud. It is truth for the moment, to match or support a feeling and like music is justified accordingly. But it must not be taken seriously. Or permitted to interfere in serious matters.' This is a view that suspects all but hard facts, and it forms the basis of rationalism's opposition to imaginative enterprize, animating the recurring belief that art deceives and perverts mens' minds.

Opposed to this view of reality, of knowledge and understanding, is the belief that life, human mental life, has a character altogether apart from the concerns and methods, from the very reality of science; that, as Wittgenstein says in the *Tractatus*, 'even when all possible scientific questions have been answered, our problems of life remain completely untouched'. Art – and the humanities generally – approaches reality quite differently from science, in the very way science deliberately avoids. The humanities' interests cover a vastly greater range and variety than science's; its concern is of a kind that is the very reverse of the pattern of scientific experiment, which seeks to limit the number and degree of changes of its variables. As a result, the questions of humanist study tend to be wider, more subjective, less clearly decidable, and associated with wider margins of error than those of science. This does not reflect a weaker desire or purpose on the part of the humanities to represent reality, nor any want of interest in precision, but follows as an unavoidable consequence of the nature of the reality that is its subject matter. The entities and theories of science, depicting as they do a reality artificial, contrived, inferred, unobservable, idealized, are every bit as, in Whitehead's (1925) words, 'strange and paradoxical', as seemingly unrelated to the hard facts of the world, as the conceits of poetry or the abstractions of music. The difference between scientific and poetic truth lies in the verifiability or, more particularly, the falsifiability of science's theories. The predictions of Relativity theory may be

tested and the theory modified or discarded according to the tests' outcomes; the same is not true of Wordsworth's view of nature. It is not the poet's intention to present truths of the same kind or in the same way as science. The humanities, in particular the arts, are not concerned with objectivity but with experience; and experience, never passive, always involves an interaction between mental life – the multifarious, conscious presences of the mind – with the real world of people and things; the admixture of feeling, sensation, memory, the inner world of mind, with the events and circumstances of living.

This difference between art and science is common cause between workers in both fields. It is science's peculiarity and strength that it concerns itself only with what can be objectively verified: that it can, as Popper (1972) says, 'face' its theories. This may greatly restrict its fields of enquiry – the laboratory may set out to reduce the very fibre of life to unimportance in order to allow the concentration of attention upon some single factor; scientific theories may construe hypotheses to account for events as exotic and bizarre as any imaginative construction of art; but all this is justified, because it can be verified objectively, or, in the end, shown to be false. Atoms, electrons, quarks, genes are not mere fancies; they behave predictably; they are, in this sense at least, real, independent of the mental life of their observers. But where science seeks to eliminate the mental life of individuals in order to achieve the objectivity of its observations of the world, art adopts just the opposite aim, seeking reality in experience itself; it does not merely intentionally preclude, but actively discards science's objectivity in favour of its own more private instruments, intuition and imagination.

1.6 Understanding Human Affairs

Inevitably, with the differences between them of outlook, of spirit and intention, science and the humanities would conflict in their approach to human affairs, and it was in this that the differences between them became most obvious. The question was whether human society should be understood through the experiences of its separate members – the relationships between individuals, the personal lives lived by men and women, their loves and hates, their differing temperaments and the accidents of their circumstances – or by the application of reason, the use of abstraction and generalization for the scientific discovery of universal, timeless laws governing its workings. Peculiarly torn between these two possible approaches to the understanding of social matters is the study of history. Seventeenth-century science disowned history: its narrative form was manifestly inaccurate, its sources, questionable, its judgements partisan, and much of what it offered in the name of knowledge, besides being unreliable, of little interest or use – in the current phrase, relevance. Cicero's servant girl, Descartes declared, knew as much about ancient Rome as the greatest classical scholars. Tedious catalogues of battles, wars and dynasties were mere

curiosities without value. If it were to compete with the knowledge pure reason provided, history needed to offer more than this. Voltaire believed that history should be instructive, illuminating the achievements of the great ages of man, and offering accounts of human stupidity and barbarousness as cautionary tales.

The *philosophes,* the utilitarians, the positivists, Hegel, Marx professed a belief in the impersonal study of human society, according to the rules, methods and objectives of science, in a search for universal, abstract principles, true at all times and for all societies; and so, by implication, of a society amenable to rational control, capable and desirous of being brought to a condition of permanent peace and self-fulfillment in conditions of order and harmony. Differing altogether from it is the view of a world of variety and change, of life and human affairs and values founded in constant flux, in which place and time are particular and concrete, reflecting always unique circumstances of life. This outlook is less inclined to see human society as perfectable, viewing it rather as perpetually changing, an holistic entity of which desirable and undesirable elements alike are part.

The difference of approach to history between the rational and scientific and the non-rational or anti-rational, cuts right through the study of human affairs, social, political and legal studies, anthropology, psychology; the rational side, purposeful and prescriptive, resting upon belief in discoverable laws, timeless, absolute and immutable, to which all men will naturally yield once they are made clear; the non-rational leaning towards a belief in the individual; in human experience attached to time and place; and mistrusting to a greater or lesser degree the idea of the world as an ordered whole obedient to laws of whatever kind, even if it is accepted that they are undiscoverable. In either case, the outlook dictates the method: for the general, abstract view and the search for universal, timeless truths, reason and the method of science are naturally suited; while understanding particular living experience calls for other techniques. Practice, of course, does not reflect these diametric differences, which are bound to remain in large part no more than the goals of effort. It is no more possible to reduce the description of human society and conduct to universal absolutes than to make sense of them in the full richness and particularity in which they occur. And historians and sociologists are alive both to the need to understand and interpret within the context of a real, everyday world, and also to verify predictions and hypotheses against real observations in a way that makes some degree of general theory and abstraction unavoidable.

Yet this practical awareness does not remove the difference in emphasis that reflects the conflict between different realities; a conflict not simply because no single method exists for the description and understanding of both realities, but because the method appropriate to describing each makes description of the other impossible. To depict life and living experience, personal relationships, the inner springs of human conduct, the stream of consciousness and of emotion,

precludes constructions of human affairs such as those of the social, economic
and political sciences, those abstract, generalized schemes that lend themselves
to prediction and objective verification. To submit the world to reason, to apply
the methods of science in order to arrive at universal and eternal truths, to
attempt to make verifiable predictions and discover objective laws, demands the
deliberate reduction of experience, the avoidance, the stripping away of its very
character, its subjective particularity here and now, its multifaceted, unpredict-
able, uncontrollable, unanalysable flow of events. And the conflict between
these realities, between the reality of particular experience and that of timeless
universality, carries over to those pursuing them, each form appearing to its
adherents as of predominant importance and to those opposed to it as trivial,
transient, lacking penetration, value and truth.

To workers in the humanities, especially those concerned with the arts, the
objective truths of science appear to belong to the least important part of life.
Even allowing that science may in fact some day be capable of major achieve-
ments in the fields of psychology and sociology – however unpromising the
hitherto insignificant advances in these areas may make this seem – of making
discoveries about human arrangements and about the inner, private world of
men, equal in importance to its successes in the external, physical one, it will
still be missing all that is most important. It is not specific enquiry and discovery
that will reveal the realities of life and the world, since the important questions
are those of which we are unaware, the questions submerged in our selves and in
the total reality, of which our mental and physical makeup reflects a kind of
embodiment. We are unconscious of what we are or what we take for granted, or
even that we do so. Experience is not simply *of* the flux of life, life *is* the flux
itself, of which all notions of objective, detached observation are a fiction bearing
little connexion with any important element of reality. So, explicitly, Hamann,
Herder, Bergson, Kierkegaard, Heidegger, Tolstoy, in our day the French existen-
tialists, have attacked those shallow, unenduring explanations of events that
offer neither insight nor understanding, that lose reality by disregarding the very
quality, the concrete uniqueness in which it resides. This uniqueness, is what is
real; this 'inscape', as Gerard Manley Hopkins called it, what makes a thing
itself and distinguishes it from other things, not the common, abstract quality,
the *quiditas* in which it may participate with them. It is for losing this particular
reality in shallow generalities that Virginia Woolf (1950) accused Galsworthy,
Wells, and Arnold Bennett of being concerned with the least important, the most
diffuse and superficial aspects of life, political and economic questions, mechani-
cal matters not touching upon the directing values, the events of individual
experience and individual relationships and individual temperament, feelings and
awareness. Their books 'leave one with so strange a feeling of dissatisfaction. In
order to complete them it seems necessary to do something – to join a society,
or, more desperately, to write a cheque. That done, the restlessness is eased, the

book is finished' (p. 99).

Some sixty years earlier, Nietzsche had already taken the terms of objections of this kind well beyond this point. The question of the treatment of events in literature was only partly a matter of choice; literature could never deal with true reality because of the nature of language itself. Reason's successes are illusory because language, the vehicle of its arguments, is based on an illusion. Reason defines reality or 'truth' as what it reveals, and then proceeds to claim the credit for revealing it. In fact the opposite is the case; language hides reality from us. Language's purposes are pragmatic; they would be undermined by the shifting footing that reality provides. Language therefore manufactures the illusion of stability and security by burying reality out of sight. If there is any chance at all of escape from this world of illusion, it is art alone that may be able to provide it; aesthetics, in which language may recover some of the original freshness, suppleness, sensuousness that long, unthinking usage has staled and hardened.

An idea of a similar kind is taken up by the symbolist poets in France, and later developed by the imagist movement in England and America, by Pound, Eliot, Joyce, in an attempt to revivify language, re-endow it with the immediacy of concreteness and particularity. Finally, it is a matter of preference, of taste; in Samuel Beckett's words, the choice is between 'Suffering — that opens a window on the real and is the main condition of artistic experience, and Boredom — with its top-hatted and hygienic ministers' (p. 28).

With varying emphases, this roughly is the case for non- and anti-rationalism. For those drawn to reason and rational argument, the world of experience appears too intractable, imagination too private and lacking in answerability to public, observable reality, its categories too vague and ill-defined, to offer useful knowledge; the reality in which it deals seems no reality at all, and its truths no truth. The conflict between the non-rational and the rational outlook is that between experience and imagination and, opposed to them, objectivity and reason; between selfhood and detachment, otherness. For rationalism's opponents, experience combines with the intuitive faculties of mind the presences of the physical world, enriching perception, awareness, apprehension of the external with the inner life of imagination; while reason, by denying personal involvement, turns reality into a bloodless fiction. Selfhood is particular and its world particular to it, transparently revealed to its direct awareness, its intuitive insights untrammelled by critical constraints. Reason sets self aside and makes its concern objectivity, what exists without self's intercession, escaping the transience of particularity for the durability of general truth, timeless and all-encompassing.

The aim of rationalism is to stand outside experience — outside the world itself if it could — deliberately denying itself the priviledged, the direct, the 'inside' view that experience provides, in order, indirectly, by inference and critical analysis, to construct a unified picture of all there is, withholding too ready credence of what imagination dreams up, putting dreams to trial in the

world of facts, accepting only what stands up to the test of reality. In support of its claims, it points to its concrete achievements, its objectivity, its progressive nature, with discovery building upon discovery, reaching always higher, approaching always closer to the universal knowledge that is its goal. To the proponents of imagination and intuition this ideal remains both trivial and illusory. For them the question is not one of setting aside critical analysis or failing to acknowledge the need to match to experience some notional, other reality that exists 'outside' of and apart from it. No such other reality exists; experience is reality. And the only effect of rational criticism is to destroy the divine spark that belongs peculiarly to spirit and imagination, the *power to create*.

2

Science and Order

2.1 Being and Becoming

The nineteenth century saw the birth of two scientific theories that were to assume a place of great importance and influence in shaping subsequent thinking, not only in the field of science, but in the understanding of man's place in the scheme of things, indeed in the appreciation of the very nature of the world. They were theories that reflected the age's divided view of its achievements and of the future they promised; a mood of optimism and a belief in progress and, opposed to it, a shadow of fear and doubt cast by the price that the progress seemed to demand. The first of the two theories made its appearance in 1859 and quickly captured the public imagination, taking its place at the centre of a battle whose contentions reached out from science, to penetrate deeply into the theological and religious, as well as the political ideas of the day. The second came in 1865, though its significance became evident only gradually. The intent of the two theories appeared to point in opposite directions, and produced by the opposition a confusion that troubled scientists and philosophers and has continued to do so to the present. The first theory, though it seriously injured many of the most deeply-held beliefs of the time, succeeding at once both in undermining the basis of Christian dogma and in severely damaging the foundations of rationalism, was itself optimistic in outlook, and in harmony with the broadly-held belief in progress that characterized the predominant feeling of the age's spirit, even justifying the methods, the unbridled competitiveness, the *laissez faire* economics, by which much of the progress had been achieved. The second theory, though highly abstract in its wider implications, reflected a view of deep pessimism that looked forward ultimately, in the words of Ludwig Boltzmann, to universal heat death, an end to time itself in universal nothingness. The theories were, of course, those of evolution and entropy, or in its more generalized formulation, statistical mechanics.

Underlying both theories is the notion of order, interpreted in the widest sense as structure, form, pattern, organization. It is a concept that is able to provide a framework within which to understand both aspects of the world's dichotomous reality, that represented by reason and its hard, external, observable,

continuing, public form, and the other, by the non-rational, as it reflects the individual, passing reality of private experience. In thought and in the world itself, order is the expression both of existence, and of its corollaries, creation and extinction; the principles, respectively, of the survival, persistence, endurance, of what is, of being; and of change, the appearance, the coming into being, the becoming of what is new and original. What I wish to suggest is that, between the characters of these two principles as they apply to the concept of order, a parallel exists with the characters, respectively, of reason and experience.

The two principles, becoming and being, although not logically opposed, in practice are antagonistic. What is original, simply by making its appearance, alters the conditions from which it springs and so threatens the existence of anything that depends upon those conditions to survive. For what exists, such novelty represents the disruption of fixed order, the transgression of rules. What is new is unknown and therefore unpredictable. It is indifferent to the demands of continuity, disregardful of progress along the established course; its newness and originality is particular, individual, concrete. The essence of the new – its newness – is just this uniqueness, this distinguishing difference from other things, not any universal quality shared with them. Indeed, from the point of view of what is, creation and destruction are indistinguishable, both equally inimical to survival. Survival calls for the opposite of the qualities and conditions that both creation and destruction bring about; for what exists to continue to do so, without the need to adapt to the new, to modify itself in ways that may be impossible without its altering to become something else, conditions must remain stable and predictable, adhering to the unchanging rules of the present, free from chance disturbance, regular, repetitive, conforming to an invariant pattern.

These opposed characters of change and survival are not contingent qualities; they are intrinsic within the principles themselves, existing both prior to and independently of experience or observation of them. They do not represent ways of looking at the world, but rather ways *of* the world that different ways of looking at it reveal; and it is in this that the parallel exists with rational and irrational methods of knowledge. Reason, controlled observation and the techniques of the natural sciences, particularly the use of mathematics, has as its objective the discovery of universal laws. This character binds it to yield knowledge of just such a world; one in which change is apparent and underpinned by the changeless regularity of a fixed and continuing reality. Experience – particular, concrete, immediate – is excited by the shocks of newness, the transgression of tradition and the disruption of the *status quo*. It is not merely attuned to, but by its nature makes its very aim the revelation of, change and flux, of the coming into being of new orders and relations, variety and surprise. The discovery of a world fitting this search, then, is more than simply an expression of belief about the world's nature, it is the inescapable result of having this aspect of reality as the sole source of knowledge. What is new, original, constitutes the

fibre of experience, with the shock of change, a source of threat, fear, pain, suffering, awakening the mind, sharpening the senses, animating the emotions. What persists unchanging nullifies experience, dulling sensation with habit, expectation and excitement with sameness, blunting alertness with abstractions, and constructing, in place of a world of becoming, one secure for quiet recollection, a place for planned observation, deliberate experiment, cautious hypothesis, assured generalization; an hygienic world, without improbabilities or surprise, in which reflective reason may make its steady progress towards the discovery of the eternal laws and principles within which it exists and functions. And the parallel that exists between the characters of survival and change, and those respectively of reason and the non-rational, experience, emotion, will, is not a matter of chance; it is inherent as the link between distinct methods of knowledge and the distinct kinds of knowledge each reveals.

Now these categories of (the) creation and survival (of order) are at once disjoint and exhaustive: all that is original is unlike what has preceded it; and, conversely, all that is like what already exists is not original. Since, therefore, knowledge arising from the application of rational method is confined to the domain of what persists, whether in a static, unchanging way, or through the steady operation of invariant laws departure from which incapacitates rational analysis, and since the immediate and particular, the unrepeated compresence of facts that make up the individual instant, are the data of experience alone, the choice between these distinct methods of knowledge that lead to separate views of the world is not, as their respective proponents have claimed, one between two possible truths, one real and the other illusory, but a choice between distinct and different realms of knowledge, reflecting separate, though equally valid, aspects of reality. The outlook that I wish to advance represents a departure both from the idea that the world is a single system, wholly accountable to reason and to reason alone, a view which the belief in rationality has taken as its greatest strength, and also from the equally vigorous insistence of more extreme anti-rationalists that the knowledge reason furnishes is empty and illusory. The differences and opposition that have divided and still divide beliefs in rational and non-rational methods of knowledge — the sense of the emptiness, of the apparent hollowness of reason when it is brought to bear upon life and experience, which has troubled many rationalists almost as much as believers in reason's non-rational alternatives, and the mistrust and fear of irrationality experienced even among non-rationalists — reflect, according to this view, differences of reality itself. The inference, if this outlook is correct, is that the claims of rationalists and non-rationalists may both be valid without inconsistency. Being is one *aspect* of reality; it is the aspect towards which rational methods of knowledge are directed and so most effectively reveal. Becoming is equally an *aspect* of reality; one to which living experience is attuned, but that largely escapes the methods of reason and science. Neither being nor becoming represents all of

reality, nor are the claims valid of either rationalists or non-rationalists to exclusive prerogatives for revealing truth.

2.2 Redrawing the Map of Science

It is a commonplace that the growth of science witnesses a progressive narrowing into specialized regions of what, to Leibniz — though he was probably the last man for whom it was so — had presented itself as an undivided territory of knowledge. The processes of intellectual enclosure, the division of open areas into segregated fields has been accompanied, within the divisions, by a more vigorous husbandry: footnotes in scientific works grow into chapters, into volumes, 'disciplines', with ever-expanding frontiers of specialized knowledge annexing new tracts of virgin terrain to their own esoteric preserves of orthodoxy and jargon, for the intensive cultivation of their own specialists, to produce, as Minsky (1972) has observed, their own crops of textbooks, journals, university departments, learned societies, seminars, councils and international conferences. Alarm at the damage to science's progress that these propensities inflict appeared early: they led, it was clear, to the needless duplication of concepts. Disguised by language peculiar to their origins, ideas of value already discovered went unrecognized by those not suitably qualified to grasp them; concepts of great usefulness needed to be hard-won in one domain, though they had long been the stock-in-trade in another, where unfamiliarities of terminology and context hid them or made them inaccessible. Aggravating such difficulties, the existence of boundaries within knowledge's realm bred, among those they confined, a reticence about trespassing even upon neighbouring terrain, a cautiousness over the exposure of the securities of reputation and position to the hazards lying in wait for too-intrepid venturers onto the unfriendly soil of foreign specializations. Generally, it was preferable to push deeper into the unknown hinterland than become an explorer in the charted but heavily defended domain of some other speciality.

And so it seemed to numbers of people working in science, to physicists and chemists and biologists, to mathematicians, and those concerned with methodology and science's philosophical basis, that the boundary regions of the separate sciences promised a rich harvest of discovery for people properly qualified to investigate them. To Norbert Wiener, for instance, as to many of the wide circle of those who like him were involved in the nineteen-twenties and thirties in such questions, it appeared that there might be whole classes of problems in certain areas to which the best and perhaps the only solutions originated in others; regions, however, against which entrance was barred by the consequences of the particular form science's advance had taken.

In some respects, the coalitions and collaborations that followed attempts to deal with these difficulties left early promise unfulfilled; enterprizes begun in

optimism led to disappointment. The 'study of control and communication in the animal and the machine', as Wiener defined cybernetics, which emerged in 1946 partly as a result of such attempts, has failed, after thirty-five years, even in marking out its own particular boundaries. While this is no doubt partly cybernetics' triumph, due partly to the very aims that it set itself, it remains an achievement that confers upon the subject itself no obvious benefits. A 'subject' needs a property of its own, and cybernetics is hard put to lay claim to one. Indeed, many advances that properly belong to it have been lost to those very regions that it had been its intention to subsume; to areas of investigation connected with computers, electrical and communications engineering, neuro-physiology, the study of organization, logic and mathematics. Moreover, concern with ideas lying in areas between the distinct disciplines of knowledge has too frequently failed in its promise, yielding instead of fruitful discoveries, an indiscipline of method and critical standards, a climate often better suited to superficiality and plain silliness than any more nourishing growth. This may be a cautionary tale. Boundaries are never easily redrawn nor sovereignty lightly surrendered. It was perhaps over-optimistic or naive of those who originated these idealistic objectives of redefinition to suppose that it might be otherwise. At the same time it would be quite incorrect to conclude that unifying efforts in science – the movement towards realizing the idea of a general calculus of discovery to which Leibniz had looked forward, and which had been adopted by Comte and his followers, and in our own century, by the Vienna positivists – attempts at increasing the accessibility and so the generality of ideas and concepts, of focusing attention upon the neglected borders between isolated regions that led to the emergence of widely-based projects, like those of cybernetics and general systems theory, have not been profoundly important, if not altogether in the way anticipated. For what set out as an attempt to permit greater freedom of movement within the body of scientific knowledge, achieving perhaps only rather modest results, has yet brought as a by-product an outlook upon which to base a unified vision of the world itself, a general view within which all facts may be interpreted, those susceptible to the observations, deductions and abstractions of rationality, as well as the objects, events, ideas, even sensations and feelings of experience. In this respect, it is a view that offers a basis for the realization of the ideal of rationalist and positivist thinking from the time of the seventeenth century, yet without violating, as previous attempts along these lines had done, the spirit of experience, of the holistic qualities, its transitori-ness, that non-rationalists had claimed was the inevitable consequence of such methods.

Cybernetics achieves this capacity from its development as the abstract study of order itself; order that may be conceived in the dual aspect of order in thought, in understanding and knowledge, most particularly in rational argument and the formal structure of reason; and, more fundamentally, order in the world itself,

in the relations of the elements, the things and the events that the world comprizes. Within this framework cybernetics is able to represent both rational and non-rational methods of knowledge and the realities they comprehend, while avoiding appeals to incorporeality and similar mysteries, and consequent conflict with the materialistic outlook, or the contradictions that arise between separate sets of beliefs founded in opposed viewpoints; between rational and non-rational, between science and imagination, deduction and intuition, the public, objective and observable, and the individual, personal and unshareable.

2.3 Materialistic Explanations

Cybernetics, particularly the study of artificial intelligence, has furnished powerful arguments and evidence for the sufficiency of the physical world alone to account for mind's existence. Craik (1943) provides a detailed justification for 'physical explanations' as being those that cover 'the most facts by the fewest postulates and leaves the fewest anomalies outstanding' (p. 49). McCulloch (1965) made it his self-appointed life's work to delineate the 'Embodiments of Mind', showing at least the theoretical possibility of making physical components that reproduce mind's attributes. The classical expositions both of Turing (1950) and Ashby (1965) have demonstrated the theoretical adequacy of physical machinery for capturing mind-like qualities. And pattern recognition, problem solving, inductive and heuristic programming, together with many related enterprizes have been at least primitive, practical demonstrations of the theory. Minsky (1965) even suggests what it is that leads to the claim for the existence of uniquely human qualities, offering an hypothesis in terms of man's self-models. He uses the term 'model' in the sense of a ternary relation: 'To an observer B an object A^* is a model of an object A to the extent that B can use A^* to answer questions that interest him about A' (p. 45). Taking ourselves the role of B, Minsky argues, we attribute the ability of a man M to answer questions about the world W, to some 'internal mechanism W^* inside of M'. Questions about 'things in the world' may be answered by reference to W^* in ways such as those suggested by Craik, consisting of machinery doing symbolic calculation with analogue characteristics. But questions about the 'nature of the world' are really questions, not about W, but about W^*. If W^* includes a model, M^*, of M, it follows that M^* can contain a model, W^{**} of W^*; and, at the next step, W^{**} may contain a model M^{**} of M^*. On the definition Minsky proposes of a model, this must be the case if M is to answer general questions about himself. M^* answers questions about himself, like how tall he is, but very broad questions about his nature, 'what kind of a thing he is, etc.' require descriptive statements by M^{**} about M^* when answers are possible at all. Minsky notes the inadequacy of his intuitive description of 'model'. Difficulties arise, for instance, immediately one questions

the internal relationships of the substructures it postulates. For example, there is a sense in which W^{**} 'contains' W^*, since W^{**} must include an interpretive mechanism that refers to it. In another, more usual sense, W^* contains W^{**}. An adequate analysis will need much more advanced ideas about symbolic representations of information-processing structures.

But Minsky's concern is to indicate how the 'dimorphism' of our world models results in notions of dualism. This, he suggests, is due to the 'distinctly bipartite structure' of these models.

> One part is concerned with matters of mechanical, geometrical, physical character, while the other is associated with things like goals, meanings, social matters and the like. This division of W^* carries through the representations of many things in W^*, especially to M itself. Hence, a man's model of himself is bipartite, one part concerning his body as a physical object and the other accounting for his social and psychological experience. (p. 46)

The man's belief that he has a mind as well as a body is the conventional way he has of expressing this to himself. The reasons for the structural divisions in our models is probably connected, according to Minsky, with the heuristic value they have for us, a value which, he indicates, should be thought of in terms of the stratification of computer programs into different levels, in which there may be executive programs, sub-routines and the like.

> When intelligent machines are constructed, we should not be surprised to find them as confused and stubborn as men on their convictions about mind-matter, consciousness, free will and the like. For all such questions are pointed at explaining the complicated interactions between parts of the self-model. A man's or a machine's strength of conviction about such things tells us nothing about the man, or about the machine, except what it tells us about his model of himself. (p. 48)

Minsky's hypothesis suggests that the antinomies of art and science reflect a world-modelling heuristic that calls for a division of models into mutually referring parts, corresponding roughly to distinguishing aspects of the world, broadly the material and the organizational. Insistence upon the oneness of the world results in a view that inclines towards science and scientific reality, a leaning that puts this oneness among its chief premises; a concern with what is distinctly human and to do with human experience is synonymous with a concern with the human self-model, and so leads to art and artistic reality, which, because it centres on what M^{**} models, emphasizes M^{**}'s qualities, namely the organizational rather than the material aspects of the world.

Goals, meanings, social matters and the like have only relatively recently become the concern of science at all. Psychology, in its psychoanalytic avatar, has, it is true, retained its early interest in literature as well as arousing considerable literary interest in itself. But 'hard' science is disinclined to take seriously

the claims of psychoanalysis to be a science at all. Behaviourism and those branches of psychology that have made special efforts to imitate the 'hard' sciences, largely by deliberately restricting their scope to domains accessible to science's traditional tools, are barren places to search for the richness of human experience; and art, aesthetic pleasure, 'resensualization', as Moles (1966) calls it, 'is proper to a psychology other than behaviourism' (p. 167). But cybernetics does offer an equipment to deal with richness, without relaxing scientific rigour. Its very origin reflects a wish to allow science the broadest possible compass. In this it is peculiarly well-suited to providing the basis for a theory of art of a kind that will comprehend art within the widest context of human effort. It is its peculiar capacity to deal with these different realities that makes cybernetics promising ground upon which to build a more comprehensive understanding than hitherto of both.

What is a theory of art? Among various possibilities, that chosen will be understood in the sense that one might understand 'theory of vision'; a theory of art should be able to say what art is, what its aims are, and to explain within the widest possible framework how it seeks and achieves their satisfaction. In particular, here the aim will be to resolve conflicts that result in artistic claims upon truth and reality contending for precedence against the claims of other modes of expression, without destroying by reconciliation the distinctiveness of the different modes or their centres of interest. It would almost certainly be impossible to distinguish art from science by assessing, if it were feasible, the different amounts of intellectual and imaginative energy that needed to be expended in the pursuit of each, even supposing these faculties were separable; and it appears therefore correspondingly futile to look for characterizing features in art that rely upon such distinctions. Ideally, one would hope to find a common set of criteria for judging both scientific and artistic work, as well as other kinds of human expression, beginning from the common starting point of the raw material of the world and the experience of it. More superficially, one would like to suggest answers to some of the more traditional questions of art theory.

2.4 The Meaning of 'Art'

The word 'art' has been used differently at different periods and a number of varying meanings persist side by side. The word may denote a set of skills as in 'the art of government' or 'the art of war', or intuitiveness, as in 'the art of politics', inviting contrast with military or political science. (Fowler (1926) asks: 'the art of self-defence, and the boxer's s.[cience] — are they the same or different?') Or the word may appear on its own, often indicating some kind of concern with the attainment of the beautiful. Even within this relatively restricted meaning it occurs in several different senses, often without explicit distinctions being made between them. According to the *Oxford English Dictionary*, 'The

most usual modern sense of *art*, when it is used without any qualification' is the 'application of skill to the arts of imitation and design, *Painting, Engraving, Sculpture, Architecture*; the cultivation of those in its principles, practice, and results; the skilful production of the beautiful in visible forms.' Commonly, the subject matter that the word denotes within this usage is often even wider, comprehending, besides visible forms, aesthetics and the artistic or 'creative' process itself, and so, by the extension this implies, literature, – particularly poetry – music and the performing arts as well as sculpture, painting and the like. Unless otherwise indicated, in what follows the word will always be understood in this broad sense. Notice that, within this meaning, reference may be made to the work of artists – painters, poets, composers and so on – to 'works of art', a subclass of this, selected according to certain more or less objective criteria; to the topic whose subject matter includes artists, 'works of art' and the criteria of artistic judgement; or to the abstract quality of 'works of art' that distinguish them from other objects. Firm prescriptive definition is lacking, eluding protracted search. Finding objective criteria for distinguishing uniquely what is art encounters the seemingly insurmountable obstacle of art's subjective nature, not simply the subjectivity of judgements connected with art, but the particular, non-repetitive, the non-rational and so subjective quality of all of which it is part.

Collingwood (1963) suggested the need for a set of necessary and sufficient conditions for deciding whether or not a thing is a work of art. His contention was repudiated on the grounds that variety among possible candidates made agreement too unlikely to warrant the effort of the search. An approach offered as an alternative to Collingwood's appealed to the idea of 'family resemblance groups'. This concept, due to Wittgenstein (1966), is of an assemblage in which each item bears some resemblance to some other item, but in which no property is common to all members of the group. Such a group lacks natural boundaries other than those implied by the word 'family', so that the 'work of art' becomes an 'open' concept. On this basis it is possible to conceive of almost any assemblage being linked by a chain of suitably chosen resemblances to any other, leaving the problem of discovering defining criteria unresolved. Functional definitions have been proposed, which distinguish works of art by what they do: express, inform, evoke, amuse, puzzle, advertize, exhort, etc. The objection to such an approach is that it prescribes, in advance of a definition, what does what. Such definitions Osborne (1972) points out, may be more acceptable than others because they may be taken as mnemonic devices for 'shorthand summaries of conclusions reached after protracted enquiry' (p. 20). A definition of a kind related to the 'functional' one makes a work of art simply an artefact, though one primarily intended for 'aesthetic consideration'. Osborne calls this a 'formula definition'. Little results from the change in approach that it entails beyond a shift of emphasis from the work of art to the question as to what constitutes aesthetic consideration, which is to say, 'aesthetic properties' as distinct from

'non-aesthetic'. Aesthetic properties are subjective, known by acquaintance, and not to be inferred from the presence of non-aesthetic properties. They are analogous to Moles's concept of 'aesthetic information', which is to be distinguished from semantic and other categories of information. Osborne lists 'descriptive "tertiary" or *Gestalt* properties ("dainty", "dumpy", "gawky"); "emotional" qualities (the serenity of the landscape, the gaiety of the music, the sombre colours of a picture); emotive or evocative qualities ("moving", "stimulating", "depressing"); structural properties ("well or ill-balanced", "formless"); a class of properties which are not but which are dependent upon, structural properties (the difference between "pretentious" and "unassuming", "eloquent" and "bombastic", "grandeur" and "grandiosity", etc.)' (p. 9). The difficulty with this definition is that most of the qualities suggested are ubiquitous rather than peculiar to works of art, and their presence, therefore, is insufficient for distinguishing works of art.

More broadly, the idea of aesthetic consideration raises questions as to what are the objects of aesthetic attention, the grounds of aesthetic judgement, and the differences between aesthetic and other sorts of appraisal. This raises questions as to what is aesthetic experience, or experience generally for that matter, and so to what distinguishes aesthetic experience from other sorts. And questions arise also concerning aesthetic consideration and works of art: is art revelatory and what is the connexion between revelatory and aesthetic qualities? Is there such a thing as 'imaginary reality', obeying only its own rules of internal consistency? What is the relationship between revelatory reality, imaginary reality and 'creativity'?

Implicit in these questions is the notion of a work of art in relation to an audience. Indeed, attempting to understand the concept of a work of art in isolation is hardly likely to be helpful (although theoretically the audience need number no-one besides the artist himself). Explicitly acknowledging an audience raises questions relating to the interpretation and 'meaning' of works of art, and the relationship of art to truth or reality; and this leads to still further questions, especially those regarding the artist's intention, what it is, how it is manifested, and what its relevance is, in aesthetic and other judgements, to his work.

Problems resist definition for numbers of reasons: they may not be real problems, in the sense that they refer to nothing that has real existence. In a similar sense, the questions they raise may have no real meaning; they may be unanswerable or at best improperly formulated; or an adequate analytical apparatus for answering the questions may be lacking. In the case of art, to these difficulties might be added, as Chapter 1 suggested, an interest served by vagueness, or at any rate a resistance to approaches that might dispel the alluring veils of mystery that linger from the romantic past.

Because of this vagueness, 'work of art' will be denoted hereafter *WOA* (pl. *WOAs*). As in the case of the elements of the 'productive procedure', intro-

duced shortly, the argument will attach no *a priori* meaning to such symbols beyond those of their definitions. The object will be to allow the various elements to develop and become familiar in their own right, like the characters in a novel, free from pre-conceptions carried over from earlier acquaintance.

2.5 Alternative Methodology — An Art Machine

If cybernetics is well-placed to deal with questions of art it is also able to offer a methodology, in the use of the concept of *effective procedures,* and so avoid many of the difficulties of more traditional approaches. Extending the view advanced by Turing (1950), that a machine that could counterfeit human intelligence could claim to share it, Newell, Shaw and Simon (1958) set out to make a computer imitate human creativity:

> . . . we should have a satisfactory theory of creative thought if we could design and build some mechanisms that could think creatively (exhibit behavior just like that of a human carrying on creative activity), and if we could state the general principles on which the mechanisms were built and operated. (p. 2)

The description of 'creative thinking' they offer depends partly upon behaviour and partly upon the kinds of problems that the thinking is about; thinking is to be classified as 'creative' according to whether or not these take the forms they do when associated with what is generally agreed to be creative thinking in humans. Such an approach is, of course, not completely general. It is restrictive in the sense that it precludes the chance of finding a non-human-based way of defining creative thinking — a way analagous, say, to a definition of intelligence not linked to purely human capacities. For Newell and others, interested precisely in an imitative procedure — one that would mimic as faithfully as possible the workings of the human mind — questions of restrictiveness did not arise. It had, after all, been Turing's argument that if a machine could behave like a mind then it could claim to possess mind's quality. Extending Turing's argument to the case of a machine aimed at imitating a human artist, however, leads to difficulties that remain hidden in his reasoning and that of Newell and others. As long as the machine artist is to be more than merely some simple-minded device arbitrarily turning out artefacts whose interest depends wholly upon what an audience, entirely by its own creative efforts, is able to invest in them, the machine will need to possess and to display its own artistic flair; though to stipulate this is to beg the question that making the machine in the first place was intended to answer; the question as to what are the objective criteria of art, artistic flair or whatever. The more explicit a machine's function, the clearer it will be whether or not it is working properly. It will for instance be quite obvious if a robot made to weld car bodies fails to perform properly;

though, with a system designed to display 'intelligence', the criteria for its proper working may be less obvious, depending principally upon the construction put upon 'intelligence'. And the machine artist's function will be as arbitrary and varied as that of the human artist. But there is a greater difficulty than this.

In Turing's imitation game, a person (or persons) interrogates a machine and a human. The latter are known simply as *A* and *B*, say; and an intermediary conveys the questions and answers between them and their interrogator. The object of the interrogator is to discover, from the answers given, which respondent, *A* or *B*, is the machine and which the human. Failure on the interrogator's part to unmask the machine is supposed to be sufficient basis for claiming that the machine possesses the faculty of mind − no less evidence indeed than we have for attributing mind to other humans. Underlying this argument is the assumption that our belief that other people have minds is based upon evidence that their conduct provides. From such an assumption, it would follow that similar evidence offered by a machine should lead to a similar belief concerning it.

It seems, however, that we are usually forced to attribute mind to people without any evidence whatever beyond knowledge that they are people; and without this assurance, it seems unlikely that superficial answers to casual questions would be likely to suffice as a substitute. This difficulty becomes obvious in the case of a machine imitating an artist.

A relaxation of the imitative restrictiveness of Turing's approach leads to a wider perspective of the kind implied by an observation of Minsky and Papert (1972): ' . . . if a theory of Vision is to be taken seriously, one should be able to use it to make a Seeing Machine!' (para. 1.0). By analogy, the ability to make and describe an art machine would imply the prior development of an art theory powerful enough to remove many of the difficulties experienced hitherto in this field.

Consider a machine capable of painting a recognizable scene in an accredited 'style'. Such an imitator might seem, by Turing's reasoning, to deserve being classified as an artist. Yet its procedures might be quite simple and well within readily available technological capacities. One envisages, for instance, a mechanical paint brush attached to an $x-y$ plotter, depositing dots of pigment of the primary colours on a canvas, at points and using such colours as might be determined according to some extremely simple algorithm from a scanned visual image. *Pointillist* paintings of the image would result. Yet the device would remain quite trivial and wholly undeserving of being called an art machine in any but this trivial sense. There is no important respect in which such a machine might be supposed to resemble an artist, any more than, analagously, a typewriter might claim to be an author or a punch card reader a seeing machine.

The problem of building an art machine immediately confronts a seemingly inescapable difficulty, precisely the difficulty it is intended to overcome, that of defining art. Lacking an agreed definition or prescriptive formula for what art is, it is not possible to say in general what an art machine ought to do; how would

one know for example whether or not such a machine were working properly? Nor would it help to follow the restrictive approach of Turing and of Newell and others, by calling for the machine to imitate a human artist, since conceivably almost anything the machine produced might be judged by some observer (a participant in an 'imitation game'. for instance) as a work of art produced by a human artist. Judging an artefact to be not a work of art, however, would alone provide no evidence as to whether it had been produced by a machine or a man: artists are not bound to produce only works of art, and judgements as to whether some object is a work of art, irrespective of how it was produced, depend finally upon the judge's decision alone. No object can ever enjoy the certainty that some given judge will classify it one way or another; and theoretically (and probably also in practice) *no* work can rely on the favour of *every* judge. But practically *any* object – certainly since Duchamp's exhibition of 'ready-mades' (everyday, usually mass-produced objects: a bottle rack in 1914 and a urinal in 1917) as aesthetically significant structures – might be classified as a work of art by *someone*.

For these reasons, therefore, because opinions as to whether different objects are works of art will differ from observer to observer, an art machine would be required at least to be able to judge itself and assess its own products in terms of what is conceived as art's demands. This would necessitate its having some 'idea' of what it 'wanted' to achieve; which is to say, an intention of producing a work of art. In other words, although one might accept an art machine that did not always – or possibly even ever – produce what qualified in human judgement as a *WOA*, it would be a minimum requirement that the machine produced its artefacts 'on purpose'.

This should not be taken to imply that the machine's intention need be in any way fixed or even explicit. Chapter 3 will show that purpose is part of the 'creative process', brought into being by the artist, or art machine, as much as and together with his work. Indeed to succeed it is probably quite necessary for the artist to modify his intention as he goes along, to cut his coat according to his cloth. During the making of a *WOA* the artist is likely to alternate continually between his two roles, as author and audience. As audience his concern is judgement, interpretation, meaning and so forth, which he may weigh against his intention as author. Each time, during the process of making a *WOA*, the artist reviews what he has done so far, he engages in two activities: he assesses his relative success or failure in realizing, by means of the object that is called the *WOA*, a state of mind that may be called his intention; and he modifies the intention in the light of the object so far actually produced.

Extending this formulation of the reflexive structure of creativity to a machine raises questions concerning the character of intention and judgement, suggesting the possibility of degenerate cases in which one or other is missing. The machine lacking judgement would

have no way of deciding whether or not its efforts represented an intention's realization, and this would appear to deprive the notion of intention of any normal meaning. It would not follow, however, that, if the machine lacked intention, it still might not appear so to an observer. The observer might 'discover' (wrongly infer the existence of) such an intention and attribute it to the machine. More probably, perhaps, the machine would appear to the observer to be operating in a 'mechanical' way, acting, that is to say, without showing any 'awareness' of what it was doing. And the observer would attribute the intention he discovered to the machine's maker. If such a 'mechanical' machine suddenly appeared to develop an intention, an observer would probably suppose that the intention had entered it by way of a controlled input, to which the intention properly belonged. The second degenerate case, that of the machine lacking intention with respect to its output and consisting simply of an evaluating facility, would be the equivalent of a *WOA*'s audience. A machine with outputs interpretable only by itself is conceivable as a further degenerate case. Such a machine might simulate a schizophrenic or a dreamer rather than an artist, though much that will apply to mechanical artists is likely to apply also to mechanical dreamers.

Excluding non-degenerate cases, an art machine would need the capacities appropriate for playing the part of its own observer in order to be able to assess what it produced. Which is to say that, in addition to the facility that determined what it produced, a further capacity for observing and judging it would be required — feedback, enabling a control to fit output to intention. The criteria it applied in reaching its evaluations would determine how far they agreed with the judgements of other observers, but would not, in respect at least of what they were, be of vital importance in the construction of the machine. The machine sketched would therefore need at least the ability to (1) entertain an intention, (2) set an output in accordance with the intention, and (3) evaluate the actual output against it. As, in general, the intention would itself be modified as the product took shape, one way of representing this process might be as a set of ordered triplets expressing respectively intention, output and evaluation at successive moments. A convergent series of 'differences' between intention and product would ensure that the machine stopped when it had, according to its own judgement at any rate, produced an intended product, one matching the final intention entertained. Divergence or oscillation of differences would result in failures.

None of this, however, greatly advances the argument, since an art machine's intentions, like an artist's, may only be inferred by an observer. Depending upon the relative autonomy of the machine to develop and set its own intentions, an observer may find them quite obscure.

In an analagous case, it is implicit in the concept of machine intelligence that it may outstrip the intelligence of its maker. Beer (1972), for instance, among many others, shows explicitly that a machine operating a suitably chosen heuristic program is likely to take decisions beyond its programmer's comprehension. Reproductive and self-modifying intelligent systems might increase their intelligence in successive generations. From a system with a human-like intelligence, the evolution of systems with intelligence vastly superior to

humans is at least conceivable. Questions as to how such evolved systems might manifest their superiority do not appear, on the face of it at any rate, to present any particular difficulties, seeming to call for answers of the same kind as questions about human intelligence. Such systems, one supposes would undertake the tasks of human intelligence with greater and steadily-growing efficiency. But would it look like that to weaker systems? Questions of this kind obviously apply in a wide range of contexts, the case of knowledge, explanation, conduct, not least in human affairs, politics, economics and social arrangements as well as in personal relations. (How would one know the best of all possible worlds?) What would a highly evolved artistic system produce, and how would lower order – human – systems interpret it?

The difficulty is that, even knowing the minimum requirements for an art machine – capacities for forming and executing an intention and for judging its execution – still leaves answers to questions about what art is hinged upon judgement of what the machine produces. Discussion of this will form the subject of Part II of the sequel, while Part III will seek criteria for narrowing the class of the machine's products generally to those classifiable as art. Restrictions of generality will be avoided as far as possible. In particular, the meaning of 'art' will not be confined to denoting only what is accessible to humans, unless and until it can be shown to admit no other possible meaning.

There may be systems, humans among them, for which a machine's output is not interpretable or even observable, as for example direct communication between two machines. Even if such communications were made observable by third systems, by provision of appropriate facilities, they might still remain uninterpretable.

Inconsistencies of evaluation make criteria permitting more stable evaluations of works of art the primary necessity. To avoid this difficulty, the problem will be reframed and its constraints relaxed. To begin with, a general productive process will be considered, a process with a product of some kind that is distinct from the process itself. From an exploration of this process, the object will be to derive properties considered to be essential or desirable for an art machine. At the outset the machine is left undefined. It is to be simply an entity with, as yet, no known attributes, save that it should be an *author*.

PART II

Authorship

For order to persist after the supervention of novelty, the
whole existing order must be, if ever so slightly, altered.
T.S. Eliot,
Tradition and the Individual Talent.

The argument of the sequel divides into two parts. The first deals with the
notion of authorship and the second with authorship's products. Both parts
propose their subjects in an abstract, general way, which restrictions gradually
narrow and make more concrete. For the most part these restrictions follow as
consequences of the characteristics inhering in the systems being considered,
though I have had no hesitation in introducing arbitrary limits where they are
needed to achieve empirical plausibility. Such limits may be thought of as temp-
orary supports to shore up theoretical weaknesses that empirical reality reveals.
The present part begins by defining a rudimentary, abstract, productive proce-
dure, and goes on to determine some of the principal characteristics it will
require if it is to furnish a basis upon which to build an art machine. The argu-
ment begins with a definition of authorship and proceeds to uncover its qualities
in some detail, with the aim of revealing the minimal requirements that will
be imposed upon any system that is to incorporate them. Broadly, the course
of argument moves towards discovering a purposeful process that depends upon
an ability to extract order from the surroundings in which it occurs, and to
transmit this order to its products.

3

Producing and Classifying

3.1 The Problem in Abstract

No pre-conceptions at the outset restrict an art machine to resemble any familiar object, and its products may naturally share its exoticism. It would beg the question to insist that, as its defining characteristic, it produce *WOA*s, since one of the objects of making the machine is to define what a *WOA* is. Expecting *WOA*s from the machine would imply the belief that *WOA*s, however unusual, shared some recognizable defining attribute, some universal objective quality that existed quite independently of the characteristics of their audience. On the face of it, no theoretical ground justifies any such idea, and it will be taken as the initial problem to find criteria of the kind that the machine itself might employ in deciding what, if anything, it produced could be classified as a *WOA*. In the context, this is the weakest condition it is possible to impose. Subsequently, enquiry will be extended to take up questions to do with the relativity of art's criteria.

The two concerns of this chapter, therefore, are a paradigm for production and its interpretation, and the evaluation of what is produced. As this product may be altogether exotic — the product of an entity, different not simply in history or culture, but not even human — its assessment will need to adhere to an explicit method. Nothing supposed about the paradigm for the productive process implies any restriction on the characteristics of its elements beyond the need for them to be able to communicate with one another and with their surroundings. Specifically, there is no requirement for either the producer or its observers to be human. Provisionally, what is produced may be anything whatever, whether it is a poem, painting, or a musical composition or recital, the solution of a problem, a theory, a strategy, or an object or assemblage excluded from human observation or even understanding. Ultimately, the wish is to assign to the process producing the product characteristics of the 'artistic process', in which the artist, his craftsmanship and technical skill, his world, his works and the works of other artists are elements. The works' 'audience', in conformity with the general properties of the other elements, may be any suitable entities, human or not. Partly this suitability will depend upon the work, since not every

work will be open to observation by every observer. A degree of conformability of the various elements will clearly be called for.

'... it is not only the material world that is different from the aspect in which we see it; that all reality is perhaps as dissimilar from what we think ourselves to be directly perceiving; that the trees, the sun and the sky would not be the same as what we see if they were apprehended by creatures having eyes differently constituted from ours, or, better still, endowed for that purpose with organs other than eyes which would furnish trees and sky and sun with equivalents though not visual'. (Proust, 1957, Vol. 5, p. 83.)

The chapter begins by outlining a paradigm for a productive process AW with a controller A and product W, and then goes on to consider the further requirements for distinguishing those Ws that are WOAs from the rest. As to meet the requirement of generality AW is taken to be non-human, the usual criteria for classifying WOAs do not apply, since W may not be interpretable by humans. Nevertheless, as the wish is to know whether the process is producing WOAs, according at least to its own interpretation, appropriate criteria will need to be found. This will be shown to be possible for meta-observers, observing, not W, but the relation between W and its observers. Typically, if this relation has characteristics in common with relations known to be between observers and WOAs, then W is classified as a WOA; if not, not. It is shown that everyday usage easily blurs the distinction between observers and meta-observers and that this leads to ambiguities, which sharpening the distinction helps resolve.

The need for an objective procedure for deciding what qualifies to be considered as a WOA is neither fanciful nor a problem confined to some shadowy boundary area dividing WOAs from the wider class of Ws. As long as art remained within the confines of readily apparent formal structures – representationalism in painting and sculpture, melody and fixed formal patterns in music, prosodic rules in poetry, classical dramatic forms, and the like – the search for some essential quality common to all forms of art that the right decision procedure would discover could seem reasonable. But the widening of artistic interest beyond the boundaries of Europe to an appreciation of the artistic achievements of other ages and cultures, and the relaxation of the hold exercized by traditional forms has steadily eroded the plausibility of prescriptive definition. Some of the difficulties that have resulted for art theory from the need for a changed approach have been mentioned in Part I. Adopting a method that relies upon abstract entities implies that, to deal with these difficulties, it is necessary to step back from too close an involvement in the subject matter. Such a view is of quite general application.

3.2 The Productive Process

The *Oxford English Dictionary* defines an author as an 'originator (of a condition of things, event, etc.)'. What kind of system will have the properties necessary to satisfy this definition?

Consider an abstract process AW, consisting of a set of procedures, A say,

coupled to a transducer M, with outputs that act upon an environment E, in such a way as to cause some alteration, call it W, in E. The process and its environment together make up a universe U.

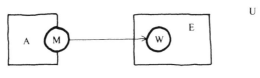

FIGURE 3.2.1

Let AW serve as a naive paradigm for a controlled, productive activity in which A is the controller of the activity that produces W. If A were not the controller we should not refer to W as its product; and if W were not A's product we should not call A the controller of AW. By definition then, A is a controller if and only if W is its product. Conversely, W, is A's product if and only if A controls AW. What this definition entails for A we shall see in due course.

Irrespective of whether or not A is autonomous — lacking inputs — W will reflect A's output states.

At this stage we disregard M. This is equivalent to assuming one-to-one correspondence between A's outputs and M's. It will become evident as we go on that M's role in the artistic process is secondary. While M should realize A's artistic goals, the part it plays in practice may have more the effect of modifying them; its imperfections — its inability to translate perfectly A's controlling inputs to make them manifest in W — becoming an intrinsic part of finished WOAs. A sets out with some W 'in mind' but, lacking perhaps the technical skill, M, to produce it precisely, or in the process of producing it perceiving in what has been produced so far some possibility, or conceiving of some idea, not previously recognized or thought of, 'changes his mind', modifying the originally intended W. The corrected manuscript, the over-painted canvas typify A's productive activity.

In particular, suppose A and E are determinate systems and, following the form of Ashby's (1962) formulation, suppose A has the set of internal states Z_A say, and E has the set of internal states Z_E, then A is defined as the mapping of Z_A into Z_A, under some function α say, and E as the mapping of the product set $U_E \times Z_E$ into Z_E, under the mapping ϵ say, where U_E is the set of E's input states. In so far as A's outputs V_A determine U_E, the operation of AW will have the effect of mapping A into E, and to that extent W will represent a mapping of A. The advantages of this kind of representation will be obvious. It at once satisfies the demands of intuition, together with the requirements for a machine that is to produce what may ultimately be made art, namely the need for a process with a product, while it also is able to furnish a vehicle for the analytical tools that are available, such as those based on set theory and logic, in the way for instance that Ashby (1967) expounds.

In general, the relationship between A, M and W in such cases is well understood and is too broad to be of particular interest for the present purpose. What is wanted is to uncover whatever appears of possible importance for the process of authorship and, in particular, for the artistic process. Beyond delineating minimal structural requirements, therefore, ways will need to be sought for understanding more about the characteristics of the entities involved. The situation becomes more interesting if a further element is introduced into the paradigm for AW, an observer, O.

FIGURE 3.2.2

Notice that now, instead of ourselves having O's role as in the previous formulation, we are one step further removed, free to look not merely at W, AW's product, but also at the relationship between W and O. This, according to Moles (1966), 'is philosophically necessary' if we are to be able to make statements about W's artistic qualities or, in Moles's terminology, about the 'aesthetic', distinguished from the 'semantic' information that W carries. 'In addition to the normal source-receptor channel, the *observer* who examines the signals received from the source constitutes an auxiliary channel. This observer, considering the signals discrete and free from noise, describes them in a universally intelligible meta-language' (p. 130). It will be shown that such a meta-observer is a necessary part of any satisfactory definition of WOA.

3.3 The Observer

What are the observer's characteristics, and what new characteristics does its presence make necessary for AW? O may be taken to be an entity of the same kind as A, M and E, namely a determinate, dynamic system with internal states Z_O, receiving inputs from E (but not from A, since initially, in order to avoid making any unjustified assumptions about the kind of thing A must be, A is supposed unobservable by O) and in particular from W. Clearly, in general not all the Ws AW produces will be WOAs, so that if O wished to identify those that were, it would be necessary for him to find ways of distinguishing between them. Some procedure is needed for judging W and some entity to execute the procedure. Since, at the outset, A must be supposed autonomous − having no input − it cannot itself assume this role. Neither can W, since W, in so far as it is assessed to be a product entity, cannot make decisions about the form it is to take. It follows that O must have the judge's role.

It may seem that making O W's observer should alone have been enough to

imply this. But notice that what this argument shows is the sufficiency of W and O alone, without A, for 'producing' a WOA! Anticipating Chapter 10, where O is shown to be a necessary feature of any process that is to produce Ws of any kind, it follows that O and W together furnish the necessary and sufficient elements for defining a WOA. (Chapter 10 will show that O may be incorporated as part of A.)

The artist, at least in the commonly understood sense of being the maker of artefacts, is unnecessary! The observer (audience) who judges an object to be a WOA fulfils the role of artist also. This is so, for instance, in the case of the *found objects* of the Dadaists and Surrealists (defined by Mayer (1969) as objects 'found, selected, and exhibited by an artist, usually without being altered in any way' (p. 152)). Later movements, like Tachism, have attempted to allow the artistic medium to display its own qualities, by the artist's withdrawing as far as possible his own intercession in the process. Dadaists also composed 'poems' by combining sets of words or phrases at random.

The reason for O's importance is that 'the real world gives the subset of what is; the product space represents the uncertainty of the *observer*' (Ashby, 1962 p. 262). The product space therefore depends upon the particular observer concerned, and different product spaces due to different observers may record the same actual events of the physical world. People, that is to say, perceive the same things differently. Now what O observes, and so how he evaluates W, depends upon the constraints that the communication between W and O imply. The observations O makes will have the form of a *relation* between W and O. Consequently, the properties of the constraint and resulting judgement of W by O will depend both upon W and O. Because judgements of W cannot be made except in this way, any theory as to what makes W a WOA will have to be concerned with properties that inhere, not simply in W but in the relation between W and O.

This argument's consequences may be more readily grasped applied to intelligence, where they admit the possible existence of intelligent systems in which the exercize of this faculty may be quite unlike, and unrecognizable to, other intelligent systems, ourselves for instance. 'There is no difficulty in principle, Ashby (1969) asserts, in developing *synthetic organisms as complex and as intelligent* as we please', as long as we understand that their intelligence will reflect an adaptation to 'keeping their own essential variables within limits' (p. 268) in their own environments, without implying a wider applicability of the adaptation to any other environments or variables. Pask (1959) observes that we will recognize such possibly unfamiliar forms of intelligence, if and only if there is a field of activity common to them and ourselves. If for instance I say that 'a chimpanzee has "grasped a concept", it is because I can imagine myself having learned from experience in somewhat the same way' (p. 881). But, in the absence of this common 'region of knowledge . . . region of connected and tentatively confirmed hypotheses' (p. 884), we shall have to rely upon observations of the relation between the organism and its environment. Specifically, suppose, for example as Sommerhof (1969) suggests, we set about defining intelligence by means of analyzing the fundamental functions of the brain as they occur throughout the animal kingdom, those of adapting, regulating, co-ordinating and integrating, in terms of 'directive correlations and

hierarchies thereof' (p. 200), with the object of using the equations that these mathematical definitions yield, as criteria for discovering brain-like mechanisms; in this case the definition of intelligence we arrive at will have assumed the existence of a meta-observer. Broadly, the meta-observer must infer that the organism's behaviour reflects intelligence, from the similarity he recognizes between the relation of this organism's behaviour to its environment, and the relation previously classified as intelligent by him, between other organisms and their environments.

The present object is to find ways of classifying Ws and WOAs such that no class of either is excluded *a priori*; and to achieve this without thereby restricting the class of observers able to identify them. Since the criteria for this will be concerned with the relation between W and O, not simply with W itself, the criteria will have to be employed by a meta-observer, call it O^*, of this relation. O^* will then be able to come to the decision, 'O judges that W is a WOA', from an observation of the relationship between W and O alone, without needing to apply or even to know the procedures that have led O to a decision about W.

Problems of finding evaluative criteria are not confined to art. 'Value judgements' generally are subject to difficulties and anomalies resulting from confusion between the two sets of procedures, respectively, of O and O^*; moral judgements, those made by a meta-observer O^* in which the Ws are ways of behaving or forms of conduct, are peculiarly susceptible, frequently failing to distinguish O from O^* assessments. Failure of a similar kind leads also – especially naive audiences – to participate in the plots and become identified with the characters of dramas and the like. Here O^*, the reader or audience, slips into the role of the character – who may, in that context, himself play the part of O, vis-a-vis the other characters. Art generally, of course, greatly relies upon this as one of its most important techniques. Brecht's 'alienation' of the audience aims to prevent the confusion. Conflicting decisions between O and O^* correspond in art to muddle in artistic judgements. Thus the critic's belief that others should accept his evaluation of a W is an example of O^* using as a criterion a decision reached as O. Being influenced by others' judgements is an example of the reverse. A single entity – in practice always human – expresses his *taste* as O and his *judgement* as O^*. Taste relates to O's experience of his acquaintance with W, judgement to O^*'s, experience of his experience. Minsky's remarks (2.3) about the inadequacy of the notion of the relation 'contained in', when applied to information-processing structures, may provide a basis for an understanding of the reasons for some of these confusions as well as of the difficulty of avoiding them.

3.4 The Meta-Observer

The blurring that occurs of the distinction between statements by O and those by O^* is connected with the correspondence that exists between the two categories of statements and the distinction that philosophy draws, respectively, between knowledge by acquaintance and knowledge by description; the former being knowledge that exists by direct awareness, without the need for the intercession of inference or the knowledge of truths; and the latter knowledge

that is not directly apprehended. Russell (1948) relates the distinction to what he calls 'egocentric particulars'. In his formulation, these are objects that we know by experience. Suppose one of these is an object a. Other objects we know by their relationships to these experienced objects. Suppose b is (known somehow to be) the only object to which a has known relation R. b is not an object of our experience, but knowing that it is the object to which a has the relation R, we can give it the name 'b' say.

> It then becomes easy to forget that b is unknown to you although you may know multitudes of the sentences about b. But in fact, to speak correctly, you do *not* know sentences about b; you know sentences in which the name 'b' is replaced by the phrase 'the object to which a has relation R'. (p. 103)

What we know about the object to which a has the relation R may be expressed in sentences verbally identical with sentences about the actual object of b. But being able to describe these sentences or even knowing up to a point whether they are true or false, we still 'do not know the sentences themselves' (p. 103). 'For in fact ... everything except myself is ... only known to me by description, not by acquaintance. And the description has to be in terms of my own experience' (pp. 103, 104). O knows W by acquaintance. O^* knows W by description. But O^* readily assumes O's role, and statements made by an observer in the two different capacities are confused, as Russell's object b is confused with its name, 'b'.

FIGURE 3.4.1

O^*'s ability to make judgements about the relationship between W and O leads naturally to the extension of the concept of a WOA, by disengaging the judge from the role of audience. The extension is achieved by means of analogy. 'An analogy relation is a relation between relations described, in extension, as a morphism (for example, a one-to-one correspondence or isomorphism or a homomorphism)' (Pask, 1974, p. 260). Minsky and Papert (1972) explain analogies in terms of descriptions. Suppose O_1 and O_2 are observers of W_1 and W_2 respectively; and suppose O^* observes and, from his observations, makes descriptions D_1 and D_2 respectively of the two relations between O_1 and W_1 and between

O_2 and W_2. If O^* knows (no matter how) that W_1 is a WOA in O's judgement, he will know that D_1 describes the relation between a WOA and its audience. If he then notes a similarity between D_2 and D_1, it may lead him to suppose that W_2 is a WOA in O_2's judgement.

It follows that a system S, in the role of O^* might classify behaviour as intelligent, for instance, which in O's role it might classify differently. This might be, say, because the behaviour was quite unfamiliar to O and therefore not open to its direct (by acquaintance) identification as intelligent. Applied to art, we might imagine two widely differing kinds of entity, O_1 and O_2 observing the same W. O_1 might classify W as a WOA; O_2 not. This might come about if, for instance, O_1 were an intelligent being that had evolved in the ocean deeps, perhaps, and O_2 were a human; or it might occur in less bizarre circumstances. Yet by assuming the role of O_2^*, O_2 would be able to recognize the relationship between W and O_1 as a relationship between a WOA and its audience, and thereby recognize that O_1 interpreted W as a WOA.

In effect, procedures for O and procedures for O^* may not differ greatly. One might regard them as overlapping subsets of the total set of procedures of the system concerned. Because of this, the distinction between the two different kinds of evaluation of W, those emanating respectively from O and O^*, is not always sharply maintained. A single entity alternates easily between the two sets of procedures that the respective judgements entail, assuming O's role at one moment and O^*'s the next, often without distinguishing between judgements reached in each of its distinct capacities. The faculty, frequently encountered, for an entity to act as a meta-observer of itself, for instance by commenting on its own evaluations and how or why it has reached them, adds to the confusion of the roles. Such entities need not necessarily be human; both animals and machines may be made to act in this way. Presumably, using Minsky's notation (2.3), a man's M^{**} model of himself, which answers questions about what kind of thing he is, must be furnished to some extent by his meta-observations. The question of what are O^*'s criteria for labelling relationships between W and O in the first place is left for Part III of the sequel. But notice here that the criteria need not at all depend upon O^*'s ability to assume the role of O.

4

Structure, Purpose and Explanation

4.1 Structure and Purpose

The argument of this chapter is complicated and difficult for a reason that is partly the subject it discusses: insufficiently evolved explanatory apparatus. The literature on the various topics that the chapter comprizes does not in general deal centrally with the intimate relationship between structure − order − and purpose. A number of authors give consideration of a secondary kind to the connexion, in the context of other questions that are their specific concern. Of those the chapter cites, Löfgren (1972) comes closest to showing direct interest in the relationship in his formulation of explication and self-reproduction. Partly, this neglect is due to the logical priority of other topics and partly, to the question's own inherent difficulty. Yet purpose and order develop side-by-side. A complicated interdependence brings purpose out of order and still wider order out of purpose. As order or structure becomes more complex, so purpose grows more important.

What begins as the more or less 'mechanical' growth of crystals and the stereospecific production of the more complex molecules that they build, has become an active 'teleonomic' performance in the still more complexly structured bacteria into which the crystals form. The concept of teleonomy is due to Pittendrigh (1958). It is to be distinguished from teleology as astronomy from astrology. Monod (1974) enlarges the concept to that of a 'teleonomic project'. He defines the 'essential teleonomic project' (a 'project' is a goal viewed within the context of some wider structure of interdependent goals) 'as consisting of the transmission from generation to generation of the invariance content characteristic of the species. All structures, performances and activities contributing to the sequence of the essential project will hence be called teleonomic'. (p. 24)

As will appear in the following chapter, the foundation for a more rigorous definition of authorship is now laid. Complex 'things' − which may or may not be *WOA*s − pre-suppose complex purposes, and at least equally complex agents to entertain the purposes. These agents, in turn, must thus also be the outcome of purposes, and so their agents, and so on. Complexity does not spring into being at a creative stroke but evolves slowly. The paths of evolution and examination of some limits on its rate will form successively the subjects of the following

three chapters. Here the wish is to emphasize the implications for art of the connexion between structure, purpose and the notion of antecedents as causal explanations. First, it appears that any object interesting enough to be called art pre-supposes an order, a structure at least as evolved, both in the artist and, by implication, in his audience, as in the work. Secondly, explanation's evolutionary character, both in its formal and intuitive aspects, and the other parallels that are seen to exist between these two modes, point to similarities between art and science that are not always intuitively obvious.

From the outset there is a demand for richness. The argument takes the notion of producing any 'work' as bound to control, control to purpose and purpose to intelligence, or more broadly to mind. Fogel, Owens and Walsh (1966) emphasize that intelligence must involve a '*wide variety of goals under a wide range of environments*'. Certainly, without the existence of a goal, decision-making is pointless and the term 'intelligence' has no meaning (p. 2). Ashby (1962) also insists on largeness of scale: an organism that evolves in an 'isolated' system must be able to go to an equilibrium involving only a 'small fraction' of its overall number of states, which must yet be of a sufficient number to permit 'a good deal of change and behaviour' (p. 173).

There are three main sections to the argument. The first concerns the properties of a controller: the minimal requirements are the ability to draw distinctions and the consequent need for a motive, implying the need for a controller to be purposeful. Goals and purposes are defined without recourse to notions of feedback, and this is shown to be justified. In the second part, the argument sets out to define W. W is within and part of the total environment, E, and therefore must be distinguished from the rest of E. The problem of achieving this distinction raises questions of order, in the sense of pattern or form. There is a review of various approaches to the definition and measurement of order, with discussion of their similarities and differences. The problem arises of the meaning of randomness, and there is discussion of order in relation to the conservation of information. The final part of the argument deals with the problem of explaining order once it has been detected. It is shown that explanations of order must be made in terms of other (corresponding) order. Certain views are discussed concerning the nature of explanation. Further discussion raises questions of order's antecedents, and shows that the explanation of order is bound to appeal to notions of purpose, and that indeed the existence of order will be taken to pre-suppose the existence of purpose. It appears that the order that is discovered will depend upon the character of the observer who makes the discovery. As the observer takes the order discovered to be the outcome of purpose, he will postulate an agent to whom the purpose belongs. It is argued that a purposeful entity is a necessary and sufficient condition for the explanation of order.

4.2 Goals and Purposes

According to the paradigm for a controlled, productive activity, AW, set out in 3.4, if W is the product of the procedure, then A is the procedure's controller. Let A be a controller in so far as it determines W, that is to say, by 3.2, in so far as it produces W. In other words, allow the possibility of degrees of control. To be a controller, A must be able to make imperative statements of the kind, 'Do X', 'Let Y', and the like, or produce outputs equivalent in their effect. So A must include *procedures* capable of producing changes in E corresponding to such statements. It follows that when A acts as a controller it maps some of its internal states into E, namely the states corresponding to those of its control commands that are satisfactorily obeyed.

This implies that A must be able to call names, such as 'X', 'Y' and so on. Adapting the argument Spencer-Brown (1969) advances in his definition of distinction, the name A calls indicates a value; the value is of a content; the content is indicated by drawing a distinction; there can be no distinction without a motive; thus, to call a name A needs a motive. But to be a controller A needs to be able to call a name. It follows that to be a controller A must have a motive. Conversely, if A has no motive, then A cannot draw a distinction; without a distinction there can be no content seen to differ in value from any other content, and therefore there can be no value; so the name A calls can indicate neither content nor value, which is to say, cannot be a name, and it follows that A cannot include procedures capable of producing changes in E corresponding to them. Thus A *may be a controller if and only if it has a motive.*

By definition A is a controller and therefore, by the conclusion of the previous paragraph, must have a motive. Let A's output state at any given moment be the command it gives, and let this state correspond to its motive. Since AW is defined as a process and must therefore be regarded as 'on-going', our concern is with its behaviour over some succession of moments, a time interval, T say. We therefore consider a succession of outputs of A over T and say that, if there is some internal state, z, of E that remains invariant under input from A over T, A's motive is invariant over T. We call z A's goal during T, defined as acting to keep (some part of) E in a state z during T. For the present purposes, A may legitimately be taken as part of E.

Strictly, to avoid problems of self-observation, it is necessary to partition A into a part that entertains and executes the purpose and a part whose internal state is kept invariant. An appropriate partitioning is likely to prove complicated since, as in the case of the models, and models of models of Minsky's formulation (2.3), the interdependence of the elements of the partition is not clear-cut. Nevertheless, it seems justifiable to ignore these difficulties here, as there is an obvious sense in which an entity (organism) may be seen to be seeking to maintain an invariant internal state. Homeostasis denotes just this activity.

It follows that the invariant state, z — the goal-state — may thus itself be an

internal state of A, z_A say. If this is the case, A's output will be seen to alter the state of its surroundings appropriately for keeping some part of its internal state invariant. In every case, it is only by discovering some invariant state that any goal-state may be identified.

More generally, if there is a subset V_A^* of the set of all the output states V_A of A, such that E's internal states remain confined to some subset Z_E^* of their total set Z_E of internal states of E as long as A's output states are confined to the subset V_A^*, we shall say that A is purposeful over that set of outputs and define its purpose in terms of Z_A^*. More succinctly, we interpret $Z_A^* \in Z_A \Leftrightarrow Z_E^* \in Z_E$ to mean that A has the purpose Z_A^* provided at least some of the elements of E in Z_E^* receive inputs from A. In the normal way, we should say A had caused Z_E^*, though present formulation makes clear Hume's objections to notions of causation being interpreted as a one way relationship. It follows that, unless A's internal states are observable, the existence of purpose will have to be inferred. Informally, we call a purpose any goal of a system that remains unchanged under alterations of the system's internal state. As a rough guide, we may take a goal to be the aim of a tactic in a strategy whose object is the purpose. It follows from this definition that in general A's purpose will include more than one goal and will be defined over a set of internal states $Z_A^* \in Z_A$ say, and a set of states of the system upon or within which it exercizes its purpose, $Z_E^* \in Z_E$, say.

This definition deliberately makes no appeal to notions of regulation or feedback. The object of finding an alternative to a more obvious kind of definition of purpose that might make use of such concepts is, in the interests of generality, to avoid placing constraints on A — such as, for instance, the need for it to have an input, which the existence of feedback would entail — before they have been shown to be necessary. This does not reduce the definition's plausibility or usefulness, however, nor lead it to violate any of the demands of the commoner kinds of definition, such as that presented as a list of requirements by Klir and Valach (1965) (p. 272) for example:

1. System S, which features goal-seeking behaviour.

2. A goal to which the system is directed by its behaviour.

3. A control element which directs the system towards its goal.

4. A representation of the goal in the control element.

5. Disturbing elements which hinder System S from obtaining its goal.

6. A connection between the goal and the control element of System S.

In fact, the definition suggested here is equivalent to Ashby's (1964) likening of goal-seeking behaviour to the maintenance of a stable equilibrium, only seen from the point of view of the observer of the entity that maintains the equilibrium rather than that of the entity itself, and with the qualification that we

must exclude equilibrium-seeking behaviour of a purely 'mechanical' kind – such as, for example, that exhibited by a simple pendulum. The distinguishing characteristic of true goal-seeking behaviour, as Sommerhof (1969) makes explicit, is that it places no restrictions upon the initial states of its variables, while in the pendulum these initial conditions are dependently linked: the acceleration depends on the displacement and arbitrary combinations of these variables are impossible. As a definition the one proposed here has the virtue of being based upon what Ackoff and Emery (1972) call 'the common properties of production [which] enable us to define the concepts of *function, goal-seeking,* and *purpose* with all the rigor of the concepts used in the physical sciences, and yet retain the core of meaning these terms have gained over the ages' (p. 15). It is consonant with Sommerhof's concept of 'directive correlation' (Sommerhof, 1969, p. 174).

The proposed definition presupposes an ordered, multi-goal-seeking system. In this it conforms to the definition of Ackoff and Emery in which a purposeful system 'selects goals as well as the means by which to pursue them' (p. 31); though it does not follow these authors into making this the basis for attributing 'will' as the characteristic peculiar to such a system. For the assumption on which this would depend, namely that selecting goals demands mechanisms basically dissimilar to those required for selecting the individual responses called for by goal-seeking, does not appear sufficiently justified. (cf. the operation of systems such as Winograd's (1972) natural language system (8.4), for example, which supports this contention.) Our view also dictates avoiding the distinction, similar to that of Ackoff and Emery, that Sommerhof (1969) draws between 'goal-directed' behaviour, which he takes to be 'objective', and 'purposive' behaviour which in his terms involves conscious striving (p. 154) and is therefore 'subjective'. For this latter kind of behaviour we reserve the name 'intentional' defined as 'consciously purposive'.

Because it says nothing about V_A^* or Z_A^*, the definition of purpose proposed may convey little of the quality of purpose as it is commonly understood to reveal itself in 'purposeful behaviour', for instance the quality that Sommerhof calls a 'primary characteristic of all obviously living systems' (p. 150). But the definition has no difficulty accommodating such characteristics. Sommerhof suggests that purpose has a hierarchical structure 'in which the goals of the various part-activities (or activities of its parts) are interrelated and integrated' (p. 150). He distinguishes 'transient' and 'proximate' goals for each part-activity, arranged in hierarchies of subservience to 'less transient and less proximate' goals of the activity as a whole, which in turn is subservient to behaviour patterns, and so on. Intermediary goals may be concerned with attaining or maintaining conditions suitable for other activities, and the various activities may all be connected in mutual interdependence. (Chapter 9 formalizes a notion of purpose similar to Sommerhof's.) Such a view may be interpreted as an assertion

about the structure of A's output, V_A^*. Thus, frequently it will be A's purpose to *bring* some part of E's internal state within certain limits, rather than simply keep it invariant. In the terms of the proposed definition, this state of affairs, of aiming to bring a system within certain specified confines at some time in the future, corresponds to a purpose of maintaining invariant the *movement towards* the desired state. There is no difference in principle between holding either a static or a dynamic state of E's invariant. The difference is practical. The two kinds of purpose, those associated with keeping some fixed state invariant and those with keeping some dynamic state invariant, correspond as aims to the two kinds of regulation that Conant (1969) distinguishes as 'point regulation' and 'path regulation' (10.3). Normally purposes connected with changing states entail setting up sequences of sub-goals to be executed in turn, *en route* so to speak to the main goals. Chapter 9 develops a rudimentary symbolism for representing such chains of goals, especially where sub-goals may involve the mediation of what are themselves purposeful or goal-seeking systems.

If A's purpose concerns its own internal state it may appear to an observer to be altering its goals with respect to E. This is likely to occur wherever its internal state varies outside the set of constraints that the purpose defines. This kind of purposeful behaviour characterizes Ashby's (1965) homeostat. Without the invariance that homeostatic performance provides, the development of purposeful structures of any kind would be impossible, since there would be no way of 'preserving the effects of chance' (Monod, p. 32). A's survival is superordinate to all other purposes A may have; it is the 'lynch-pin' of A's motivation (George, 1970, p. 142) since it is a pre-condition for its achieving any other purpose whatever. A system giving preference to purposes other than the ones that combat threats to its survival will be extinguished with a probability approaching unity as time passes. Evidently, therefore, naturally occurring purposeful systems must incorporate mechanisms for overriding other goal-directed behaviour in favour of survival goals whenever appropriate. The ultra-stability of Ashby's homeostat represents what is necessary for just such a performance. An ultra-stable system receiving an input that threatens to force any of its variables outside the limits that mark the boundaries of its viability will automatically change the parameters governing its transfer function, and continue changing them until it either fails finally or finds a new transfer function that keeps its variables within the required limits.

4.3 Discerning Purpose

Let A be motivated to realize some fixed goal, g say. According to our definition some internal state z of part of E will remain unchanged over that succession of outputs V_A^* of A that correspond to the realization of g. As W is the trace that O observes A to make in E (by 3.2, that showed W as a mapping of A in E), we

may suppose that W represents a product corresponding to A's purpose – or purposes – up to the time when O makes its observation. As O can observe only E in which it can distinguish the product W of AW, one may ask under what conditions O will suppose that W is the product of a purposeful process.

Minsky (1972) notes that when something moves we attribute the movement either to a physical force or a purpose, seldom both.

Supposing that O can observe W implies an assumption that it can distinguish W from the rest of E, and we ask to what extent its ability to do this depends upon its own characteristics and to what extent upon W's. 'The essence of ... a "thing", a unity, rather than a collection of independent parts corresponds to the presence of ... constraint' (Ashby, 1964, p. 131). It follows that, if E consists of distinguishable elements, O will need the ability to distinguish constraints existing between these elements if it is to be able to perceive objects in E, in particular W, since W is itself a 'thing' or 'object' (or 'event') with spatial or temporal extension (Ashby, 1964, p. 131). Various ways are available for measuring such constraints, such as for instance the mean auto-correlation function computed across some space or interval as,

$$F(\zeta) = \int_0^\infty \bar{f}(z)f(z + \zeta)dz \text{ or}$$

$$F(\tau) = \int_0^\infty \bar{f}(t)f(t + \tau)dt,$$

where ζ and τ represent the space and interval respectively in which the message develops. But such devices provide only the crudest kind of measure, as will become clear when perceptrons and the like come to be examined. It seems unjustifiable to claim, as Moles does, that 'the sensation of form is the perception of auto-correlation' (p. 88). What is important is that W presents itself as a *form* or pattern *relative to E.*

It follows that the notion of a 'thing' is necessarily vague, since it depends upon what constraints O identifies, which in turn depends upon what constraints are important to it in terms of its goals, and what constitutes background; and so, complementarily, the 'thing' that stands out against it can 'be defined only on the basis of intent' (Moles, p. 100). Moreover, as Moles observes too (p. 77), numbers of 'forms', things, co-exist which have high or significant auto-correlations in their own domain though null correlations with one another, so that background will be made up both of 'things' that are objectively real, existing by virtue of auto-correlations between their elements independently of observers, and noise in a more commonly understood sense. No 'thing' can be strictly independent of its surroundings, since this would imply that it was a closed system which would make it unobservable. 'Things' are merely relatively

independent. Objects may be pictured as if consisting of clusters of constraints, or regions of relatively high 'connectedness' between unitary elements, provided it is assumed that all elements in an observable world are connected, at least via one another — that is we picture some kind of network of inter-connexion. This is why what makes a thing is always partly subjective, though generally, in practice, (as appears in the following section) the arbitrariness does not present insurmountable difficulties to arriving at objectivity.

An analogy exists between this notion of arriving at objective knowledge by means of partly subjective observations and the idea, due to von Neumann, of constructing a properly functioning machine using components that have some likelihood of failing. It is, in a sense, a restatement of the view mentioned above that, while perceived order may be subjective, it does not follow from this that order does not exist also in an objective sense, due to the existence of connexions of some kind, auto-correlations or the like, between the elements of things, independently of observations of them. An approach might be made to the present problem along lines similar to those taken by von Neumann for dealing with the problem of machines with unreliable components. At a time when it has become a widely-held, popular view that objective knowledge is impossible, a rigorous treatment of the subject of objectivity might have some significance.

4.4 Order

There is an obvious relationship between the notions of constraint and *order* in a system. Von Foerster (1960) interprets Shannon's definition of 'redundancy' in such a way as to provide a measure of order. Ashby (1972) relates constraint, order and variety. Löfgren (1967, 1969, 1972) associates order with the existence of descriptions, which consist of programs shorter than the sequences they generate. (These descriptions, as we shall see, Löfgren equates in turn with explanations; learning, explicability and theories, with various kinds of 'order extraction'.) Popper (1959), von Foerster and Löfgren (1967) agree that it is desirable for any measure of order to reflect the relative connotations of the term as it is commonly used. Among these is the notion that order may vary from absolute order on the one hand to absolute disorder on the other. Von Foerster interprets Shannon's definition of redundancy to make it furnish such a measure. In the formula $R = 1 - H/H_m$, in which H/H_m is 'the ratio of the entropy H of an information source to the maximum value it could have while still restricted to the same symbols' (p. 37), R may be taken as the desired measure. It will vary from zero, for H equal to H_m (maximum entropy), to 1 when H is zero, that is to say, when the position of one element of the system is sufficient to determine the positions of all the others. Löfgren (1967) formalizes von Mises' *axiom of randomness*, cited by Popper, in terms of a universal Turing machine. The axiom of randomness is sometimes called 'the principle of the excluded gambling system'. It postulates that among the classes of sequences

of events capable of indefinite extension – tosses of an indestructible coin, for example, – those that are random would be such as to make it impossible for a gambler to find any *system* of betting on their individual outcomes such as would improve his chances of winning. Löfgren (1967) uses a formalized concept of description as a basis for rigorous formulations of 'intuitive notions' of order and randomness. According to Solomonoff (1964) we say that 'S is a description of T with respect to machine M' if $M_1(S) = T_1$, where S is the input string to the machine and T its output string. Löfgren's definitions of order and randomness derive from this definition. They are, respectively,

> ... there is a U such that for any two equally long patterns ξ and ζ, ξ possesses more order than ζ if and only if $s(\xi,U) < s(\zeta,U)$.
> ... there is a U such that for any two equally long paaterns ξ and ζ, ξ possesses more randomness than ζ if and only if $s(\xi,U) > s(\zeta,U)$.

where U is a universal Turing machine that may generate the sequences ξ and ζ from different starting tapes, such starting tapes being known as the U-forms of these sequences, and where $s(\xi,U)$ is the shortest U-form of ξ, and $s(\zeta,U)$ of ζ. (s is thus totally random, since by definition there is no s^* say, such that $s^* < s$.)

But none of these definitions indicates any effective general test for regularity; or, *a fortiori*, how to find s such that we may be sure that there is no s^* say, such that $s^* < s$, not even how to know s when we have found it; '... our tests of randomness are never tests which exclude the presence of all regularity' (Popper, p. 359). So all we can do is apply successive tests for specific regularities, though never knowing when or whether all regularities may have been revealed. We have a criterion of success in our search, namely a contracted description – U-form, – but our goal, the shortest description, is specifically what is not known. Thus failure to reveal regularities after a number of tests does not mean that some regularity will not emerge when the next test is applied. Indeed, in an arbitrarily long sequence, we should perhaps expect to find at least some regularity, since 'No arbitrary, long, randomized sequence can be generated effectively' (Löfgren, 1969). On the face of it this conclusion of Löfgren's appears to conflict with Popper's assertion that 'we can develop a theory which allows us actually to construct ideal types of disorder' (p. 359). But, by a 'type' of disorder Popper means one defined by the failure to discover by testing some '*specific* regularities'. In agreement with Löfgren, Popper concedes that 'there are no tests for presence or absence of regularity in general' (p. 359). So the observer remains bound by the limitations of the specific tests for regularity that he applies, the success of which, registered as the discovery of regularities, he denotes by phrases such as the 'discovery of order', 'the recognition of pattern' or 'form', and the like.

The considerations of the preceding paragraph imply that order and disorder (randomness) are both relative terms, and may be regarded as predicates assigned according to the results of the application of particular tests. In so far as such tests must necessarily be conceived by some observer, we may take the concepts to apply *relative to an observer*.

> By saying that a factor is *random*, I do not refer to what the factor is in itself, but to the relation it has with the main system. Thus the successive digits of π are as determinate as any numbers can be, yet a block of a thousand of them might serve quite well as random numbers for agricultural experiments, not because they *are* random but because they are *uncorrelated* with the peculiarities of a particular set of plots. (Ashby, 1964, p. 259.)

Notice that this view does not contradict Popper's injunction against the temptation to attribute randomness to *lack of knowledge* as to the order prevailing, if any order does prevail. If anything it clarifies his objection. Advancing this clarification further, Ashby (1964) points out that the observer of the output of a machine dependent upon an input of 'random numbers' will see the machine as determinate or indeterminate according, respectively, to whether he is aware or not of the numbers input. Consistent with what was said in 4.3 – that what order is distinguished will depend upon the observer that distinguishes it – this implies that Löfgren's definition of order must also be interpreted relative to an observer. If Ashby's notion of randomness is to be taken as equivalent to Löfgren's it follows that the magnitude of the correlation in Ashby's case must be proportional to the ratio of the length of the U-form to that of the sequence generated in Löfgren's. We achieve this result by the following interpretation: in Ashby's case we interpret the agricultural experiment as the 'observer' and the successive digits of π as the sequence observed. Löfgren's use standardizes the observer as a universal Turing machine. The tape required to 'convert' some given Turing machine into a universal one describes the particular Turing machine in question. Löfgren's case thus becomes equivalent to Ashby's, by substituting in Löfgren's definition of order, a particular Turing machine for the universal one.

The relation between observer and order observed is, broadly, the reason why, in practice (as observed in the previous section) little difficulty generally results from the evident arbitrariness with which 'things' are delineated and distinguished from one another. It is because the things distinguished in the first place are distinguished as a result of correlations between them and the observer that distinguishes them; which is a way of saying that individuals evolve in a manner appropriate to their environments. Fogel, Owens and Walsh (1966) have 'evolved' machines in specific simplified environments (8.7). They conclude from their experiments that 'each living creature may be viewed as a tentative model of some significant aspects of its environment' (p. 111). More generally, one might put it that every entity of the kind able to maintain equilibria within the limits necessary to ensure its survival under conditions of a range of disturb-

ances – entities showing in some degree the characteristics defined previously as intelligence – is itself a *description* of those aspects *of its environment* that have given rise to the disturbances that make up its history; and that the quality of the description might be defined – or even quantified – as having been (good) enough to make possible the entity's survival so far. It follows from this as a corollary that individuals evolving in similar environments are likely broadly to share some at least of their form-discerning propensities, thereby reducing the arbitrariness of the discernment of order referred to in 4.3, at any rate among the inhabitants of the same world. In general, it is only changes in resolution level that lead to difficulties in delineating things (9.3), and this is to be expected, as such changes are equivalent to altering an entity's environment.

4.5 Causal Explanations

Having distinguished W from the rest of E, suppose O now attempts to account in some way for W's existence, to explain, say, how W came into being, or to provide what is called a 'causal explanation' of W. A priori there are no restrictions on what O might postulate. For instance, O might assert that W had come into existence of its own accord, out of nothing. An objection to such an explanation might be that it was 'subjective' and not communicable to or understandable by anyone at all, probably not even the individual making it. To be communicable in the sense of being understandable, an explanation would have to be able to win wider approval. O would have to be able to sustain it against criticism (Craik). Ashby (1962) points out that communication implies constraint; an event at A is communicated to B if its occurrence at A limits subsequent possibilities at B. Extending this idea to the notion of explanation, the measure of how far an explanation was communicable – understandable – would be in proportion as stating it limited the range of possibilities flowing from it. For instance, the unqualified statement 'There is W' conveys almost nothing about W; that is to say, almost nothing to limit the range of things that W might be. But, like a description, an understandable explanation E of W does restrict W. The question relates to how this restriction is effected. Clearly, at least in as much as they share this restrictive capacity, explanation and description must be related. They have in common the adducing of consequent from antecedent conditions. Thus, according to Popper (1959)

> To give a *causal explanation* to an event means to deduce a statement which describes it, using as premises of the deduction one or more *universal laws*, together with certain singular statements, the *initial conditions* (p. 59).

In Löfgren's (1972) terms a relatively effective explanation 'is effective in relation to . . . an interrogator in the same sense as a program is effective in

relation to a computer. It permits the interrogator to check (like a computer) every step in the chain of arguments' (pp. 343–4). Formally, this view, with its overtones of Descartes' 'Method', expresses an hypothesis which 'cannot itself be proved because the meaning of "effectively understandable" is only intuitively understood' (p. 345). Löfgren gives formal expression to the hypothesis, as

EXPLANATION HYPOTHESIS I. If an explanation E is effectively understandable (relatively effective), then it is understandable in terms of the rules (explanation arguments) and axioms (postulates) which constitute an r-formal theory \mathcal{T} , such that E is a p-explanation in \mathcal{T} . (Löfgren, 1972, p. 345.)

'A sequence E is a p-explanation in \mathcal{T} (relative to \mathcal{T}) if E is a proof sequence in \mathcal{T} and \mathcal{T} is r-formal.' (Löfgren, 1972, p. 344.)

A *formal theory* \mathcal{T} is a set of A of wffs, called the axioms of \mathcal{T} together with a set of predicates, the *rules of inference* of \mathcal{T}. When $R(Y, X_1, X_2, \ldots X_n)$ is a rule of inference of \mathcal{T} , the wff Y is said to be a consequence of the wffs X_1, X_2, \ldots, X_n in \mathcal{T} by R.' (p. 396)

'A formal theory \mathcal{T} is r-formal if \mathcal{T} has a recursive set of axioms and a finite set of recursive rules of inference.' (p. 396)

Newell and others (1958) extend the detail of this view, distinguishing 'specification by state description' from 'specification by process description' (p. 30) and illustrate the distinction with a number of examples. We may either, they assert, write down an explanation in logic or stipulate the operations on the axioms (the proof) that will produce it. This distinction is equivalent to Spencer-Brown's distinction between 'injunction' and 'description': a musical score is a set of injunctions to a performer which, if he follows them, will cause him to produce the sounds that *are* the musical composition.

But O faces an immediate difficulty because, of all the explanations he may offer, few are likely to be theorems in formal theories. However, this difficulty is not necessarily insurmountable. For suppose, for example, O's explanation were a statement in a natural language, it might still be made effective in Löfgren's sense. Many, probably most, relatively effective explanations must have begun as natural language statements, from which embryonic existence they gradually acquired their more rigorous form. The question is how this formative process was accomplished. Is there an effective procedure for it? Von Mises offers the concept of connectibility.

We call a group of words (sentences and sequences of sentences) 'connectible' if they are compatible with a system of statements which, it is assumed, regulate the use of language – connectible i.e., with respect to this system (p. 73).

The 'place of linguistic rules' is taken by 'the totality of sentences, in which a given sentence is "embedded"' (p. 76). The similarity between this concept and

that of a 'formal theory' is obvious. Where two sentences are not connectible with one another, this must be because they belong to separate systems which need to be in some way 'joined' together to form a single system, if they are to be made connectible. Unfortunately, von Mises does not say what makes two groups of words 'connectible' with one another in the first place. Within Löfgren's framework one would 'join' two expressions by deriving them from the same rules and axioms.

Explanations of Löfgren's kind are determinate. Within Löfgren's framework an explanation would win wider approval or be sustained against criticism (Craik's requirements) if new sets of rules and axioms could be found that generated both the criticism and the explanation that it criticized. Thus, if an explanation were not effectively understandable it might nevertheless be partially, and be made more, understandable, by making it sharper, while at the same time broadening its basis; which is to say by (1) increasing the explanation's restrictiveness (increasing its determinacy) through restating it in such a way as to impose narrower limits on the range of possibilities flowing from it; (2) incorporating in it, so to speak, criticisms made of it, (including the elimination of inconsistencies and contradictions, either by dropping elements of the explanation, or, where this proved impossible, by means of finding new axioms and rules from which to generate it). But notice that no effective procedure exists for carrying out this process, because, by 4.3, no effective procedure exists for finding regularities, and it is precisely upon the discovery of regularities that (1) and (2) depend. For even if we were to postulate that some statement of O's was a wff in some formal theory unknown to us, joining together numbers of separate wffs from separate theories would require finding some regularity of pattern such as would permit the separate wffs to be derived from common rules and axioms.

Thus, if O asserted that W had come into existence of its own accord, we might argue for example that, to have done so, it would have needed to be self-organizing in the strict sense of arriving at its organization — coming to be the thing it is — without interaction with its environment. We might furnish a proof that this was impossible by recalling von Foerster's (1960) argument to demonstrate that the existence of such a strictly self-organizing system would violate the Second Law of Thermodynamics; or we might point to a similar conclusion that Ashby (1962) reaches from consideration of the properties of machines, without appealing to laws derived from other theories.

Monod refers to the practical effects of the Second Law of Thermodynamics. He describes the growth of *Escherichia coli* in a suitably prepared medium, consisting of a few milligrams of sugar and certain mineral salts in a millilitre of water. Thirty-six hours is sufficient to permit the growth of several thousand million bacteria. Forty percent of the sugar will have been converted into cellular constituents, the rest oxidized into carbon dioxide and water. If the experiment is carried out in a calorimeter, the entropy of the whole system

(bacteria plus medium) will be found to have increased slightly more than is predicted by the Second Law of Thermodynamics. 'Thus while the extremely complex system represented by the bacterial cell has not only been conserved but has multiplied several thousand million times, the thermodynamic debt corresponding to the operation has been duly paid' (p. 29). Ashby distinguishes two kinds of self-organization. The first, which he characterizes simply as 'self-*connecting*', may come into existence of its own accord, but will show no properties that relate to (correlate with) any other system (and therefore, in particular, any observer), and will thus always appear to be random (by 5.3); that is to say, not organized, and so, *a fortiori*, not self-organized in the strict, non-interacting sense. In the second kind of self-organization, the observer of the self-organizing system distinguishes 'good' organization from 'bad'. 'Good' organization of a system is that which is in some way appropriate to (correlated with) some second system. As this appropriateness could only come about by changes affecting the functional relationships between the states of the first system (the one that appears to be self-organizing), they could not at the same time depend upon those states. Thus they would have to depend on the states of the second system. Organization would therefore occur as the result of this second system and would thus not be self-organization in the sense described; and the Second Law of Thermodynamics would not be violated. Roughly, if a machine alters its own organization, it must do so by altering its transfer function; yet, if it does this itself, by failing to retain the same transfer function, it ceases to behave in the way that it is required to do in order to qualify as a machine, namely, to keep the same transfer function. Thus, if a true machine alters its transfer function, it must do so as a result of action from without.

If O's choice of what he asserted as his explanation – namely, that W had come into existence of its own accord out of nothing – were dictated by a desire to be understood as widely as possible, he would have to choose that set of rules and axioms from which he could generate explanations of the largest possible number of things and events. For it is this set that would have the greatest chance of encompassing within its own terms the kinds of explanations that other Os found satisfactory; of making its own explanations connectible with other explanations. Thus, faced with an objection to its explanation of W that was rooted in thermodynamic theory, O would be obliged either, (1) to provide a new explanation of W, understandable within the terms – axioms and rules – of a theory that might accommodate the theory of thermodynamics as well as the explanation, or (2) to hold to its assertion in disregard of criticism of it, or (3) to abandon its assertion of W's spontaneous creation and concede that W must have come about as a result of some other, previously existing system. Option (1), if O can achieve it, is the equivalent of O's finding a meta-language to accommodate both its own explanation and criticisms of it. It may be, however, that O's own language is insufficient even to understand the criticisms of it, which are themselves meta-linguistic for O. If O opts for (2) in the face of objections, it may be for this reason. But if it is not; that is to say, if O can understand the meta-language of the objections to its explanation and still disregards them, we should judge that explanation was not O's aim. For what O said would offer none of the qualities of explanation that we have supposed to be desirable, and this would contradict the assumption with which we started, namely that O

wished to be understood. It follows, therefore, that O will either have to find a single explanation to encompass simultaneously thermodynamic theory and the notion of spontaneous creation, or postulate some entity antecedent to W as W's causal explanation.

The parallels between organisms and theories evolving to completeness and consistency is obvious, and intuitively may often seem quite plausible and natural – and it is often claimed though less often plausibly demonstrated that the arts are 'organic' in nature. One of the principle aims of this chapter is to elucidate the correspondences between organisms, explanations and ideas, and their evolution. So Proust finds the names of guests at dinner at the Prince de Guermantes, linking in his mind with the French and European history with which they are connected.

> Thus the empty spaces of my memory were covered by degrees with names which in taking order, in composing themselves with relations to one another, in linking themselves to one another by an increasingly numerous connexion, resembled those finished works of art in which there is not one touch that is isolated, in which every part in turn receives from the rest a justification which it confers on them. (Proust, 1957, Vol. 6, p. 314.)

The connexion between explanation and WOAs will be taken up explicitly only in Part III. Here we merely observe the evolutionary process as it occurs in its several incarnations. The 'finished' WOA is evidently a kind of 'knowledge structure', (cf. Gagné, 1962). What Proust describes is clearly similar in many respects to Pask's *entailment structures*, which are closed 'relational nets'. This is expected, as WOAs are simply a sub-class of the wider class of Ws, and knowledge structures are morphisms of effective explanations, procedures that themselves correspond to the processes AW from which Ws emerge.

4.6 Causal Explanations and Effective Explanations

Let us take it, then, that O supposes W has been brought about by the action of A. A suitable A would have to be the controller of some process AW that mapped A into E in the form of W, and by the conclusions of 4.2, this process AW would have to be purposeful, with its purpose inhering in A. In other words, O's assumption would be equivalent to supposing that W were the observable trace of the operation of certain stable processes, and therefore, by the definition of purposeful (4.2), that it must represent the realization of the purpose or purposes inhering in them.

A definition of Löfgren's provides a formal basis for describing O's concept.

> *An object A is productive in a surrounding S* if A causes S to produce another entity B, symbolized $A \rightarrow d_s \rightarrow B$ and read as follows: the configuration (output state) of A forces S to produce B. Here d can be considered a description of B relative to S. (Löfgren, 1972, p. 358.)

Notice that A's relation to S corresponds to the 'interaction' between what reproduces itself and the surrounding in which this occurs, by which Ashby (1962a) characterizes the process of self-reproduction.

We recall from 4.4 the formal concept of description as a *program that computes*; that is to say, as equivalent to the tape expression S (the description) from which a machine M will compute (describe) a sequence T. Interpreting this definition in terms of the previous paragraph it turns out, as we should wish, that it corresponds to the paradigm for a productive procedure adopted earlier (3.2). B may be taken as equivalent to the W O distinguishes, d to the purpose of which W appears to O to be the realization, and A to the entity A in which O supposes the purpose inheres.

So if O seeks a causal explanation of W, that is an explanation by means of an antecedent, then O will interpret W as defining the antecedent's purpose. As the purpose will in turn determine how O defines the antecedent's characteristics, it follows that O will define A according to the W it distinguishes. In the broadest sense, therefore, the way O defines A will depend on O's capacity for finding descriptions for E. This is because W is part of E and therefore O's descriptions for E will determine what Ws it discerns. In general, at best, the W O distinguishes will only partially accord with Ws distinguished by other Os or the W distinguished by the A that produces it (cf. 3.3). In particular O's resolving power (9.3) and variety − temporal and spatial − will be determinants of the forms it distinguishes, that is to say, of its descriptions of W; and these descriptions may be unrecognizable − or even of the same order of size − as W to other Os. For instance, if W were some random sequence of numbers, O's description of it might consist of the mean of that part of the sequence it had observed. Such a description would provide a sufficient rule for O to produce another sequence W^* say, with the same mean as W, though possibly having no element the same as W. For O, W and W^* might be distinguishable, though another observer O' say, with a different description of W, based perhaps on W's specific elements, might discern no likeness between them.

Thus going back to 4.5, if O distinguishes a form and wishes to give it an effectively understandable causal explanation, his explanation will have to postulate a purpose that the form defines. Moreover, it will have to postulate an agent as the producer of the form and attribute the purpose to the agent. The identity of the agent will thus have to be consonant with the form O distinguishes and will therefore depend on O's capacity for distinguishing forms, that is to say, of finding descriptions of E. In other words, the form O distinguishes will depend upon O's characteristics.

4.7 Plausibility of Explanation

In general, O will be unable plausibly to explain or account for W's existence; which is to say, its account will not be effectively understandable. Generally, O's explanations are likely to be arbitrary, lengthy and complex, identifying somewhat tentatively, if at all, not some unitary system or 'entity' as W's ante-

cedent, but numbers of more or less independent entities, none of which may be even individually plausible but merely the best O can do. The plausibility or otherwise of O's explanations will depend in the main upon their 'determinacy'. We shall call O's explanatory entities (the antecedents of W that O postulates because it cannot find a single one) determinate, if and only if, from the same initial conditions, they always lead to the production of the same W. Antecedents that behaved in an indeterminate way, sometimes leading to one and sometimes to another consequence, would be considered unsatisfactory: the lack of a unitary antecedent would tend to make explanations of W implausible.

In this sense it may be misleading to speak of 'entities', A, or their purposes at all, since the concept of an entity depends upon the notion of an underlying unity, what 'holds' the entity 'together' as a thing. To be consistent, however, until it becomes possible to distinguish what constitutes such a unity, it will be easier to retain these terms.

Explanations evolve towards shortness and simplicity. '"Interesting" functions usually have features that permit enormous reductions in the sizes of the nets required to realize them.' (Minsky 1972, p. 55.) Similarly, as Lorentz (1977) says, 'progress in organic development is almost always achieved through the integration of a number of different and independent systems to form a unit of a higher order' (p. 28). The nets – descriptions in Solomonoff's sense (4.4), starting tapes for Turing machines – may all be thought of as having information *potential*, which becomes an information flow when these are realized in operation. 'The overall scheme of a complex, multimolecular edifice is contained *in posse* in the structure of its constituent parts, but only comes into actual existence through their assembly' (cf. 'step-by-step' effectiveness, Chapter 11). 'The epigenetic building of a structure is not a creation; it is a *revelation*.' (Monod, p. 87.) (This suggests an answer to the question posed in Chapter 2 as to whether art is creative or revelatory.) Extending explanations (4.9) by 'joining' them, so that they may generate larger runs of information flow, might in these terms, be thought of as 'adding' potentials – perhaps in ways analogous to the 'composition' of mathematical functions, the addition of vectors or procedures for incorporating computer programs as sub-routines in larger programs. Löfgren's definition of order (2.3.2) or Solomonoff's assignment of *a priori* probabilities to strings of symbols according to the way they might be produced by a universal Turing machine, suggest possible bases for *information potential* measures.

Thus U-forms with lengths that were small compared to the lengths of the sequences they generated, or high *a priori* probabilities of strings generated by a Turing machine, would measure high information potentials; and conversely. Of interest is the evident aesthetic value of information potential. Sensitivity (among human subjects) to form and pattern of high or low information potential may be extremely acute. Moles observes that an intelligible auditory message requires a noise level four to eight times higher than its *fortissimi* to destroy it. 'Intuition' and conjecture are frequently more sensitive detectors of pattern than available statistical techniques. High information potential assumes aesthetic value. Notions of elegance in mathematical proofs, as in design, are closely linked to brevity and economy. '... "beautiful" often means short in the sense that we have discovered some abstract concept of invariance, that permits a short recursive description.' (Löfgren, 1967, p. 166.) Images, including metaphors may have a high information potential. For they have the information potential of descriptions raised, as it were, to a higher power, possibly a number of times, by morphisms between the domains the images describe and other, analogous, but distinct domains. That is to say, an image is a description of more than one

thing, standing at the nexus of a number of morphisms. This 'evoluted' information potential provides greatly heightened aesthetic value. '. . . the image is not an idea. It is a radiant node or cluster; it is what I can, and must perforce, call a VORTEX, from which, and through which, and into which, ideas are constantly rushing.' (Pound, 1914, p. 469.) Pound's 'node' is an image, but Minsky's 'net' is closer to a literal reality; though the value of the concept of a net in automata theory has probably been at least as great when it has been an image as it has when an actuality. A node with numbers of connexions in a real net of the kind Minsky means, or in some conceptual net such as a knowledge structure for example, would in reality have qualities like those Pound mentions.

In general, a multiplicity of antecedents implies disorder. So, for example, if O were human and W were a stone, asked to account for the existence of the stone, O might be unable to attempt any account. Persistent interrogation might elicit from him a catalogue of antecedent conditions and events, including perhaps references to wind, water, plant growth, bacterial activity, temperature changes, movements of the earth's crust, galactic upheavals and so on, in a sideways- and backwards-stretching net. The net might extend as far as O were able to conceive, in some more or less arbitrary, subjective way, of more or less suitable antecedent entities; namely those characterized by the possession of such equilibria (goals or, in their more complex forms, purposes) as appeared to him might have led to the emergence of those objects that he wished the entities to 'explain'. But even supposing each element of O's explanation were determinate in the sense described, simply the number of elements would quickly make his explanation difficult or impossible to use as a predictor, unless he furnished with it information on the relations between its elements, the constraints binding them; that is to say, unless – in effect – he reduced the number of *independent* elements in his explanation by joining them together to make fewer, larger independent elements, that is, by Löfgren's definition in 5.1, found more order.

But for O, the constraints that make the stone a 'thing' (4.3) are not such as enable him to point to some unified order that they reflect. O attributes (by 4.5 and 4.6) the arbitrariness of his explanation to the thing he explains, so that, from his failure to account for it plausibly, the stone acquires an 'accidental' quality for him: his disordered explanation reflects on the thing he explains. It appears to him no more than the fortuitous *accretion* of numbers of purposes diffused throughout a productive system that consists of numbers of separate – in the sense of more or less independent and unconnected – elements, which has come about largely for reasons simply of their *chance* coalescence. Section 4.8 suggests that the reason for O's impression is connected with the amount of 'work' this kind of explanation leaves to him, compared with more 'satisfactory' explanations. Such an impression would show an intuitive appreciation of Occam's razor, 'an interpretation of which is that the more "simple" or "economical" of several hypotheses is the more likely' (Solomonoff, p. 3), so that, conversely, the less economical, more complicated explanation would come to seem more fortuitous.

Solomonoff explicates the concepts of 'simplicity' and 'economy' by means of Turing machines, the 'simpler' of two hypotheses being the one with the shorter 'description' (defined in 4.4) and so, by Löfgren's definition (4.4), and confirming the conclusion of the previous paragraph, the simpler description is also the more ordered.

The length of an explanation determines its usefulness. Because O fails to provide constraints binding together into a single thing the antecedent entities it postulates for W — something to which O may make a brief reference without needing to explain the thing itself, or to say how its elements relate to one another — these unbound-together entities remain a diffuse account that cannot provide the determinacy an explanation demands (5.7). There is little about O's explanation that fits it to *this* particular stone; it would do, it seems, equally well for almost any stone.

'If an explanation or interpretation of a phenomenon or state of affairs is to be fully satisfying or actable-on, it must have a special, not merely a general relevance to the problem under investigation. It must be rather specially an explanation of whatever it is we want to explain, and not also an explanation of a great many other, perhaps irrelevant things as well.' (Medawar, 1972, p. 64.)

Moreover, this indefiniteness is likely to grow roughly inversely with the explanation's 'usefulness' (shortness, relative simplicity), at least in relation to the particular stone in question. Conversely, the more specifically O attempts to make his explanation refer to this particular stone, the lengthier, more complex and 'useless' it is likely to become.

In important respects the difficulties with O's explanation depend upon the antecedent entities he chooses for it, though it is not necessarily the case that choice of more rigorously definable antecedents would alone be sufficient to arrive at a shorter, simpler or more specific explanation. An account of the stone made in terms of rigorously expressed chemical and physical laws, for example, would not necessarily do so because, in fitting such explanations to this particular stone, they would become unmanageably long. Even if the entities O postulated were all well-defined and behaved in a well-defined way in their respective environments, objections to O's explanation would be bound to persist, because of the persistence of the reason for them, the stone's apparently — to O — 'accidental' nature; from O's inability to detect regularities in it such as would enable him to furnish a unified, precise and definite explanation. To meet the objections, O would need to find a shorter, and at once less vague way, to account for the stone. The degree of his success would correspond exactly with a a reduction of the stone's evidently accidental quality. The discovery of some single system or entity as the stone's antecedent, by furnishing a set of constraints that might be mapped onto the stone — namely those that make the single entity single — would reduce the stone's apparently accidental quality.

4.8 Description and Explanation

While it is true that O's inability to account properly for W's existence makes W appear to have an accidental quality, it is true too that any regularity that O distinguishes in W identifies as an entity any antecedent that O may postulate to account for it. In this respect O's accounting for the stone's existence closely resembles his description of it, as (by 4.5 and 4.6) we should expect. Were O able to discern regularities in the stone's appearance such as would enable him to identify this particular stone, he would be able to attribute the regularities to the outcome of a purpose and the purpose to some antecedent entity; he would be able to suppose that the regularities of his description existed as the result of some pre-existing regularity, such as the equilibrial state of a pre-existing, purposeful entity. So the more concise O's *description* of the stone, the more concise (and therefore less accidental-seeming) his *explanation* of it. This would be the case even if, initially at any rate, O had characterized the entity he postulated simply as an 'entity A such that it produces W'; simply, that is, as some pre-existing coherence, reflecting a coherence he had discovered in W.

Very much the object of this section is to indicate the stubbornness with which regularities persist. O does not believe in purpose arising spontaneously, nor in regularity existing in isolation, and part of the aim here is to show that O has reasonable theoretical grounds for his prejudices. One might take as a simple model of O's views a chain of related regularities with purposes linking them. (For a more detailed view of this notion see the examination provided by Chapter 9, which may stand as a reasonable plausibility argument for present assertions.) A more complex model entails a net, in Minsky's sense, in which purposes join nodes (in Pound's sense) of regularity.

> Since there are flowers whose fertilisation is impossible except by means of an insect, flowers which eat insects and therefore understand them, since so low and unconscious an order has these correspondences with the one above, may there not be animals and birds who make use of man and study his habits and if they do, why not insects and vegetables? What grape, to keep its place in the sun, taught our ancestors to make wine? (Palinurus, 1961, p. 13.)

O will tend to use correlation as explanation. So, for example, if apart from W, O identified a dynamic entity, A, whose purpose (set of equilibrial states observed as output) correlated with W, then O might use A to 'explain' W's existence. The products of reproduction or 'self-reproduction', the offspring of biological species, say, do not have the accidental quality of the stone; though compared with a stone, accounting for a member of a biological species, other than by pointing to its parents, would probably require an even longer and more complex explanation. What makes the difference between the two explanations is not that O has a more precise idea of the connexion between the biological offspring and its parents than between wind, water, etc., and the stone. It is that,

in the case of the biological offspring, identifiable entities (the parents) exist, into which the offspring map, apparently with little residue, while no equivalent mapping is available for the stone. Such entities − the parents − being true (coherent) entities, may themselves be thought of as (determinate or probabilistic) systems whose internal workings O is at liberty to ignore, since they occur *independently* of him. While the 'entity' wind, water, etc., into which he maps the stone, being an arbitrary collection of separate elements, requires that O should, as it were, 'operate' it himself by defining the elements' relationships.

It appears that we are here concerned with the *accumulation of purposes* such as enables them to be transmitted or realized as a body. What the purposes *are* or *how* they are transmitted is of secondary importance. An example of an entity able to 'accumulate' purpose in this sense is provided by Fogel and others. These authors have 'evolved' machines to perform particular operations in certain well-defined environments. One such machine for instance is required to predict the next input state of an environment whose input states consist of a cyclically repeated string of randomly distributed zeros and ones. Simplified, their method is to begin with some arbitrary machine (finite automaton), (1) let it run for a time, (2) measure its performance, using a measure based on the number of its outputs, zero or one, that are the same as the next input, (3) 'mutate' it, by making some random alteration in its internal or output states, and repeat steps (1) and (2). If the new machine performs better than the old one, producing more outputs the same as the next input than the old one did, it is retained. Otherwise, (4) the old machine is restored and a new mutation tried. Steps (1) to (4) are repeated until improvement in performance ceases, by which time the machine may perfectly predict its environment. If this occurs, the machine's and its environment's outputs will be identical. At least they are likely to be very similar. The machine is then itself a perfect, or very close, *description* of its environment, in the sense that its order has evolved to correlate with the relevant aspect of its environment's order − in general one that is more concise than a simple enumeration of the environment's output states would be.

My hypothesis is . . . that thought models or parallels reality − that its essential feature is not 'mind', the 'self' 'sense-data' nor propositions but symbolism, and that this symbolism is largely of the same kind as that which is familiar to us in mechanical devices which aid thought and calculation. (Craik, p. 57.)

Taken alone, the outputs of the machine are precisely as random as the string of random numbers it has been evolved to predict. To O they appear 'accidental', the products of chance, like the outputs of the environment. But if O notices the correlation between the two sets of outputs, it is likely to postulate a causal link between them. (In practice any causal link actually postulated is likely to depend upon temporal arrangements. For example, in the present case, A

would probably see the machine evolved to predict its environment's outputs as if it controlled them!) Irrespective of any postulated causal link with its environment, however, the machine is likely to be supposed purposeful, simply because the alternative explanation, that the observed correlation between its outputs and the environment's came about by chance, is unacceptable — the likelihood of its having been a chance event and instinctively felt to be so, being negligibly small. And this will be because O's intuitive definition of purpose matches the more rigorous one proposed in 4.2. Notice that the machine's evolution has come about as a response to the environment as a whole, particularly its cyclic character, not to its individual outputs. But this does not affect O's deeper assumption, namely that the correlation observed did not occur by chance but 'on purpose'. It does not matter to O that he may be incapable of describing the machine beyond pointing to or naming it as the ('black box') producer of the output observed; all that is needed is that O should be able to identify it.

It is always possible for O to find an explanation that appears satisfactory. Broadly speaking, O either identifies an object or state of affairs by finding a description of it and then postulates a matching purpose of which the object is supposed to be the realization, or O identifies some purposeful entity which enables him to distinguish objects or states of affairs to which the entity's purpose is supposed to have given rise. (An implication of 4.3 is that the object or purposeful entity O distinguishes will itself depend upon O's purpose.) In either case, the description of the object and that of the purpose are morphisms of one another.

Recapitulating, O's procedure when it sets about accounting for W's existence is first to distinguish W as an entity in E — what makes W an entity is the constraints existing between its parts. O's distinguishing W depends upon its discovering these constraints, which is equivalent to O's finding a description of W sufficient to enable it to name W or delineate it in some way. To account for W's existence, O postulates some pre-existing, purposeful entity with which it supposes W stands in some kind of correspondence. The entity is equivalent to and may be an explanation. Finding an entity suitable for this object consists in finding one that incorporates a procedure whose operation on E will be sufficient to bring W into existence. Provided O is satisfied that the entity is determinate and that it does in fact bring W into existence, O may take the entity as, in this sense, sufficient to account for W's existence.

4.9 Improving Explanations

As asserted above, an account of W by O depending upon an antecedent entity may be regarded as equivalent to an 'effectively understandable' explanation (4.5), in the sense that it may be characterized as a sequence generated by an effective procedure, even though the effective procedure belongs to the entity

and not to O itself. Such an explanation is (1) repeatable (determinate), (2) equivalent to the sequence that a universal Turing machine would compute given the proper starting tape, namely one consisting of the axioms and rules of the appropriate r-formal theory. Moreover, an effectively understandable explanation of W would be that part of any sequence, from its start, up to and including the p-explanation of W, included in a finite segment of the total sequence. Thus there is an equivalence between the explanatory entity that O postulates and an effectively understandable explanation, in the sense that, given the proper initial conditions (either the entity or the appropriate starting tape for the Turing machine), the end conditions (the required explanation) will come about (automatically) by the execution of a determinate procedure. Both kinds of explanation, Löfgren's and O's, represent effective procedures.

But we have seen that a relatively effective explanation is not necessarily effective for any particular given observer, O. The variety required for an effective explanation may exceed O's capacity as a channel (see 9.4), and even if it does not, we have observed (4.7) that O's explanation is unlikely in general to be effectively understandable. Now suppose E is an explanation that is not effectively understandable, then, by Löfgren's *Explanation Hypothesis 1*, it is not a p-explanation in an r-formal theory. Nevertheless, (recalling 4.5), it may still contain 'parts' that are or could be made effectively understandable, each perhaps consisting of a sub-sequence generated by an effective procedure from the set of rules and axioms peculiar to that sub-sequence. (In the limiting case the sub-sequence might consist merely of individual elements.) Such a 'partially' understandable explanation would become '*more* understandable', in the sense in which we are using the term, if a new set of rules and axioms could be found from which it were possible to generate more than one of the sub-sequences. That is, if the number of sub-sequences could be reduced by joining sub-sequences together to form longer sub-sequences.

The idea that this formulation expresses occurs more or less equivalently in other formulations such as Beer's (1972) in which an explanation's increasing understandability corresponds to rising through a hierarchy of meta-languages. Compare also von Mises' view on connectibility (4.5); or Schrodinger's (1947) two 'mechanisms' for producing order, 'The statistical mechanism which produces order from disorder and the other one producing "order from order".'

This, indeed, is in accordance with the way O is bound to proceed in order to increase the relative effectiveness of an explanation. For, recalling the example of the stone, we see that O's procedure consists in naming antecedent entities, wind, water and so on, which we take to be equivalent to selecting by their code numbers appropriate starting tapes for a universal Turing machine for generating particular sequences, or of choosing finite automata, like those evolved by Fogel

and others (4.7), such as have outputs of the kind required. And, supposing for the moment that we are justified in assuming this equivalence, we may regard O's explanation as a collection of names arranged in a sequence with some degree of order relative to O. In this case, the understandability of O's explanation would increase as O discovered more order in the sequence, that is to say, as O found entities capable of generating ever longer segments of the sequence. If our assumption is not justified; that is, if the antecedent entities O names turn out to be inconsistent or indeterminate through being insufficiently specified, then (by 4.5) these shortcomings may be remedied, as we have shown.

5

Authorship

5.1 Authorship and Order Extraction

The concept of order extraction and order-extraction work provides the basis for the definition of 'author'. A purpose in A to produce W requires order in A, and the purpose makes A W's author. In so far as A has acquired the order that it passes on to W by its own order-extraction work, it is said to have created W, and is called W's c-author. Definitions follow of partial authorship and there is discussion of the subjective nature of the definitions and of the evolutionary character of 'author' as defined.

The most important idea to grasp from this chapter is that a WOA is seldom likely to be a product purely of c-authorship. Indeed, by the arguments of the preceding chapter, this could be the case only if A, or that part of it responsible for W, had come into existence more or less spontaneously and without antecedents. As an actuality, such a state of affairs is next to inconceivable. What appears to occur generally in reality is almost the reverse of this. In the case of art, first and foremost the artist, as a human, is a product of millions, the culture in which he develops, of tens of thousands, of years of evolution; his history, culture, his art, his technique, his medium, the work of other artists, his school, tradition, 'that great Poem' as Shelley calls it, 'which all poets, like the co-operating thoughts of one great mind, have built up since the beginning of the world' (*In Defence of Poetry*), all contribute to an overall structure. The '"motion of spirit" (Dante's own phrase) which underwrites poetic craft is collective and cumulative' (Steiner, 1976). To this structure, the individual (artist) adds little; what he adds is the outcome of his creative effort. 'There are some things which cannot be learned quickly, and time, which is all we have, must be paid heavily for their acquiring. They are the very simplest things and because it takes a man's life to know them the little new that each man gets from life is very costly and the only heritage he has to leave' (Ernest Hemingway, *Death in the Afternoon*). Because of its relative smallness, how much the individual adds may be difficult to assess. The difficulty is not peculiar to art but is also the case in science.

Science is frequently distinguished from art on the grounds of its progressive character, though the view developed so far here hardly justifies this distinction. If science and art both rely on the use of developed forms, both must have similarly progressive natures.

> I was led to ask myself whether there was any truth in the distinctions which we are always making between art, which is not more advanced now than in Homer's day, and science with its continuous progress. Perhaps, on the contrary, art was in this respect like science; each new writer seemed to me to have advanced beyond the stage of his immediate predecessor; and how was I to know that in twenty years time, when I should be able to accompany without strain or effort the newcomer of today, [cf. 6.7] another might not appear at whose approach he in turn would be packed off to the limbo . . .? (Proust, Vol. 6, pp. 22, 23.)

What gives science its apparently progressive character is the impression of the almost pre-destined course of its development; an impression gained from events like the very nearly simultaneous but independent invention of the calculus by Leibniz and Newton for example – though such coincidences might be explained on the basis of Spencer-Brown's observation that proofs are found for those theorems that lead somewhere. The review of scientific development commonly tends to emphasize the convergence of whole domains of knowledge into some single new 'discovery' (heuristic; explanation) and to neglect the huge new vistas that such discoveries open up. Among great discoveries one would include Mendelyev's Periodic Table, the Theory of Evolution, Bragg's Law, Maxwell's synthesis of magnetism and electricity. After such discoveries, the problem of finding alternative explanations for the knowledge they draw together is even more difficult than that of coming by the explanation offered in the first place. An alternative to the Theory of Evolution for example, which would 'explain' the same set of data as the Theory, would need the same order-extraction effort as was needed to create the Theory, *plus* an additional effort to overcome the 'blinkering' effect (8.3) the theory exerts, once created. This is one reason for the tendency to emphasize the convergent aspects of scientific development. But what leads away from discoveries is highly divergent (see 7.1). Without Bragg's Law, for instance, the discovery of DNA would probably have been impossible. Yet this discovery would have been hard to predict, even in approximate form, at the time the Law was first enunciated. Art does not take along all its knowledge at each new departure, and is often contrasted with science in this. But with science too, much becomes useless and is discarded. As we shall see in the following chapter, there is no escape from the difficulty that results from having to build new order upon old. In art or science, order extraction is limited by the relatively low variety of the processor that does the order-extraction work, compared with the high variety of the surrounding from which the order is to be extracted.

This conclusion raises a question as to the interpretation of W, in particular of a WOA; namely how much difference is tolerable between the order accumulated in A and in O (in his role as audience), before the $W A$ produces ceases to be a WOA for O, or even distinguishable by him as a W. How much creativity is an artist allowed before his work is rejected by an audience as 'unintelligible'? How much 'genius' is necessary for it to escape recognition? Chapter 3 dealt in part with this question, though on the assumption that W would be distinguishable. When this is not the case, the argument of Chapter 3 fails, but then the question never arises. But even in the absence of bizarre differences between A and O – placing the restriction that both should be human, say – what are the chances that the WOA A produces will receive greatly varying interpretations from the two individuals? The question is clearly wide and outside the scope of present concerns. Here observations will be confined to the effects of $O - A$ differences on taste, interpretation and expression.

Moles, for instance, asserts that the size of the public interested in a concert varies inversely with the concert's originality, (where he defines the programme's originality H as $H = -5p_i\log_2 p_i$; the factor 5 derives from the classification of composers into five groups according to the frequency of their works' performance; and $p_i = p_w \times p_c$, with p_c being the composer category and p_w the composer's work category). Implicitly, this defines public taste in terms of frequency of performance, and so, in a sense, is circular, defining taste in terms of audience size and making audience size depend on taste. But, more simply, the definition also suggests that people like what they know. Knowing the music increases the audience's capacity as a receptor, so raising what we have called the information potential of, in this case, the concert, and also therefore (2.7) its aesthetic value. 'Any study of the value or quality of a message' – taste – 'must be based on the capacity of the *ultimate* receptor' (Moles, p. 19).

Clearly, this approach raises questions of the artist's and his audience's education, sociocultural milieu, and so on. Misconstruction is possible at many levels. Intelligibility at one level does not ensure it at another. Karen Blixen (1964) records telling the story of *The Merchant of Venice* to her Somali servant in Kenya. The Jew should have used a red-hot knife, the servant argued, it draws no blood. What about the pound of flesh, neither more nor less? He could have taken a little at a time.

> But in the story the Jew gave it up.
> Yes, that was a great pity, Memsahib. (p. 279)

For the artist such difficulties raise problems of expression: how much creativity will destroy intelligibility? Many artists, especially in this century, have been content to ignore such considerations. Others, without either the intention or the wish to do so, have fallen foul of their own creative achievements, only to be vindicated by later generations. In any event, the problem of the balance between novelty and banality remains interesting. According to Moles, intelligibility varies inversely as originality. The difficulty of transmission of a message increases with its information content. '. . . a proper balance between banality and originality is now a cornerstone of aesthetic perception' (Moles, p. vi). Montaigne quotes Horace: 'I strive to be concise/And grow obscure'. To pursue this question (7.4) a more detailed understanding is called for of what choices the artist has. These problems vanish only if A and O are identical individuals; that is to say, if O and A are subsets within the same set of procedures, both drawing upon the same data base. Chapter 10 will show that a structure incorporating both A and O elements in this way is not simply desirable but actually necessary for any art machine. In art as in science,

> the order which the scientific [artistic] discoveries reveal will be talked about not only by the scientists [artists] themselves but also by their colleagues in other fields, and eventually will be taught to a new generation of scientists [artists]. In this way a potential is created for asking deeper questions about the system [techniques, approaches] revealed, and finally new or related orders and systems may be found. (Löfgren, 1972, p. 342)]

The previous chapter, together with the one preceding it, complete the preliminaries to the definition of authorship. The definition adopted makes authorship transmit order but reserves the terms creative-authorship for authorship that generates order, though with the qualification that generation of order is not an autonomous process, but occurs within a surrounding, in a manner similar to

'self-organizing'. The distinction between the two kinds of authorship provides a basis for answering questions like Minsky's (1972), 'When can one credit a machine with solving a problem and when must one credit its designer or programmer?' (p. 7) It has the advantage too that it permits emphasis of the gradual, evolutionary character of the 'creative process'.

5.2 Approach to Authorship

As the distinguishable 'thing', W represents a mapping of A into E, (or of that aspect of A that may be regarded as the purpose that led to W's production) A will be called W's *author*. Although A will be embodied in some sort of physical hardware, it is not the hardware itself, but its organization that is of interest. This is the reason why A is defined as a set of procedures (3.2). Where A is a single coherent entity, the term author as it is used here will be seen to correspond to its normal dictionary meaning (3.1). A's coherence, as was shown in the previous chapter, will depend upon the coherence of the purpose that O discerns in W. If, as in the case of the stone in the preceding chapter, a human observer discerns little coherence in the purpose realized in W, he will reflect this by attributing authorship to a series of entities $A_1, A_2 \ldots$

A number of simplifying assumptions have been made in arriving at this definition of author. First, it has been tacitly supposed that authorship may be regarded as some kind of step-wise process whereby A is activated and W emerges on an all-or-none basis, emitted as a single output. It will become clear from more detailed examination of the authorship process (Chapter 9) that this assumption is not necessary to the definition and has been made simply for the sake of initial simplicity. Later the restriction will be relaxed. Secondly, and consonantly with this assumption, A and W have been treated as if they were unitary entities. Moreover, although A's purpose has been distinguished from A itself, the matter has been left vague. Clearly, the ultimate aim is to be able to discuss complex and complicated As and Ws. Later, these simplifying assumptions will be justified and the constraints they imply relaxed, without damaging the concepts concerning which they have been made. Thirdly, all mention has so far been avoided of how A exercizes control during the production procedure that gives rise to W. Regulation and control is the subject of Chapter 10.

5.3 Order Extraction

Implied by the proposed definition of authorship is the notion that whatever results in the production of W may be regarded as the outcome of an accumulation in A, before W is produced, of the regularity that W reflects; that is to say, as having been part of A's organization or structure. Now since A is an entity of

some kind, possibly a loosely bound set of objects or events, it has some form of organization, which it must either have acquired, or possessed when it came into being. (It follows from arguments mentioned earlier (4.5), showing the impossibility of self-organization, that if an entity manifests any new organization it must have 'acquired' it at least in the sense of having generated it as a response to changes in its surroundings that have affected it.) In the latter case, A itself may be thought of as a W produced by some previous A, to which similar remarks about its organization apply. Thus the purpose realized in W must either have been acquired by A or channelled through it, although the possibilities need not be mutually exclusive and generally will occur together. Löfgren distinguishes these two cases as forms of *order extraction*.

> *Learning-programming hypothesis.* An object A can learn from a surrounding S if A can extract order (regularities) from S. The more order that is extracted (the shorter the description of S produced by A), the more genuine is the quality of learning. The amount of work done by the learning mechanism (the order-extraction mechanism) in A represents the amount of learning done by A and is hence a subjective measure. If A obtains the properties of S without any proper order-extraction work, A is said not to have learned S but to have been programmed by S'. (Löfgren, 1972, p. 356.)

Notice that, according to this hypothesis, order-extraction work may be regarded as a necessary, though not a sufficient condition, for learning, as order extraction can occur without learning. A procedure capable of solving problems or recognizing patterns for example is not necessarily modified by the results it achieves, except at the instant when it reaches its solution or makes its recognition.

If, for the present, we dispose in this way of problems of audience and interpretation that result from differences in the accumulated order of A and O, the question of A's 'creativity' remains. Newell and others define creativity within the context of problem-solving. This is not in itself restrictive, as any purposeful activity might be defined as problem solving in which the problem was to realize the purpose. However, the four conditions they list as sufficient to characterize creativity in general are wholly based on experience of human creativity. The conditions are: (1) 'novelty and value' (for the thinker or his culture); (2) unconventionality, achieved by modifying or restricting previously accepted notions; (3) the need for high motivation or persistence 'over a considerable time' or 'at high intensity'; (4) part of the problem consists in formulating the problem itself. The notion of order extraction covers the first two of these criteria – the way Newell and others stipulate them simply adds to our own terms a vague and arbitrary requirement as to the quantity of order that must be acquired before the acquisition qualifies to be called 'creative'. The third criterion is psychological. While it is likely to be a feature of human creativity one would not regard it as a necessary one. The creative act might be quick and depend entirely upon previously-programmed (in our terms) order that, by definition, did not depend upon prior activity. Nor would one suppose the condition sufficient. The fourth criterion does appear sufficient to justify giving the name creative thinking to problems that required it, since re-formulating a problem, while it may not necessarily solve it, is itself creative. It is also probably a necessary condition of creative problem solution; for a problem stated in such a way that it needed no reformulation would contain its solution *in posse*, rather

as the starting tape of a Turing machine contains *in posse* the end tape it generates. Fogel and others liken 'creativity' and 'imagination' to artificial intelligence and suggest that, given these qualities, 'it is possible to seriously consider programs that would provide the machine with self-awareness and, ultimately, with an ability to select its own goals' (p. 123). So, if this were the case, we should argue from our proposed definition of authorship that self-awareness would be one of the characteristics it determined.

5.4 The Evolution of Authorship

Authorship is an evolutionary process. Within the terms of the present hypothesis connecting authorship with order extraction, we may suppose that A's initial structure — its structure when it 'came into being' as an entity — must itself have been the result of order-extraction work carried out by some entity antecedent to it, A' say. Similar observations apply to A' and to its antecedents, resulting in a backwards evolutionary chain, modified only by possible successive acquisitions of losses of order of the entities that make it up. Corresponding to these different origins of A's structure — namely order-extraction work carried out by A (learning), or structure acquired by what, corresponding to the idea of an evolutionary process, may be called 'heredity' — two separate forms of authorship will be distinguished. In so far as the purpose to provide W existed in A from the outset (by heredity), or if A acquired the purpose without proper order-extraction work (by being programmed), then in either case we shall refer to A as the *apparent author* of W. In so far as the purpose to produce W came into existence as the result of proper order-extraction work performed by A, we shall refer to A as W's *creative author*, written *c-author*. Particular Ws will be taken to be original to the extent to which the purposes realized in them have originated in A, by A's order-extraction work.

Returning to the question of purpose, we may restate the definition of authorship as follows: given a purposeful process AW, an observer O, able to observe events in E but not in A, will attribute W to the *creative-authorship* of A so far, and only so far, as he judges that (1) W corresponds to the execution of a purpose entertained by A, and (2) the purpose emanates from (has been generated as a result of acquisition by) A. We arrive at the definition of *authorship* by relaxing the second of these conditions.

A number of further definitions follow:

A productive process AW will be called a *creative process* (*c*-process) if and only if the controller A is a *c*-author, in which case we shall denote the process by *c-AW*.

If A denotes a number, n, of distinct controllers A_i of W (that is to say, if A is made up of a number of separate entities $A_i, A_2 \ldots A_n$, then these will share the authorship of W and will be called the *partial authors* (or *partial c-authors*, as appropriate) of W.

Correspondingly, we call W a *c-W* (or partial *c-W*) if and only if it is the

product of a c-process (or partial c-process).

The chief advantages of these definitions are, that they are based upon a rigorous conceptual foundation that recognizes the connexion between structure and purpose, and so, the *inevitably self-reproductive aspects of purposeful activity*, and the overriding homeostatic purpose concerned with equilibrial states and the invariance of identity. For art theory the definition is satisfactory, providing as it does a framework within which to examine the qualities 'we demand in our sensations' from an 'object of art', which

> will be order, without which our sensations will be troubled and perplexed, and the
> other quality will be variety, without which they will not be fully stimulated . . . there
> is something more – there is the consciousness of purpose (Fry, 1937, pp. 32,
> 33.)

5.5 A, W and the Order-Extraction Process

Authorship emerges as a subjective concept: the definitions arrived at all depend upon the subjective measure of order-extraction work which has been proposed as authorship's basis. To show that this subjectivity is no mere accident of the definition but is inherent in the character of what is being defined, we recall that A, A's purpose and W are all defined by, and therefore dependent upon, the characteristics of O. (See for example 3.3 and 4.6.)

> Because any real 'machine' has an infinity of variables, from which different observers
> (with different aims) may reasonably make an infinity of different selections, there must
> first be given an observer (or experimenter); a SYSTEM is then defined as *any set of
> variables* that he selects from those available on the real 'machine'. It is thus a list,
> nominated by the observer, and is quite different in nature from the real 'machine'.
> (Ashby, 1956, p. 16.)

For 'machine' in this quotation we may read W. Our concern is not with 'the real' W but with what we may regard as an abstraction of the observer's.

Although the definitions proposed are subjective, they are embedded in effective definitions of order and will be shown to provide a foundation for extending those principles such as it is hoped will furnish a basis upon which to build an art machine. We shall go about this by seeking to show that W plays a part in the *process* of A's order extraction and is not merely the outcome of order-extraction work preceding its production. We shall begin by examining briefly various principles of order-extraction work. This is an extremely wide field covering practically the whole domain of artificial intelligence and including those studies usually denoted by the names 'problem solving', 'pattern recognition', 'learning', 'evolution', as well as 'creativity' and 'imagination'. Only those parts of the field will be touched that are relevant to indicating some of the principal forms of order extraction. This review will be followed by a more detailed examination of purposes and it will be shown how order extraction

works to produce 'teleonomic' (4.1) entities and how these transmit purposes. Thereafter, the realization of purposes will be taken up: control and regulation, and the constraints exercized on order extraction by the growing structures of the teleonomic entities and their environments. These last two topics, constraint and control, will lead naturally to questions as to the kind of W that we should expect different kinds of teleonomic entity to produce.

product of a c-process (or partial c-process).

The chief advantages of these definitions are, that they are based upon a rigorous conceptual foundation that recognizes the connexion between structure and purpose, and so, the *inevitably self-reproductive aspects of purposeful activity*, and the overriding homeostatic purpose concerned with equilibrial states and the invariance of identity. For art theory the definition is satisfactory, providing as it does a framework within which to examine the qualities 'we demand in our sensations' from an 'object of art', which

> will be order, without which our sensations will be troubled and perplexed, and the other quality will be variety, without which they will not be fully stimulated . . . there is something more − there is the consciousness of purpose (Fry, 1937, pp. 32, 33.)

5.5 A, W and the Order-Extraction Process

Authorship emerges as a subjective concept: the definitions arrived at all depend upon the subjective measure of order-extraction work which has been proposed as authorship's basis. To show that this subjectivity is no mere accident of the definition but is inherent in the character of what is being defined, we recall that A, A's purpose and W are all defined by, and therefore dependent upon, the characteristics of O. (See for example 3.3 and 4.6.)

> Because any real 'machine' has an infinity of variables, from which different observers (with different aims) may reasonably make an infinity of different selections, there must first be given an observer (or experimenter); a SYSTEM is then defined as *any set of variables* that he selects from those available on the real 'machine'. It is thus a list, nominated by the observer, and is quite different in nature from the real 'machine'. (Ashby, 1956, p. 16.)

For 'machine' in this quotation we may read W. Our concern is not with 'the real' W but with what we may regard as an abstraction of the observer's.

Although the definitions proposed are subjective, they are embedded in effective definitions of order and will be shown to provide a foundation for extending those principles such as it is hoped will furnish a basis upon which to build an art machine. We shall go about this by seeking to show that W plays a part in the *process* of A's order extraction and is not merely the outcome of order-extraction work preceding its production. We shall begin by examining briefly various principles of order-extraction work. This is an extremely wide field covering practically the whole domain of artificial intelligence and including those studies usually denoted by the names 'problem solving', 'pattern recognition', 'learning', 'evolution', as well as 'creativity' and 'imagination'. Only those parts of the field will be touched that are relevant to indicating some of the principal forms of order extraction. This review will be followed by a more detailed examination of purposes and it will be shown how order extraction

works to produce 'teleonomic' (4.1) entities and how these transmit purposes. Thereafter, the realization of purposes will be taken up: control and regulation, and the constraints exercized on order extraction by the growing structures of the teleonomic entities and their environments. These last two topics, constraint and control, will lead naturally to questions as to the kind of W that we should expect different kinds of teleonomic entity to produce.

6

Principles of Order Extraction

6.1 Order and Entropy

The outlook of this chapter is conservative in the strict sense of viewing order as hard won and able to grow only if what already exists is largely preserved. The theme is taken up of the difficulty and slowness of order extraction from a point of view differing from that of the two preceding chapters. The implications for an art machine of the chapter's conclusions remove some of the difficulties revealed earlier, though at the cost of limiting the scope of possibilities of what we may hope to construct. The results of order extraction may be used as heuristics to advance further order extraction: c-authorship fuels itself. But finding heuristics is slower than it often may seem, simply because habituation conceals how much structure many common heuristics – like Beer's dog-training heuristic (6.2) for instance – may incorporate. Moreover, because of the slowness of order extraction, any art machine will have to depend for its initial structure upon what its maker is able to provide. As the maker will, in turn, have to rely for this upon his own structure – the structure with which he has been 'programmed' and what he has acquired – the art machine will be bound to resemble its maker in what it produces. Chapters 8 and 9 will explore this further.

The aim of the present chapter is to draw together the concept of heuristics with the wider concept of order to which it belongs. Heuristics are slow and difficult to acquire and may lead to error. Matching the power that each new heuristic confers is a countervailing loss of flexibility. Without heuristics order extraction is slow; with them it may be rapid but ultimately disastrous.

The chapter begins with a review of a number of definitions of the two concepts, algorithms and heuristics. Heuristics fill a role where algorithms are unavailable. Heuristics are aids to order extraction, but unlike algorithms, heuristics may not merely fail but actually lead to error which would not have occurred if the heuristic had not been used. Especially in novel situations, there may be a trade-off between error and heuristic power, which may be thought of as analagous to 'type I' and 'type II' errors in statistics. The power that heuristics confer on an order-extraction process is often wrongly attributed to the process's authorship rather than to the authorship of the system to which

the heuristics are due. What belongs to the user system may be simply the recognition that the heuristic is usable. Heuristics' power and error-risk both relate to the 'distance' from the goal at which the heuristics are applied, power increasing inversely and error risk directly with 'distance'. The chapter ends with a suggestion for measuring both heuristic power and error risk.

6.2 Heuristics and Algorithms

The object of setting out to discover the principles for building an art machine is to arrive at an effective theory by which to interpret the whole enterprize of art in the broadest context of knowledge. It has been shown that there is a strong relationship between art and order; that order comes into being through a process of order extraction; and, by 4.4, that there is no effective procedure for extracting order. In these unhelpful circumstances we are therefore led to examine the principles of order extraction, especially the use of heuristics, with the object of discovering necessary features that an art machine will have to incorporate.

Heuristic methods are concerned with order extraction. They are often contrasted with algorithms. Minsky (1965) makes 'algorithm' synonymous with effective procedure (p. 105). Klir and Valach define the term as 'every precise instruction which uniquely determines the procedure leading from the initial information to the sought-for resulting information' (p. 145). Beer uses algorithm to mean 'a comprehensive set of instructions for reaching a known goal' (p. 305). Defining heuristic is more difficult. A number of authors do without the term. Ashby (1964) avoids both algorithm and heuristic, though his discussion of trial and error — which he prefers to call 'hunt and stick' — is essentially a treatment of heuristics. The *objective properties of getting success by trial and error are shown when a Markovian machine moves to a state of equilibrium* (p. 230). Such movement is *'homologous* . . . to movement by a determinate trajectory,' for both are the movement of a machine to a state of equilibrium' (p. 231). Other general texts that do not mention heuristics are those of Klir and Valach, and Minsky (1972).

Polya (1948) starts from the *Oxford English Dictionary* definition of heuristic as an adjective meaning 'serving to find out'. He associates the notion with an absence of 'complete certainty'. Heuristics are 'provisional', the 'plausible guess' that precedes attainment of the 'final goal'. 'We need heuristic reasoning when constructing a strict proof as we need scaffolding when we erect a building' (p. 102). This contrasting of *provisional* and *strict* procedures appears to imply a difference of function. The provisional procedure somehow gets one to the goal while the strict procedure justifies one's having got there. These functions are distinguished by Reichenbach (1968) as the 'context of discovery' and the 'context of justification' (p. 231).

Reichenbach comments, 'the act of discovery escapes logical analysis; there are no logical rules in which a "discovery machine" could be constructed that would take over the creative function of the genius' (p. 231). Five years later, Newell and Simon (1956) reported on a *Logic Theory Machine* that proved theorems in Russell and Whitehead's *Principia Mathematica*. Chapter 8 will provide detailed examples of the use of heuristics in related machine enterprizes.

According to Reichenbach, an example of what may be thought of as occurring might be as follows. Suppose one's heuristic were an analogy (3.4). Suppose T were a theorem in a formal theory, an electrical network theory, say, for concreteness; and suppose one were faced with a problem in hydrodynamics. Then, if one noted an analogy between the network to which T applied and one's particular problem in hydrodynamics, it might be possible to use this heuristic (the analogy) as the basis for a 'plausible guess' at the solution to the problem in hydrodynamics. One might set up the hypothesis that the analogy one had noted between the two systems might be extrapolated to include the result T (in its appropriate form, call it T_{hydro}), thus suggesting a solution for the hydrodynamics problem. T however would not provide a 'strict proof' of T_{hydro}. It would stand as a 'conclusion' that might then act as a statement of what was *required to be proved*, in a form that might itself indicate lines along which the proof could possibly be expected to run; the analogy might act as a kind of goal-setting or problem-formulation device. This argument and Polya's are clearly close to one another; and the idea it expresses satisfies the fourth criterion of creativity that Newell and others (1958) list (5.3). Minsky (1958) makes the point explicitly. We

> ... use the term [heuristic] in describing rules or principles which have not been shown to be universally correct but which often seem to be of help, even if they may also often fail. The term 'heuristic program' is thus used in reference to the distinction between programs which are guaranteed to work (and are called 'algorithms') and programs which are associated with what the programmer feels are good reasons to expect some success (p. 36).

'... the codification of a proof procedure or any other directive process, although at first useful, can later stand as a threat to further progress.' (Spencer-Brown, p. 10.) In other words, it is not just error in the normal sense to which heuristics may lead but, more broadly, to determining the path of evolutionary development. (See Chapter 9.) The action of the mechanism that leads to this determination is what also conceals it from us, concealing awareness of the part our received order plays in determining what structures we discover and, more particularly, what we do not. Pask, Scott and Kalliarkourdis (1973) examine the dependence of problem solutions upon problem structures. In heuristic problem-solving programs the problem is largely solved before the outset of the 'solution' by the program's operation, either because the problems themselves are embedded in highly structured domains – chess, theorem-proving or the like – or because the author has already selected what he considers relevant to the solution in specifying the problem. And his selection may entail a huge reduction in variety between the actual problem and its specification. The

alternative, a system that had 'not evolved to match the world into which it was born' (McCulloch, p. 221), would have to acquire its own heuristics and face the slow task of reducing the world's variety to manageable proportions.

The author is bound to feel ambivalent about heuristics, which, while they increase his power as a *c*-author in one way, diminish it in another. The author cannot escape from old, long-developed structures, his human form for example; though at the frontiers of authorship there is some opportunity for him to choose his own forms (heuristics). Here, one of his problems might be communication with an audience. For *c*-authorship is innovatory by definition and therefore a departure from, a 'creation' added to the world of the author – and so, *a fortiori*, his audience. The question is, what degree of departure is permitted an author before his message becomes unintelligible to an audience? But the author's problem is only secondarily one of communication (Chapter 9). As heuristics are really variety reducers, his deeper problems remain those of choosing them, in as much as choice is possible. The author must strike his own balance, within the limits open to him, of doing more with less or less with more. Selfridge, in the discussion following a paper presented by McCarthy (1958), expresses a view that draws attention to a consequence of the use of heuristics: 'he [Professor Bar Hillel] made a remark that conclusions should not be drawn from false premises. In my experience those are the only conclusions that have ever been drawn' (p. 86); an observation that could be taken to express Popper's (1963) belief that scientific knowledge grows as a series of conjectures and refutations. Popper contends that this view follows from Hume's conclusions concerning causation which preclude any other view. Popper's argument receives closer examination in Part III. (cf. also the fourth criterion for creativity of Newell and others (1958), 5.3)

6.3 Going Out on a Limb

Newell and others (1958) denote by heuristic 'any principle or device that contributes to the reduction in the average search to solution' (p. 22). The shift of emphasis away from questions of the validity of heuristics towards those touching their operation reflects the authors' concern with the realization of effective procedures in the form of computer programs for actually solving problems. An heuristic for such a program is quite specifically a means of reducing the number of branches to be searched by some tree-searching procedure, for instance. The hope would be to eliminate only those branches *not* leading to solutions, while leaving for search those others along which solutions might be found. The authors point out that it is not necessarily always possible to fulfil this hope. For heuristics may eliminate fruitful as well as barren branches.

It appears from this that 'error' may arise from two sources due to the use of heuristics, one that leads to the neglect of aspects of a problem where solutions are to be found, and another, that allows the retention for investigation of aspects where no solutions exist. This suggests a measure for the efficacy of heuristics, analogous to the familiar statistical procedure for distinguishing *type I errors* (barren branches retained) from *type II errors* (fruitful branches pruned). That is to say, two populations of branches are pictured, barren and fruitful. *A priori*, there is no way of knowing to which population a given branch belongs.

Heuristics may be regarded as ways of guessing how branches should be classified. The better the heuristic the fewer 'wrong' classifications it will lead to. In the absence of an error-free heuristic, knowledge of the relative magnitudes of the type I and type II errors will clearly help in choosing the 'best' among a number of heuristics that may be available for a given task. Indeed such a choice might itself be heuristically systematized in order to optimize the balance of the two kinds of error in such a way as to maximize problem solutions. Evidently then, a feature of heuristics, as distinct from algorithms, is that they give no assurance of reaching a particular goal. Indeed they may actually block progress towards a goal that would have been reached if another heuristic had been used, or if search had proceeded without the aid of heuristics, 'randomly'.

Problems devised by early *Gestalt* psychologists, such as those for instance that were supposed to demonstrate 'insight', Ruger puzzles and the like, may be interpreted in these terms. Typical insight problems are of a kind that can only be solved when the subject recognizes that he is using a wrong heuristic. The problems devised are such as would be likely to call forth some habitually used heuristic that would *not* lead to a solution. The subject would show 'insight' when he abandoned his wrong heuristic in favour of a better one – restructuring of the problem called for by Newell and others (1958) (5.3). From this viewpoint, random procedures are likely to prove most creative, since they will be likely to achieve the most novel and unconventional solutions to problems, along with a high degree of wastage, (just as random choices in the football pools are likely to win the highest prizes).

6.4 Distinguishing Algorithms and Heuristics

Beer appears to make a somewhat stronger claim for heuristics. Like Minsky, he contrasts heuristics and algorithms. An heuristic he defines as a 'set of instructions searching out an unknown goal by exploration, which continuously or repeatedly evaluates progress according to some known criterion' (p. 306). Or again, 'An heuristic specifies a method of behaving which will tend towards a goal which cannot be precisely specified because we know *what* it is but not *where* it is' (p. 69). The 'basic trick' is to provide an 'algorithm determining an heuristic' (p. 71). So we end up with an algorithm. It is not immediately clear what the relationship is between the 'known goal' that Beer refers to in his definition of algorithm (6.2) and the 'known criterion' associated with the heuristic. Nor is it obvious how the algorithm's 'known goal' differs from the heuristic's 'unknown goal'. The difficulty may become clearer by means of an example. A multiplication algorithm computes a product. Such an algorithm might be embodied in some kind of mechanical device, such as a Turing machine. Given the appropriate starting tape, including on it the multiplier and the multiplicand, the machine would perform the desired computation. It would execute its procedures in a determinate way, and to that extent its starting tape would determine its end tape (cf. 4.5). But beyond this, it could not be said to

'know' its goal. The machine's programmer (the observer) might know (be able to state in his meta-language) that the machine's goal was to compute the product of two numbers printed on its starting tape; that is to say, he might know what the machine 'aimed' to do, namely carry out a certain computation. But in general the programmer would not know what the product was going to be, any more than the machine would, unless he had previously performed the computation himself, using an algorithm homomorphic with the one given to the machine. The observation that, in the case of an heuristic goal, 'we know *what* it is but not *where* it is', is not helpful in the present example. For the Turing machine will execute the multiplication algorithm without knowing its goals in any usual sense. Whereas the programmer who knows the goal (that is, what the goal *is*, namely how to perform a multiplication with given multiplier and multiplicand), will not necessarily know whether or not the machine has attained it, if he does no more than inspect the answer it reaches without himself carrying out the multiplication to check it.

What then are the characteristics of heuristics that distinguish them from algorithms in Beer's terms? Let us look at an example that Beer provides: to climb a conical peak in a mist you could use the *heuristic* 'keep going up'. As long as a peak existed and was conical, such an instruction would get one to it.

Though even this instruction is not as straight forward as it looks. For it immediately gives rise to the question how to carry it out. An example of Selfridge, cited by Minsky and Papert (1969), provides an instance of a 'good hill [conical] with a bad algorithm' (p. 179) for executing the heuristic that Beer suggests.

FIGURE 6.4.1 A and B are lower than O. (Sketch after Minsky and Papert, 1969, p. 179.)

The sharper the ridge, the more likely it is that a search of 'local' surrounding points by someone standing on it will fail to discover any point higher than the one he is on. In general the problem is even more complicated, since hills are not normally conical. 'Success depends . . . on the extent that the summit is not as globally defined as it might appear. In cases where the hill has a complex form, with many local relative peaks, ridges, etc., hill-climbing procedures are not always advantageous. Indeed, in extreme cases, a random or

systematic search might be better than a procedure that relentlessly climbs every little hillock' (Minsky and Papert, 1969, p. 178)

Given a compass and a tape measure, one could plot one's path as one went, so that it would subsequently be possible to specify a path leading from one's particular starting point to the top, as an algorithm of the form: 'Go a distance d_1 in a direction s_1; change direction to s_2 and travel a distance d_2', etc. What then are the differences between the algorithm and the heuristic? The algorithm is sure while the heuristic is not: given a map of the area not showing the peak, the algorithm would enable one to plot the position of the peak, provided one could find the starting point to which the particular algorithm applied; not so the heuristic. To do the same by means of an heuristic would require a contour map of the mountain which would, of course, show the peak at the outset. The algorithm is a set of instructions for getting from some particular point on the mountainside to the summit; the heuristic is independent (in principle, if not in practice) of the starting point. Without either algorithm or heuristic though, one could still probably get to the top of the mountain by going on a series of 'random walks'. But even on a random walk one would need to have a way of recognizing the top when one reached it; an altimeter say, and a rule for interpreting its readings. Such a rule, however, would be bound to overlap with the heuristic 'keep going up'. For the heuristic would have to include an instruction such as, 'Go to the "local", highest point; if it is the point you are at, stop. You are at the top.' And the rule for interpreting the altimeter would have to be of a form such as, 'Is the altimeter reading higher than it was before you made your last move? If not, go back to the point of your last move, and so on.' Thus, given an algorithm, one *need not know the goal at all*, (cf. 6.4) since blindly following the algorithm to the instruction 'stop' will suffice to get one to it. While lacking an algorithm, one must have at least a definition of the goal sufficient to allow its recognition. When Beer associates algorithms with known goals, the goal is known only in the meta-language of the algorithm's *author*. The known criterion (6.4) that he associates with the heuristic refers to the object-language of the heuristic's operator.

A three-dimensional plot of a large number of random walks, some reaching the summit and some not, might reveal a common feature of paths that reached the peak, that they all *kept going up*. Clearly, it is by noting this common feature that one arrives at Beer's heuristic. But the business of noting it is precisely what we have been calling order extraction. *So the heuristic does not avoid order-extraction work, it represents its results.*

It appears, therefore, that including heuristics in an algorithm may assist in order-extraction work (such as is performed by the *General Problem Solver* of Newell, Shaw and Simon (1963) for instance) by providing the algorithm with the benefits of the previous order-extraction work that has resulted in the

discovery of the heuristics that it incorporates. And this furnishes the basis for a kind of hierarchical procedure by which, roughly speaking, the algorithm is enabled to proceed by ever larger steps. We may interpret this view in the terms used in the previous chapter, discussing order, to provide a stricter statement. (The present interpretation corresponds to the conclusion of 4.9.) According to this formulation we should say that an heuristic, in so far as it represented the results of order extraction, might be regarded as a description that was relatively shorter than what it described. In passing from the starting point to the goal, therefore, the algorithm that incorporated the heuristic would need to pass through relatively fewer steps than would have been required in the heuristic's absence. This suggests lines along which an effective definition of heuristics might be attempted, by taking heuristics to be analogous to the partial explanations and partial descriptions of 4.8.

Solomonoff (1964) provides a formulation of inductive inference that suggests a basis for such a theoretical measure of heuristic 'power'.

He defines a 'probability' in the following way. Suppose we have a universal Turing machine, M, with a starting tape S that makes M generate T, written $M(S) = T'$, then we say that 'S is a description of T with respect of M' (p.9). The probability that Solomonoff defines takes into account all the possible outputs of a universal Turing machine and all possible descriptions of each output, with the object of constructing a function for computing the 'probability' $P(\alpha, T, M_1)$ that might be called '"the probability with respect to M_1, that [the string] α will follow [the string] T"'(p. 8). By adopting the view that has been argued, that an heuristic is a kind of description, then $P(\alpha, T, M_1)$ would be reduced for any machine using the heuristic, since the heuristic would limit the numbers of descriptions of strings that the machine could output. The relative extent of this reduction might provide a basis for the measurement of the heuristic's 'power'.

The forms that the arts (including music and literature) employ, compositional patterns of all kinds, traditional rules and conventions, and so on, are heuristics analogous to those of the general 'problem solver', which greatly reduce the unstructured, unordered variety that the arts, in common with every individual, animal as much as human, in comprehending the data of ordinary experience, must face and conquer. Authors are both drawn towards and turned away from these structures, and, with the abandonment of traditional forms (beginning in earnest with the emergence of the impressionist movement in painting; see Chapter 9), the arts have confronted immense difficulties. Pre-occupation with the medium over the subject in the fine arts, especially painting, the 'de-structuring' of literature and the turning away from meaning towards concern with syntactical form or pure phonemic content, as in concrete poetry, have demanded new structures, drawn — with the rejection of traditional forms — from other domains, from philosophy, psychology, anthropology, sociology, politics, to impose upon multiplied variety a structure to make it manageable, comprehensible.

6.5 Minimal Heuristics and Algedonic Control

Notice that, in any heuristic process, the heuristics used may derive from order-extraction work that has occurred outside the process, like Beer's hill-climbing rule for instance. Or the process may provide its own heuristics by means of its own order-extraction work. For example, order extraction occurring within a problem-solving procedure might produce partial solutions in the form of heuristics. These might then be incorporated within the procedure (possibly in a way laid down in advance) to modify and strengthen it. The distinction between these two possible origins of heuristics is not always strictly observed. Sometimes it appears tacitly to be assumed that a procedure may as easily be detailed for developing its own heuristics as furnished with them from the outset; even though, in the latter case, its heuristics may reflect the order-extraction work carried out by very much more powerful systems, such as the human programmers of computers, for example. The failure to maintain a distinction between the two possible origins of heuristics occasionally even leads to confusion as to the source of the power that heuristic procedures display, what is due to the system that has *produced* the heuristic being credited to the program that *employs* it. Such confusion fails to recognize that the problem of discovering heuristics is precisely the problem of extracting order — which is to say, the problem of creative-authorship. Many procedures employ heuristics aimed at order extraction (as, for example, all problem-solving procedures, which may be taken to include all situations as defined by Newell and others (1958) in which 'Given a set, P, of elements, the problem is to find a member of a sub-set, S, of P having specified properties' (p. 11); a wide class indeed). Finding heuristics to find heuristics evidently is one way of describing the *study* of order-extraction!

Once provided with appropriate descriptions, structures and other suitable heuristic devices, their systematic use by effective procedures into which they are incorporated may greatly increase such procedures' power. But order extraction itself, as we shall see in the following chapter, is subject to severe restrictions. Thus Beer's 'algedonic' loops (procedures that 'reward' right moves and 'punish' wrong ones) make powerful control elements, though one should be careful to notice that their power may often conceal the extent of the order-extraction work that has been needed to produce them. For example, it is misleading to suggest that the dog-trainer, who trains his dog by means of rewards and punishments 'does not understand "how the dog works"' (ibid. p. 78). Simply understanding what constitute rewards and punishments for the dog implies such 'understanding' of an important kind, not necessarily readily come by. It is easy to overlook how much is (correctly) assumed about what gives dogs pleasure and pain, by simple extension from self-knowledge. How much needed to be learned would be more obviously apparent if it were required to discover rewards and punishments for a complex system of quite unknown characteristics. Even among

humans, whose properties are not quite unknown, the discovery of algedonic principles is not necessarily always straightforward. Indeed, important among the broad aims of educational strategy is finding out just this. A 'random' search procedure for algedonic loops in a system of variety comparable to a dog's might easily demand computational power exceeding the limits calculated by Bremermann. (Bremermann (1962) used quantal considerations to calculate an upper limit to the rate at which computation may be performed. The rate works out at 10^{42} bits per gram mass of computer per second.)

It follows from this argument that the power of algedonic systems may be less than it at first appears. When outputs emitted by one system alter the organization of other systems, without the first system's knowing what might act on them as rewards and punishments then, by 3.2, the name 'controller' does not apply to the first system, because the first system is unmotivated (being unable to distinguish the states of the system whose organization it is affecting). Only where one system demands, and can distinguish in another, changes of a particular kind or confined to a particular class, does the name controller properly apply. And this requires that the first system should be able to control and hence communicate with the systems in which it wishes (entertains the purpose) to bring the changes about. Analagously with our observations about the goals of algorithms and heuristics (6.4), we notice that any outside agent that knows the control effects of some given system on another may use the first system to control the second. Even though the agent has no idea how or why the control procedure works, he will at least have to know what it achieves, a state of affairs, S, say. Knowing this will be equivalent to knowing an heuristic for achieving S. The outside agent in this situation has the role of a *meta-controller*.

6.6 The Control Language

'Pleasure' and 'pain' may be taken to be the two words of a necessary and sufficient (binary) language in which to communicate minimal control commands. To learn (extract order), any search procedure must possess a way of 'knowing' when it has succeeded: it requires an answer, 'Yes' or 'No', to the question, 'Have I reached the goal?' Without such knowledge learning is impossible since the procedure will never halt. To bring about, in the organization of two systems, changes such as to produce correspondence (or correlations – 4.4) between them – that is, to permit order extraction to occur – the two systems must be able to communicate. The minimal language that permits this is a mutually interpretable binary language. Ashby's 'good' and 'bad' forms of organization (4.5) are those forms respectively that the algedonic controller rewards and punishes. Both pairs of terms, pleasure and pain, good and bad, refer to the organization of one system altering in a way that tends to favour

its survival in conditions of disturbance brought about by another system in relation to which the terms are defined.

Controls based on algedonic principles are error-free. This is because algedonic control refers *only* to the *goal* of the procedure with which it is concerned (the two words of the language refer only to whether or not the goal has been attained) and not to any earlier phases of the movement towards it. For this reason, heuristics of this kind, if they may properly be called heuristics at all, cannot block possible goal paths, as they might if they referred to choice points encountered earlier along the route to the goal (6.2).

It is evident from this that the magnitude of the error that an heuristic may produce must be related to the phase of the goal-search procedure to which it refers. In a tree-search procedure, for example, a tree might have k levels of branching and m branches at each branch point. Such a tree would have m^k branch ends. If only one of these ends represented the goal, then the probability of reaching it by chance (random search) would be $1/m^k$, assuming the equiprobability of branch choices. An heuristic that eliminated $m/2$ branches at the first branching would double this probability. But it would *increase* the size of the maximum possible type II error (6.3) by the same proportion. An heuristic that eliminated $m/2$ branches at the second branching would eliminate only $(m^k - 1)/2$ paths overall. Such an heuristic – assuming it worked – would not so greatly increase the probability of reaching the goal as the first heuristic, but neither would it so greatly increase the risk of type II errors, because it would be eliminating far fewer paths. There is a trade-off between the efficiency of the heuristics – in speeding up goal attainment – and risk of error. In the limiting – algedonic – case no paths are eliminated, since in this case there are no further choices of paths to be made.

In the true algedonic case (rather than the pseudo one that conceals the previous order extraction upon which it is based) the procedure accords with none of the cited definitions of heuristics. It differs in two respects from the notion described: (1) it is error-free; (2) it does not accelerate goal attainment. The operation of the algedonic procedure may possibly be better understood from another point of view. One might regard the kind of 'heuristic' of this limiting case as a sufficient though possibly not a necessary condition for any kind of *instruction*. In this case we might let the two words of the binary language be 'correct' and 'incorrect'. The schoolmaster who set his pupils problems and then restricted his teaching to marking ticks and crosses against their efforts to solve them might find that the pupils learned rather slowly. Yet undeniably the dog-trainer, who is unable to give his dogs any more positive instructions than the hypothetical schoolmaster, does get them to learn. He may increase his successes by dividing the dogs' tasks into numbers of phases; that is by sub-dividing the tasks and carefully watching the dogs' behaviour, a technique quite familiar from Skinnerian reinforcement schedules – as well, no doubt, as practical dog training. In other words, he resorts to a repertoire of understanding that he has achieved and that now represents *his own learning* (acquired through his own order-extraction work). In practice, moreover, though the algedonic language may be binary, it is not necessarily so. The dog-trainer is likely to employ rewards and punishments of different strengths; the schoolmaster

to award answers marks instead of simply ticks and crosses. But notice that in general any increase in the vocabulary available for the algedonic language will have to be bought at the price of (1) an equal increase in the number of final states its user is able to distinguish in the system he wishes to control with it, and (2) his gaining sufficient understanding of that system to enable him to describe those end states to it, in a way that it will be able to interpret correctly. Thus the effect of the controller's procedure for shortening the search is once again seen to (1) depend upon how much order there is in the heuristic's power, and (2) increase the possibility of error (by risking, in this case, wrong identification of some intermediate task state, or misinterpretation by the controlled system of the controlling system's language). A corollary to these conclusions suggests a basis for the resolution of differences between Skinnerian and opposed psychologists. It is evident that though the Skinnerian framework is a sufficient one for learning, it does not follow that it is *all* there is. If psychologists' endeavours had been restricted to homeostatic search it is doubtful whether Skinnerian psychology would exist at all.

6.7 Heuristics and Homeostatic Principles

We should say what is a better and what a worse result, but the computer has to determine a better strategy, a better control system than we ourselves know. And of course it can do it. Because its algorithm, what it is programmed to do, specifies an heuristic. Alter the solution you are now using a little bit, says the algorithm, and compare the outcome with the erstwhile outcome. If this is more profitable, or cheaper, or whatever else we say, adopt it. Go on like this until any variation you make leads to a worse result than you already have. Then hang on to this solution, until the situation changes: whereupon you may do better once again by producing a new variation (Beer, p. 71).

Attention has already been drawn to the observations of Minsky and Papert (6.4) concerning the critical importance of local and global features in hill-climbing procedures, such as the one Beer describes above, as well as the dangers of simply passing the buck of order extraction to a computer (6.5), in the name of suppressing variety. In the end, the order extraction required for effective modelling, description, explanation, theory development, etc., is inescapable, and the simple 'power' of computers is in itself a poor substitute for structure. In general, purely homeostatic principles might be regarded as laying down the *minimal* conditions necessary for two systems to become correlated, in Ashby's sense (4.4). But it is necessary to recognize that these principles are no more than minimal. The following chapter will show more clearly the way in which heuristics add to powers of order extraction.

In practice the use of heuristics in 'heuristic programming' and the like appears to have been confined principally to the use of heuristics provided 'from without', by some (human) agent, outside the procedure that uses the heuristics. In general, it seems that, while it is possible to modify and improve such heuristics by the operation of the program or procedure that uses them, their innovation is more difficult.

One of the key heuristics that underlies physical intuition in dynamics is the notion that forces produce changes in velocity (rather than producing velocities). Evidence from which this idea might be derived is available to anyone with eyes. Yet at least hundreds of man-years of search by highly intelligent men were required to discover the idea, and even after it was enunciated by Galileo, another century of work was required before even the most intelligent scientists had cleared it of all obscurity and confusion (Newell, Shaw and Simon, 1958, p. 73).

To show how homeostatic principles alone may be sufficient to extract order gives little idea of how heuristics operate to enhance the power of order-extraction procedures. In the homeostatic case, the actual business of extracting order is left to 'self-organization', with little attention paid to the formation of the heuristics that the homeostatic procedure may use. Homeostatic principles alone do not furnish a full account of how order extraction occurs. It is essential to show fully both how heuristics help and how they come into being in the first place. For, as we have shown, finding heuristics and using them are part of the same broad order-extraction process. Minsky and Papert (1969) sum up some of the shortcomings of enquiries that fail to penetrate deeply enough into notions of 'self-organization' and the like.

A perusal of any typical collection of papers on 'self-organizing' systems will provide a generous sample of discussions of 'learning' and 'adaptive' machines that lack even the degree of rigor and formal definition to be found in the literature on perceptrons. The proponents of these schemes seldom provide any analysis of the range of behaviour which can be learned nor do they show much awareness of the price usually paid to make some kinds of learning easy. (p. 16).

7

Limits of Order Extraction

... one of those perfect wholes that it takes centuries of time
to produce ...

Proust

7.1 Further Questions of Structure

The considerations of this chapter impose strict limits on the scope of any art machine to be a *c*-author. For it follows from the argument advanced so far that an art machine capable of producing an output such as we should be able to distinguish from a background (from randomness) would have to rely heavily upon structures with which its builders provided it. Unfortunately, that is the only kind of machine we should be able to construct with an output rich enough to be of interest. It would be mistaken, however, to over-emphasize the importance of this restriction. First, as a restriction, it is by definition no more severe than the restrictions on the *c*-authorship of every human artist or, for that matter, on every form of human activity. Theoretically at least, the restrictions on the machine should represent a relaxation of human limits — depending as they do only upon abstract systemic considerations, and not on physiological or physical ones, connected with the materials of which the machine might be built. Secondly, the restrictions that the need to 'pass on' structure implies are themselves flexible, standing as points of departure from which there is a wide choice of directions in which further exploration may embark. (Chapter 8 examines the operation of a few structures in greater detail.)

In fact, systemic structure is bound to be largely inseparable, in a quite fundamental way, from physical structure, if only because some systemic structures are probably attainable *only* by way of certain physical (atomic) events. Altered, these physical events might produce corresponding alterations in the logic of the system of a kind that could be neither avoided nor nullified by other atomic events — because of the structure that is already a part of physical atoms. Theoretical equivalents between McCulloch-Pitts neurones and natural nervous systems do not in themselves furnish sufficient grounds for supposing that natural neural logic might not have differed had natural nervous systems developed in some other form.

The argument of the chapter takes up in more detail some of the general conclusions reached so far, with the object of arriving at a deeper understanding of where and in what form restrictions are likely to be encountered on the kind of art machine that might be constructed. It has been suggested, in the previous chapter, that the task is not hopeless, but that it will be necessary to look for success of a more limited kind than might have been hoped for at the outset. Here this idea is examined with a view to discovering where the limits may be expected to fall; what kinds of questions should be asked about the machine's capabilities; what in general will be the relative demands for time, power and structure and what are the prospects for meeting them. Above all we persist with questions as to the sources of structure. The answers to these questions concern the scope and power to be creative that we may reasonably expect of any art machine we might be able to construct.

Restrictions on c-authorship resulting from the use of existing structure, form handed on by tradition, history, culture, the work of other artists, poets, painters, composers, are a problem for any artist (5.2): how to make use of others' efforts without stifling originality. Yet 'power flows through the forms, [in this case, of poetry, though the reference could equally have been to music or painting] so that to study them is to plug oneself into a source of imaginative strength'. (Wain, 1975, p. 50) Form 'is a source of strength, of subtlety, of awareness' (ibid. p. 56). But form uninvigorated by imagination becomes banality, habit, which 'Of all human plants, . . . requires the least fostering, and . . . is the first to appear on the seeming desolation of the most barren rock' (*Remembrance of Things Past,* Marcel Proust, cited and translated by Beckett, 1970, p. 28) (cf. Beckett quotation, 2.2). Wain's words are a plea for forms that comes late in a cycle which began with a rebellion against them: '. . . poets in our civilization, as it exists at present, must be *difficult* . . . The poet must become more and more comprehensive, more allusive, more indirect, in order to force, to dislocate if necessary, language into its meaning' (Eliot, 1951, p. 289). 'Difficult' poets will rely less on form, and it is an easy step that brings a shift of emphasis from Eliot's positive injunction to a negative abjuration of form itself; which, in the end, Wain argues, is impoverishing, as our own conclusions would make us expect. '. . . it is not given to any human artist to be so original that he breaks free of *all* influences and still remains an artist . . .' (Wain, p. 54) In other words, the choice, as we have suggested, is between retaining much of the received structure − most is in any event too deep to reject − and suffering a degradation of creative power. Individualism of more than a very modest order is impossible; there is only 'a choice of different categories of alignment' (ibid p. 50). (See also Chapter 12.)

We begin here by classifying various forms of order extraction, according to the time scales within which they proceed, and the degree of definition of their goals. The classification is presented as a table (Table 7.1.1) of kinds of order extraction, from pattern recognition to biological evolution. Technical differences are discussed between parallel and serial processes before an examination of perceptrons as paradigms for parallel processes. Some of the conclusions of the investigations of Minsky and Papert (1969) are contrasted with earlier, more optimistic, forecasts for perceptrons. Conclusions are generalized to the wider

TABLE 7.1.1

KIND OF ORDER	GOAL CRITERION	MODEL	HEURISTICS
Patterns to be classified: patterns given by experimenter	Correct or incorrect classification stipulated by experimenter	Pattern recognition	'Natural' shape recognizers: Lettvin and others (1965), McCulloch and Pitts (1971), Sutherland and McKintosh (1971), Guzman SEE program, Rattner, SEEMORE program (Ch. 6)
Problem solution: solution pre-known to experimenter	Criterion for solution stipulated by experimenter	Problem solving	Tree-pruning rules (non-adaptive), tree-pruning with adaptation based on feedback and hindsight analysis (adaptive)
Evolution to prescribed criterion in specified environment	Acceptable 'fit' to prescribed form	Development evolution	Knowledge of results in n-ary language: Fogel and others (4.7)
Classifications of 'new' patterns	Consistency of classification as judged by experimenter	Pattern recognition	
Solution of unsolved problems	'Fit' to prescribed criteria; e.g. criteria for proof	Problem solving	'New' proofs of theorems: Newell and Simon (1956)
Evolution to prescribed criteria in 'open' environment	As for 3	Evolution	'Structured' changes: Pask (1959, 1969) Theory of Evolution; Löfgren (1972) Breeding experiments and the like
'Free' evolution	Survival	Biological, social theory, etc., evolution	Biological structures, social structures
'Free' evolution in 'open' environment	No goal	Connectivity	None

field of order extraction, with reference to the Law of Requisite Variety. It appears that both the rate of order extraction and the kind of order that is extracted are determined by already-existing order, order extracted previously. It is conjectured that order-extraction rate grows exponentially with order extracted. Finally, it is suggested that the transmission of order leads to the development of teleonomic systems.

7.2 The Classification of Order Extraction

Pattern recognition, learning, adaptation, problem-solving, thinking, creativity, development and evolution are among numbers of headings under which order extraction of various kinds has been studied. Computer science and cybernetics both contribute an extensive literature in experiment and theory. The particular concern of the present argument is with the principles of order extraction, what kinds of order extraction may be distinguished, the minimum conditions that permit it, what facilitates it, the rates at which it occurs, what forms it may take. Broadly speaking, cybernetics has studied order extraction largely under three heads; as a perceptual problem, for the most part under the name 'pattern recognition'; as problem solving, which has included questions of thinking, creativity and the like; and as self-reproduction and evolution. Learning and adaptation have been treated both as aspects of all the former studies as well as in their own right. Though learning entails order-extraction work, order extraction does not necessarily produce learning. A procedure for example that solves a problem or recognizes a pattern, though it may be said to have done order-extraction work (in the sense of 5.3), need not be in any way modified by the result it achieves. In the absence of some degree of retention, even temporarily, of the results of the procedure, we should not call its performance learning. No sharp divisions delineate the groupings mentioned. They differ more as to the aspects of order extraction they emphasize than in points of principle. Broadly, in practice, much of the difference between the various approaches is associated with time. Thus in general, perception, or at any rate recognition, occurs over short time intervals, and accordingly it is chiefly in the area of pattern recognition that relatively rapid parallel, as distinct from generally slower sequential procedures, have been investigated. Problem-solving (chess, theorem proving and the like) typically takes place over longer time intervals, which seem more 'naturally' to call for sequential searches aided by heuristics. Pattern recognition and problem solving may both occur without learning. Evolution, on the other hand, requires at least some kind of homeostatic adaption (which, at its simplest, may not warrant the name learning — see 7.3). Evolution is normally associated with long durations and may enjoy little heuristic guidance, initially at any rate, beyond what the most primitive of binary controls, survival or non-survival, provides.

With these differences have become associated corresponding differences in the kinds or order with which the various approaches are concerned. These relate to goal definition and the kinds of heuristics used. Pattern-recognition procedures tend to specify goals most fully. Uhr (1966) refers to pattern recognition as the 'problem of assigning a name to, or classifying the many different exemplars of a particular class' (p. 2). In practice, this has frequently meant no more than naming correctly various shapes or hand-written alpha-numeric characters say, projected on some sort of 'retina'. The goal's specificity – to name the character or shape – arises partly as an artefact of the experimental design. It is necessary for the experimenter, in this case the meta-observer, to be able to say whether or not the procedure he is using – which is the observer – is making what he, the meta-observer, decides is a correct classification of some given pattern. This means that the experimenter specifies in advance what the procedure (observer) is to recognize. (If the procedure identified a pattern that the experimenter could not himself identify, the event would necessarily fall outside the domain of the experiment and the procedure would receive no credit; that is to say, the experimenter would put it down to malfunction of the procedure.) In problem-solving procedures the goals are generally less specific than in pattern recognition. While the pattern-recognition experimenter *provides* the various 'exemplars of a particular class', the experimenter in problem solving merely provides a class description according to which exemplars may be identified – criteria for logical proof provided to a theorem-proving program for instance – allowing the *procedure* to produce the exemplars themselves – in the form of particular proofs of a theorem, say. Evolutionary procedures are unique in requiring no goal at all as a necessary condition of their operation. Survival or non-survival will alone determine what order such procedures extract. Simple 'self-connecting' (4.5) is a sufficient operating principle for the procedure. Survival itself need not even be a goal at the outset, though it is bound to emerge as one simply because survivors are likely to evolve procedures for retaining and protecting survival mechanisms just as they evolve the mechanisms themselves. While goals, in this sense, are not necessary, evolutionary procedures do not preclude specific goals, as for example in the (artificial) procedures of Fogel and others (4.7). The differences outlined in this section presented in the table are offered simply as a general indicator of differences whose numerous, readily-apparent inconsistencies show the inadequacies of the arbitrary categories into which the study of order extraction has fallen.

7.3 Parallel and Serial Processes

Order extractions's formal treatment leaves many of its practical aspects concealed, though an important formal difference examined explicitly is that between serial and parallel processes. A parallel process gathers information on a wide

class of events, taking up, as independent inputs, the various separate 'pieces' of information upon which it acts. Order extraction that occurs – a decision taken, based on the 'event' of the gathered information – may depend upon only a tiny fraction of the total information assembled, only an extremely small part of the total information gathered being used to determine the decision taken. The information not used for the decision is 'wasted'. The cost of gathering this wasted information is the price paid for being able to acquire order (reach some required decision) in a single step by the simultaneous assessment of the information gathered, rather than by the series of steps needed by a sequential procedure.

> The *total amount* of computation may become vastly greater than that which would have to be carried out in a well-planned sequential process ... whose decisions about what next to compute are conditional on the outcome of earlier computation. Thus the choice between parallel and serial methods in any particular situation must be based on balancing the increased value of reducing the (total elapsed) time against the cost of the additional computation involved. (Minsky and Papert, 1969. p. 17.)

Perceptron is the name given to a class of abstract machines that use parallel procedures. They were first conceived as devices for pattern recognition. 'Perceptrons make decisions – determine whether or not an event fits a certain "pattern" – by adding up evidence obtained from many small experiments.' (ibid. p. 4) In an early paper on perceptrons, Rosenblatt (1959) makes it clear that hopes for these machines was high: '. . . a properly designed perceptron will be capable of spontaneously forming meaningful classifications of the stimuli in its universe *without being taught by an experimenter*' (p. 421) (Italics added). Perceptrons were conceived as promising to capture the properties of order, proceeding from a *tabula rasa* (cf. the comments on heuristics in 4.7). Thus, although in practice the order that the perceptron is required to extract has been pre-determined by the experimenter, real order-extraction work is nevertheless required of the perceptron, which itself must discover a pattern that it has not previously identified.

Minsky and Papert offer the following paradigm and definition for a perceptron.

> Let $\Phi = \phi_1, \phi_2, \ldots, \phi_n$ be a family of predicates. We will say that Ψ *is linear with respect to* Φ
> if there exists a number θ and a set of numbers
> $\{\alpha_{\phi_1}, \alpha_{\phi_2}, \ldots, \alpha_{\phi_n}\}$ such that $\Psi(X) = 1$ if and only if $\alpha_{\phi_1}\phi_1(X) + \ldots + \alpha_{\phi_n}\phi_n(X) > \theta$. The number θ is called the threshold and the αs are called the coefficients or *weights*. . . . We usually write more compactly $\Psi(X) = 1$ if and only if $\sum_{\phi \in \Phi} \alpha_\phi \phi(X) > \theta$ (p. 10).

> *DEFINITION*: A PERCEPTRON is a device capable of computing all predicates which are linear in some given set Φ of partial predicates (p. 12).

It was hoped at the outset of investigation of perceptrons that appropriate alteration of the weights achieved by feedback from the truth or falsity of computed predicates might provide the basis for a sufficient form of adaptation to enable such devices to come to distinguish 'patterns'. Yet the promise seen in the first perceptron separability theorems remains unfulfilled. Minsky and Papert write that 'There is not yet any general theory of this topic'. In particular, 'the problem of relating speeds of learning of perceptrons and other devices has been almost entirely neglected'. They argue that perceptron learning should entail a better procedure than simply the ability to find a separating predicate. A simple homeostat might achieve this with a finite number of errors. But 'it would be hard to justify the term "learning" for a machine that so relentlessly ignores its experience' (p. 181).

7.4 The Costs of Order Extraction

The broad conclusions reached by Minsky and Papert apply not only to perceptrons or pattern recognition, but to all systems that may be analysed in this way. Ashby (1962) looked forward ten years earlier to the kind of treatment Minsky and Papert undertake. He pointed out that *there is no getting selection for nothing*. 'I suggest that when the full implications of Shannon's Tenth Theorem [Ashby's *Law of Requisite Variety*] are grasped we shall be first sobered, and then helped, for we shall then be able to focus our activities on the problems that are properly realistic, and actually solvable' (p. 273).

The observations of Minsky and Papert on 'The Seductive Aspects of Perceptrons' aim in this regard 'to separate reality from wishful thinking':

> ... it is easy to imagine a kind of automatic programming which people have been tempted to call *learning*: by attaching feedback devices to the parameter controls they propose to 'program' the machine by providing it with a sequence of input patterns and an 'error signal' which will cause the coefficients to change in the right direction when the machine makes an inappropriate decision. The *perceptron convergence theorems* ... define conditions under which this procedure is guaranteed to find, eventually, a correct set of values. (p. 14).

But the matter may not simply be left there. These authors present the following formulation' if Φ is a set of partial predicates and $L(\Phi)$ is the set of all predicates linear in Φ, then $L(\Phi)$ is the repertoire of the perceptron, the set of predicates it will compute when its coefficients a_φ and its threshold θ range over all possible values. In practice, $L(\Phi)$ is limited by the size of Φ possible for some actual device, and this puts a limit on the repertoire of any (physically real) perceptron. 'The ease and uniformity of programming have been bought at a cost! We contend that the traditional investigators of perceptrons did not realistically measure this cost' (p. 15).

The authors list three 'crucial points' neglected by investigators:

1) As a paradigm, $L(\Phi)$ tends to lose the 'geometric individuality of the patterns', because it leads to the treatment of classes of geometrical objects as classes of n-dimensional vectors $(\alpha_1, \ldots, \alpha_n)$. There are, they show, '*particular* meaningful and intuitively simple predicates that belong to *no* practically realizable set' (p. 15). '$\Psi_{\text{CONNECTED}}$' is an example of a predicate that cannot be computed by a wide class of perceptrons. ($\Psi_{\text{CONNECTED}}$ is the name the authors give to a function that computes 'connectedness' — the property of being able to get from one part of a 'thing' to another by a path that lies wholly within the thing.) Yet some analysis of connectedness is clearly important, if not actually a necessary condition, for defining 'things' in physical space (cf. Ashby, 4.3). As a more concrete example, '. . . we can construct, by special methods, a perceptron that could learn either to recognize squares or to recognize circles. But the same machine would probably not be able to learn the class of "circles or squares"! It certainly could not describe (hence learn to recognize) a relational compound like "a circle inside a square".' (Minsky and Papert, 1972, paragraph 4.3.)

2) The authors find that the question of the information content of the parameters ϕ_1, \ldots, ϕ_n has been neglected. There are examples, 'which we believe are typical rather than exceptional' of 'meaninglessly big' ratios of the smallest to the biggest of these coefficients. 'In some cases the information capacity needed to store ϕ_1, \ldots, ϕ_n is even greater than that needed to store the whole class of figures defined by the pattern!' (p. 15).

3) *Time of convergence* in a 'learning' process is a related area of neglect. As perceptrons are in practice finite state devices, it is always true that a correct setting of the ϕ_1, \ldots, ϕ_n can be found, if one exists, by an exhaustive or random procedure, simply by trying different combinations of settings until the right one turns up. The significant question is how quickly some given perceptron might arrive at the desired state, compared with one that used such a procedure. There are 'sets of some geometric interest for which the convergence time can be shown to increase even faster than exponentially with the size of R' (p. 16), the retina.

Broadly, we may take the conclusion that Minsky and Papert reach to be that '*significant learning at a significant rate presupposes some significant prior structure*' (p. 16). This might be taken as an extension of Ashby's dictum, 'There is no getting selection for nothing'. Put in the terms of the argument here, its generalized interpretation is that order extraction will be accelerated by making use of order already extracted; which amounts to a conjecture that the amount of order extraction is likely to grow according to some kind of exponential function of the amount of order extracted. This corresponds to the conclu-

sions of the previous chapter about the use of heuristics – which may be regarded as equivalent to the prior structures to which Minsky and Papert refer. As these authors' conclusions are neither intuitive, nor of only a practical application (though practicality is always part of their concern), but rest upon detailed and rigorous analysis, they provide important support for the broad conclusions we have reached so far. Most significant in their analysis is the detailed indications the theory suggests of the limits and benefits to be expected from structures of various kinds.

These remarks on heuristics and prior structures imply certain conditions that will apply to the requirements of an art machine, notably that the machine will have to rely upon us, its builders, to provide it with its important and significant order or structure. For, in the light of the conclusions of Minsky and Papert cited in the previous paragraph, as well as our own conclusions reached hitherto, to ask that the machine acquire its own structure for itself by its own order-extraction work, is precisely what we cannot do. We shall therefore ourselves have to 'invent' structures for the machine or select from those already available to us. We may suppose, on the basis of the view of Minsky and Papert, that we shall be better at inventing structures than any unstructured machine, because of our ability to draw upon the structure we already incorporate in ourselves. We may suppose further that we are likely to remain better inventors for as long as our structure, including what culture, history, social and personal relationships and the like provide, exceeds that evolved by machines! This means that it would be likely to prove extremely difficult if not impossible to evolve within the life-time of an experimenter, wholly novel structures, owing simply to an insufficiency of time and computing power. 'No man', as Lorentz (1969) says, 'not even the greatest genius, could invent, all by himself, a system of social norms and rites forming a substitute for cultural tradition' (p. 229); still less the rest of what makes a person. It follows that all the structures we provide will necessarily, to some extent, reflect ourselves. This is no more than a re-interpretation of Löfgren's view (4.6) that the product of a productive process will bear a resemblance to at least part of the productive element in the process; or more broadly, as was argued in Chapter 4, that every purposeful process is partially self-reproductive. Even if a machine were built that was able to generate 'new' kinds of structures, its builders would probably be unable to distinguish them, precisely because they would *not* be cast in their image and would therefore appear to them merely 'random' (cf. 4.4). By the Law of Requisite Variety, capacity as a selector cannot exceed capacity as a channel of communication. In our terms this amounts to saying that what has to be *given* (by programming) to a system as structure, because neither the time nor the power are available for it to evolve for itself from scratch an equivalent structure (measured in quantity of order-extraction work) may not be acquired by the system through its own effort, except by an equivalent amount of order-extraction work. But as it was

the lack of time and power to do the order-extraction work that made it necessary to *give* it the structure in the first place, programming is unavoidable.

More precisely, suppose two order-extraction systems A_1 and A_2, are both systems provided with a structure S representing a given quantity Q of order-extraction work. A_1 is then set to work extracting order from a surrounding E. After performing a quantity Q' of order-extraction work in this surrounding, A_1 has succeeded in adding to its structure S the further structure S'. Suppose A_1 now attempts to communicate this newly-extracted order to A_2. On the assumption that A_1 has no more information regarding A_2 than it had of its surrounding, E, at the start of the experiment, then by the Law of Requisite Variety, communicating S' to A_2 will require precisely the same order-extraction effort Q' as extracting S' in the first place. If A_2 had lacked A_1's structure S, then A_1 would first have had to provide it with this structure, since S' is based upon S, in the sense that A had used S in acquiring S'; and because of the growth of order-extraction rate with order-extracted, S or its equivalent is indispensable. If the reason for providing A_1 with the structure in the first place was to economize on A_1's time and effort, then the same reason will apply to A_1's 'passing on' S to A_2. But if A_1 cannot pass on S, then neither can it pass on S' (cf. 3.3).

There is no particular reason why this should be discouraging, unless because it frustrates the wishful thinking that seeks an escape from the consequences of the Law of Requisite Variety. Evidently a relatively conservative policy regarding order is called for. Even if it were true that the structures the human species had developed were far less powerful than they might have been had some other course been followed, the Law of Requisite Variety would bar the way against evolving wholly novel structures without difficulty. The problem is to balance the advantages of tenaciously sticking to an unsatisfactory heuristic against the disadvantages of the flexibility that can perhaps be won only by doing without heuristics altogether. Chapter 4 argued that teleonomy resulted from structure. Here it appears that the overall teleonomic purpose or 'project' *is bound to be* the structure's reproduction of itself!

8

Prior Structure

8.1 Phases in the Use of Structure

The results that this chapter discusses are at once encouraging and disappointing, though their achievement — or lack of it — furnishes no apparent basis for any clear-cut argument on progress: whether for instance Turing's (1950) prediction of successful machine mimicry of human intelligence by the turn of the century was over-optimistic or not. Turing's analysis failed to distinguish clearly between the 'size' of computers and their structure, easily assuming that human programmers would be able to guide the evolution of the structures required: 'One may hope ... that this process may be more expeditious than [biological] evolution ... The experimenter, by the exercize of intelligence, should be able to speed it up.' It should be clear by now, however, that the problem cannot be swept away so easily. If the rate of structure acquisition grows exponentially, (cf. 7.6) as this chapter suggests, achievements like Winograd's language understanding program (8.4) are perhaps more hopeful. For while Winograd's robot is not half way to human intelligence it might indeed be half way on some logarithmic scale. What the present chapter will aim to show is the inseparability of the two sets of requirements, those for an art machine and those for machine intelligence or rationality. Obvious as this may now appear, the link between the capacities required for humanistic or artistic expression and those to be associated with reason is neither always clearly understood nor acknowledged. It may be that analysis of pattern-recognition procedures tends to emphasize the intimacy of creativity and intelligence, but this is no more than incidental to its showing the importance of structure, order, to both.

 The chapter examines examples of 'prior structures', in particular descriptors developed for use in pattern-recognition procedures. Brief descriptions are given of Guzman's SEE program (Minsky and Papert, 1972); and Winston's program for concept formation, based on the SEE program. These provide examples of how lower level structures may be built up, into higher level. Finally, Winograd's (1972) natural language program shows a way of imparting structure acquired in one domain for use in another. There is discussion of the trade-off between power (gained from using descriptors) and flexibility, as these affect further development.

8.2 Object Identification

To understand more precisely the nature and extent of its advantages and restrictiveness some examples of the use of prior structure will be briefly examined. In the realm of pattern recognition, prior structures may take the form of descriptors. A pattern-recognition procedure based on such structures recognizes a *description* of a geometrical figure rather than the figure itself. For example, in the SEE program the aim is to divide a three-dimensional scene into 'objects'. The objects for the purpose are rectilinear blocks in two-dimensional projection. This program works at several distinct levels. The first level operates on the optical data, identifying certain optical features: regions, edges and vertices. As the program is to use the vertices as its descriptors, it first identifies them and then classifies them into types, the most important of which are shown in Figure 8.2.1.

| Arrow | Fork | Tee | Ell | Trans |

FIGURE 8.2.1.

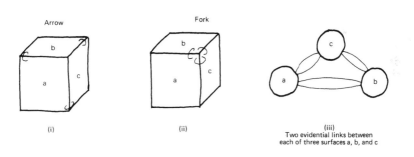

FIGURE 8.2.2

Now it uses these classified structures, interpreting them as *evidence* that indicates 'links' between regions, and thereby decides which regions should be grouped together as belonging to the same objects — those for which there is the strongest evidence of linkage. In this example the programmer decides both upon what descriptors shall be used and what they are supposed to indicate. They are not evolved or developed by the program. Thus the ARROW-type of vertex is to be taken as resulting from an exterior corner of an object, where two of its plane

surfaces form an edge. It is therefore to be regarded as evidence of a link between the two surfaces. A FORK-type vertex is to be taken as evidence for the meeting of three planes of a single object and thus for links between them. These links may then receive abstract representation, as in Figure 8.2.2 (iii).

(i)

(ii)

FIGURE 8.2.3.

FIGURE 8.2.4 (After Minsky and Papert 1972.)

(i)

(ii)

FIGURE 8.2.5

At a further level, the program assesses its own descriptions. For example groupings for which there appears to be strong evidence of connexions (regions grouped by more than one link) have single link connexions severed (Figure 8.2.3 (ii)). And there are other devices to assist correct identification. Figure 8.2.4 shows

an example of a scene in which the program successfully separates all the objects. Errors still occur for various reasons, such as the coincidence of lines, as in cases like that depicted in Figure 8.2.5 (i) that may mask the situation of (ii). Where errors of identification persist, some, at least, of the difficulties experienced by the program are similar to the difficulties that humans have when faced with similar scenes.

What is chiefly of interest here is not the details of the program, but the use they make of the descriptors (structures) that the programmer provides. Bruner, Goodnow and Austin (1956) suggested the operation of similar kinds of procedures in human perception. They refer to descriptors as 'configurational attributes'. Their remarks draw attention both to the way these configurational attributes provide *evidence* for perceptual decisions as well as how they might lead to error. 'A bird has wings and bill and feathers and characteristic legs. But the whole ensemble of feathers is not necessary for making a correct identification of the creature as a bird. If it has wings and feathers, the bill and legs are highly predictable' (p. 47). (cf. Moles's definition of symbols, 12.2.)

The program's descriptors are heuristics for the attainment of goals *defined by the programmer.* Using such heuristics, the programmer is unlikely to be surprised by the program's results (cf. Nietzsche's observations on language cited in Chapter 1); it is not to be expected that they will reveal anything previously hidden from him. This is precisely because any procedure using these heuristics will closely mimic the programmer, his perceptions, behaviour, or whatever, since the heuristics are likely to resemble those he uses, or at least is able to recognize himself. It has been the object of the programmer to produce a program that will make of the world, or at least that limited aspect of it, to which he is confined, the same kind of sense as he has already made of it. The programmer never intended the program as an instrument of *discovery* of new visual images. The use of descriptors in normal human perception is so ubiquitous as to be quite taken for granted. It occurs, like vision itself, without the perceiver's awareness.

But for the painter making a conscious analysis of his vision, or the writer of the way he comprehends people or things, the world may reveal itself as if its descriptors represented reality itself. *'Traitez la nature par le cylindre, la sphere, le cone',* Cézanne advises. More often, descriptors will be explicitly present in *WOA*s, without verbal vindication. Examples are numerous; the subject is vast and quite outside the present purpose. Apart from the more obvious kinds of examples, such as the match-stick figures of Klee, the shapes used by Kandinsky or Miro, the *descriptive* rather than representational figures of 'primitive' artists and of children: painting in which 'importance' rather than perspective dictates size, as in some Japanese landscape painting, there are other less apparent, though often far more important uses. To some extent the very possibility of *depicting* with paint or, more obviously, by drawing, depends upon descriptors more complex and numerous perhaps, but of a kind similar to those Guzman uses. Perhaps in the fine arts the most important descriptors of all – traditionally at any rate – are those upon which perspective depends, the heuristics that make possible the depiction (or description) of three-dimensional space on a two-dimensional

surface. Byzantine painting is without perspective. Giotto 'discovers' it, though he fails to master its use. Perfecting it becomes a dominant pre-occupation of Renaissance painters, Paolo Uccello, Piero della Francesca, Leonardo. Once perfected, however, later European painters take it for granted, losing awareness of it – and so also of its dispensability; that it is possible to ignore it. Habit conceals the effort that has led to discovery, until the modern movement, under numbers of influences, seeks to throw off its constraining effects. But perspective is almost as difficult to abandon as to discover, and vestiges cling until and throughout the period of Cubism, until in fact Clement Greenberg (1947) is finally able to announce that *Flatness* is painting's aim and 'integrity of the picture plane' comes to dominate modern painting (cf. 7.2).

Descriptors in literature and music are less obvious, though no less important. Music as an 'abstract' form does not, as part of its aim, have to establish direct links between itself and the 'real' world for which it might look for descriptors. Literature uses words which are already descriptors of a kind. Their relation to other kinds of descriptors, such as those of the SEE program emerges in the use Winograd makes of them. But literary forms are not restricted to words alone. Symbols, in the literary sense, may be descriptors of a kind. Moles calls them forms which 'may be *normalized and repertoried*' (p. 59). Pound (1914) likens them to images (cf. 4.5), only where 'symbols have a fixed value, like numbers in arithmetic, like 1, 2, and 7 . . . images have a variable significance, like the signs a, b, and x in algebra' (p. 463). Prosody and poetic forms are not descriptors in the present sense. Nor is form in music. Discussion of the function of these forms must wait for Part III.

8.3 Concept Formation

The significant departure of Winston's extension of the SEE program is the emphasis it places upon the active role of the learner. Rather than visualizing simply a passive receptacle into which information and knowledge are poured – what Popper calls the 'bucket theory of mind' – learning by Winston's program is an active process in which the learner – the programmed machine – is *creatively* involved. Winston extends those devices of the SEE program that recognize objects to provide a procedure that can identify assemblies of objects and simple constructions. Winston's program *builds up* descriptions of complex assemblies by adding to descriptions it already has. The descriptions the program uses are of classes of objects, not individuals. New classes come into existence by means of enumerating the differences between the description of a new individual and some class into which it does *not quite* fit. The new class consists of the old class plus the (critical) differences. Thus description, and so also identification of new classes has to proceed to some extent stepwise or the program will end up with a complex set of relations that it is unable to use.

It is immediately clear that, as a form of learning, Winston's technique represents a considerable departure from traditional 'adaptive' theories. His procedure uses the SEE program as a sub-process and is further equipped to recognize *spatial relations,* such as contact and support, between the objects that it uses the SEE program to identify. By means of these provisions it is possible to furnish it with descriptions of assemblies. Thus an assembly of three

bricks, one supported by the other two might be presented as an example of an arch (Figure 8.3.1 (i))

ARCH

(i)

FIGURE 8.3.1 (i)

The program then stores a description of the example, using the terms it has available such as 'brick', 'supported-by' and so on, in a form that may be represented by a network.

SCENE

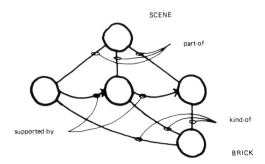

part-of

kind-of

BRICK

supported-by

FIGURE 8.3.1 (ii) Large circles represent particular physical objects, small ellipses other kinds of concepts, and labels on the arrows relations.

NOT AN ARCH

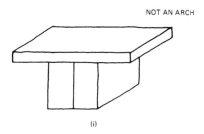

(i)

FIGURE 8.3.2 (i)

Given another example (Figure 8.3.2 (i)), it is told that it is not an arch.

It forms a description of the new construction, compares it with the arch description, notes the differences (contact between the support bricks) and adds to its arch description that there should be no contact between its support bricks (Figure 8.3.2 (ii)).

FIGURE 8.3.2 (ii)

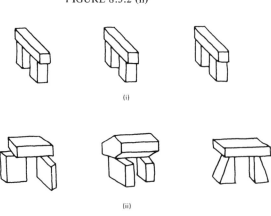

FIGURE 8.3.3.

Further examples of arches and non-arches may be given, and the arch and non-arch descriptions modified accordingly. For instance, the support bricks may be supporting an object drawn from a wider class than the class of bricks, the class of prisms say. Or the supports themselves may be drawn from this wider class. Using these examples and its procedure for noting differences, the program 'generalizes' the description of its 'concept'. So that, starting with Guzman's descriptors and a few classifications of relative spatial relations, it can

build up (learn) concepts that enable it to identify, first objects, then assemblies of objects and then, using these new concepts, relative spatial relations of these assembles. Thus it will learn to identify a complicated scene such as Figure 8.3.3 (i) or Figure 8.3.3 (ii) depicts by means of the network of Figure 8.3.4 as a row of arches, a good example of what Gagné (1962) refers to as 'productive learning' (p. 355).

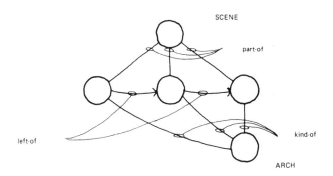

FIGURE 8.3.4.

Like the SEE program, Winston's procedure relies for its capabilities upon descriptors provided for it by the programmer, both those – the Guzman vertices – that enable it to break scenes up into objects and those that relate the objects spatially. Taking order extraction as an hierarchical process, as Winston's program does, we should conclude that the program's power derives from its use exclusively of relatively 'high level' concepts – its descriptors. By the conclusion of the previous chapter, the fact that they are high-level implies that these descriptors must have been slow and difficult for the programmer to have acquired in the first place, acquisition dating far back into the evolutionary past. Notice that using these descriptors makes other 'kinds' of concepts literally inconceivable for the procedure. They are descriptors that, in terms used by Lorentz (1977), 'precede all experience and must do so if experience is to be possible at all. In this respect, they correspond absolutely to Kant's definition of the *a priori*'. Being specifically adapted to acquiring a particular kind of information, he goes on, most such structures are 'tied to a very rigid, narrow programme' (p. 26). It has already been intimated by the observations of Newell and others (6.7), how difficult new descriptions may be to digest; and the 'blinkering' effect that partly accounts for the difficulty is intensified by making use of the descriptors relatively early in the identification task, that is before much other order-extraction work has occurred – lopping off whole sectors of the tree near to the bole without ever allowing an opportunity to search them. Evidently, the power of the descriptors is bought at the cost of narrowing the set of attainable goals (6.6).

Notice too that the concepts the procedure acquires will depend upon the order in which the program encounters its examples, though not in a entirely inflexible way. The noting of differences between concepts must involve a procedure for comparing descriptions. If descriptions are held in the form of a series of networks, then the description of the difference between two such networks will itself be a network in which each node might refer to a pair of nodes, one from each of the compared descriptions. Such comparisons would require conventions for deciding which nodes of the compared descriptions were to be matched and which matchings were to receive priority. And the conventions and priorities might themselves be subject to adjustment by the application of heuristic rules. In general, although what concepts are formed will depend upon the order in which modifications occur, flexibility will derive from the mode of operation of the program. This is because the procedure operates by matching a description to an example, as an hypothesis, which is then whittled down into a plausible form by noting differences. Flexibility will partly depend upon whether hypotheses are relatively generous or tend to be conservative, that is whether descriptions are broad or narrow.

8.4 Supports for Language Structure

Going on from here, Winograd adds to the objects and their spatial relationships of Winston's program *actions* that may be performed upon them. The 'blocks world' becomes a *micro-world* able to stand as a subject domain for discourse in a language-understanding system. To make the micro-world suitable for this purpose, Winograd provides it, besides objects, properties, – a class including relations – actions with goals, processes and simplified forms of concepts like space, time and purpose.

> We can describe the process of understanding language as a conversion from a string of sounds or letters to an internal representation of 'meaning'. In order to do this, a language-understanding system must have some formal way to express its knowledge of a subject, and must be able to represent the 'meaning' of a sentence in this formalism. The formalism must be structured so the system can use its knowledge in conjunction with a problem-solving system to make deductions, accept new information, answer questions, and interpret commands. (Winograd, 1972, pp. 23–24).

> In practical terms, we need a transducer that can work with a syntactic analyser, and produce data which is acceptable to a logical deductive system. Given a syntactic parser with a grammer of English, and a deductive system with a base knowledge about particular subjects, the role of semantics is to fill the gap between them (p. 28).

In Winograd's system, meanings are mostly represented by programs written in PLANNER (due to Hewitt, 1969), a language for proving theorems concerned with the actions and goals (of a robot), which is able to guide its proofs by heuristics provided from the knowledge of the world in which the actions and

goals occur. PLANNER sets up series of sub-goals to be carried out in a set order, to bring about an event. Told to GRASP a block, the robot which performs the actions on the blocks (in this case, a simulated robot depicted together with its world on a CRT screen), may first have to GET-RID-OF a block it is already grasping. To do this it must FIND-SPACE in which to set the block down. Having got rid of it, it may have to CLEARTOP the block it has been instructed to grasp, by removing a block covering it. This may involve finding space to which to move this covering block, and so on. The names in capitals represent PLANNER theorems. Each action which cannot be carried out causes the program to back up to a preceding theorem, until this process is exhausted, at which stage failure is reported. A series of actions constitutes an 'event' which is remembered and which furnishes information about the past as well as *reasons* (explanation) for carrying out actions. Events are timed by a clock which starts at zero and is increased by one every time a motion occurs. A second kind of memory keeps track of the positions of objects as they are moved.

The success and flexibility of Winograd's system results from the interposition of its semantic system between the syntactic constructions and the PLANNER program that defines the meanings of words and other constructions, so that it can deduce from these new procedures for the deductive system to use in answering questions about obeying commands and in acquiring new knowledge from and as a result of the dialogue. Since the dialogue is *about* the blocks world, syntactic problems are usually soluble by reference *to* this world. It is the ability to make such reference that enables the program to avoid building an unwieldy, purely syntactical system to overcome all the difficulties and ambiguities of the syntax. In the terms formulated in the foregoing chapters, the success of Winograd's system depends upon the arrangement that succeeds in providing the syntax of the system with a richer source of order than is represented by syntactic rules alone. Heuristics like the edges and vertices of the SEE program embody the results of very great amounts of order-extraction work, which is absent from the quickly-growing systems of rules in language-understanding systems that rely purely on syntax.

A's problems of expression and communication, or *O*'s of interpretation, are partly alleviated by *O*'s position, 'between' *A* and *W,* somewhat analagously to PLANNER's position 'between' the 'blocks world' and the syntax of Winograd's language program. Just as Winograd's program is able to economize on syntactical rules by importing structure from the 'physical' world of the blocks, so *O* is able to interpolate knowledge he may have of *A* to fill gaps in his understanding of *W.* Such a procedure enables *O* to distinguish *A*'s intention from its execution simply by comparing his knowledge of *A,* or possibly even the techniques *A* has employed, with *W. O* progresses like a man climbing a rope, using first his feet then his hands in alternate extension. Chapter 4 intimated some such process when it showed (4.8) how *O* distinguished *W* or *A* and then used it to discover respectively a matching *A* or *W.* The effect is analogous to that of a ratchet. This technique, as Lorentz (1977) explains,

is what is known as the *principle of mutual elucidation*. In Chapter 11 we shall discover similarities between this technique and the conjectures and refutations described by Popper (1963) by which, he argues, science progresses. In Winograd's program, W is the 'blocks world'; in scientific progress, W is what Popper calls 'objective knowledge'. Chapter 12 will argue that WOAs are Ws with a similar role, though in a different sphere; indeed, that both science and art are representations of the real world that help to close the lacunae in our knowledge of it; and which, in turn, by the real world's falsifications (Popper's 'refutations') of the hypotheses that these representations comprize, has its own lacunae reduced.

This interpretation relies upon the theoretical considerations so far developed and upon the supposition that the blocks world descriptors reflect large amounts of order-extraction work. Several independent lines of empirical evidence support this supposition. For instance, human retinal function acts to increase the acuity with which 'edges' are detected, while the SEE program provides edges as data. But anatomical and physiological features responsible for edge acuity in humans evolved over extremely long periods, though the SEE program almost wholly conceals the extent of the order-extraction effort that the period's length suggests. Edges are quite taken for granted; it is only their combinations that are thought of as heuristics supplied by the programmer. Other naturally occurring descriptors are also comparable with Guzman's vertices, and also represent results of order-extraction work accomplished over long periods of evolution. The mechanisms of the frog's eye, identified by Lettvin, Maturana, McCulloch and Pitts (1965) suggest specific, simple, analytical features for detecting kinds of order important to the frog's survival, namely shapes related to food and to danger. Considerable evidence for similar kinds of mechanisms in other species is collected in Sutherland and Mackintosh (1971). *Gestalt* psychology provides another line of empirical evidence of a kind suggesting that descriptors play an important part in 'recognition'. So does developmental psychology. A child's 'matchstick' drawing of a man, as Minsky and Papert (1972) point out, is more intelligibly seen as a visual description than as an attempt at visual representation.

9

Extending Received Order

9.1 The Milieu of Purpose

The examination of purposeful systems thus far has paid little attention to the surroundings in which they operate. In reality these surroundings are all-important. The milieu of a structured dynamic environment, filled with the activity of mutually competing and co-operating systems in continually changing organization, is not merely the backdrop to purposeful behaviour but forms the fabric of purpose itself. It has been observed (5.1) that the creative additions to organization that any structured system achieves are likely to be small in relation to the complexity of interconnexions and constraints of the evolved, existing order into which such systems are 'born'. Ashby (1964) remarks that 'the organism can adapt just so far as the real world is constrained, and no further' (p. 132). So, even its creative effort – its adaptation – merely reflects its world and its ability to survive in it. Commonly, adaptation and survival, especially in varied circumstances, are taken to signify intelligence. But it has been argued that that aspect of intelligence to do with extracting order from the surroundings, what has been called creativity, is of particular importance. This chapter seeks to step back from the structures that have been our concern, to see them in that wider context.

Attention shifts away from structure, descriptors, heuristics, forms and the like, to the organization of goals and purposes. Goals and sub-goals are discussed, particularly when sub-goals operate through the agency of what are themselves purposeful systems. This raises questions of specifying goal-seeking systems. The 'transmission' of goals raises problems of coding and communication between systems.

Concepts of compatibility and redundancy and apparent compatibility and redundancy of specifications are defined and examined in the light of notions of requisite variety. This leads to conclusions as to the limits to the possibilities of goal transmission – what restrains one purposeful system from communicating to another what the goals are – both absolute limits and those due to problems of interpretation. There is discussion of the relative limits between two systems in relation to the concept of 'fuzziness'. The chapter then proceeds to apply the conclusions it has reached. The object is to discover the limits of creative

performance, to obtain a view of purposeful systems within the constraints of an active surrounding that restricts the possibilities of goal-generation and, thereby, of the capacity for c-authorship. Constraints are defined in terms of goal specifications. This enables the physical world and goal-seeking systems to display their mutually dependent contributions towards forming a world for A. There is discussion of chains of goals, with the broad object of capturing the notion of development, both past and future; and there is a discussion of specification by injunction and by description in relation to limits on originality.

At best, any art machine we can make will resemble the human artist; that much has emerged. Osborne remarks that 'it is always necessary to regard the work of art as an intentional object, created by a human being within a cultural milieu and subject to specific social conventions' (p. 23). The cultural milieu and the social conventions are a part of the WOA's structure, because the artist has deliberately used them as part of his heuristic repertoire. He musters whatever structure he can from himself and his history – specific and personal – in order to lengthen the strides of his own creative progress. But doing so he pays a price in narrowing the limits of the kind of creativity he may achieve; and incidentally, the audience he can reach: Moles notes that meaning is not 'transmitted'; it pre-exists the message, resting on a set of conventions, which receptor and transmitter hold *a priori* in common (cf. what Monod says about 'creation' and 'revelation', 4.5.) The art machine will not escape the human artist's dilemma; it will be no more able to do without cultural milieu and social conventions than the human, not unless it reduces its own capacities. The artist's and the art machine's goals and goal-generating potential – creativity – extend both backwards and forwards in time. The relevance of the present chapter is in tracing some of the aspects of this extension from the goal's inception, or conception, back towards its origins and forward towards its execution.

9.2 Linked Purposeful Systems

Section 3.2 defined purpose in terms of a system A acting within (and as part of) a surrounding E. A's purpose was to maintain invariant some internal state of E – or part of E, possibly itself – by suitably varying its own output. In many instances, as we have mentioned, A's purpose was to *bring about* some particular state in the future. We interpreted this, in accordance with our definition, as the maintaining invariant by A of the 'movement' towards the desired state. We referred to A's description of the state as a *concept* of A's. The generality of such abstractions, although providing clarity of definition, obscures the richness and complexity of the detailed working of purposeful behaviour in complicated systems. In particular, it ignores the structures of A and E. Thus, for A to bring about some internal state Z_E of E may entail its first bringing about z_E and so on. Such ordering of goals and sub-goals may be expressed in terms of procedures such as PLANNER or given more general representation as 'knowledge structures' such as those of Gagné (1962, 1964) for example, or other kinds of 'relational nets' such as Pask's 'entailment structures' (see for instance Pask, 1975). We arrive at a concept of 'an integrated sequence of activities' (Sommerhof, 1969),

which *'stands for a relation between these activities which enables us to attribute an individual goal to each, and at the same time an ultimate goal to the whole sequence'* (p. 188). This concept leads directly to the further concept of 'hierarchies of directive correlations, integrated by a single ultimate goal' (p. 189). Fogel and others note that complete goal specification calls for a full statement of penalties and pay-offs for each point of time in the future, though in general, as will be seen (9.3), it will be possible to assume a limit to the number of future scenarios that a finite machine will be able to discriminate. The same reasoning permits the reduction of possible histories of a machine to a finite number (see for instance Minsky, 1972). These discriminable scenarios are the distinguishable states of the system.

An extension of the use of sub-goals toward the attainment of an ultimate goal of particular importance to authorship as we have defined it, occurs when the sub-goal of a system itself involves other purposeful systems. In this case A does not achieve the sub-goal 'directly', but instead specifies to the intermediary purposeful system, call it A_{ext}, the goal which that system should aim for. The specifications that A provides take the form of instructions that A issues, to be carried out by the intermediary system A_{ext}. If A's sub-goal is $g(A)$ say, then A's problem is to provide A_{ext} with an input state such as will cause it to emit an output that will constitute the execution of $g(A)$.

We have defined A as a set of procedures and shall extend this definition to provide a definition of goals in terms of sets and combinations of sets. Roughly speaking, we shall regard the goals of a system as so many target areas, each defined by a set of specifications, with intersections and unions of such sets representing – mapping onto – corresponding intersections and unions of respective target areas. We shall suppose that specifications are compatible and, to capture the sense of an hierarchy of specifications, monotonically narrowing the target area. We shall suppose further that redundant specifications have been deleted. The sets we are left with will therefore form a monotonic sequence corresponding to a partially-ordered system, presented as a list. Pask's entailment structures are examples of such systems. Notice that presenting such systems as hierarchies is to some extent arbitrary. Entailment structures, for instance, begin as closed 'relational nets' in which certain nodes are selected as 'head' nodes and the nets pruned accordingly to yield partially-ordered sets. If A is a set of procedures there must be among them subsets corresponding to each goal (including its sub-goals) that A may entertain. Suppose \mathcal{G} is the set of all such subsets. We shall call a subset $G \subset \mathcal{G}$ a *specification* of A's goal. A sequence of such specifications, G_i ($i = 1, \ldots, k$), say, defines a subset $G' = \bigcap_i G_i \subset \mathcal{G}$. G' might be an insufficient specification of g, as would be the case if for example it left ambiguous what was required of A_{ext} at some point in the procedure it specified. We shall say, in such a case, that g is an *under-specified* goal of A. But if G' is sufficient and A_{ext} is able to use it to set up its

own goal state $g(A_{ext})$, to be the same as A's sub-goal $g(A)$; that is to say, if $W(A_{ext})$ is the realization of $g(A_{ext})$ and $W(A)$ the realization of $g(A)$ are identical, we shall call G' a *full* specification of A's goal and say that G is a *fully-specified goal* of A.

Suppose G' is such a full specification of g and G^* is an additional specification, such that $G^* \neq G_i$ for any i, then, together with G', G^* defines a new set of specifications $G' \cap G^* = G''$, say.

1) If $G'' = \emptyset$, we shall say that G* is *properly incompatible* with G'. This will occur if for example G^* represents an instruction that is mutually contradictory with G', or if G'' is ambiguous or incomplete as above.

2) If $G'' \neq \emptyset$ and $G'' \neq G'$ represents a full specification of a new goal $g(A)$. We call this *proper compatibility* of G^* with G'.

3) If $G'' = G'$ we shall say that G^* is *properly redundant* with G', since the goal $g(A)$ specified by G'' cannot be distinguished by A from that specified by G'. (This definition is consistent with that of Shannon and Weaver (1949). For, if the redundancy R of an information source is given by $R = 1 - H/H_m$, where H is the entropy of the source and H_m is the maximum possible entropy it could have while restricted to the same variables, and if we take A as the information source, and the set of instructions G' emanating from A as the variable then, by hypothesis, G^* will not alter the information carried by the source; that is to say, $H(G' \cap G^*) = H(G')$ though, since $G^* \neq G_i$ $(i = 1, \ldots, n)$, H_m will be increased.)

But as G' is a specification by A for the direction of A_{ext}, it must be interpretable by A_{ext}. Clearly, this raises questions of *requisite variety*. Thus, given case (1) of the previous paragraph, A_{ext} might interpret G^* either as compatible or incompatible with G'. In the former case we shall say that G^* is *apparently compatible* with G', with respect to A_{ext}. And consistently, cases (2) and (3) give rise to interpretations that we should call respectively *apparent incompatibility* or *apparent redundancy*.

Examples of these various cases are as follows. Suppose G' could be mapped into a white plane surface to make a black pattern on the surface, and suppose this pattern were then to be mapped onto a regular grid of squares of given fineness of 'grain' (resolution level, corresponding to length of side of squares), according to the rule that a square more than half covered by the pattern should be made entirely black, otherwise entirely white. Such a 'retina' could represent 2^n different patterns, where n was the number of squares in the grid. (In fact each grid pattern would represent an infinity of 'real' patterns, since there are an infinity of ways of more than – or less than – half covering a square with a pattern. Figure 9.2.1 illustrates the various cases that arise.

If (1) $G' \neq \emptyset$ and (2) G^* is either properly (or apparently) incompatible or

properly (or apparently) redundant with G' for every $G^* \subset \mathcal{G}$, then the goal g that G' specifies is (apparently) unique, since it cannot be specified in any other way. Thus the (apparent) redundancy of G' is zero. We call g a *specific goal*. (cf. Löfgren's definition of order (2.3.0).) The specifications of a specific goal are equivalent to the shortest starting tape X from which a universal Turing machine will generate the sequence ξ.)

Case (1)
Proper incompatibility
$G' \cap G^* = \emptyset$

Case (2)
Proper compatibility
$G'' = \emptyset$, $G'' \neq G'$

Case (3)
Proper redundancy
$G^* \supset G'$

Apparent compatibility
$G' \cap G^* \neq \emptyset$
grid G' and grid G^* merge

Apparent incompatibility
$G'' \neq \emptyset$, $G'' \neq \emptyset$
grid $G' \cap$ grid $G^* = \emptyset$

Apparent redundancy
$G'' \neq \emptyset$, $G'' \neq G'$
grid $G^* \supset$ grid G'

FIGURE 9.2.1

In the creative process AW, the generation of A's goal may be characterized as the operation of imagination, inspiration, creativity. For A the artist, the goal is the idea, which is part of him, distinguished from the thing he makes, which exists separately from him. His skill at manipulating his medium enables him to 'translate' his idea into something not himself, when it becomes the object of his own and others' contemplation (cf. Fry, 1961). As a paradigm, AW clarifies the distinction between the artist's conceptual and imaginative skills and his technical skills, which the single term 'artist' confounds. The artist's technical skills are the means by which he makes an observable thing; those skills denoted by the word *craftsmanship*. A's goal corresponds to what Collingwood (1963) calls the 'work of art proper', which exists 'in the head' of the artist. Whatever the merits of this idea, it is clear in its emphasis of the importance of the artistic creativity, the c-authorship content of the *WOA*. But Fry's demand appears no less important. However secondary or 'incidental' Collingwood may believe the 'bodily or perceptible thing' that we call the *WOA*, without it there can be no way of knowing, even for the artist himself, whether the contents of his head amount to art or no more than something quite trivial, for some extraneous reason heightened in his estimation to appear more. As Chapter 12 will show, the *WOA* represents

'objective knowledge' without which no A can be more than a dreamer, never more than imagining what he might create.

But the credit accorded an author depends also on the knowledge of his problem, of what he set out to accomplish. A move on a chess board may win (aesthetic) approval, though only from one who understands chess. O assesses the solution against the problem and takes both into account in arriving at a judgement of the author. In cases of shared authorship this acts to diminish the degree of c-authorship that O is prepared to assign to the various partial authors. This is what happens in practice. The present formulation provides the practical situation with a theoretical framework, while suggesting grounds on which c-authorship might be apportioned, roughly according to the scope for c-authorship left to successive partial authors acting within the confines laid down for them by their antecedents.

Thus a musical score shows a high degree of structure (information content), being a selection of one from all possible musical scores. Whereas the degree of structure of the performer's rendering of it shows a lower degree of such structure, being a selection from the narrower range of variety that is left to the performer, after the composer's selection (his composition) has been completed. This is the range of choice between the injunctions of the musical score with its limited capacities to designate gradations of amplitude, tempo etc., and the finer discriminative capacities of the individual's auditory and motor apparatus. C-authorship is credited both to composer and performer, though generally, if not invariably, a higher degree goes to the composer. The performer is the composer's instrument as much as the performer's may be the piano or the violin.

The architect A^*, the builder A and the building W provide another example of shared authorship. In this case, O apportions c-authorship in different shares. A^* sets A's goals by realizing a sub-goal in the form of his plans and specifications for the building, but receives most of the credit as author, not simply for the plans, which are quite likely to be forgotten once the building has been completed, but for the building itself; while the builder receives an author's credit only for such a limited interpretive role as the architect may have allowed him.

Other co-authors are the computer and its programmer – what conditions 'allow us to assert that the programs problem-solve'? (Newell, 1962) – and, at the other end of the scale, the patron and the artist he employs. The patron may commission work from an artist, specify the subject and even make stipulations as to its treatment but, unless he were to take a substantial role at least in planning the details of its execution, he would receive little credit for playing a creative part in the finished work. In all these cases the information-content test for authorship applies, at least in principle.

These cases are all sequential; purposeful systems operating in linear sequence. Other possibilities may be more complicated, such as for example the production of a play or an opera, a film or a television programme, though such cases reduce to sequential forms, (cf. the reduction of networks to hierarchical structures, 9.6) if the various participants in the productions are assigned priorities. Indeed, this is almost certainly a necessary practical condition for the achievement of such productions at all.

9.3 Interpretation

Clearly, as the figures of 9.2 suggest, difficulties arising out of what have here been called the *interpretation* of goal specifications or instructions are part of the whole field of pattern recognition and order extraction. The grid examples

illustrated show, for instance, that much that was said about perceptrons will apply, literally, here too. More broadly, the ability of A_{ext} to interpret goal specifications provided by A will involve many of the questions discussed in connexion with heuristics and order extraction generally.

The difficulties of what might be called *goal transmission* reveal problems of considerable depth, to which Chapter 2 referred when dealing with questions relating to observers. Basically, we are concerned with the *effectiveness* of goal specifications. What has so far been said tacitly assumes the existence of a 'real' set of goal specifications underlying, as it were, the specifications entertained by any given entity, (as we might assume some 'real' length 'underlying' the approximations to it of actual measurements). We might approximate such a set of specifications using the grids of 9.2.1, by allowing the grain of the grid to become arbitrarily fine. But such a procedure would require giving an interpretation to the notion of a goal with an arbitrarily long specification; one, that is, that took an arbitrarily long time to specify and which therefore could not be a goal at all, as the term is ordinarily used.

Suppose for example an entity A were given the goal of partitioning the set R of real numbers by means of a Dedekind Cut at a point y, into two sets L and U. It would appear that such a specification to A should be effective, since it provides a procedure according to which, given any number $x \in R$, it would be possible for A to decide to which set, L or U, to assign it. But R is an infinite set; and, in particular, contains an infinity of members designated by more than some arbitrary number k of (say) decimal digits. In particular, R contains an infinity of members of this class whose first k digits are the same and which differ only in digits following the k^{th}. It follows that if y consists of k or more digits, it will take A an arbitrarily long time to check any number having the first k digits the same as y (assuming it takes some finite time to check each digit). If A were a Turing machine, it would require arbitrarily long tapes, or if it were represented by a grid, the grain would have to be arbitrarily fine. Turing (1937) uses an argument similar to this to show that, 'If we admitted an infinity of states of mind, some of them will be "arbitrarily close" and will be confused' (p. 250). A's task becomes impossible when y is a non-computable number. In other words, in general A will find the goal specification for partitioning R non-effective. 'Reality', in this sense, is thus unknowable by any finite machine and approximations to knowing it depend upon the machine's variety.

What then does A understand by the instruction to partition R? In one sense it might be argued to the effect that A has a 'belief' that it is possible to partition R. Such a belief need not have a merely intuitive basis. It might be based upon a p-explanation in an r-formal theory (4.4). However, such a p-explanation would itself depend ultimately on a set of axioms that remained unexplained (being the 'final explanans ... without explanation' (Löfgren, 1972, p.341)). (Notice that it follows from this that no entity exists which could effectively understand (in the sense of 4.4) the 'perfect continence' on which Spencer-Brown

bases his definition of the primary distinction.)

Zadeh (1965) defines a 'fuzzy set' A in X, where X is a collection of points $\{x\}$, by means of a characteristic function $\mu_A(x)$, which assigns a number in the interval $[0,1]$ which represents the 'grade' of membership of x in A. The nearer the value of μ_A to unity, the higher the grade of membership of x in A, and conversely. We might relate the term 'fuzziness' as we have applied it in this paragraph to Zadeh's concept, by associating the value of Zadeh's characteristic function μ with the fineness of the grain of the grid. In view of the argument of 9.4, the grid's fineness has a finite limit, so that in effect μ must fall in the semi-open interval $[0,1)$, unless it is a measure applied by a meta-observer. It appears, therefore, that the 'fuzziness' of instructions given to A, as A is able to interpret them, depends upon A's variety. We might put it that A's goal in the case of partitioning R, even A's notion of R, has the status of an *hypothesis* not of an *experience* (Chapter 12). It represents knowledge by *description* rather than knowledge by *acquaintance*.

In general, if A specifies a goal for A_{ext} in the form of an effective procedure, A_{ext} will need variety at least as great as A's in order to be able to execute the procedure. Recalling the grids of 9.2, we might put it that A_{ext}'s *resolving power* should be at least as great as A's. But sufficient variety may not in itself provide a sufficient condition, since A_{ext} will require also all those forms of orderedness (constraints on its variety: what we have discussed under the headings heuristics, descriptors and the like) that A exhibits in specifying the goal in question. A lower variety in A_{ext} or an absence in A_{ext} of some form of orderedness such as is present in the goal specifications from A, will lead A_{ext} to judgements of compatibility, incompatibility or redundancy in these specifications that are not evident to A. It follows from these arguments that the terms *proper* and *apparent* as we have used them to denote kinds of goal specifications, are meaningful, in effect, only with respect to some given A. The implication of this is that the term 'apparent' as we have defined it, may only be used by an observer to describe *his* judgement of some particular *operator* executing a given set of goal specifications. When an observer in such a case uses the term 'apparent', it implies that the description 'proper' applies to the observer's own judgement of the same specifications. Clearly, it would not make sense for the observer to apply the word 'apparent' to himself, though having in mind an argument like the present one, he might do so as a meta-observer.

9.4 Coding and Communication

These observations imply certain broad restrictions that would apply to making an art machine. We have shown reasons why it is necessary to furnish the machine with structure: heuristics, descriptors and such. They are that (1) significant learning, (order-extracting ability, on which depends the capacity for c-authorship) at a significant rate presupposes some significant prior structure; and, as 'There is no getting selection for nothing' (7.4), the cost in computing time and power of

evolving the required structure from scratch would make such an evolution impractical; (2) even if the machine were able to evolve a sufficient structure for itself, the likelihood is that the structure would be of a kind that its observers would fail to distinguish — to be able to make art that its maker will recognize, an art machine will need to resemble him. This was previously shown to be the case in the domain of order extraction. Here the notion is extended to apply explicitly in the realm of purpose. This implies that the machine's maker will provide it with structure that resembles his own — including all the structure he has acquired by his own order-extraction work — at least in as much as this is its only source. He does this to permit communication between himself and the machine, and because he could not do otherwise, having no other structure to offer. Such structure will in turn restrict the kinds of goals that the machine will be able to generate and thus, in terms of the definition proposed in 4.3, its powers of c-authorship. How much scope for c-authorship may the machine enjoy? Too little structure provided to the machine will render it incapable of significant results. The evolution of structure too unfamiliar, corresponding to too wide a scope as a c-author, will cause failure to recognize its products. Here is a dilemma for the machine's maker: unless he furnishes the machine with previously extracted order, its order-extracting ability will be limited; providing all the order its maker could give it will make it indistinguishable from him. Clearly, the machine will have to be constructed along the lines of heuristic chess-playing programs for instance, beginning with some simple device and adding structure to it. Chapter 14 looks forward to devices with which a beginning might be made. Here we note that before a machine could show a significant creativity, it would probably need to incorporate most of its maker's (human) structure. The rest of this chapter is devoted to questions as to the kinds of limits that given structure will impose. As an art machine will be a purposeful system, questions will be examined of the relation of structure to goal-generating capacity — that is, to c-authorship.

A's structure restricts its freedom to set goals. Its structure represents a diminution of its variety and therefore of its capacity to be a c-author. According to Ashby (1964) a constraint is a relation between two sets that limits the variety under one condition, making it less than under another. It follows from this definition that a constraint on one system may be brought about by another system or systems. Thus we take it that A's structure that restricts its freedom, includes its goal structures as part of it. If a condition C restricts \mathcal{G}, the set of all possible goals of A, to some proper subset $G \subset \mathcal{G}$, we shall call C a *constraint* on \mathcal{G}. Thus the constraint C has the force of a goal specification, since it has the effect of making A include G among any set of goal specifications $G' = \bigcap_i G_i$, $(i = 1, \ldots, n)$. It is a condition that restricts the goals that A may generate. We distinguish *internal* constraints due to A's structure from *external* constraints resulting from structures existing in A's surroundings. Among external constraints

on A we distinguish those due to other purposeful systems from those arising out of non-purposeful elements.

Suppose a purposeful system A suffers constraints due to another purposeful system A^*. Specifically, suppose A^*W is a process in which A^*'s goal is to operate on E to produce $W(A^*)$. Suppose further that this entails A^*'s working through the agency of A. Instead of itself operating directly on E, A^* utilizes the operations of an intermediate process AW that in turn will operate on E to produce $W(A^*)$. But A is itself a purposeful system and will therefore produce $W(A)$ as the realization of its own goal $g(A)$. Thus A^* must *control* A to make it produce $W(A^*)$. Controlling A represents A^*'s sub-goal which we write $g_s (A^*)$. The execution of $g_s(A^*)$ results in the production of $W_s(A^*)$, where $W_s(A^*)$ has the properties which A^* supposes necessary to exercize the required control of A in AW. That is, $W_s(A^*)$ constitutes a set of instructions provided by A^* to A from which A^* supposes A will derive specifications $G(A)$ of a goal $g(A)$, whose execution will result in $W(A) \equiv W(A^*)$. When A^* aims to realize a goal in this way we shall call the aim A^*'s *intention*. We may imagine a process AW such as we pictured in 3.2, consisting of a purposeful system A that operates through a transducer M. M is the *effector* system through which A acts on its surrounding E to produce W. By extension, in the present case we may suppose that A^* acts through M^* to produce W^*. For A^*, M^* includes the whole process AW, along with whatever other elements there are in its own effector system (see Figure 9.4.1). We may picture this process extended.

FIGURE 9.4.1

If, as in the last paragraph, $W(A^*)$ represents the realization of both $g(A^*)$ and $g(A)$, that is to say, if $W(A^*) \equiv W(A)$, we shall say that A^* *controls* A to produce $W(A^*)$. Moreover, in so far as A is purposeful, we shall suppose that it must have 'consented' to A^*'s control (or 'contracted' to be controlled by A^* – cf., for instance, Pask (1968), Pask and Scott (1973)): A must have entertained the goal of being controlled by A^* (with respect to the production of W) as part of its own goal specification $g(A)$. In such a case, where A is a purposeful system controlled, as defined here, by another purposeful system A^*, we shall say that A is *voluntarily* controlled by A^* if and only if the goal to accept A^*'s goals exists as part of A's procedures.

Presented with a WOA, we look for the artist, for evidence of c-authorship, and will even withhold or assign the name WOA together with its associated qualities according to the

degree of c-authorship discernible. In the limiting case, for instance, a painter copies someone else's canvas. Making an exact copy requires him to use the same kind and mixture of paints, the same quality and size of brush, the same kind of canvas, of brush strokes, etc. Indeed, it is probably to gain understanding of these features of another painter's work that the artist decides to copy his canvas in the first place. A perfect copy may lead us to admire his skill, though we should not think of him as the artist any more than we should a computer that reproduced a picture according to some relatively simple process, by scanning an existing one say, and translating its light intensities into a pattern on a CRS or some kind of print-out. (Yet pictures made in just this way have been described as 'computer generated'! – see, for instance, Harmon and Knowlton, 1968). The WOA must exhibit the artist. We wish to recognize the painter in his portraits of different sitters, the actor in the character he plays, the performer in his rendering of a piece of music.

What about group production processes in which the participants may not be supposed – as hitherto – to have the same goals, but may share no more than certain sub-goals? Such processes are the milieu of *designers* rather than artists, though the distinction, as we shall see, is somewhat blurred. We may assess the designer as c-author according to the same principles we used for apportioning c-authorship among groups of partial authors, namely by the variety within which his order extraction occurs. Suppose a productive process consists of a chain comprising a number of purposeful systems to each of which priorities have been assigned, so that the process is sequential, as above. Suppose A has voluntarily accepted a relatively low priority in the chain. Then A's freedom to generate goals will be circumscribed and curtailed by the goals of all the systems in the process that have higher priorities. For instance, A might be an industrial designer required to design an object for mass production, conforming to specifications laid down by various different departments of a manufacturing firm, variables occurring under such heads as marketing, tooling, material availability, production costs and so forth. Clearly, these variables show a high degree of inter-dependence: a more expensive material might increase sales but put up costs; or a popular material might be difficult to handle or call for special equipment or have unreliable suppliers. Each department would have its own main goal to which A would have to conform. The tooling department might wish to use available machinery; the sales department to compete with some particular item on the market, and so on. Or A might be a 'craftsman' making a table, say. In this case his own sub-goals will take the place of the main goals of the various departments of the industrial designer's firm. The cases are clearly equivalent. In terms of the formulation adopted here, A faces a double task, first to form an explicit goal set, made up of elements that comply with all priority goals and sub-goals, and then to select from this residual set a complete set of compatible, non-redundant specifications of his own goal – or in the craftman's case, his own artistic goal. This is a problem whose solution, to an observer without knowledge of it, displays little if any evidence of how it has been reached. Clearly, the variety of A's residual goal set (what the constraints due to prior goals have not eliminated) will be greatly reduced compared to those of the artist on whom constraints of comparable severity seldom result from goals of higher priority than the making of a WOA. Credit for c-authorship of a design normally goes to those for whom the design has been the main goal. But in evaluating the quantity of c-authorship, the character of the designer's task inevitably emphasizes his problem-solving ability in circumstances that frequently conceal from the design's judges, the problem he has solved.

A^*'s goal specifications for A may take various forms. Supposing that A voluntarily accepts A^*'s control, we distinguish different degrees of constraint on A that A^* may exercize, beginning with (1) the most restrictive case, in which A^*

controls A step-by-step, as a starting tape controls a Turing machine. Following Spencer-Brown (p. 78) we define such a state of affairs as representing control by *injunction*. If A proceeds according to A^*'s injunctions, A^* may direct A to any goal whatever (in as much as A and A^* are able to communicate – see 9.4) irrespective of whether or not A is capable of conceiving (generating) or even entertaining (distinguishing) such a goal. (This definition of injunction corresponds to what we have up to now been calling description – a starting tape for a machine that makes it generate an end tape. The present departure from this usage aims simply to facilitate the analysis in this section.) Relaxing the conditions of (1) results in (2) the case in which A^* fully specifies A's goal, though not how to reach it, and we shall reserve the term 'description' for goal setting of this kind. Here A must proceed according to a goal description offered by A^*, the description itself representing the realization of A^*'s sub-goal. We may regard these conditions as providing a *problem-solving task* for A and, following Newell (1962) for example, view the problem as a combinatorial one, involving the choice of a sequence of operations out of a set of possible sequences. In this combinatorial case, AW will terminate only when A has chosen a sequence (assuming one exists) that leads to the production of $W(A) \equiv W(A^*)$. Notice that, if A is successful, AW will terminate with the same result, *irrespective* of the sequence it has followed reaching it. In other words, no evidence of A's control or part in the process of producing $W(A)$ inheres in $W(A)$ itself. Whatever A's role has been, it remains concealed; problem solving frequently leaves little or no observable trace to indicate how solutions have been reached (which is the reason why experimental design in problem-solving psychology so often aims specifically at displaying the normally hidden aspects of problem-solving processes). And the solutions themselves, the end products of the processes – the answer to a complicated calculation; a move on a chess-board – mostly provide little or no evidence to an observer of any complex process preceding them. An observer inspecting W will attribute c-authorship to A^*. Only an observer ignorant of A^*'s instructions to A will attribute A c-authorship.

9.5 Communication between Purposeful Processes

Clearly, in practice, there are limits to the kinds of goals that might be wholly specified by description. Specifically, these limits depend upon what we have broadly referred to (7.4) as the 'communication' between A^* and A. In the language of information theory, this is what is sometimes called the *transinformation* between A^* and A, or the average mutual information or transmission between A^* and A, which Conant shows is 'an essential component of the regulatory process' (p. 336). Goals specified by description (in the present sense) depend on a generative process 'within' A, which does not occur where specifications are by injunction. A's generative process is thus subjective to A and may

therefore lead to production of the wrong W – in A^*'s terms – namely, $W(A)$ $\not\equiv W(A^*)$. In more detail, A^* is supposed to have two goals, a goal $g(A^*)$ that when executed leads to the production of $W(A^*)$, and a sub-goal $g_s(A^*)$ leading to the production of $W_s(A^*)$. $W_s(A^*)$ takes the form of a set of instructions to A from which A may derive the specifications $G(A)$ of $g(A)$. Strictly, A^*'s sub-goal g_s is to cause A to generate its own g such that its execution will lead to the production of $W(A^*)$. $W_s(A^*)$ is no more the realization of $g_s(A^*)$ than any W is the realization of g. It is simply the best A^* can do given its own limitations due to M and additionally its possible ignorance of A's characteristics.

Evidently, it is unwarranted in practice to draw too sharp a dividing line between injunction and description. For goal specifications provided by A^* to A (in the form of commands or instructions) are *all* injunctive, though not necessarily complete. To execute A^*'s instructions, A must 'interpret' and then act upon them. Only step-by-step instructions that need no interpretation call for no goal-generation by A; and this case is trivial since it entails A's voluntarily surrendering all its capacity for c-authorship to A^*. Where A^*'s control is less than absolute, A's interpretation and subsequent generative process consists in interpolating missing computational steps. A's interpretive role increases as A^*'s description becomes more fuzzy. In practice, therefore, the difference between injunctive and descriptive specifications depends upon the degree of autonomy that A^* accords to A for realizing the goals specified; and hence A's opportunities or potential to be a c-author. By definition (4.2), A^*'s goal, is to hold invariant some state, or movement towards some state of E (or part of E). The specifications that A^* provides to A stipulate what the state is, either all at once, or by means of continuing direction as A proceeds. A must then maintain the state or determine the path to it, possibly by itself setting up sequences of sub-goals. (In the following chapter we shall see that A^* and A may be characterized respectively as what Ashby (1964) distinguishes as *controller* and *regulator*.)

The correspondences respectively between injunction and description and algorithms and heuristics will be clear. Thus, for example, a theorem-proving procedure might provide proof heuristics based on some proof criterion along with a facility for checking its results against the criterion. The criterion might be some general definition of proof, in terms as of well-formed formulae. But the procedure might equally get on without the heuristics, simply by combining axioms say, according to some algorithm for forming wffs, and checking after each step to see if the required proof had been accomplished, that is whether the newly formed wff was the required one. Similarly, we might provide a hill-climbing procedure with a general concept of a peak, as say the highest point in a region. Or we could give a particular definition of a particular peak, based upon route directions. Notice that the more general the definition of a concept, the more widely different the procedures that may adopt it as a criterion, while the more narrowly it is defined, the more restricted its applications will be. In the limiting case for generality, A^* need do no more than retain a veto over what A produces, thus ensuring that anything finally produced conforms to the realization of $g(A^*)$. This is the homeostatic procedure examined in Chapter 6, under the heading algedonic

control. All the remarks made in that chapter on the relative advantages and limitations of heuristics and algorithms apply, *mutatis mutandis,* equally here. Notice that purely injunctive specifications are tied to particular processors. If the processor is a universal Turing machine, the starting tape will need to include instructions for producing the particular machine required to execute the program.

In practice, A will sometimes prefer (find it easier) to use descriptive, sometimes injunctive specifications. To use Spencer-Brown's example, it is easier to describe a cake or a piece of music by means of the injunctions respectively of a recipe or a musical score than in terms of descriptions of taste or sound. Conversely, it might be easier to leave the solution of a theorem to a suitably programmed computer than prove the theorem oneself. But 'the description is dependent upon and secondary to the set of injunctions having been obeyed first' (Spencer-Brown, p. 78). Once the cake recipe is known its name will be enough to describe it. In practice, numbers of factors will dictate the choice between injunctive and descriptive control procedures. Generally, A^*'s instructions to A will be a mixture of both. A limiting consideration for A^* is its ignorance of A's structure, which in general will differ from its own. (If A^* and A are identical then questions of control between them are equivalent to questions of their own internal control.) A^* must compensate for its ignorance by the specificity of its instructions. Paradoxically, by the conclusions we have already reached, the more specific the instructions the more closely bound they will be to a particular processor. But the less A^* knows of A the greater its uncertainty of its properties as a processor. So there is a point beyond which it does not pay A^* to make its instructions more specific! In practice, the problem does not occur.

9.6 Chains of Control

In general, we picture the two-stage process A^*W envisaged above, in which A^* produces $W_s(A^*)$ to provide A with a basis upon which to select a set of specifications $G(A) \subset \mathcal{G}(A)$. To these, according to this formulation, A provides additionally, self-generated specifications, to obtain finally the specifications $G'(A)$ of $g(A)$. We define such a case as a special case of partial c-authorship and call A *co-author* with A^* of W, and write W as $W(A^*, A)$. In principle, at any rate, the relative contributions of A^* and A to W corresponds to the degrees of order in W attributable respectively to the two entities.

The two-stage process due to A^* and A extends naturally to a multi-stage system, consisting of a sequence of processes $A_i(W)$, $(i = 1, \ldots, n)$, say. Each A_i *generates* $g(A_i)$ and possibly one or more sub-goals, corresponding to sub-processes of the sequence. We write $g_{s_j}(A_i)$ to denote the sub-goal of A_i whose execution is intended to control A_j. $W_{s_j}(A_i)$ denotes the product of A_iW when this goal is executed. This W consists of a set of instructions to A_j, which may

include both injunctions, such that they will lead A_jW to produce $W(A_j)$, or descriptions from which A_j will be able to construct $g(A_j)$ whose execution will lead A_jW to produce $W(A_j)$, or both injunctions and descriptions. As a sub-goal $W_{s_j}(A_i)$ has as its ultimate object either that (1) $W(A_j) \equiv W(A_i)$, if A_jW is the penultimate process or, more generally, (2) $W(A_j)$ should form the basis for A_k say, to set specifications for $G(A_k)$ (where k may but need not equal $(j + 1)$), to make $g(A_k)$ and so on.

A_i intends that the execution of $g_s(A_i)$ and $g(A_j)$ should lead to the production of the same W. But as we have noted, this may not always occur. If A_i's instructions to A_j are not effective, and A_j is not able to use them as a basis upon which to form a fully specified goal $g(A_j)$ (or sub-goal $g_{s_k}(A_j)$), or if A_j's variety is greater or less than A_i's, or in the presence of noise, A_j may generate a goal different from the goal A_i intended it to generate. That is to say, it may happen that the execution of $g_{s_j}(A_i)$ and $g(A_j)$ lead to the production of $W_{s_j}(A_i) \not\equiv W(A_j)$. In general, if $W_{s_j(i)} \supset W(A_j)$, ($W$ is an object or an event rather than a set of processes; nevertheless, we may describe it by means of a monotonically convergent sequence of sets, exactly as we described goals (9.2)) then we should suppose that A_j will regard $g(A_j)$ as underspecified by A_i. While, if $W_{s_j}(A_i) \subset W(A_j)$, we should suppose A_j's variety or power resolution to be lower than A_i's. Other coding discrepancies between A_i and A_j, or the presence of noise might give rise to disjoint or overlapping W's.

In general, we need not suppose that the process AW will necessarily consist of a simple sequence of nested processes and sub-processes $A_iW(A_i)$ as we have pictured so far and that might be written as

$$AW = A_1(A_2(A_3 \ldots (A_n W(A_n)) \ldots W(A_3))W(A_2))W(A_1).$$

It need not be supposed that only one process occurs at a given time, nor that any given sub-process $A_iW(A_i)$ will occur only once; sequences of nested loops of recurring processes in complex arrangements may be pictured. Other forms of constraint, apart from those already considered, will also play a part in determining the structure of such arrangements. In cases where such processes have parallel components they may be reduced to sequential forms in the same way as information processing procedures.

In addition to constraints on A due to other purposeful systems — among which we should include A's culture and the history, and traditions that affect his chosen field — are constraints due to the 'real' world. A human A owes his own structure very largely to the long, evolutionary order-extraction process that has permitted the development and survival of the human species. As shown in Chapter 4, this process has led to correlations between A and those aspects of the world with which A's antecedents have survived contact. A's perceptions further these correlations, reflecting, not simply *some* 'real' world, but the one with which A, both specifically and individually has a relationship. For creatures to survive, 'the self

image must be in close correspondence with the reality of themselves and their environment'. (Fogel and others, p. 122.) If A is a machine, then, as Chapters 6 and 7 showed, much of its structure will derive from its human maker. To this extent, any A is also a W. It is the product of a process in which both purposeful and non-purposeful processes have played a part and, in this, is constrained in the goals it can generate and thus the Ws of which it can be the c-author. But for A the controller, the constraints that make up the structure of M and E also restrict the Ws that AW can produce. These limits, being 'physical', naturally are most confining for As working in the 'physical' world, like painters and sculptors, or those who rely upon a physical medium, such as musicians, whose music depends on the phenomena of sound and the characteristics of musical instruments. But no A is free of physical constraints. Commonly, A will turn constraints to his own purpose. They do not 'make the work any less individual, and whether it be that of an architect, a cabinet-maker or a composer, [they reflect] no less minutely the most subtle shades of the artist's personality'. (Proust, Vol. 4, p. 292.) These constraints do not detract from A's achievement. Unlike the designer who may be compelled to work in oak or stainless steel when he might have chosen walnut or pewter, the artist is normally free to make his own choice, and uses the choice to achieve the effect he wants. The painter cannot determine the position of every particle of paint. Instead he relies upon his knowledge of their characters to choose oil paint, watercolour or whatever as his 'medium', to pick the brushes and the kind of surface on which to work, so that these will 'arrange' the paint particles for him. The musician chooses his instrument and relies upon his choice for achieving what he would be unable to do in any other way. Writers, especially poets, deliberately draw upon 'physical' qualities when they might have been supposed relatively free from the restrictions these impose. Their repertoire consists of rhythms, rhymes, the tonality of words and imagery appealing to the senses, including the kinaesthetic – what William Empsom calls 'muscular imagery'. Indeed the artist uses the constraints of his *chosen* medium to extend his own variety into the wider variety of the world. (Aspects of this notion, especially in the form in which it has been considered here, are treated by Kepes (1965), Rudofsky (1965) and Whyte (1961).)

9.7 Designers

The controllers A_i of AW's sub-processes have so far all been supposed to act *voluntarily* under the control of superior processes and *in the absence of competing goals within AW, or of their own*. But this may not always be the case. The individual A_js may entertain their own goals and sub-goals. Moreover, this may be so whether or not the A_is act voluntarily under the control of superior controllers. More strictly one may imagine *qualified voluntariness* in the sense of voluntary control being accepted only *if it does not require actions that conflict with or prevent the pursuit of an independent goal*. Purposeful processes and sub-processes with conflicting or mutually interfering goals, in which control is not voluntary, give rise to problems that are of more than tangential interest to our present object, since we are concerned with possible conflicts between the purposes of our art machine and its controller, and the orders of linked systems on which it may draw to augment its own structure. The voluntarily-controlled sub-processes of such compounds will act in a way that is the converse of that in which conflicting sub-processes act that do not accept voluntary control by

superiors. That is to say, such sub-processes will pursue their independent goals *only if these goals do not require actions that conflict with the pursuit of the goal of the superior.* A sub-process in this case will have to 'accommodate' its own purpose to the superior purposes. Such accommodation will detract from the *c*-authorship of the sub-process in executing its own independent goal, in so far as it restricts the goal. The superior processes whose goals it has had to accommodate will not be co-authors according to our definition.

Ashby (1972) shows the relative importance of constraint on *A* due to the conflicting and other goals of other purposeful systems. He pictures a designer furnished with a set of instructions, which may include instructions from goals differing from *A*'s, but by which *A* is nevertheless bound. He represents the situation by a diagram: Figure 9.7.1.

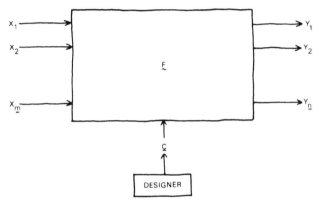

FIGURE 9.7.1

Ashby asks how much information processing by the designer is implied by his translation of the demands made upon him into completed designs that he produces such as meet these demands. He enquires how the *least safe capacity* (ibid. p. 90) in channel *C* is related to the capacity in the channel from $\underset{\sim}{X}$ to $\underset{\sim}{Y}$: what is the minimum capacity of channel *C* which will ensure that, whatever the actual situation between some given $\underset{\sim}{X}$ and $\underset{\sim}{Y}$, *C*'s capacity will be sufficient to enable the translation to take place. The designer receives a message via the channel *C* in the form of demands $\underset{\sim}{X}$ to produce $\underset{\sim}{Y}$. From a set of functions he selects $\underset{\sim}{F}$ such that $\underset{\sim}{Y} = \underset{\sim}{F}(\underset{\sim}{X})$. $\underset{\sim}{F}$ is the 'message sent'. Ashby notes that the number of functions from a domain of *d* elements to a range of *r* elements is r^d. If the numbers *r* and *d* are not small, *d* will be relatively far more important than *r* in *increasing* the number of functions and therefore the work required of the designer.

This acts as a severe constraint upon the capacity of any system for *c*-author-ship. For we may generalize this formulation to include, in the 'demands on the

designer' A, which constitute the constraint, instructions from other purposeful systems, either pursuing the same goals as A or different goals, or 'demands' not necessarily due to other purposeful systems at all, but merely to the structure within which the designer operates. All such structure, whether it is the physical structure of the world, the structure of A's effector system or the structure of a problem domain, detracts from A's capacity to be a c-author. Thus the product of a problem in multiplication is fully determined by the rules of arithmetic, and one would not call a system that performed the multiplication the product's c-author. Evidently, the extent to which A is 'free' to generate its own goals is severely restricted whatever form A may be given.

The reduced variety of the world within which the designer may be a c-author is seen to detract from his achievement and to assign him and his works a position of importance inferior to that of the artist. Similar considerations, which detract from the assessed artistic merit of Ws, applies in all cases in which the object of making a WOA has not been paramount. Examples are propagandist writing or painting, advertising, or any form of art in which the communication of a 'message' or some other didactic purpose has taken precedence. It should be emphasized that this view derives from the conclusions of the theoretical arguments presented, not from observation, though various empirical arguments support it. Two in particular seem important: (1) the notion that art should be didactic ('committed' as it is today sometimes popularly called) has been present to a greater or lesser extent at most times, within Western culture at any rate. The interpretation of ethnological evidence as to the uses of primitive art suggests the importance of the need to solve quasi-didactic problems in art's origins. Yet the element in art whose merit has survived the judgement of successive generations of critics has tended to be non-didactic; and the art – including ethnological artefacts – of earlier, more explicitly and generally didactic periods, has tended to survive despite its didactic intent rather than because of it. (2) The arguments so far advanced have applied equally to art and science. Science at least casts no empirical doubts upon the conclusions they have led to. Science is supposed not to promote its theories, nor come to its observations with pre-conceptions as to what they should reveal. Scientific theory or experiment whose main goal is anything other than that of extracting order from its data, or of adding to the data by discoveries, is judged worse in so far as it is seen to be the result of pre-conceptions. Alchemy, and Lysenkean genetics are among more obvious examples of the consequences of failing to follow these precepts. (Monod draws attention to Engels's (1935) applications of Dialectical Materialism to science. In elementary algebra for example these reveal that, 'stripped of the veil of mystery in which it was wrapped by the old idealist philosophy and in which it is to the advantage of helpless metaphysicians ... to keep it enveloped', for any algebraic magnitude whatever, call it a,

negated, we get $-a$ (minus a). If we negate that negation, by multiplying $-a$ by $-a$, we get plus a^2, i.e. the original positive magnitude, but at a higher degree, raised to its second power. In this case also it makes no difference that we can reach the same a^2 by multiplying the positive a by itself, thus also getting a^2. For the negated negation is so securely entrenched in a^2 that the latter always has two square roots, namely a and $-a$. (pp. 152, 153.)

– next to whose mysteries, those of idealism may be thought to pale significantly.)

In modern times the movement against ulterior purposes in art flourished partly in

reaction against earlier didacticism, but was associated also with notions of individual liberty. Williams (1961) traces the rise of the idea of the individual to the notion of the individual soul, which nourished the Reformation, 'man's direct and individual relation with God', rather than his 'destiny within an ordered structure' (p. 91). Artists frequently had had to fill the diminished role of designers and had been wholly dependent upon patronage. Duchamp's answer when he was offered a number of commissions after his success in 1913 expresses a widely held attitude: 'No thanks. I prefer my liberty.' (Cited by Lake and Maillard, 1956, p. 84.) Though by this time the attitude was probably hardly more than what Tom Wolfe (1976) refers to as 'the anti-bourgeois sing-along of bohemia, standard since the 1840's, as natural as breathing by now [the 1920s], and quite marvellously devoid of any rational content' (p. 74).

10

Regulation and Control

10.1 The Purposeful Individual

This chapter ends the examination of authorship. It argues that A must include among its various features one that resembles O; such a member is a necessary part of its control and regulatory apparatus, without which it would be unable to realize any goal in E. This conclusion provides a basis for an answer to an important question that has so far been neglected; what is a *WOA*? Beyond asserting that a *WOA* must be the product of authorship, we have nowhere been explicit about its distinguishing characteristics. In 2.5 some of the difficulties of arriving at a satisfactory definition of a *WOA* were enumerated. Definitions turned out to be either too wide, admitting all comers without providing sound reasons why, or they tended to depend upon other notions as difficult to define as the idea of a *WOA*, to avoid which they had been invoked. The breadth and evident arbitrariness of what have come to claim to be *WOA*s has increasingly in this century, particularly since the Dada movement, confounded the task of definition. But the problem partly vanishes if we adopt a paradigm for an author, such that it acknowledges the controller-observer's role, which as we have seen, other reasons demand in any event. For if A asserts that W is a *WOA*, then (provided A is not disbelieved) it is – for A. The problem of possible hoaxes, which might have been serious, turns out not to be, because any claims A makes for W will have to satisfy the individual judgement of each particular O whose assessment may be sought. This is the case whether A claims that W is a *WOA* or that it is not – the question of the emperor's clothes demands an individual answer.

Ethnological objects are not intended as *WOA*s by their makers or even their users, yet may be judged to be *WOA*s by certain Os – as happened in the case of primitive African art in the first decade of this century. Indeed 'found objects' may become surrogate *WOA*s simply on the judgement of their finders. As Mayer (1969) observes, 'The artist's role in its presentation is creative only in that it points out aesthetic values that the object already possesses but that were not deliberately considered in its construction' (p. 153). How this comes about will appear shortly.

Treatment of the subject of control and regulation has deliberately been left to

this, the concluding chapter of Part II with the object of showing as vividly as possible, not simply the necessity, but the sufficiency of a controlled productive process as a basis for our purpose of making an art machine. From the outset we have insisted on the necessity for AW to be a controlled process, though we have avoided hitherto any mention of how A's control might be exercized. This avoidance has led to certain difficulties and anomalies which we shall shortly be able to remove. The first difficulty was to define purpose without appealing to control. This was an obvious problem, though it appears to have been overcome in a way that did not detract from the utility of the definition adopted: as we observed, control is an inferred aspect of purposefulness, at least for one observing it. Chapter 5 observed that the problems of interpreting W were exacerbated by differences between A and O, and Chapters 2 and 3 drew attention to the related problem of how to know a WOA. Here we shall show that A, as a controller, is also O, and that the way the productive process proceeds is sufficient to ensure that A produces WOAs if that is its object. Moreover, we shall infer that Os other than A must undertake a productive process not unlike AW in order to apprehend and appreciate a WOA in the role of audience or critic.

The argument of this chapter bases itself on the formulations of Ashby (1964) and Conant. The argument begins by outlining a paradigm for regulation, which is applied by degrees to the process AW, while the implications for A's structure are examined at each step. Different varieties of regulation are discussed, in particular cause-controlled and error-controlled forms. The initial paradigm is extended to apply to a purposeful individual, and it is shown, by means of diagrams of immediate effects, that a purposeful individual is homomorphic with a controlled procedure. It is found that a cause-controlled regulator needs a model of the world in which it operates and this implies a need for it to have an order-extraction facility so that it can acquire the model. A canonical representation for an art machine is suggested and its operation as a productive process observed.

10.2 Regulation, Control and Purpose

We come at last to control. From the outset (3.1) A has been defined as a controller. As a purposeful system, A must be able to control its actions so that they serve its purposes. Chapter 4 defined A's purpose in terms of invariance: an observer O that identified some characteristic in A's output that remained invariant over a time interval T, supposed that the characteristic represented the realization by A of a goal entertained by A over the interval. If the characteristic remained invariant under changes in A's input state, A was said to be purposeful. Thus, broadly speaking, it was concluded that A needed to be able to (1) set the goals it wished to pursue; (2) 'protect' against disturbance (the notion of the

source of disturbance as an adversary of regulation is due to Conant (p. 334)) whatever procedures corresponded to those set goals; (3) execute the goals. The procedures required by (2) and (3) are of a similar kind, but differ from the procedures required by (1). We shall show that these two kinds of procedures, those of (2) and (3) and those of (1), correspond respectively to what Ashby (1964) distinguishes as *regulation* and *control.* He pictures them by means of a diagram of immediate effects as in Figure 10.2.1, in which *D* represents a source of disturbance, *C* a controller (goal setter in our terminology), *R* the regulator, *T* 'the hard external world, or those internal matters that the would-be regulator has to take for granted' (p. 209), and *E* the set of 'outcomes'. *R*'s job as regulator is to provide inputs for *T* such as will, when *taken together with T*'s inputs from *D*, force *T* to emit *E*, such that *E* shows the required characteristics of invariance – or such that certain values of *E* remain within some acceptable range.

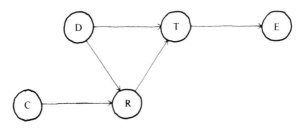

FIGURE 10.2.1

We might re-arrange Ashby's diagram of immediate effects to represent *A* within the terms of our definition, as in Figure 10.2.2., in which *D* represents disturbances affecting *T*.

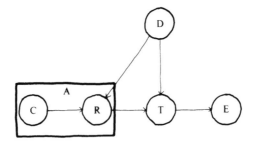

FIGURE 10.2.2

Such a representation would be incomplete, however, as it would provide only the goal-setting and execution systems, *C* and *R* respectively, without allowing for a system to protect against disturbance the goal that had been set. In our

terms this system would be a goal-seeking rather than purposeful. To be purposeful, *A* must be able to maintain invariant that part of its own internal state that represents its goals. This implies that it must include a regulating system as part of itself. We might represent such a system as in Figure 10.2.3.

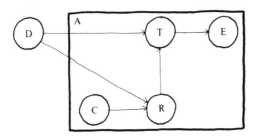

FIGURE 10.2.3

Here *D* represents inputs that *A* receives from its surroundings, internal and external; *C* acts as goal-setter by determining what *E R* will aim for; *T* refers specifically to the 'internal matters' mentioned in the previous paragraph, and *E* is the representation of *A*'s goal. Combining the representations of both these diagrams, 10.2.2 and 10.2.3, we obtain a full representation of *A* as a purposeful system, arriving at 10.2.4.

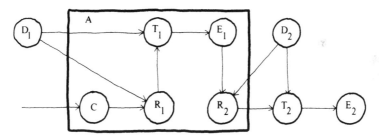

FIGURE 10.2.4

Regrouping the elements of this figure, we get Figure 10.2.5, which reduces to a homomorph of Figure 10.2.1, the figure we started with. That is to say, we have not departed from Ashby's formulation, which we might interpret as follows: *C* sets *A*'s goals, with or without specifications received from elsewhere. We might say that *C* does *A*'s order-extraction work, or is the creative or imaginative element in *A*; D_1 represents disturbances affecting *A*; T_1 represents the internal matters that Ashby mentions; E_1 is *A*'s representation of its goal, and plays a role in *A*'s effector system that corresponds to *C*'s role in *A*. Notice that *C* controls R_2. R_1 protects, as we have called it, the goal that *C* has set for *A*

against the disturbances of D_1; E_1 may now be taken as A's goal representation and R_2 as the regulation of A's effector system against disturbances D_2 that act upon it. T_2 represents the external world and E_2 represents W, the realization of A's goal.

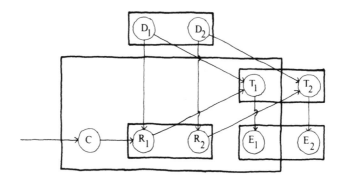

FIGURE 10.2.5

Notice that we might have achieved the requirements of a purposeful system more easily by a simple modification of the original paradigm, Figure 10.2.1, by allowing a channel of information between E and C, as in Figure 10.2.6.

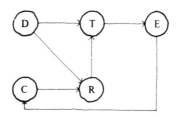

FIGURE 10.2.6

This system, by reviewing the success or failure of the regulation procedure it has determined, may see to it that E remains appropriate. It is an ultra-stable system in Ashby's (1965) sense, with C having the role of altering the parameters of the transducer R. If C operated on a step-function, this system would resemble Ashby's homeostat. However, we have chosen to portray purposefulness in a form that emphasizes the complexity of the internal structure of the system, and to illustrate the symmetry between the regulating mechanisms directed respectively at the internal world of the system, and the external world, which is the system's primary concern.

10.3 Types of Regulation

Ashby distinguishes three varieties of regulators, those characterized by the diagram of immediate effects of 10.3.1 (i), which correspond to the regulator part of the system of Figure 10.2.5, and those systems that may be characterized as in Figures 10.3.1 (ii) and 10.3.1 (iii), in which the information available to R concerning the disturbance D that R is required to block, is forced to take longer routes to R, passing respectively either through T or through both T and E.

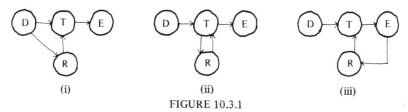

(i) (ii) (iii)

FIGURE 10.3.1

The last type of system (Figure 10.3.1 (iii) has the 'basic form of the "error-controlled servo-mechanism" or "closed loop regulator", with its well-known feedback from E to R' (Ashby, 1964, p. 223): The error-controlled regulator 'differs from that of the basic formulation [Figure 10.3.1 (i)] only in that the information about D gets to R by the longer route $\boxed{D} \longrightarrow \boxed{T} \longrightarrow \boxed{E} \longrightarrow \boxed{R}$ (p. 223).

Conant gives the name 'cause-controlled regulators' to regulators that receive their information about D by the shortest route, directly from D. Figure 10.3.2 portrays Conant's representation of cause-controlled regulation. R utilizes information from the source that affects S to determine appropriate regulatory action aimed at preventing S from affecting Z. D is a source of 'primary disturbances' (p. 338), a sequence of activity that affects both S and R. Without R's regulation, D's activity would be transmitted through the channel S to Z. R must co-ordinate its own actions with S's so that the resultant outcome of their joint activity is invariant; that is to say, so that the channel from D to Z which R and S form jointly has 'minimal information capacity' (p. 338).

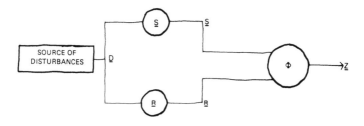

FIGURE 10.3.2

Conant goes on to show that the amount of regulation achieved by a cause-controlled regulator will be maximized if R is or behaves 'isomorphically or perhaps homomorphically with respect to S', in which case R will be a perfect regulator. This constitutes 'information theoretic grounds for the observation that regulators are often isomorphs of what they are regulating' (cf. 4.8). Error-controlled regulators receive all their information about the errors they are required to regulate from the already-regulated signal. They therefore have more the role of what we might call *error-attenuators,* since their action relies on the survival of at least some error for its direction. Cause-controlled regulators are able to avoid the defect of being theoretically never quite able to eliminate error, by relying purely on information coming directly from the source of disturbance, without the intercession of any external agent. Notice that a model of D alone does not provide R with sufficient information for its regulatory task. This is because R forms a joint channel with S and it is therefore S's outputs that R must 'neutralize'. Conant's formulation is equivalent to Ashby's of Figure 10.3.1 (i) with Conant's S corresponding to Ashby's T and Conant's Z to Ashby's E.

For perfect regulation, R's and S's responses to D must reach their point of summation — in Figure 10.3.4 — simultaneously. That is to say, the time it takes for the information about the disturbance to reach the regulator and the regulator's output to reach the point of summation must be the same as the time required for the disturbances to reach the point of summation, via the channel S.

Furnished with a model of S, R might determine its outputs in some quite simple and direct way, as for instance by using a coding procedure based on the model's outputs; or it might use its model as the basis for a surrogate error-controlled process, in which it pre-tested actions on the model, modified them, re-tested them and so on, *before* emitting them in the form of an output. Observation might not always make it obvious which of these forms R was using. The reason for this may more easily be understood from an example. We recall the machine of Fogel and others (4.8) that was evolved in such a way that it predicted the output states of its environment. These outputs consisted of a cyclically repeated string of randomly mixed zeros and ones. If, instead, the machine had been evolved to output ones simultaneously with the environment's zeros and zeros with its ones, the net output obtained by summation of its own outputs and the environment's would have been one invariantly. Such a machine, in the role of R, would perform perfectly in its environment S, against disturbances D that produced the environment's emissions. If the regulator's environment consisted of more than one pattern of zeros and ones, a more complex regulator would be called for, specifically one that included an 'anti-pattern' to neutralize each pattern the environment emitted, and in addition a device for selecting the appropriate 'anti-pattern' to use at a given instant. Such a device would need to incorporate some means of recognizing what pattern S was emitting and of

selecting an appropriate 'anti-pattern' from whatever stock of them it might have. Put slightly differently, there might be a number of distinct Ss of which R had models, and R would therefore need a way of knowing which one was operating at a given moment. Clearly, there is room for R to conduct tests using its models of S. What these tests achieve will depend upon the rate at which testing can be carried out on the models, relative to the time-scale of the environment in which regulation is required. At worst testing will reduce the likelihood of disastrous actions on the part of the regulator, more or less irrespective of the relative time-scales of S and R's model of it. At best it may promote relatively effective actions of R. Where regulation is not error-controlled, in the strict sense that the actual *commission* of error is vital for the regulator if it is not to block its only source of information about the disturbance it is to regulate, it might more properly be called regulation by error-anticipation. But error-anticipation must rely upon the availability of some kind of model of the environment within which disturbance is to be regulated, so that regulatory actions may be tested, modified, re-tested and so on, before they are used; or which, through isomorphism or homomorphism may permit *simultaneous* regulation by some kind of matched reaction.

> That very intricate regulator, the brain, is successful because it contains, in some sense, a model of the environment which is an approximate isomorph or homomorph of that environment; on the basis of that model, the brain apparently calculates how S will respond to an observed disturbance and then formulates its own regulatory response which is coordinated with S. (Conant, p. 338).

10.4 *AW* in Operation

At last we are in a position to portray the productive process AW as it might operate to produce W, and to examine its goal-generating more closely. To permit goal-generation of sufficient interest to justify calling it creative, we shall suppose that A is provided with a facility for modelling its goals, and since these will all be concerned with producing W in E — by definition — we shall assume that the modelling facility extends also to E or, in other words, that A can model W-in-E. This implies that A must also incorporate an order-extraction facility to enable it to furnish its models. We propose the paradigm portrayed in Figure 10.4.1.

A disturbance D emanating from A's external environment E affects A — sets up a disequilibrium, say. This is registered at O where there is a modelling facility to set up a goal for restoring equilibrium, possibly with test and modification procedures carried out on the model of the environment E*. Call the goal W^*-in-E^*, or simply W^*. O sets R_A to regulate against internal and external disturbances, D and D_A; and within A's internal environment E_A, to produce

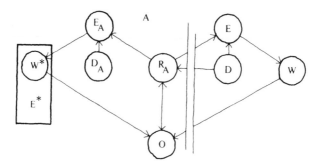

FIGURE 10.4.1

W^*. R_A also acts via M – omitted from the figure for simplicity – to produce W symmetrically with W^*. The process ends with the restoration of A's equilibrium. The W that exists at that time is the realization of O's last goal. We mention O's 'last' goal, because O has been depicted as receiving information from both W^* and W. The information channel from W to O makes the system purposeful in the sense of 10.2; what, by extension from the definitions of that section, we should call an error-controlled purposeful system. The information channel from W^* to O provides cause-controlled regulation of the system's controller, so that we should describe it as a cause-controlled purposeful system too. Here is the justification for the paradigm of purposefulness portrayed in Figure 10.2.5, intimating the place and importance of a modelling facility.

W and W^* will be subject to differences of variety and of conformability in their structures. Returning to the notation of the previous chapter, let us suppose A's goal g has in A the internal representation W^* provided by the set of specifications $\cap G$. W^*'s variety may be greater than, less than or the same as the variety available for its realization, W; or its structure may be unattainable in reality, a difficulty that might easily come about through manipulation of E^* not possible for E, or though a bad fit between E and E^* in the first place. Suppose A commences its operation with an initial goal g_1, which AW begins to realize as W_1. If, for one of the reasons suggested, AW either halts or detects discrepancies between W^* and W, A will need either to find a way of removing the discrepancies or will be forced to alter or abandon g_1. If A is unable to avoid the discrepancies and wishes the process AW to continue – because the state of disequilibrium that gave rise to the process in the first place persists – then A will have to alter g_1 to g_2, causing M to begin executing g_2 in E as W_2 (either modifying W_1 as it has come into existence so far, or by beginning again). Recurrences of these events will result in two sequences, g_i and W_i, $(i = 1, \ldots n)$ say, of goals and their partial realizations respectively. AW halts at $n = k$, if W_k realizes g_k.

For this to occur, the sequences g_i and W_i must converge towards equilibrium points g_k and W_k respectively, and successive g_is must find on the whole closer approximations to their respective realizations in successive W_is. We picture two sequences g_i and W_i $(i = 1, \ldots, k)$ converging to the point at which W_k realizes g_k. In general, we may relax the condition that makes A set out with a fully specified goal g, and assume instead that A's goal is under-specified, call it $\overline{G} = \cap G$, where \overline{G} has more than a single member. Successive Gs will form what Wittgenstein calls a 'family resemblance group' (2.4). Similarly successive Ws. (In practice W is an on-going enterprize. By 'successive' Ws we mean Ws delineated by changes in G – or g.)

The time-scale for goal-setting procedures is not necessarily the same as for the procedures for realizing goals: goal-setting procedures operate according to the time scale appropriate for measuring 'events' in A, call it T; realization procedures, 'events' in E, call it t. That is to say, T instants in A correspond to t in E. The rate at which A can respond to information reaching it from E, has an upper bound determined by T, while the rate at which E can respond to operations on it, controlled by A, has an upper bound determined by t. If T is faster than t, information from E^* regarding W^* may cause G_1 to alter to G_2 before G_1 can be realized, that is before W_1 can be produced in E. It follows that to produce W in E it is necessary for G to remain fixed for at least some minimum time. This formulation suggests that AW will always terminate with W as the realization of g, or at any rate G. But this is obviously not the case. Apart from those goals that A will abandon, it will have to show tolerance in the cases of those with which it persists. A perfect match between W^* and W is unlikely ever to occur.

Of particular interest in AW, as this chapter newly depicts it, is the relationship between W and W^*. How do the two entities affect one another and where does A stand between them? Section 8.2 intimated that O's position 'between' W an its producer enabled O to use each as a source of information about the other, and this procedure was likened to the use of PLANNER in Winograd's language program. The present paradigm clarifies these earlier ideas. Some O, as we now see, must be part of A and, though W may have other Os – those that are its true audience – considering them rather than the O that belongs to A – the artist's role as self-critic – introduces separate and, in this context, extraneous problems. In the greater detail the chapter furnishes, O appears symmetrically between W^* and W. Looking forward to the discussion of objective knowledge that follows at the beginning of Part III, we anticipate the main idea that the argument there advances, that all Ws that AW may produce represent objectifications of W^*s; and that therefore WOAs, as members of the class of Ws, represent objective knowledge. We shall look to the present argument to support this view. For the present conclusion imparts to W – from consideration of AW alone, irrespective of the kind of W it produces – the status of objective knowledge. Since, as we have observed, the value of the objective knowledge that any W provides is to be assessed relative to the O that uses it, this value will depend upon similarities and differences between the user-O and the particular O that was part of the process that produced it.

The creative process is by no means a unitary event, but proceeds rather by successive

approximations during which not just W but W^* too, the model of W that A's goal-setting procedure uses, alter – if AW succeeds – in gradual convergence, until the correspondence between them is sufficient to permit the process to halt. This occurs in the manner 8.2 describes, with the O in A – that is to say, A in its capacity as O, write $A(O)$ – alternating between two production processes, AW^*, the construction of W^*, and AW. W provides a test facility for *ideas* that develop in W^*, according to the results of which W^* may be modified and the ideas further developed. Such a procedure is possible provided the time-scale T of events in W^* is more rapid that the time-scale t of events in the real world, which is the case for the human A. We recognize in this process a resemblance to a 'scientific method', though lacking formal proof procedures that enable the connecting together or ordering of ideas, in the manner described in Chapter 4. The symbiotic relationship between W and W^* depends upon the differences in variety and structure of E^*, A's representation of the environment, and E, the environment itself. In general, correspondences between E and E^* will be both loose and changeable. E^*'s variety is lower than E's with the result that A will use E as a stimulus for its own creativity.

A's initial goal is likely to be quite inexplicit. T.S. Eliot has observed that a poem may begin from no more than the idea, in the sense of an experience, of a rhythm, say. Perhaps it may be less explicit still, no more than a sense of restlessness for instance, sufficient to set AW in motion. From here A may seek to narrow his goal's specification through recourse to E. This may even take the form of an appeal to the characteristics of the medium itself. Artists will allow colours to run and generally to use physical constraints in the manner 9.6 noted. Such procedures have become highly explicit this century. Arnheim (1971) cites works of Abstract Expressionism, particularly Jackson Pollock's paintings of the late 1940s, which 'show a random distribution of sprinkled and splashed pigment controlled by the artist's sense of visual order' (p. 23). The Dadaists' scissors-and-paste poems have already been mentioned. William Burroughs (1970) reports the use of a similar technique. Francis Bacon (1975) reports making use of the artistically suggestive qualities of partially destroyed photographs. Less randomly, though still providing explicit examples of the nourishment afforded W^* by W, Steiner (1972) shows how writers who write in more than one language are able to cross-fertilize their linguistic styles. He cites the example of Samuel Beckett, who has translated his own writing in French into English, showing how he will often develop the words of an expression when he translates into English, from expressions suggested by the French written previously.

> No outside translator would have found the equivalents chosen by Beckett for the famous crescendo of mutual flyting in Act II of *Waiting for Godot* . . . The English version springs from the French not by translation but by intimate *recreation*; [italics added] Beckett seems capable of reliving in either French or English the poetic associative processes that produced his initial text' (p. 18).

Most finished WOAs conceal the developmental process that underlies them, as much or more than a scientific paper or the proof of a theorem conceals the intuitions and heuristic stratagems that led to it – more, because it is often the object of the artist to conceal his way. (See for example Medawar, 1969.) Moles observes that 'The artistic deed is *autonomous, independent of its technique of construction. It may be accessible through its structures, but nothing *a priori* indicates that these are connected with the technique of construction' (p. 114). Pentimento or original manuscripts of music or writing reveal what the finished WOA does not, the deletions, additions and changes of mind of partial goals partially realized.

Notice that A's goal, whether fully specified or not, is reached only if and when W satisfies A as sufficiently realizing it. In general A is likely to be unable to give objective

specification of its goal, *except by means of W*. (Chapter 12 takes up this subject in detail.) So what A's goal is may never be more explicit even to A than W makes it. In practice A may employ various criteria for determining whether or not W realizes a goal. A may seek *justification* for the development of W by making explicit reference to the received criteria of his art, rather as a mathematician may seek proofs to justify his intuitions. But what indicates to A whether or not a goal has been attained, may equally remain quite vague. For T.S. Eliot (1950 c.) 'there is an analogy between mystical experience and some of the ways in which poetry is written' (p. 144). Writing poetry is less a personal struggle than one by the poem to get itself written; not by "inspiration" as we commonly think of it, but by the breaking down of strong habitual barriers . . . The accompanying feeling is less like what we know as positive pleasure, than a sudden relief from an intolerable burden' (pp. 144, 145). Nadezhda Mandelstam (1971) reports that her husband, the poet Osip Mandelstam, would experience a sense of buzzing in his head during the composition of a poem, which would persist, evidently outside his control, until the poem assumed the form that he then took to be 'right'. W^* is not stable: the goal is known only when it is reached. Bell (1937) records an account by Poincaré of his solution of a complicated mathematical problem connected with *Fuschian functions* 'apparently with nothing in my previous thoughts having prepared me for it' (p. 550) – stepping onto a bus, crossing a street. Such experiences are by no means unfamiliar among mathematicians. Lorentz (1977) refers to the term *fulguratio*, 'lightning flash', 'emanation' employed by medieval theistic philosophers to denote 'the act of creation, thereby conveying the notion of a sudden intervention from above, from God' (p. 29). Leibniz (*Monadology, 47*) attributes the birth of the Monads to the continual fulgurations of the Deity, by which he appears to understand something similar on the part of the Divinity to Poincaré's assembling and ordering of the elements of his mathematical formulation: for Leibniz, the continual fulgurations of God are an on-going process of this kind, allowing the Monads of the actual world to unfold and develop their nature.

It is worth stressing the indefiniteness of goals because the reverse is commonly supposed: unless failure occurs, A's goal – final goal – is what W, more or less, realizes; and although alternative goal descriptions may be offered – such as a verbal description of a painting given by an artist – W still furnishes his *only* means for fully revealing the description's meaning. Thus a young child, asked to draw a man, may be satisfied with lines resembling a spider. One would look for reasons for this, connected with the child's repertoire of descriptors, with his 'understanding' of the instruction, and with the state of his perceptual and motor development. Klee's figures that sometimes resemble children's naturally call for quite different explanations, reflecting as they do the realization of different goals. Before the modern movement, painting in Western culture had frequently been deceptively clear in its objectives, which is why 'modern art' – which often deliberately sets out to destroy the subtleties that veil the goals WOAs express – provides many illustrations in which it is easier to see the operation of the processes that are our concern than do earlier works. What goals for instance are realized in Morgenstern's poem *Nightsong of the Fish,* a wordless composition consisting merely of prosodic markings? The theory so far developed appears to offer a richer source of understanding of matters like those mentioned above than approaches that ignore artistic purpose, such as for instance the information theoretic approach of Moles or the *Gestalt* psychological one of Arnheim (1967).

We must have imagination awakened by the uncertainty of being able to attain our object, to create a goal which hides our other goal from us . . .

There must be between us and the fish which, if we saw it for the first time cooked and served on the table, would not appear worth the endless trouble, craft and stratagem that are necessary if we are to catch it, interposed, during our afternoons

with the rod, the ripple to whose surface come wavering, without our quite knowing what we are intended to do with them, the burnished gleam of flesh, the indefiniteness of a form, in the fluidity of a transparent and glowing azure. (Proust, Vol. 4, p. 133).

The argument of 10.1, that every WOA is particular to the O that claims it is one – an assertion whose truth only the general agreement that occasionally occurs among groups of Os, the received taste of the time, or of a particular school or tradition, conceals – implies that to apprehend a WOA, *O must undertake a process similar to the creative process by which A produced the WOA in the first place.* Analogously, with the way we have portrayed A's creative process, we may picture O's role as audience. We envisage a state of disequilibrium induced in O by W, or more properly, by O's addressing himself to the task of a series of references back and forth between W-in-E and O's representation of E, $E^*(O)$ say. The disequilibrium vanishes when O has extracted order from W, which he can represent as a $W^*(O)$ that matches W. Two immediate consequences of this portrayal of A's audience are first that, if W is to cause O to enter a state similar to A's at the completion of W, then O and A must share similar kinds of structure; and more particularly, the variety of O's representation of E must be at least as great as A's. Osborne mentions Elliott (1972) among a number of theorists who have insisted that aesthetic apprehension of a great work must have 'full imaginative commitment to its evocative force'. Secondly, O may need, in addition to the indicators W provides, evidence such as W does not display of A's intention in producing W.

Various indications support such a view of O's role. Section 10.1 mentioned the 'artistic' role of the finder of 'found objects', or of the O who viewed some ethnological artefact as a WOA, even though its maker had never intended it as one. This argument may be taken further. For O must settle questions of A's intention generally. O is not passively manipulated by W, like a computer by a simple program. He assumes meta-roles, and reflects on his own reactions and the relation between A's goals and product, using evidence that is likely to come from a wide variety of sources besides any particular WOA that may be the subject of his attention at the time. O does not differ from A in any of this. Questions of A's intention in a WOA touch on problems of 'unconscious' intentions; multiplicity of interpretations – such as of Shakespeare's plays, especially in production, for example; how A's intention may be known if he has failed to express it in a WOA; how knowledge of A's intention from an external source might influence interpretation or judgement of a WOA by O; what the relation is between O and a WOA. Answers will come from the criteria and conventions governing the use in the judgement of WOAs of what is elsewhere referred to as knowledge of the problem; in our terms, through a study of the structures by which A may have been previously programmed (5.3), with the object, by means of this study, of gaining an understanding of the kinds of goal structures that A might have been trying – perhaps unsuccessfully – to realize by means of some given W. The problem of which knowledge is sought here includes the full contextual specifications of A's task. There is the context of 'art' itself: *Nightsong of a Fish* is a poem only because it is proclaimed to be one by inclusion in a poetry book; just as a heap of leaves or a pile of bricks becomes a 'sculpture' only when an art gallery exhibits it as one. There is the historical context, the particular tradition and development of which W forms a part, with which it may consciously associate itself by alluding to some specific aspect of the tradition – allusions whose force will be lost on an audience ignorant of their objects. There is A's biography and his development as an artist, his sketches, cartoons and first draughts, the critical evaluations of his work made both by himself, by critics and by the 'public at large'. And there are wider contexts known by names such as *'Zeitgeist'*, *'Weltanschauung'*, 'ethos', which may involve many aspects of the

world in which W is produced. All this and much more besides makes up O's evidence of A's intention. This is why, beyond A's intention, 'an artistic intention may be internally apparent in the work itself, although this intention may not correspond with any conscious or unconscious intention in the biography of the artist'. Nevertheless, 'it is possible to judge how far a work of art succeeds in realizing the intention implicit in it' (Osborne, p. 22).

So A may betray an emotion as well as express one, or generally endow a WOA with content, without being aware of it, simply because he has been 'programmed' with it. And O, by discovering A's programming, may uncover what the content is. *A acknowledges O's creative role. Nightsong of the Fish*, 'minimal' art, the simple act on A's part of placing W in a context associated with art — publishing *Nightsong of the Fish* in a book of poems, or exhibiting a plain black canvas or a pile of bricks in a picture gallery — may often be sufficient to embark O on his creative role. Osborne cites Cioffi: 'A conviction that a poet stands in a certain relation to his words conditions our response to them.' With this relation established, O may at once undertake his creative task. Notice how the theory of the mutual convergence of W^* and W is what enables us to assign O his creative role. The creative process of A and that of the independent O differ only in that O's carries the restriction — and it is a less important difference than is commonly supposed — requiring W to remain physically fixed; so that, the 'direction' of O's creative process is the reverse of A's, with O seeking a W^* to match W rather than the other way about. Thus Duchamp may present his 'ready-mades', or the Dadaists their picture painted by a brush tied to a donkey's tail, and Os will emerge to create WOAs out of them. And when they have done so, the full received critical apparatus will be at their disposal to reinforce their creative achievement with critical acclaim.

The critic, as a particular O, differs from the normal O of the audience in playing an additional, active role. He apprehends a W in a particular way, and then proceeds to try to induce the same apprehension in others; and, by drawing attention to particular properties and presenting particular kinds of descriptions of the W, to induce others to adopt them. His selection of properties and presentation of his description mimic A's own operations.

10.5 Progress in Art and Science

Presumably, it is the separate creative roles of A and each individual O that gives art a bad name with science (Chapter 2), though nothing assumed in arriving at this view makes it apply only to WOAs and not to other Ws. If there is a distinction to be mentioned here — Part III will deal with W in greater detail — it must be connected with the relative degrees of agreement between the judgements of different Os that Ws in science and Ws in art command. A scientific theory for instance, such as the Theory of Evolution, brings together into a connected whole a large body of knowledge, about which there may already have been a wide measure of agreement; a new theorem attaches to the axioms and inference rules within which it is proved and, unless some O disputes some notion with a very wide acceptance — such as the nature of proof itself for instance — there will be little ground for major differences between different Os' assessments of it. Clearly, the case of WOAs is different, though the differences are exaggerated for several reasons. First, it is true that a random collection of smudges on a canvas may be pronounced a WOA by some and dismissed as a random collection of smudges by others. But, in practice, discrepancies will generally be less

bizarre. For the rule of connectibility, which calls for rational structures, for each W to fit into some existing structure, applies to art too; and wide discrepancies of interpretation are unlikely to persist for very long, as each particular WOA or group of WOAs, is required, over a period of time, in common with scientific Ws, to connect to a wider and wider base. Secondly, the extent of agreement between Os in science may easily be over-estimated, if only because of the unifying power of sciences 'successful' concepts, which allows 'failures' to be neglected and quickly to vanish almost without trace. Thirdly, the explicit technicality of science successfully excludes from among its judges many of those whom ignorance of its problems properly disqualifies from that role; while art, lacking any comparable technical barrier, attracts judges with too little knowledge of art's problems to permit them meaningful assessments. In short, scientific Os are screened by the filter of science's technicality, while art must accept the disparate opinions of all comers.

It is probably of interest that although we have approached the problem quite differently from Collingwood (1963), the WOAs that AW will produce within our formulation satisfy all Collingwood's criteria for works of art, namely, (1) that art is not a means to an end — goals extraneous to a WOA detract from it (9.5). (2) in art there need be no distinction between planning and execution — W^* alters along with W; (3) following from (1) and (2), no reversal of order is possible from ends to means or execution to planning; (4) there is no distinction in art between raw material and finished product (cf. Moles's observation, 10.3). A *uses* the constraints of his medium to make W's production progress (9.6), and W^* moves therefore with the medium; (5) by (4), there is no distinction in art between form and matter as there is in craft, which is the product of design (9.6); (6) Art lacks the hierarchy that crafts show, each dictating ends to the one below it, and providing either means, or parts or raw materials to the one above (9.5).

PART III

Authorship's Products

Part II set out to discover what conditions were necessary for authorship and more particularly for constructing a machine that would be able to act as an author. What emerged defined a category, including entities of every description displaying the characteristics of intelligence, purposefulness, and imagination or creativeness (the ability to generate their own goals). Moreover, it appeared that, if the products of any entity of this character were to have meaning or significance for humans, the entity's intelligence and so forth would have to make sense of the world in the same kind of way as humans do. Showing this might alone be considered useful, because it makes explicit what is frequently overlooked or neglected or simply taken for granted in the theory of art – and elsewhere – namely, first, the close relationship between the various capacities that the production of art demands, and secondly, the limits that confine innovatory power. The latter conclusion appears of particular interest for art theory, which sometimes tends to endow such faculties as imagination and creativeness with powers transcending such mundane matters as natural laws. Nothing said so far, however, suggests in what way, if any, an art machine might *differ* from other machines for authorship. Part III sets out to deal with this question by concentrating on W, with the object of discovering differences distinguishing WOAs within the wider class. For knowing these differences will indicate differences between an art machine and the wider class of author machines, or more simply between artists and a wider category of 'producers'. As previously, the objective is to arrive at plausible and useful conditions – the use of plausibility as a criterion of truth is itself vindicated by Part II – in the least restrictive way that presents itself. We therefore proceed as before, from abstract considerations, without appealing to any particular state of affairs. The argument begins by exploring W's value for A. From here it proceeds, establishing descriptive dimensions for W, which it finally uses to arrive at a definition of WOA and specific suggestions for an art machine, followed by a brief assessment of the future of the project of constructing one.

11

Objective Knowledge

11.1 The Utility of *W*

Here, explicitly, begins a drawing together of art and science. The attitudes and arguments that Chapter 1 cites of mutual antagonism between the sciences and the humanities needs to be differently founded. Because *W* has been allowed such full generality, all that has been said of authorship is equally true whether its products are scientific or artistic. Section 4.1 noted similarities between scientific and artistic progress. Subsequently, 10.5 suggested, using similar arguments, likenesses between scientific and artistic 'justification' (cf. Reichenbach, 6.2). Here the uses of *W* are explored. Distinguishing features of scientific and artistic *W*s are seen to be less sharply defined than they are usually represented to be. Objectivity and explicitness and their opposites are not dichotomous features but the poles of continua, or more properly of continuous mixes. Effectiveness depends upon knowledge of it. Conjectures and refutations will have unconscious as well as conscious elements. Objections to literature (Chapter 2), expressed from Francis Bacon to I.A. Richards and P.B. Medawar, that though it is required to be internally consistent it is not expected to be empirically true, might apply equally to an axiomatic system. But a correspondence would be looked for between the latter kind of system and the real world which, if it were discovered, might provide the basis for an empirical theory; allowing the theory, if the correspondence were 'close', to extend the notion of reality beyond the realm of experience, as for example in the case of modern physics. Yet no reason is immediately apparent why an internally consistent piece of literature or other work should not be put into a similar kind of correspondence with reality, though art might prove more suitable as a model of a somewhat different 'aspect' of reality from that for which we should use an axiomatic system, an aspect that does not lead itself to the straightforward verification procedures of 'theoretical' statements — *WOA*s — that may be made about it, and in this differs from the aspect that is science's concern. The different aspects of reality that the axiomatic system and the work of art might be used to model could, for example, be those corresponding to the two parts of the bi-partite structure of the heuristic that Minsky mentions (2.3). In other respects the

conclusions of this chapter suggest no reason in principle, on grounds of explicitness, objectivity or effectiveness, for denying artistic Ws equal status with scientific ones.

The task Part II set itself was to determine the principles of authorship, which were defined in terms of a productive process AW. Preconceptions as to the kind of thing W might be were deliberately avoided. W was explicitly allowed to take the form, either of a performance or an object, as long as it left some trace — possibly only fleeting — in its surrounding, observable by some observer O. The reasons for insisting on such an unrestricted W will emerge more clearly in this chapter. Although concern has been mainly confined to artificial systems, it is obviously the case that the only actual producers, where the term in the sense that we use it connotes any acceptable degree of richness, are natural systems. Similarly, although purposeful activity of all kinds has been discussed, interest has been particularly in those purposeful performances that result in fairly permanent Ws. Ws that are in some sense objects, especially where these are of no obviously immediate utility. We are naturally led to ask why such Ws should be produced and what part they may play in furthering the — higher level — goals of the As that may produce them. This chapter enquires into the nature of Ws of this and other kinds and examines what use they may be to A.

We begin by noting the characteristics of a W that satisfies Popper's requirements for 'objective knowledge'. Objective knowledge is not necessarily explicit nor does explicitness assure objectivity: empirical systems can never be fully explicit. Effective procedures are examined. If these are to be objective the observer must have a view of the whole procedure, not merely its step-by-step execution. Conscious and unconscious criticism are compared. Both conjectures and refutations by natural systems are likely to include unconscious elements; what differs between the two kinds of criticism is not so much A's procedure, as the Ws involved. Conjecture and refutation call for objectivity, but this may be conscious or unconscious. In either case A must have the structure of an author. The notion of 'unconscious' processes vanishes if we provide A with a stratified object language.

11.2 W as Objective Knowledge

Recapitulating, it has so far been concluded that an art machine must be an author, in particular a c-author, for which, we have said, it needs to be purposeful and in particular able to generate its own purposes. For this to be possible, it was shown to be necessary for the machine to possess an order-extracting capacity and a reflexive structure, to control its production. Furnished with these capabilities, a machine might produce Ws. Such Ws in the machine's, A's say, intention, would be partial self-reproductions of A in A's world E; in realization, they would be subject to constraints due to the structure of E —

including the effector system A used in their execution – and the characteristics of A's control of E. The relationship of A to W was shown (10.3) to be partly that of observer to object, where an object in this case is a distinguishable part of E, namely W. An immediate question is, what will be the general nature of the Ws A produces.

As a first approximation, because our earlier conclusions suggest its possible suitability, we might characterize W as what Popper (1972) calls 'objective knowledge'. The idea is plausible because W is 'objective' relative to A, enjoying as it does a separate existence in E, where A may observe it. What are the characteristics of objective knowledge?

> Only objective knowledge is criticizable: subjective knowledge becomes criticizable only when it becomes objective. And it becomes objective when we *say* what we think; and even more so when we *write* it down, or *print* it (p. 25).

This description conceals certain difficulties. In the first place, unless we place severe restrictions on the meaning of Popper's phrase 'what we think', we shall be forced to allow objective status to any W that an A may produce. This is first because, as was mentioned, W is certainly objective *vis-a-vis* the entity that produced it, being an entity distinct from its producer; and secondly because, as a product of order-extraction work – A's either by acquisition or 'programming' – it qualifies as the objective part of 'what we think', where 'we' refers to the producer, 'what' to W and 'think' to the process of authorship or c-authorship. In the second place, there is a difficulty over the notion of the possibility of *degrees* of objectivity that Popper's statement implies, writing down what we think being in some sense more objective than saying it (cf. 10.2). It is not immediately obvious whether, in Popper's terms, it is necessary to say 'out loud' what we think, rather than say it 'to ourselves'. But, as all these implications may probably be taken to refer to practice rather than principle, we conclude, on the face of it at any rate, that there appears no reason in principle why an idea said out loud should be more objective than one said to oneself, given that both ideas are held with the same clarity. Presumably, it is precisely the clarity that the practical expedients of print and speech are supposed to assist.

11.3 Objectivity and Explicitness

In addition to differing in objectivity, what we think – the more so if it is not said out loud but only to ourselves – may vary in explicitness, from the degree of explicitness associated with formal systems, to what may be almost wholly inexplicit, such as the kind of heuristic model we may have of the world (cf. 2.3). And even though such models might be regarded – following Popper (p. 172 and elsewhere) – as conjectures about the world that are subject to refutation, this

in itself would not be enough to ensure their explicitness, or even to make us fully 'aware' of them, since many such models, although they are 'used', are never even consciously adopted, let alone made explicit. Explicitness does not imply objectivity, nor does objectivity necessarily lead to explicitness. In saying what we think, our statements may still carry implications that are quite likely to receive subjective interpretations until they are made explicit. For example, though the axioms and inference rules of a formal theory imply all the true theorems of the theory, this alone does not enable us to write down the theorems. Barring subjective intuitions, we should not know what they were until they had been explicitly proved; nor is the end tape generated from a given starting tape by a given Turing machine any more than implicit or immanent in the starting tape and the Turing machine, until the mechanical procedures of generating it have been completed. 'Arithmetical propositions are . . . always synthetical of which we may become more clearly convinced by trying large numbers.' (Kant, 1934, p. 33; cf. Turing 9.3.) The explicitness of the formal theory or the starting tape of the Turing machine lies in the furnishing of a procedure which, if mechanically followed, will lead to a particular result, though the result itself will be synthetic and may not be reached 'by mere analysis of our conceptions' (ibid. p. 33). Saying what we think does not in itself necessarily make our thoughts explicit. It is a practical expedient that facilitates aligning the thoughts with the real world to which they refer, helping us to test them against this reality. But the testing itself will not necessarily make the thoughts any more explicit for whoever entertains them explicitly in the first place.

In actuality, explicitness may seldom be taken as an absolute. Like objectivity, what we think will probably possess it in varying 'degrees'. In general, implications will unavoidably underlie most explicit statements (Löfgren's unexplained explanans (4.4)). Only in a closed, formal system might one be certain of making all implications − the synthetic propositions immanent in the system's axioms and inference rules − explicit, and this only in systems in which it were possible to prove completeness. In complex, 'open', empirical systems, each new explicit statement is likely, in varying degrees, to give rise to new implications. Nearly all empirical propositions contain a mixture of explicit and implicit elements. (The following chapter develops this view further.) As an example, we think of a partially-ordered system − a hierarchy or some kind of network, say − representing a domain of possible propositions. Certain nodes − representing concepts say − are explicitly identified, thereby implying the identification of certain other nodes, namely those that lie on the various 'paths' that lead to the explicitly-identified nodes. The possibility of alternative paths interprets the notion of subjectiveness. For, if A and B use respectively paths a and b to get to the same concept (node) W, they will each identify different sets of (implied) nodes on the way. So W will imply different things for A and B. (The operation of PLANNER-type procedures provides a concrete example; for two PLANNER

procedures with different 'experience' might appeal to different back-up theorems in executing a goal.) In general in an open system, each new explicit idea will carry new implications, unless there is only one way that the idea may be inferred.

Summarizing these arguments, we should say that (1) every *W* is objective, in the sense that it is distinct from its producer *A*. Thus *A* is like Einstein in Popper's (1972) formulation:

> ... the main difference between Einstein and an amoeba ... is that Einstein *consciously seeks for error elimination*. He tries to kill his theories: he is *consciously critical* of his theories which, for this reason, he tries to *formulate* sharply rather than vaguely. But the amoeba cannot be critical *vis-a-vis* its expectations or hypotheses; it cannot be critical because it cannot *face* its hypotheses: they are of it (p. 25).

A can certainly *'face'* *W*. (2) Objectivity, in the sense merely of something said or written down, is neither a necessary nor a sufficient condition for explicitness; and (3) while full explicitness may be possible, in general in empirical systems many explicit 'ideas' are likely to contain implications which, when made explicit, will contain further implications, and so on, in an explosively divergent way. Thus all *W*s will be objective in the sense of (1), and in general will vary as to their degrees of explicitness. What distinguishes Einstein from the amoeba is his capacity for authorship, the ability to produce *W*s. In the terms of the previous chapter, what the amoeba lacks is a world model distinct from its own overall structure. But the differences are not absolute. The two characters of Popper's distinction are no more than two markers on a continuum that might be traced from the explicit, complete, consistent, formal theory on the one hand, to the functioning of the amoeba, or of a much simpler entity such as the machine of Fogel and others (4.8), on the other. Einstein's reflective capacities, his ability to 'face' his hypotheses, are due to — and demand — a structure of the kind represented in Figure 10.4.1, and shown to embody certain minimal necessary requirements for authorship.

11.4 *W* and Effective Procedures

Apart from these questions of principle there are practical questions already mentioned concerning the heuristic value of objectifying a theory and the reasons why what is written down is somehow more objective than what is simply said or thought. In part, the practical advantages of objectifying knowledge concern the peculiarities of the working of the human machinery and therefore fall broadly within the domain of psychology. To a large extent these advantages are the rewards that Descartes looked for in his 'Method':

> ... never to accept anything for true which I did not clearly know to be such; ... to divide each of the difficulties under examination into as many parts as possible, and as

might be necessary for its adequate solution ... to conduct my thoughts in such an order that, by commencing with objects the simplest and easiest to know, I might ascend little by little, and, as it were, step by step, to the knowledge of the more complex; ... in every case to make enumerations so complete, and reviews so general, that I might be assured that nothing was omitted. *A Discourse on Method*

A procedure that satisfied these rules might provide an adequate starting formulation for a definition of a formal system. But, as 10.7 noted, nothing in principle demands that we literally say out loud or write down what we wish to objectify, nor *a fortiori* that some non-human entity do so. All that is needed is for the entity in question to have a structure of the kind suggested in 10.3, namely one that allows the separation of two distinct functions, those respectively of producer and observer of what is produced. But notice that it is more than a quirk of the machinery of human psychology, the human mind, that the observer's function is facilitated by the heuristic aid of paper and pencil. Rather the reason is inherent in the structure of any entity that utilizes a model of its surrounding. For A's model E^* of its environment E shares only such features as A may need it to. Isomorphism between E^* and E would be impossible, if only because of the huge differences in the varieties of the domains in which the two structures occur. In effect E^* corresponds to some 'aspect' of E that has relevance for A. On this account, lacking E's constraints, E^* may be manipulated by A in ways that E may not, with each manipulation altering E^*'s structure and thereby degrading its correspondence to E. Given A's capacities, the use of paper and pencil combined with a method of the kind outlined by Descartes, opens the way to developing an effective procedure. Because of the structure of the entity that will use it, such a procedure may be taken to fulfil the necessary and sufficient requirements for objectivity, and not merely to act as an aid towards attaining it.

An effective procedure is explicit at each step. This is the criterion of its effectiveness. But it is objective, in Popper's sense, only for an *observer* able to *compare* it with something else. Step-by-step the inputs and outputs of a machine do not even tell O whether or not the machine is determinate. To find this out, O must be able to remember inputs and outputs as they occur, in order to build up a model that he may then test. If O is able to use the machine's procedure to objectify knowledge he has, he will have to do so in this overall, rather than any step-by-step sense. Thus a given Turing machine's output is fully determined by the machine's characteristics and its starting tape, though the machine has no objective knowledge of either. Like Popper's amoeba, its actions are part of it. But the machine's observer does have objective knowledge, because he can compare the Turing machine and its starting tape with its output. It follows from this that no essential difference distinguishes the knowledge of the Turing machine that its programmer has from the knowledge that the O has who understands its operation. Both need to know the machine's overall behaviour.

Von Foerster (1972) observes that the scientific method 'rests on two fundamental pillars'. These are (1) the 'principle of the conservation of rules' according to which rules observed in the past shall apply to the future; and (2) the 'principle of necessary and sufficient use', a variant of Occam's razor, which requires that 'almost everything in the universe shall be irrelevant'. Of interest here is that 'relevance is a triadic relation' (p. 86), which relates two sets of properties and the mind of whoever wishes to establish the relation; in our present terms for instance, the set of properties represented by the Turing machine's starting tape, that represented by its end tape and the O or programmer of the machine. In the terms of Chapter 6, the observer must acquire the order that the machine's program represents, so that it can 'understand' the machine, while the programmer must have this order in advance.

In general, an effective procedure need not in principle be sequential, though in practice the human observer will probably require any parallel process to be reduced to a sequential process in order to be able to check it step by step for effectiveness; that is to say, to check its determinacy and to be sure that at every step a procedure exists for deciding what the next step must be. This practical requirement is no more than an heuristic, offering benefits of the same kind as saying what we think. But suppose a parallel process were reduced to sequential form by means of an effective procedure, checked for effectiveness and then restored to its parallel form by another effective procedure; or suppose more simply that a sequential effective procedure were operated too quickly to allow for step-by-step checking of its operation by an observer, then no observer could have objective knowledge of the process-in-operation, although this would in no way alter the way the operation occurred. Clearly, if an observer O_1 had checked that a procedure P was effective, an observer O_2, who had been unable to check it, might merely, seeing it in operation (comparing input with output, say) suppose it to be quite haphazard; suppose, in fact, he was witnessing a nondeterminate process. Even O_1 would have no way of being sure that P operated in the same way when it was running at high and low (checkable) speed, although in the former case he might devise *tests* to provide *evidence* about the way it was operating. Thus, though an effective procedure may operate without being observed, if it is to provide O with objective knowledge, O must be satisfied that it is effective. The degree of O's satisfaction will be determined by the extent or weightiness of the evidence to this effect he is able to assemble, and may be taken to correspond to the degree of objectivity of O's knowledge. In the limiting case O will have to be able to check the procedure at every step, and in doing this he may be aided, if he is human, by recording his findings by means of paper and pencil. The procedure has no value as objective knowledge, except to an O who has satisfied himself of its effectiveness by checking it.

11.5 Unconscious Processes

The argument so far implies that objective knowledge is a property of some particular O who is an observer by virtue of being distinguishable from the knowledge: he can write down the knowledge as a formal theory expressed as an effective procedure for example, and is thereby enabled to 'face' it in a 'consciously critical' way. But this image may be misleading. For, if instead of picturing Einstein seated at his desk with a pencil in his hand, writing on a page already partially covered with signs, we imagine successively a tennis player practising his forearm, a pianist his scales, a child learning to walk, an earthworm making an appropriate turn in a T-maze, the notion of an O *facing* his theory grows steadily weaker. The tennis player may make 'conscious' corrections to his strokes, telling himself to stiffen his wrist or follow through and, if his shots improve, this may be partly due to his conscious analysis. But part at least of any improvement is likely to be due simply to 'practice', the word psychologists use to describe situations in which, typically, numbers of repetitions of some action lead to a gradual 'improvement', usually some kind of assymptotic approach to a performance goal – activity resembling the amoeba's more than Einstein's. Traditionally, psychology has viewed such 'practice effects' as the result of gradual strengthening of those components of action that mediate closer approach to the goal, and weakening of those components with the reverse effect. But even without adopting this traditional view, we shall still find that we are left with processes similar to the consciously critical ones Einstein uses, only 'unconscious'. For instance Minsky and Papert (1972) take the view that 'The external appearance of slow improvement . . . is an illusion due to our lack of discernment. Even practising scales, we would conjecture, involves distinct changes in one's strategies or plans for linking the many motor acts to already existing sequential process-schema in different ways, or altering the internal structures of those schemas'. 'Improvement' results from 'definite . . . moments of conscious or unconscious analysis' that will include conjectures and 'structural experiments'. 'Thoughtless' trials are essentially wasted. The authors compare the process to debugging a computer program. 'It is not a matter of strengthening components already weakly present so much as proposing and testing new ones' (paragraph 4.3). If this is true of practising scales, it is presumably as true of the child learning to walk, with the possible difference that the child may turn more to unconscious analysis than the musician – though on the face of it there appear no obvious reasons even for this. For the scientist, who Popper says advances his theory by series of conjectures or guesses, and refutations, it seems likely that the refutations may result from his 'consciously critical' attitude, but that the conjectures are more likely to arise, at least in part, 'intuitively', due to unconscious processes, however deeply these may be embedded in the appropriate structures that are part of the existing

apparatus at the command of the scientist's thinking.

But it is for being 'criticizable' that Popper commends objective knowledge. Its objectivity is what facilitates the consciously critical method of one who seeks to 'kill' his theories. Refutation is what objectivity permits. But it appears that even refutations may come about through 'unconscious' processes. The child that improves its walking – even if it does so in the way Minsky and Papert suggest, *thoughtfully* – is probably satisfied with the improvement until new inadequacies appear *by chance.* The scientist, on the other hand, who improves his theory, sets out to find its inadequacies *by design.* But even this difference is not as sharp as the way it is stated may make it seem; the child learning to walk will probably go in for at least some more or less conscious experimentation in which it tries out 'ideas' (conjectures) for new techniques in new situations; and the scientist is often likely to miss obstacles to his theory until he stubs his toe against them by chance. Furthermore, the conscious criticism that the scientist directs at his guesses is likely to rely to some extent on guesses itself.

Criticizing need not be conscious, and 'unconscious' criticism does not call for objectified knowledge. The foregoing argument suggests that Popper's assertion (11.2) should be understood to mean that only objective knowledge is *consciously* criticizable. This interpretation neither appears nor aims to violate the spirit of Popper's view, which might be paraphrased as a recommendation that *knowledge should be put where it can be got at,* that is to say, where it is both accessible and assailable. Objectivity confers the practical advantage of fixing ideas so that they may be tested – 'What you put down stays there', David Hockney observes (during an interview on *Omnibus,* BBC Television, 7 May 1975) – which as the previous section showed, is a facility indispensable to any entity capable of objectifying what it knows. Our object has been to show that, despite its advantages, objectivity should not be supposed the only way through which knowledge may be advanced. Conscious criticism demands objectivity, but unconscious criticism is also possible, and does not. It is to avoid such confusion that Pask (1975) introduces a stratified object language into the theoretical structure of his conversational and tutorial models. Thus instruction may occur by means of the higher level, tutorial language (English) called the L^1 language or by means of a lower level language, L^0, which is a performance or 'task' language. The stratification offers an escape from the need for undesirable concepts, like notions of unconscious processes, to explain practice effects. This in turn permits the assumption that the objectivity of performance – at tennis say – is no less for those processes governing it, than the objectivity of a theory for the process that produces it. Essential to both kinds of process is a structure that permits the process's controller to separate itself in the manner depicted in Figure 10.3.1, from the models – of the world and itself – that it utilizes for producing the Ws that represent its 'knowledge'. Interpretation of Popper's assertion to mean that objective knowledge should be consciously criticizable

implies, in these terms, a preference for the higher level object language. But such a preference must be based, not on any claim for the greater objectivity of the higher level language compared to the lower, but to its wider applicability, which greatly enhances its capacity for representing order. Thus *W*s that are tennis strokes will not easily connect with *W*s that are piano-playing techniques, as long as both *W*s exist at a performance level only; whereas a higher level representation may reveal connexions (cf. 4.4) between them. Among the concerns of the following chapter will be the question of the language level of *WOA*s.

12

Experience

12.1 Subjects and Goals in Art and Science

Chapter 11 explored some of the general properties of *W*, especially in regard to their possible usefulness to *A*. Here we look for descriptive dimensions such as will allow us to distinguish *W*s of different kinds. We argue that art's distinguishing characteristic is that its *W*s are intentionally closely linked to experience, in contrast particularly to science, whose *W*s are made deliberately to avoid such connexions. Experience is individual, particular, unrepeatable and untranslatable; it is the world of the senses and the emotions, of memory, imagination and the inner life of the mind. The language of experience is a performance language (11.6). Art is its simulation. Chapter 1 cited views that assigned art the status of a kind of second best to science. Here we contend that the goals of art and science – the subject matters or, more properly, what each comes to convey of the same subject matter – cluster at the extremes of the continuum that joins respectively the concrete and particular at one end to the abstract and general at the other, with less easily classified works occupying the space between; and (as the following chapter will show) with art and science each dictating its own mode of approach to the common subject. Here is the origin of much confusion and often of contradition in the views and attitudes about these two realms; from the point of view of subject matter, especially with the development of psychology and the social sciences, it has become increasingly difficult to deny science and art common interests; while, seen from the outlook of methodology, science and art have appeared – literally, in our terms – poles apart. Art's concern is experience; not its analysis but its reproduction. If play and exploration are the route to performance concepts in a performance language, art is their objectification and extension.

The chapter takes the problem of 'individuation' as its starting point, using a formulation of the problem, due to Russell (1948), that depends upon the concept of 'compresence'. This formulation is interpreted in terms of a machine with input, which is then used to define experience. Experience is shown to be particular and subjective. The formulation permits some comments on objectivity and subjectivity. Problems of derivation and the description of experiences are

considered with a view to arriving at a notion of the dimensions of the concept of experience. There is discussion of the characteristics of modelled experience. The chapter ends by characterizing art in terms of the reproduction and production of experience.

12.2 Compresence

We shall base our definition of experience on a formulation that Russell uses in dealing with the problem of 'particulars'. Russell's formulation depends upon a notion that he calls 'compresence'.

> There is a relation, which I call 'compresence', which holds between two or more qualities when one person experiences them simultaneously – for example, between high C and vermilion when you hear one and see the other (p. 312).

We can form groups of qualities into single complex wholes each of which has the two properties that '(a) all members of the group are compresent; (b) given anything not a member of the group, there is at least one member of the group with which it is not compresent'. Giving its constituents defines such a complex whole but it is itself 'a unit not a class'. Its existence derives, not from its constituents' existence, but from their compresent existence in a single structure. When such a structure comprises 'mental constituents', Russell calls it a 'total momentary experience' (p. 315), what in other contexts has been called a *Gestalt*, or, in Pound's terms, an Image: 'that which presents an intellectual and emotional complex in an instant of time', (Eliot, 1954, p. 4) 'real because we know it directly' (Pound, 1960, p. 86).

In reality a 'moment' has finite duration. Empirically, with humans for instance, there is a lower limit to the time intervals between which human subjects can discriminate, the length of time for which a musical tone is sounded for example. Moles calls this time 'the length of the present' (p. 15).

The items of the complex may themselves occur frequently and 'are not essentially dated' (p. 312), while the complexes, consisting as they do of many components that depend upon the spatio-temporal position of an observer, are empirically highly likely to be spatio-temporally unique and therefore time-ordered, in the sense of being non-recurrent; though repetition of a complete complex of compresence cannot be excluded simply on logical grounds.

Notice though that, although a 'total momentary experience' is almost certainly unique, nevertheless we may know and name a complete complex of compresence without having to know all its constituent qualities, in the sense that we may know (identify) a man by those of his qualities his passport

enumerates, without the need to know anything else about him. Moles calls such identifying qualities 'symbols'. A complex signal E, consisting of the set of 'simultaneous' elements $\{E_i\}$ that separately create 'elementary perceptions' $\{P_i\}$ acquires a *mnemonic symbolization* when some 'well-chosen' element of E is sufficient to provoke the set P of elementary perceptions. Moles calls the well-chosen element the 'symbol of the set ΣE_i' (p. 98). (cf. the observations of Bruner and others, 8.2).

In the physical world, a 'complex of compresence' is constructed on the same principles as those employed in dealing with momentary experiences, merely by supposing an absence of percipients. Events may be defined in terms of 'incomplete' complexes, where an incomplete complex receives a topological definition in terms of a region of space-time. Thus an incomplete complex occupies a continuous region in space-time, if a continuous route (consisting entirely of points of the region of which the complex is part) connects any two space-time points of the complex. 'Such a complex may be called an "event". It has the property of non-recurrence but not that of occupying only one space-time point.' (Russell p. 322).

The distinction between a unit and a class parallels the distinction between a quality and an 'instance' of a quality. The latter 'is a complex of compresent qualities of which the quality in question is one' (ibid. p. 316). Clearly, there can be any number of different instances of the *same* quality. But notice that instances of qualities are time-ordered, though the qualities themselves are not. Indeed, it is wrong to speak of two occurrences of the same quality, since, being the same, they are indistinguishable and can therefore only be counted as one. 'When the same shade of colour exists in two places at once, it is one, not two' (p. 316). The distinguishing characteristic of a complex of compresence depends upon its separability from other complexes, and in particular on its time-orderedness. Statements about purely logical structures such as classes reduce to statements about their components, which is not possible in the case of time order.

12.3 State Descriptions

Russell's formulation may be interpreted in terms of state descriptions. Suppose we take a complete complex of compresence to correspond to the state description of a system at a given instant. Such a state description might be represented as a vector whose elements represent the 'qualities' compresent in the particular complex. A compresence composed of 'mental constituents' is termed by Russell a 'total momentary experience'. Such an 'experience' might be represented in the same way as any other complex of compresence. Russell indicates that a mental compresence is to be regarded as the result of a physical one. A

mental compresence occurs in a 'percipient' who may be 'aware' or not of certain 'qualities', like redness for example, which are constituents of a physical complex. In our terms we might picture two systems, or more precisely a single system partitioned into two sub-systems, representing respectively the percipient and his world. Interconnexions between these two sub-systems permit the percipient to receive inputs from his world, which depend on the world's state. In this way the percipient's states come to correspond to correlative states of the world, and these states of the percipient's are called his experience. The states will themselves depend upon the internal state of the percipient at the time of receiving them as inputs. But this raises no difficulty because the percipient's internal mental states are simply correlates of his physical state, which is to say, included in the state description of the total system. The percipient's mental states depend upon his 'awareness', which in turn is related to the interconnexions between the sub-systems that the percipient and his world represent. For this reason 'We can never know that a given complex of compresence is complete, since there may always be something else, of which we are not aware, which is compresent with every part of the given complex.' (Russell, p. 232.) (cf. the views of Popper and Lofgren cited 4.3; also Pask and Scott (1973), who identify mental states with the Cartesian product of inputs and outputs of the entity in which the states subsist.)

More formally, if the percipient has internal states S, and input states I, then the product state, $I \times S$, will be mapped into S under some mapping f say, that depends upon the percipient's characteristics, what Ashby (1962) calls the 'dynamic drive of the system'. The mapping will correspond to the percipient's experience of I. In this formulation, the state description of I may be taken to be the physical complex of compresence and that of S its 'mental constituents'. Referring this formulation back to Russell's, we notice that if we remove the state description of S, we still are left with the state description of I. Presumably, in the absence of a percipient, the physical complex of compresence would consist of the state description of I alone; and conversely, that the percipient's experience at a given instant is defined by the state description, at that instant, of S alone, irrespective of I. (Notice that this accords with common usage that attributes experience to inanimate systems, so that one may make statements for example about 'the world's experience of men'.) Events are definable in these terms as groups of transformations of vectors, and the *experience of an event*, consonantly with this definition and the definition of experience. The order of the vectors that occur will be finite, though high enough to make recurrence of any particular set of values exceedingly unlikely, thereby satisfying the require-ment of particularity. In nearly all cases of experience, most of the variables that define a space-time point-instant will be unknown; and in practice a tiny proportion of the variables of a given vector will often be sufficient to distinguish the vector uniquely (in a non-recurring way). (cf. Moles's formulation, 12.2.)

The 'qualities' of Russell's formulation are to be associated with the values of the individual variables that comprize the vectors.

12.4 Experience

The concept of compresence and our interpretation of it should not lead us to visualize a dichotomy, consisting of 'particulars' on one side and 'purely logical structures' on the other, no more in the world of experience than in the physical world. Complexes of compresence are not necessarily complete. Events are examples of incomplete complexes of a special kind, and, as observed in the previous section, it can never be known whether a complex is complete because we may be unaware of part of it. Particulars and classes may therefore be regarded as the extremes of a continuum, between which occur events and other incomplete complexes of varying particularity. The more incomplete a complex, the less its particularity and thus the greater the empirical likelihood of its recurrence (where a complex that recurs is such that, given a complex and its recurrence, we should be unable to say which had occurred at the earlier and which the later date). Corresponding to this view, we visualize a 'continuum' of vectors defining states that vary in generality inversely with the vector's order, from the completely general, single variable at one extreme, to the high order vector with all its variables defined and known at the other.

The greater the degree of particularity, in the sense understood, the more subjective the experience of it. The space-time point-instant is the total momentary experience of a single observer at a single instant. Conversely, the experience of a quality, such as redness say, is not subjective or private, but might, theoretically at any rate, be experienced by any number of observers. Only *instances* of qualities are subjective; that is to say, qualities taken as components of complexes of compresence. Extending this argument, it follows that there will be *degrees* of subjectivity, which will vary in proportion to the size of the complexes of compresence, or the order of the vectors by which they are represented. In general, experiences will be complexes sufficiently large to make the same experience for two observers highly unlikely. We should say that almost all experience is necessarily wholly subjective, in the sense of being *unique to a particular system.* While conversely, experience that can be 'shared' by any number of observers — a quality say — is wholly objective. This formulation clarifies one of the difficulties of objective knowledge encountered in the previous chapter, namely that objective knowledge was likely to have a subjective and non-explicit content. This difficulty results from a failure to distinguish fully the difference between a quality and the instance of it, which is what is experienced. It is the problem of the observer that will be met in the following section, that of 'knowledge by acquaintance and knowledge by description'.

The conclusion of the present argument is that Russell expresses (cited in 3.4): '. . . everything except myself is . . . only known to me by description, not by acquaintance. And the description has to be in terms of my own experience.' The ability to distinguish qualities at all from instances owes to the power to abstract, as psychologists sometimes call it. In our terms we may think of abstractions as logical *relations* between complexes of compresence that define instances of the same quality. Thus the join of a number of instances of red may contain only the single element red, which we should call the abstracted quality, redness.

As defined, the experience of an individual is his internal state at a given instant. It follows that it will be impossible for him ever to compare directly his own experiences one with another, or with the experiences of another individual. Such comparisons would require changes in his state that would obliterate the experience he wished to compare. Yet the recognition of similarities between experiences is itself a common part of experience, different from either of the experiences being compared. Since it is impossible to compare experiences, however, apparent similarities between experiences are in reality similarities between some kind of representation of them. Two experiences, each represented by a vector, could be compared in this represented form by comparing the vectors by means of some kind of mapping of one onto the other. If the vectors were both of a high order, the likelihood of discovering a morphism or 'fuzzy' (9.3) similarity between them would presumably be lower than if they were of a lower order. So the fact that similarities between the representations of experience do occur suggests that the representations used are of a simplified kind and possibly acquire a degree of uniformity from the way they are arrived at. For two apparently similar experiences, the individual values of the elements of their constituent internal states — the values of the individual elements of the vectors defining the experiences — may be 'fuzzily' equal or homomorphic, because both occur as the result of similar physical complexes. A visual scene viewed by two observers would furnish experiences to each that shared numbers of identical components as well as numbers that differed by a negligible or unimportant — in the context — amount. Or apparent similarities might be due to the effects of the internal states of the individuals or systems concerned in determining the experiences compared: *for it is not the experiences that are compared but descriptions of them.*

12.5 The Description of Experience

Dewey (1934) distinguishes between experience and *an* experience, 'with its own individualizing quality and self-sufficiency' (p. 35). The *concept* 'experience' derives from descriptions of experience, of which it is itself a description. The definitions we have suggested give an indication as to how descriptions of

experience might come about. In humans this is a matter for psychology, though broader, more abstract questions concerning description are, as Part II indicated, of wide generality. To describe his experience an individual must observe it. Now, by definition, experience is subjective. Observation by contrast is not, at least not in the same degree. For although an observer registers an observation as a change in his internal state brought about by what he observes, it is not the observer's internal state itself, but what it *refers to* — the state of the observed system that is of interest. And the observer who aims at objectivity is normally able to adopt expedients to minimize the effects of his own internal states upon his observations and to maximize those of the system he is observing. In the case of experience, however, it is the internal state of the system having the experience that is of primary interest, with any system to whose state it refers of secondary importance only.

Ignoring for the moment difficulties of comparing the internal states of different systems, the above arguments will allow certain observations concerning subjectivity. In particular, earlier discussions (Chapter 8) about perceptrons and procedures such as those of Guzman, Winston, and Winograd have indicated some of the kinds of processing that the data of a complex may undergo. Perceptrons, for example, weight the 'evidence' supplied as the data of their inputs by the component of a complex, and arrive at a *decision* — expressed by 'naming' the complex — on the basis of this weighted evidence. Guzman's and Winston's procedures also utilize input data as evidence to which varying weights attach. Their procedures operate on already-structured data. They depend upon complexes consisting of relatively small numbers of components, with the 'other', in this case purely notional components — such as those that would accompany a human *experience* of Guzman's or Winston's blocks, for example — assigned a zero weighting by the outside agency of the designer of the procedure.

As noted in 8.3 this, as well as the descriptions with which the procedures are provided, represents the greatest part of the order-extraction work associated with the success of these procedures. It is precisely the extent of this work that defeats the perceptron required to build up its own weights from a starting position in which every component of its 'experience' has equal weight. (And notice that even here a perceptron's experience rests upon only a tiny fraction of the number of components that make up the experience of the experimenter, say.) The experiences that such procedures represent have clearly been drastically attenuated — probably by an amount proportional to the ratio of the order-extraction work programmed into the procedure by its designer, compared to the total amount of order-extraction work that the procedure performs.

Clearly, Russell's formulation was never intended as a practical guide for the observer, to show him how he might describe the abstract concept of experience — rather than individual experiences, from which the concept initially derives — so as to capture its quality in a way he might find intuitively familiar. But

procedures such as Guzman's should not be taken too literally either, as providing descriptive models. A virtue of Russell's argument is that it emphasizes the transitory nature of experience, while in procedures such as Winston's or Winograd's, or more especially procedures such as those used by perceptrons, experience tends to become associated with fixed descriptions. What is lost in such fixed, 'ended-off' processes is precisely the quality of on-goingness or changefulness, the transitoriness, and, associated with it, what is described by words like subtlety and nuance, which, to our intuitive conceptions, characterize the very fibre of experience. It is mistaken to suppose that, simply because 'awareness' encompasses only a tiny fraction of the components to which it has access it follows that experience, stripped of these 'unimportant' components, would necessarily retain the quality of the *notion* of experience familiar to us; remain recognizably the same thing that the word 'experience' commonly denotes. What it would be like to *experience* the stripped world of Winograd's 'robot' is literally inconceivable to the human mind. Moreover, awareness is not dichotomous, it varies in degrees. Changes in components of a complex of compresence that were not part of awareness may make them part of it. It is the case too that an experience can exist at varying 'levels' of completeness — number of components of a complex of compresence in awareness — and in a way which may make it seem that the levels represented separate experiences, following one another perhaps in rapidly changing sequence. The experience an individual describes, the one he uses as the basis for some deduction, the one to which he gives a name and the one that reminds him of some other experience, may all consist of components due to the same physical complex, though each represented in 'experience' in different combinations and strengths. It is by no means obvious what descriptions might be used to characterize the *concept* of experience in a way that would make it as recognizable as the lines and vertices used by Guzman's SEE program make the shapes of its world — the more so because experience is ever-present and on-going: to be aware or conscious is to be experiencing; to cease experiencing is to be unconscious, unaware.

Compresence appears able to furnish the attributes that a description of experience requires. The concept captures at once the qualities both of simultaneity and time-orderedness, which introspective awareness distinguishes as characteristics of the abstraction 'experience'. And it is also able to describe other characteristics of experience. Thus the experience that the observer may describe or the experience that has some utility for him beyond itself and which he therefore strips of what, for his purpose at the time, are its inessential components, has less the characterizing qualities of experience than the fuller experiences from which these derive. And progressively the more 'inessential' components that are discarded, the less the residual ones are able to embody these characterizing qualities. Yet the concept of compresence is quite as able to interpret these qualities as it is the more subjective, particular ones. That the irrevocably

subjective character of experience as it is present to subjective intuition, as well as the non-subjective nature of abstractions, such as qualities and logical constructions, is captured by the single notion, comprescence, and that moreover we can formulate the notion in terms of vectors and their products, appears a sufficient justification for adopting it as a basis for interpreting experience.

12.6 Art

Chapter 4 interpreted the Ws that A produces in terms of order: as the outcome of order-extraction work. A's goals have the force of procedures whose execution reproduces order extracted in the form of Ws. Chapter 10 showed the necessity of having Ws of one kind or another for the operation of any interesting control procedure: the Ws furnish such procedures with the objective models of the world that the procedures require for predicting the world's behaviour. Chapter 11 noted the heuristic value for the extension of order extraction of being able to 'face' a W in the consciously critical way called for by the need to eliminate errors. The foregoing section of this chapter showed that, while experience is wholly subjective, descriptions of it are possible and permit objective operations with subjective experience as a basis. Without the possibility all objective knowledge or even communication would be impossible (cf. Russell's observations on 'egocentric particulars' (3.4).) These descriptions are normally operated upon in a trimmed and generally more tractable form than the one that might portray the actual experiences that they describe. It was shown how trimming was achieved, by reducing the characteristically high order vector by which we might describe the internal state constituting an experience of a given individual, to a vector or vectors of lower order, either closed within the same set of elements or homomorphic to them. It was suggested that these reduced homomorphs of experience steadily lost those qualities by which we should normally characterize them as experiences, becoming, as the order of the vectors representing them diminished, increasingly disembodied and abstract. It was noted too that, while experience was necessarily subjective, we might picture a 'continuum' with subjective experiences at one extreme, non-subjective abstractions at the other, and 'events' of varying degrees of abstraction between. (In view of the problems associated with the notion of objectivity (see 12.4), the term 'non-subjective' will be used here to denote what is not purely private, but enjoys public, shareable characteristics.) We shall *define as WOAs those Ws concerned with experience*, as we have characterized them (12.4).

In his essay, *Politics and the English Language*, George Orwell enunciated a number of rules for writers, including recommendations to prefer the active voice to the passive, the particular to the general and the concrete to the abstract. Roughly speaking, Orwell argued that unclear writing reflected unclear thinking, and that, if a writer could not express what he

wanted to say, it was because he was not sure of it himself. This is a view that positivists would accept, and which extends naturally to the notion of effective procedures. Tom Wolfe (1976), writing about modern painting in an essay entitled *The Painted Word* argues that, as art turned away from realism towards abstraction, the theory underlying it became more and more important until now the *New York Times* art critic, Hilton Kramer, finds that 'frankly, these days, without a theory to go with it, I can't *see* a painting'. Juxtaposing these views makes an important point about art, especially as it differs from science. Approaching the question from different sides, both Orwell's and Wolfe's arguments (Orwell's concern here is writing and particularly writing with a purpose, but there is nothing in the spirit of what he says to preclude its extension to a wider field) imply a need for self-sufficiency in art, a belief that art's concern is with the particular, the concrete, the observable, the thing that exists in its own right, accessible without the aid of special knowledge or analytical apparatus. Without this self-sufficiency, art ceases to be art. No such demands are made upon science. On the contrary: science's concern is with the abstract, the general, with conclusions based upon the broadest possible theoretical foundation. No scientist would expect to be able to understand the papers in a scientific journal without a grounding in the theory on which they are based. Wolfe's view must not be pressed too far. We have argued throughout for the importance of forms and structures for art. Nevertheless, we should interpret the development that Wolfe complains of in painting, as vindicating the ideas we have advanced. For, as observed (7.2, 9.5), the movement towards abstraction in painting began partly as an attempt to break with what was seen as the tyranny of received forms in art. And now

> How far we've come! How religiously we've cut away the fat! In the beginning we got rid of nineteenth-century storybook realism. Then we got rid of representational objects. Then we got rid of the third dimension altogether and got really flat (Abstract Expressionism). Then we got rid of airiness, brushstrokes, most of the paint, and the last viruses of drawing and complicated designs (Hard Edge, Colour Field, Washington School).
> '*Enough*?' Hardly, said the Minimalists . . . (Wolfe, p. 79.)

In some degrees at any rate traditional forms and techniques had all been readily accessible to almost anyone in Western culture and well beyond. Abandoned as tyrannies, the forms now appear to have been art's indispensable framework, which surrendered, had to be replaced, if art were to be possible at all. If structure does not exist, it is necessary to invent it; though replacement by private theories of art's publicly accessible tradition is a movement towards a subjectivity that denies art the general value that it otherwise enjoys as a *W*. And though the theories are individual, they tend nevertheless to be unoriginal – as we should expect from what has been said (especially in Chapter 6) about the slowness and difficulty of invention – eclectic assemblages, heavily dependent upon other orthodoxies: '. . . what it is that the artist, as such and essentially, produces . . . is two things. Primarily it is an "internal" or "mental" thing, . . . something of the kind we commonly call an experience' (Collingwood p. 37). To this 'mental' thing Collingwood gives the title, the 'work of art proper'. A *WOA* is one owing only to its relation to this 'work of art proper'. Within the theory developed in Chapter 10, this view is untenable as it stands. It requires the relaxation of the condition that demands that the 'work of art proper' should exist in the artist's head alone. As Chapter 10 showed, the *WOA* is only apprehended and given the name by an observer, when he has constructed his own 'mental' thing to match what he observes. The problem is related to questions of knowledge by acquaintance and knowledge by description. Experience represents knowledge by acquaintance (12.4). If a *WOA* represents experience, it does so by description. George (1965) compares the two kinds of

knowledge respectively to the machine languages and the automatic programming languages of general purpose digital computers. How art's automatic programming language operates is the subject of the following chapter. Here concern is with the idea, which results from the interpretation of art we have arrived at, of transmitting experience.

In a certain respect, it is obviously true that art is its own justification, sufficient for those who want it and unconcerned about detractors. But is there a defence against the charge that art is merely doing – in a second-rate kind of way – a job that science will eventually take over? Is there anything that art can do that science cannot? 'Experience' must provide the answers to these questions, in particular its uniqueness. Chapter 10 looked at the way A's goals develop and mentioned the gradual convergence, during the progress of AW, of W and A's representation of it, W^*. Moreover, it has been argued that the finished W is the most specific description of A's goal possible. Suppose, however, that this were not the case, that it were possible to describe in words say, the goal that some A had realized in some given WOA, a painting for instance. In order to replace the description that the painting provided, clearly the words would have to convey the same *experience* as the painting. It follows that, though the alternative to the painting might be possible, it would be (by 12.2) highly unlikely. (Cluttering the argument with the complications of A-O and between-O variations, and those due to variations in the experiences occasioned for a single O by the same complex at repeated presentations, are avoided here for simplicity. They are not matters that affect the argument's principles in any way.) In the final instance, the meaning of a painting is the painting; the meaning of the poem, the poem; the symphony, itself. Other descriptions – usually, though not necessarily, verbal – can be no more than approximations. Pictures, novels, poems, music are not illustrations of *ideas,* they are the programs of experience. And though it may be possible to abstract ideas from them – especially their verbal forms, in which ideas specifically may feature as part of a wider ensemble, or describe in words or some other form what they are, it is next to impossible to find substitutes for them. The chief reason for this is the time-orderedness, the compresence that represents experience (12.2). So a poem, for instance, may include images, symbols, rhythm, sound, associations, etc., all occurring simultaneously or in a fixed pattern as complexes of compresence giving rise to sequences of 'total momentary experiences' in some fixed order; similarly, *mutatis mutandis,* a painting or a piece of music.

But WOAs are no mere surrogates of the reality that is experience's usual source, they are sources in their own right. They do more than simply 'help us extend our personal experience' (George, 1970, p. 130) in the sense of multiplying it, providing in surrogate form experiences we might lack. 'Art', Aldous Huxley (1956) says, 'is not one thing but many ... it is a device for making sense of the chaos of experience, for imposing order, meaning and a measure of permanence on the incomprehensible flux of our perpetual perishing' (p. 112). Though WOAs may resemble recognizable realities they also are able to convey what reality cannot. This widely-accepted view has long been associated with creativity. Thus Osborne observes that, 'in so far as it is creative', poetry has been supposed to embody imagination and meaning, in the sense of being 'something added to all reality outside the poem and ... not to be gauged by its correspondence with the reality' (p. 2). Moles notes that 'the peculiarity of a work of art is that its richness transcends the individual's perceptual capacity' (p. 166), and that its value is 'as a creator of sensations' (p. 2). 'A painting by Kandinsky gives no image of earthly life – it is life itself. If one painter deserves the name "creator" it is he' (Diego Rivera cited by Guy Brett in *The Times,* 17 April, 1973). 'Only a work of art can say with validity and force, as *Anna Karenina* does, "This is life" ' (Leavis (1967), p. 13.). The notion is always the same, that the WOA has brought something into being:

He had shown in this water-colour the appearance of the roses which he had seen, and which, but for him, no one would ever have known; so that one might say that they were a new variety, with which this painter, like a skilful gardener, had enriched the family of roses. (Proust, Vol. 8., p. 123.)

The precision here resolves nicely the conflict between this view of art as creative and the idea of art's purely revelatory role. It is clear that A's revelations result from order extraction he has carried out, which we have argued is his creative effort. 'It had taken me about forty years to invent Russia and Western Europe', Vladimir Nabokov tells us about the writing of *Lolita*, 'and now I was faced with the task of inventing America.

The obtaining of such local ingredients as would allow me to inject a modicum of average 'reality' (one of the few words that mean nothing without quotes) into the brew of individual fancy, proved a much more difficult process than it had been in the Europe of my youth . . . (cited by Bradbury, (1976)).

'The European visual image of America was created largely by artists who never went there', Hugh Honour (1976) writes, naming Holbein, Rubens, Tiepolo, Goya, Delacroix and many others; also 'the literary image of America was partly the creation of writers who never crossed the Atlantic – Tasso, Ronsard, Montaigne, Spenser, Shakespeare, Hobbes, Prevost, Rousseau, Goethe, Schiller, Blake, Wordsworth, Byron, Keats'. Those who did go, went with America already 'invented in the image of the inventor', beginning with Columbus's not only seeking, but finding the East in the West.

When the question of aesthetics comes up in the following chapter it will appear that aesthetic value is often associated with the 'uniqueness' of aesthetic experience (cf. 12.3), what our terms associated with the order of size of the complex of compresence that a WOA represents, the closeness of the given W to the extreme of particularity on the continuum that joins it to generality (12.4). Science, as we have seen, aims for the opposite extreme. The continuum, therefore, provides an aesthetic evaluative criterion: the region between the extremes of generality and particularity contains Ws of varying scientific and artistic merit. At the extreme of generality one looks for the 'best' science and expects zero aesthetic value. There is no conflict in supposing this while simultaneously admitting the high aesthetic appeal of the best science! To anyone lacking knowledge of the background of 'facts', the knowledge and theory that some scientific formula draws together into a relatively short description – one with a high 'information potential' (3.5) – the theory will be devoid of aesthetic interest, missing the experiential self-sufficiency (12.1) art demands; while for one possessing the necessary knowledge, the theory will draw the knowledge together into a highly information- and so aesthetically-charged formula or whatever. Naturally, the notion of the self-sufficiency of art is not to be taken too literally. Much that applies to theories of science applies, in many respects almost equally perhaps, to art. Art differs from science in usually leaving a self-sufficient residue that rests upon the structures that O and A share simply by their both being human with human experience, structures that science's abstractions remove entirely. This, deceptively, can produce the impression that there is, to a painting for instance, no more than meets the eye. Levey (1966) cites Sir Joshua Reynolds writing about the 'great style' of Michelangelo: 'It must be remembered, that this great style itself is artificial in the highest degree, it presupposes in the spectator a cultivated and prepared artificial state of mind'; consonant orders in O and A.

But there is still an anomaly when it comes to scaling the aesthetic dimension. Ws that fall at the zero point of the particular-general axis are, in the terms here, neither art nor science, occupying a place somewhere between the two on the continuum, uncharged with

information: face-value ideas and descriptions; the report of the experiment as distinct from the experiment reported; writing in which individual style will be eliminated, imaginative beauty and formal art banished; prose, as Cyril Connolly (1961) observes, 'not only as unassuming as good clothes, but as uniform as bad ones'. Here questions of aesthetics do not arise. This, not the generality extreme, is the appropriate point to set zero aesthetic value, with deviations from it towards either extreme assigned equal aesthetic ratings. High aesthetic values at the generality end of the scale go to non-self-sufficient Ws of high information potential – the chess move, mathematical proof, physical formula – and equally high values to self-sufficient ones, the portrait, the Shakespearian sonnet, the *image*. In terms of the compresence formulation, the world of 'events' occupies the neutral zone, novels receiving in general lower aesthetic ratings than poems, *genre* paintings than landscapes and still lifes, and so on; and with sociology seldom rising to aesthetic heights.

The Method of Art

13.1 Synthesis and Simulation

The previous chapter argued that the objectives of art and science differed. It was shown that while art aimed at producing *W*s that were particular and therefore needed to be in some measure self-sufficient, independent of the need for outside knowledge in *O* for their appreciation, science aimed at general *W*s based on previous, non-evident structure. Here we contend that this difference of aim dictates a difference of method which, more than differences of explicitness or objectivity or conformity to empirical reality, distinguishes and characterizes art and the content of *W*s generally. The difference between art and science is broadly that between *simulation* and *synthesis*. The ontological status of *WOA*s is analagous to that of a simulation program for a computer. *W*s that are scientific theories are the occasions for synthesis. This view appears to furnish a basis for a resolution of the conflict between art or science. Theoretically at any rate, nothing can prevent science's taking over art's function, in so far as this is to provide *W*s that constitute objective knowledge. On the other hand, nothing can take the place for *O* of the experience that a *WOA* affords. The success of a given synthesis or simulation represents a *W*'s merit, which is variable, whichever way the particular *W* inclines. This chapter completes the answer to the problem set initially, to determine the principles of an art machine. Part II showed what kind of machine would be needed. Thus far Part III has shown what the machine will have to be able to do. The argument here yields a number of conclusions which, though they follow from the arguments that have led to this point, represent in some respects a more speculative departure than others so far.

This chapter begins with a view of art as a model of a model, capable of answering questions of a general nature about experience. It discusses the differences between models of reality and of experiences of it, and difficulties arising from the relatively greater variety of the real world than *A*'s. This leads to discussion of *surrogate* experience and the means of supplementing *A*'s variety to facilitate its producing such surrogates. It appears that art produces surrogate experience by a mixture of simulation and synthesis. Differences between real and surrogate experience are discussed. Finally, the chapter examines the way in which A may approach producing surrogate experience. It emerges that *WOA*s

have a dual existence, as surrogate and real experiences, and that each furnishes *A* with a language consisting of the same words but with different meanings. The chapter ends with a discussion of aesthetics.

13.2 Reproducing Experience

So far, in discussing *W,* we have concentrated on the minimum requirements for a procedure that would produce *W* (*c*-authorship), the sort of structure the procedure would need and the relation of the procedure to the *W* it produced. Only at the end of Part II did we show explicitly how *W* might stand as a model of *A*'s world or part of it, and we left for Chapter 11 touching on some of the broader advantages (objectivity) of such models for advancing understanding of what is modelled. The reason for following this course has been, as observed previously, to avoid restricting unnecessarily the generality of conclusions reached; the area of speculation has been narrowed only where necessary. Recapitulating, *W* is pictured as some kind of observable (to a properly constituted observer) object or set of objects, distinguishably (physically) separable from *A* and modelling some part of *A* which may include some part of the 'model' *A* has of the world. By 'model' is understood a broad notion, like the one Minsky (1965) describes (Chapter 2). 'To an observer *B* an object A^* is a model of an object *A* to the extent that *B* can use A^* to answer questions that interest him about *A*' (p. 47). In our terms W^* is an 'internal' model in *A* that *W* is supposed to represent. Thus *W* is a model of W^*; in Minsky's terms, the model, W^{**}, of a model. From 2.3 we recall that such a model of a model, W^{**}, answers questions about the *kind* of model W^* is. Part III has dealt with aspects of this question in some detail, and has confirmed and in some respects extended Minsky's view. Thus the models *art is able to furnish of particular experiences are the means by which to answer questions about the kinds of experiences they are.* Remaining discussion will be devoted to examining how this is accomplished and finding out what we can about the kind of procedures it requires.

The difficulty of modelling experience results from the wish to model the *experiences* themselves, not simply conceptual abstractions. What kind of model of an experience would provide a means of answering questions about that experience, without reference to the experience itself? As 12.5 indicated referring to an actual experience is anyway impossible, as the 'reference' would destroy the experience. Yet such modelling is evidently possible; for, although experiences are by definition unique, unrepeatable and momentary, it is possible and habitual to remember and reflect upon 'them'. Memories of experiences dreams, fantasies and the like, must depend upon models of the kind we are discussing. They are not themselves *the* experiences — although the act of remembering, dreaming or whatever is itself an experience — but enable the

recollection of the experiences and to some slight degree their re-enactment. Here we must notice an important distinction, namely that between the model of an experience and the model of what occasioned the experience, the experience's physical, publicly-observable correlate. An example will make the distinction clear. A visual scene affords a visual experience to the individual looking at it. The scene is something the individual observes. His internal state that results from the observation is his experience of the scene, but the scene itself (cf. 12.3) represents the state of a system distinct from the individual; call it the *original* of the experience. All a given individual can tell about the scene must come from his experience of it, which is to say that, for the same individual, a perfect model of the scene would not differ, would be indistinguishable from, a perfect model of his experience of it. In so far as the individual's models fall short of perfection, the purpose for which he intends them will, at least partly, determine their form. Thus the 'true' model of a scene, and the model of an individual's experience of the scene, are likely to differ. The best model of anything is one that provides answers to *any* questions about the thing. So the best model of a physical object is a fully isomorphic object − not an identical object, since this would not be a model in a normally accepted sense − and so also the best model of an experience. Were experience exclusively of the physical world, then modelling experience and modelling the physical world would, if perfect models were the aim, present identical tasks. But from the definition of experience proposed in 12.4 it appears that this is not the case.

Section 9.4 cited Spencer-Brown's comments concerning description and injunction were cited and it was suggested that descriptions referred to goals and injunctions to the paths that led to them. Or, as one might put it, that descriptions referred to ends, injunctions to means. Accordingly, it appeared that descriptions were to be associated with heuristics, injunctions with algorithms, and it was shown that the division between the two was not entirely clear-cut. The tacit assumption that underlay the discussion referred to was that possible goals were relatively fewer in number than possible starting points from which to set out for them. In the discussion of hill-climbing for instance (6.4) it was supposed that the climber might begin from any of an infinity of points below the summit with the same aim, to arrive at the single point that was the summit. Modelling experiences presents in one sense the reverse of this problem: the same original may occasion innumerable experiences of it. In the formulation of 12.3, given an individual with internal states S and inputs − from the original − I, the experience will be represented by the mapping of $I \times S$ into S. Even supposing S's variety were very much smaller than I's, as it will in any event be large, the Cartesian product as it stands offers no sensible limits to S. To limit the variety of experiences that a given original may occasion, it is necessary to suppose that a 'correlation' exists between the individual and his world. That is to say, for the reproduction of what we shall call an *original*

experience, we suppose that the individual has at his disposal descriptive components corresponding to the components of the particular original, such that these components enable the original in some sense to be computed from them in a manner such as that Chapter 4 suggested (cf. for example Craik's assertion that 'thought models or parallels reality' − 4.8). These descriptive components are the descriptions of 4.4 or the descriptors of Chapter 8, and thus fulfil a synthetic role; so that the reproduction of experience is evidently a mixed synthetic-simulatory procedure. The components of the synthetic part of the procedure may be taken as the building blocks, consisting of simulation procedures, put together to make the WOA. These building blocks constitute the artist's prior structure, discussed in Chapters 6 to 8. If O lacks any of the descriptive components that A relies upon, he will be unable to reconstruct that part of the original to which they refer. Such deficiencies will appear as lacunae in the experience that the WOA occasions and may distort the entire simulation. Distortions will also occur if O and A synthesize A's descriptive components differently. Such problems are the subject of the commentary that ends this chapter.

13.3 Surrogate Experience

So a WOA enjoys a dual role. It provides at once the occasion for what is an experience in its own right, while standing also as a surrogate for another experience for which it provides a simulation procedure. The previous section referred to descriptive components that A uses as the building blocks of this procedure. If, ignoring possibly different hypothetical possibilities that are of no interest here, it is supposed that A's variety is very much lower than E's, we may usefully look upon the descriptions A uses as ways that A employs to increase its variety. For example, among A's descriptors are a class often called percepts, which, following the terms we have been using, might be thought of as the building blocks of perception. The vertices of Guzman's SEE program are crude examples of what is meant. These vertices have a real existence in the world in which the program operates − as observers of the program in its world we are qualified to say so. In a sense the program exploits its world as a kind of memory store to supplement its own too limited one. In this interpretation, A's percepts have the force of accessing sub-routines aimed at this memory. We should argue in favour of the view that an important part of W's role as depicted here is simply to be an extension of this accessing facility, one in which A actually builds the kind of memory store he wants in the physical world, rather than relying upon what he can find there − A the cultivator, no longer simply A the hunter.

Empirical evidence that might be taken to lend general support to this view of A's relation to and connectedness with its surroundings is the intuitive difference made between recognition and reconstruction. We may recognize a bird from appropriate clues (8.2), as we may know a man by his passport (12.2). But to draw the bird with a pencil it would probably be necessary — particularly if drawing a bird for the first time — to have it in front of one for frequent checking of details whose absence from the mental picture of the bird pass unnoticed, as the blind spot passes unnoticed in normal vision. Instead of storing a surrogate of the bird in memory, a way of accessing birds is stored instead, called a description of birds. The rapid loss of mental function of subjects under conditions of sensory deprivation appears to offer further vindication of the view advanced here.

This view of A's use of descriptors furnishes a basis for a way of understanding the operation of the descriptive components A uses in simulation procedures. In the formulation of 12.4, experience was taken to be defined by a complex of compresence consisting of mental constituents, and it was shown that 'total momentary experiences' were highly unlikely to be repeated. Experiences consisting simply of the raw data of some complex might turn out impossible to compare at all, and therefore *a fortiori* impossible to judge as similar. The unfulfilled promise of perceptrons, as seen in Chapter 7, owes largely to a too simple belief in their power to process such raw data without the intercession either of local or global descriptors. But remarkably, experiences are comparable and the appearance of similarity between them commonplace, as long as descriptors are available to simplify descriptions. Descriptors' power derives (as in 3.8 and 3.9) from the way they permit shortening of descriptions. Or, put in terms more useful here, from the way they reduce descriptions' varieties. To describe a grass lawn, say, by means of a numerical representation of some finite 'retinal' projection of it, would require a variety proportional to the number of points on the retina, raised to higher powers according to the number of wave-lengths and intensities distinguished, a variety that 'lawn' reduces to a single word. So we reach the conclusion we have reached a number of times before in different contexts, that without the structure, the heuristics, the descriptors or whatever, WOAs are impossible. And moreover, also as we have previously said, because 'there is no *a priori* unique information output in communications between individuals' A's audience will need to share most of his structure. 'The real information depends on the common knowledge of the transmitter and receptor.' (Moles p. 52.)

With the description A has at his disposal he can do more than simply reproduce experience, he can create it. The idea of a WOA reproducing an experience is paradoxical. For what we have called the original, which is the occasion of the original experience, may bear little resemblance in its physical reality to the WOA, and O may thus in a sense be thought of as having an experience without having it.

An analogous state of affairs exists in physiology, which distinguishes between adequate and inadequate stimuli. Light is the adequate stimulus for the cells of the retina; pressure on the eyeball, when it activates them, the inadequate stimulus. Hallucinogenic drugs or electrical stimulation of the brain display comparable inadequate-stimulus properties, defining the domain of imaginary, as distinct from real − 'adequately'-based − experience. In cases of drug-engendered hallucinations and even dreams, experiences may be difficult to describe or even retain. In support of the contention that A's perceptions are also a facility that permits using the physical world as a back-up memory, it might be argued here that the difficulty of dream image retention resulted at least partly from the poor correspondence of the images with 'reality'. This would then lead to inadequate access (percepts) to the back-up memory, 'reality', with resultant difficulty of storing, leading to the kind of poor retention usually associated with dreams. In the case of other forms of hallucinatory experience − such as that reported by Penfield (1958) − due to direct electrical stimulation of the brain using micro-electrodes, what the patient experiences may be precise, explicit and even familiar. It may be tempting to suppose what many theorists have had in mind from the earliest mechanical conceptions of the brain, most explicitly perhaps since Craik's exposition, that anyone knowing and able to operate the brain's equivalent of a computer's machine code, would have it in his power to induce in any given individual, any experience he wished by means of an appropriate inadequate stimulus. Yet it appears that during hallucinations the descriptions themselves may become distorted, in the sense that the reality they generate does not resemble the 'normal' reality of the physical world whose correlates they should be. In addition the constructions that are made out of these distorted building blocks may themselves be bizarre.

13.4 Creating Surrogate Experience

A's task is to find appropriate 'inadequate' bases with which to make such WOAs as will provide the imaginary experiences he wishes. Among such bases he must find the techniques he requires, whether they are merely the coding procedures necessary to produce the illusion of perspective on a flat surface, or the injunctions to bring about the simulations that will induce some particular mood or emotion. But what has been said so far needs to be qualified. The foregoing argument of this chapter has been put in a simplified form, as if it had been believed that O might be unable to distinguish an experience due to a WOA from one due to an original that the WOA represented. Naturally, this was never supposed. It might be A's intention to make a WOA such as would delude O into believing that it was real − *trompe l'oeil* for instance − but this would not generally be the case. As previously observed, WOAs have a dual role, as the occasions of real experiences in their own right and as surrogates for other real experience due to originals that they represent as 'copies' − achieved, as we have asserted, by means of fixed simulatory and synthetic procedures. Both A and O are aware of this duality, which A is expected to, and generally will, make use of. Thus A's purpose may be illusion and he may achieve it with considerable success. Or he may wish the surrogate to provide for the detached contemplation of the real. Clearly, W's capacity for 'fixing' in reality some more or less fluid

condition of A's (10.4) is of particular value in WOAs that are able to apply this capacity to the transitory, moving aspect of experience, so that a single experience, or at least an aspect of it, is available for repeated review (see final commentary to this chapter). A may wish to utilize the immediate juxtaposition and alternating presence of the experience occasioned by a WOA and by the original of which it is a surrogate. Clearly, A may have any among numbers of objects.

Section 11.6 raised the question of a stratified object language for A. Clearly, from the foregoing it appears that A commands not merely an object language but a meta-language too, in which he may discuss such matters as the relation of the WOA to its original. As suggested, these meta-linguistic discussions may be — and often are — themselves included as aspects of WOAs. It is necessary to be clear what these terms mean when applied to a WOA. The language that concerns us is the one in which the WOA speaks to O. Ignoring the question of a meta-language for the moment, it is clear that A may use a mixture of higher and lower level languages in a WOA. Because of the duality of the WOA, he may often, within a single statement, capture the force of both higher and lower levels at once. A speaks two languages at once, using the same words. In a sense this is the crux of artistic achievement and the examples of it are so numerous that choosing among them is necessarily quite arbitrary. In Michelangelo's *Pieta*, Jesus's figure *depicts*, in a higher level language, the limp body of a young man recently dead. In addition its presentation offers O a set of injunctions in a lower level performance language **that** induce an *experience* of limpness in his own body, by a process that Wilhelm Wonniger used the word 'empathy' to describe. Such an experience may often be conveyed, or at any rate is usually in practice more faithfully conveyed, only by such lower level injunctions as have the force of a simulation procedure — as the injunctions of the musical score convey the composition. Injunctions in a higher level language (in this case to 'be limp') would almost certainly fail to be effective, simply because O lacked the synthetic components necessary to carry them out. O simply does not know how to 'be limp', or at any rate cannot achieve limpness through his own efforts as well as he can by means of the empathic control of his muscles. (This is not to deny that such effects might be achieved synthetically, by means of description. Techniques such as the **Method** of Mattheus Alexander aim at just this. But the descriptions this Method employs are complicated and lengthy, took years to evolve, and in practice turn out to depend more upon actual physical manipulation by an instructor than verbal description.) Considerations of a similar kind apply no less when A's 'medium' is language itself or even, in some cases, music. Notice that nothing compels A to use his two languages as in this example, to convey sympathetic or reinforcing messages; on the contrary, he is free to seek effects by any number of means including the languages' antithetical use. The joint effect of A's dual messages, frequently commenting upon one another,

implies A's view of his WOA as it strikes him in his role as O. In this way, his stratified language provides the vehicle for his meta-linguistic comments. Here again is language stratification. A's implied statement about a WOA, which emerges from the mutual commenting that takes place between the two levels of his object language, is itself like a performance language, which induces a 'frame of mind' in O without explicit statement. In certain circumstances — chiefly in literature — A may make explicit comments too. But one would not wish to stretch this notion of a stratified meta-language too far. For the division of levels is not clearly defined and the notion is of no obvious utility here.

13.5 The Uses of W

Why make WOAs — or Ws for that matter — at all? A's complex, purposeful structure ensures that the reason must form part of the overall 'teleonomic project' that Monod speaks of, whose main goal is survival; ' . . . it is survival that is the lynch-pin of our motives . . . ', 'the fundamental feature' in the motivational hierarchy. (George, 1970, p. 142.) In several places W's broad utility for A has been mentioned, without an attempt being made to decide whether or upon what grounds it might be possible to distinguish WOAs as a sub-class of Ws, simply from knowing their utility to A. This chapter contends that WOAs deal with experience, extend experience, 'fix' it for contemplation and repetition. It has been observed that WOAs generally are concerned with more than simply mimicking 'real' experience; A has the capacity to stand back from real experience and observe the relation between it and the experience occasioned by WOAs. This latter capacity is clearly a necessary part of A's equipment. Without it no productive activity A began would ever end. Being trapped within an on-going experience, A's goal for producing W would be continuously changing, rendering its realization impossible.

Among the advantages for A that might be associated with these and other of his characteristics, which he in turn imparts to his WOAs, is one in particular; it is the capacity that WOAs provide for allowing A gradually to move from simulation to synthesis, from imagination to description. The contemplation of experience repeatedly re-provided by a WOA facilitates order extraction. It provides hindsight, which Polya among others identifies as a powerful problem-solving heuristic. Understanding (order extraction) occurs when A is able to map a description (4.4) onto the WOA's set of injunctions.

As a final observation, notice that A is self-sufficient. It requires no observers or audience. Once it exists communication with other entities that may exist also is incidental. In effect, however, as a complex machine, A must be the product of a complex process controlled by some antecedent complex individual, and so on, back. Normally, therefore, it would find itself one among many, with questions of audience arising naturally from this. But theoretically, if it were

possible to identify A as the end product of the continuous evolution of the same, single individual, it might exist and produce WOAs quite unaffected by the absence of an audience.

Notions about how art 'works', and the beginnings of the idea of artists producing *causes* to bring about somewhat different *effects* are one of the chief pre-occupations of theorizing about art. *'Peindre, non la chose, mais l'effet qu'elle produit',* was the way Mallarmé (Hartley, 1970) expressed his discovery, as he saw it, of this phenomenon. The difference between having an idea of something and having an experience of it is a matter of what is often called feeling. Normal usage applies the word impartially to sensations and emotions. And artists – including as usual here writers, musicians and so forth – and art theorists have proposed numbers of explanations as to how art should set about capturing 'feeling'. Underlying many of these explanations, and more or less explicit in some, is a view shared with the one this chapter advances of WOAs engendering simulated experiences, but in such a way that |the experience engendered enjoys the status not simply of a surrogate experience but includes also a comment on it, making it something to be contemplated from a position of detachment. This was a view of certain theories of the last and early this century, 'that the artist embodies or symbolizes in the art work an emotion or feeling in such a way that the observer savours and enjoys it without experiencing it in the full sense' (Osborne, p. 18). This is partly what is meant by art's dual role, and accounts for the conflicting views of those who hold that art is no more than revelatory and those others who hold that it is creative.

Langer (1953) adopts a view similar to Pound's notion of images (4.5). For Pound an image is at once something to·be grasped in an instant and something which may yet be finely and lengthily elaborated into minute detail. Pound cites the *Divina Commedia* as an example of an image. The notion is not contradictory: the work forms a single unitary whole; it is, as Osip Mandelstam sees it, 'one single unified indivisible stanza' (cited by Steiner, 1976). For Langer art is not a language, but an expression in which each WOA reproduces by means of its own structure some pattern of feeling. Bullough (1957) stresses the notion of the WOA's dual status as a surrogate experience, able at once to evoke and comment upon some real experience. He proposes the idea of the artist's 'Psychic Distance' from his subject, which may be seen as an extension of Wordsworth's view in the *Preface to the Lyrical Ballads* that poetry 'takes its origin from emotion recollected in tranquillity.' Tolstoy (1929) emphasizes art's role in extending experience.

> To evoke in oneself a sensation which one has experienced before, and having evoked it in oneself, to communicate the sensation in such a way that others may experience the same sensation . . . so that other men are infected by these sensations and pass through them; in this does the activity of art consist. (p. 123)

But the artistic process offers more than simply a means for recollecting or reproducing experience; ' "emotion recollected in tranquillity" is,' as Eliot (1951c) observes, 'an inexact formula.

> For it is neither emotion, nor recollection, nor, without distortion of meaning, tranquillity. It is a concentration, and a new thing resulting from the concentration, of a very great number of experiences which to the practical and active person would not seem to be experiences at all; . . . These experiences are not 'recollected', and they finally unite in an atmosphere which is 'tranquil' only in that it is a passive attending upon the event (p.21).

Roger Fry calls art 'the chief organ of imaginative life; it is by art that it is stimulated and controlled' (p. 29). Freud (1966a) thought of literature as a controlling and controlled mode, reaching to the private depths of the poet's consciousness and connecting with universal human problems.

How does the artist achieve these objects? He

> ... has gradually evolved the law, the formula of his unconscious gift. He knows what situations, should he be a novelist — if a painter what scenes furnish him with the subject matter, which may be anything in the world but, whatever it is, is as essential to his researches as a laboratory might be or a workshop' (Proust, Vol. 4, p. 210).

The artist learns gradually the performance language that provides the characterizing feature of his *WOA*s. By means of this performance language, 'Genuine poetry can communicate before it is understood' (Eliot, 1951a, p. 238). This is because its basic language is injunctive and has the capacity to induce states in *O* by the simulation procedures it constructs that *O* could not induce in himself, lacking synthetic understanding of them. The communication guides him to the understanding, and so produces new elements to be synthesized, new building blocks out of which to construct new *WOA*s and simulation procedures, in a continuing chain, in a way that accords with Dewey's (1934) view of the nature of creativity, that it is to reorder, rearrange, reorganize in a fruitful way, perceptions, experiences and ideas into new shapes and modes of consciousness. Pound reports an incident: he gets out of a 'metro' in Paris and sees 'suddenly a beautiful face, and then another and another, and then a beautiful child's face, and then another beautiful woman'. He tries all day to find words for what this had meant to him but can find none 'worthy, or as lovely as that sudden emotion'. But later he suddenly finds 'the expression', not 'words, but . . . an equation . . . not in speech, but in little splotches of colour . . . a "pattern" ' (p. 465). (Compare the hallucinatory quality of what Pound reports to Osip Mandelstam's buzzing in the head when he composed poetry (10.5).) In these cases at least the comparison between the hullucinatory and creative aspects of imagination do not appear too far-fetched. Pound believed that his discovery provided the basis for a new 'school . . . of non-representative painting, a painting that would speak only by arrangements in colour' (p. 465). Re-ordering, re-arranging, reorganizing over a period of eighteen months or more, having destroyed first a thirty line poem and later a shorter poem, Pound, as he tells us, the Japanese *hokku* in mind, arrived at a poem which, as Kenner (1975) says, 'needs every one of its 20 words, including the six words of its title':

IN A STATION OF THE METRO

The apparition of these faces in the crowd;
Petals on a wet, black bough.

Into which 'vortex' is drawn, as Kenner observes, the contrast between the world of machines, the Metro, and the image of vegetation; the underground crowd, 'as Odysseus and Orpheus and Koré saw crowds in Hades'; and, detaching *these* faces, with the 'suggestion of wraiths', from all the crowded faces, the word 'apparition'; 'Flowers underground; flowers out of the sun; flowers . . . in this place where wheels turn and nothing grows' (p. 185).

Art is not self-defeating, constantly allowing new synthetic knowledge to erode its own preserve; every new synthesized description it furnishes is immediately available as a new

module for further building. In this sense art progresses no less than science (cf. 4.1, 11.1). Its traditions, the evolution of its forms, the development of individual artists, coalesce — though not necessarily to enhance those powers by which art is uniquely characterized; these are always to do with the experience it can provide; and this is the realm of the artist's performance language.

> The only way of expressing emotion in the form of art is by finding an 'objective correlative'; in other words, a situation, a chain of events which shall be the formula for that *particular* emotion; such that when the external facts, which must terminate in sensory experience, are given, the emotion is immediately evoked (Eliot, 1951b, p. 145).

This procedure confers considerable freedom on A. It frees his creations, his WOAs, from the confinement of physical reality. A may 'extend' reality either by relaxing the constraints that bind his world picture or by securing new constraints or by both procedures, with his only restriction the possible consideration of an audience, which conceivably might lose itself in the unfamiliar landscape his actions created. Similarly, he may loosen the binding strength of form or seek escapes from the limitations his medium imposes, or he may invent new forms and new media. But, in either case, whether relaxing constraints or inventing new ones, his actions require order-extraction — are creative. To relax a constraint he must first discover that it exists. And, in any case it is not always obvious how a particular 'extension' of reality has been achieved, whether by relaxing or adding constraints. The devils and hobgoblins that decorate Gothic cathedrals, are they the result of relaxing reality's constraints or of strengthening them? If both, which of their characters is due to which procedure? The more that enters A's work that is private to him alone, the less of it an audience will be able to apprehend. However, neither A nor the audience need fear too greatly on this account. For, structure being hard to come by, if a WOA were truly complex — highly structured — it could not contain more than a relatively small quantity of 'new' order, due to A's creative effort. And if O found it unintelligible, apparently due to A's excessive inventiveness, he could reassure himself that his failure to understand must be due to a degradation of structure, which from his point of view it would be, not to the reverse, and to offer himself the comfort that what sense he made of the work was attributable to his own efforts.

 A's objects in producing 'distortions' of reality might be, and perhaps usually are, part of an attempt to achieve the opposite effect, that of rendering reality more sharply. It has been seen (3.5) how A will arrive at descriptions of experiences that suit his purposes. What has become habit with him will strip the experience of reality of whatever constituents are inessential to the furtherance of these purposes. In the case of memory, for instance, Proust says, 'Habit weakens every impression'; the better part of our memory exists outside ourself ... wherever ... we happen upon what our mind, having no use for it, had rejected' (Vol. 3, p. 308). What we store in our memories is principally what is useful to us. It is recalled by the cues most commonly associated with it. Suppose the memory is of a thing or a person, and suppose, whichever it is, it vanishes or ceases to exist. The common cues will vanish too. But other, more 'loosely' associated cues may still occur, being not part of the vanished object itself, but part of some experience in which the object was present — an instance of the object (12.2) — and these cues may re-evoke the memory of the object when it is neither expected nor desired. Without a goal 'memory is blind and even survival hinges on pure chance' (Fogel and others p. 122). The shock of memory evoked without a purpose, or of reality otherwise surprised, are effects of the kind A as artist may deliberately seek. For this he may blind memory or twist reality to force some aspect of one or other upon O, in this respect the manipulable and passive subject of chance's experiments — that A simulates.

13.6 Aesthetics

Though it was never part of this book's purpose to deal with the question of aesthetics — the appreciation and, in the present case also the production of beauty, which remains largely separate from the sorts of questions with which the book is principally concerned — nevertheless, the argument would be incomplete if it ignored aesthetics altogether. Following the principle adopted from the outset, therefore, only such aesthetic questions will be examined as might have a general application to art machines as well as human artists; that is to say, we shall look for criteria that are not merely free from cultural or educational or socio-economic influences, but that have a universal applicability; the quality that Clive Bell (1914) claimed must be common to all objects that provoke aesthetic feeling; what Moles characterized and attempted to measure as aesthetic information. Yet how is such a quality to be identified when there is often so little agreement between observers about its presence? Is it possible to advance beyond the view taken in Chapter 3 that aesthetic quality can be identified only as a relation between particular objects and those entities that assert that they possess it?

Perhaps the matter might be carried somewhat further by consideration of the possibility of an objective correlation between what we have called information potential, the concentration of information, particularly information of different kinds, in an object — artefact, description, image or whatever — and the aesthetic feeling it arouses. In a *WOA*, information potential arises as part of what we have called the *simulatory* aspects of the *WOA*. In human terms, these simulatory aspects are those that are 'built-in', emotions, sensations and the like that are the ready-made responses — programmed-in by heredity and the normal learning associated with life and living — that the *WOA* is powerless to control in themselves, but that *A* can control by the way it synthesizes them, the way it relates them to one another, juxtaposing them in particular orders, calling them in chosen sequences, and so forth. These simulatory elements that art synthesizes but cannot directly influence may be displeasing, repugnant, of negative value to *O*, at least as easily as they may be attractive, pleasure-giving, positive in value. It is the simple *power* of a feeling they occasion, irrespective of its content, that carries the aesthetic charge. The speculative view I wish to suggest is that it is the quality of information potential itself, the charge that appropriate synthesis by *A* can accumulate in simulated experience, upon which aesthetic value depends. Information is vital to survival: 'The acquisition and storage of relevant information', in Lorentz's (1977) words,

> is a basic function of all living organisms as is the absorption and storing of energy. ... Otto Rossler, was the first biologist to point out that not only do energy absorbing processes form a positive feedback cycle in themselves, but they also have a positive feedback relationship to the information acquiring processes. (p. 27)

Information as such carries a high positive value for whatever is the outcome of long evolution; and what concentrates information, concentrates also this positive value.

Beyond the possibly quite general positive associations of information as such, there appear also to be more specific links between the particular qualities of physical and perceptual forms, qualities that have been of vital and enduring importance in accommodating us to our worlds. Our scale of values, Lorentz (1977) asserts, stretching from 'high' to 'low', we apply across the whole spectrum of our experience, 'to animal species, cultures and works of art. This correspondence might have arisen because man, as a thinking being, has become aware of certain processes that are active in the whole of the organic world; in this respect feeling, thought and being would thus be one, and a value judgement based on feeling would be *a priori,* i.e. innate and necessary' (p. 247), and so, by our argument, of aesthetic value.

Indirect and distant associations with survival may be associated with physical form and the structure of perception. Particular physical features and perceptual mechanisms in animals have been of very general importance in survival. The generality of a few of them extends widely in the living world and even beyond. Symmetry is such a structural feature. Symmetry may be taken as a morphism of balance and so of gravity, against whose downward pull it offers a general protection, at least in regard to orientation, as the basis of balance; 'and the balance of a mantlepiece by Adam or a phrase by Mozart', Lord Clark (1970) says, 'reflects our satisfaction with our two eyes, two arms and two legs'. Symmetry is as much a feature of plants, especially the more primitive varieties, as it is of insects, fish and animals. Rhythm is another such structural feature. Associated with breathing and the beating of the heart, it has predictive value, creating the expectation of its continuance; and it lies at the heart of music, poetry and dance. There are innumerable instances that display the close match between the individual and his world: the sensitivity spectrum of the human retina which closely coincides with the spectrum of the sun's radiation; correlations that exist between physiological and anatomical features of living species and those of habitat, geography, climate. Apart from phenomena of this kind, there are possible developmental correlates between perception and information that are also perhaps of value for survival. Taylor (1962) expounds a theory, now largely superceded by neuro-physiological findings, that remains of interest in suggesting the closeness with which perception is tied to its physical correlates. According to this theory spatial co-ordinates are learned through the references of gravity and self — providing orientation and centrality respectively — and the differentiation of sensory modalities according to responses made to the outside world. Correct response must precede perception, rather than the reverse, as might intuitively seem more likely. Such a theory leads naturally to the idea of 'good' and 'bad' responses and so, by association, of 'good' and 'bad' per-

ceptions, providing thereby, a possible starting point for aesthetics, not far removed from the eighteenth-century idea expressed by Hume that a certain natural relationship existed between aesthetic qualities and the constitution of the human mind. The difficulty about any theory of this kind is that the primitive correspondences — supposing they exist — between structural features, and so forth, and aesthetic values are not more than the theory's building blocks. Elaborating these in such a way as to account for all the detailed problems of aesthetics moves the subject deeply into the realms of psychology in its more speculative avatar.

More philosophically-orientated approaches to aesthetics are no less problematical and fraught with disagreement. Discussion in these areas ranges over questions as to what are the objects of aesthetic attention, the nature of aesthetic experience and the grounds of aesthetic judgement, with differing views as to which aesthetic theory should emphasize. Under the first head come questions — mentioned in Chapter 2 — as to what is a *WOA*, with suggestions, sometimes based on hedonistic assumptions (not far removed perhaps from what the previous paragraph suggests) that a *WOA* should elicit aesthetic attention. This naturally leads to the next question, as to what is aesthetic attention or, more broadly, aesthetic experience. Some characteristic is sought that renders objects able to sustain aesthetic attention. Without such a characteristic it is argued aesthetics becomes simply a study of subjective taste. The aesthetic attitude is supposed to lead to the apprehension of objects for their own sakes, rather than for pleasure or the extension of understanding. What then are the grounds of aesthetic judgement? How does it differ from judgements of taste? Is natural beauty a legitimate object of aesthetic attention?

Moles attempts to define aesthetic value by means of information theory. He identifies what he calls 'aesthetic information'. The term is operationally defined by the results of certain psychological tests. It 'refers to a repertoire of knowledge common to the particular transmitter and particular receptor'; 'One may liken it to the concept of personal information'; it 'has no goal, properly speaking. It does not have the characteristic of intent; in fact it determines *internal states*' (pp. 129, 130). Unlike 'semantic information' it may not be translated (into a foreign language, say) nor transposed into another medium. To an extent, apparently it resembles what we call the simulatory components of *WOA*s. Moles proposes ways of measuring aesthetic information, based upon various kinds of methodical destruction of *WOA*s by known perceptible quantities, 'following the variation in aesthetic sensation, value and knowledge as a function of this destruction' (p. 201). Unfortunately, such a method, while destroying one *WOA* would be creating another, due to the creative role of the *O* being tested as he apprehends the *WOA* at each stage (10.5), and this would no doubt be a factor difficult to control. In another place, Moles suggests that aesthetic information is to be associated with the individual *A*'s preferences, expressed, for

example, as a 'choice of certain frequencies and certain combinations, to compose spectral symbols, of certain lengths of phonemes, of certain phonemic combinations, etc.' (p. 132), rather like what we described (9.4) as the creative contribution of the musical performer to the performance of some printed score. Similarly, he finds aesthetic information in the orator's tone, semantic information in his message. Overall, the concept of aesthetic information appears to add little to the general formulation arrived at here, and itself clearly suffers from defects that seriously reduce any effective value it might have in the construction of an art machine. For instance, if as Moles suggests, a speaker's words convey semantic information and the timbre of his voice aesthetic, then to use this fact, an art machine would need criteria for distinguishing what we might call 'positive' from 'negative' aesthetic information. And finding what such criteria might be is precisely the main problem of aesthetics.

14

Conclusion: Prospects

14.1 The Practical Problem

The earliest and most primitive examples of 'art' are the cave paintings discovered at numbers of sites in Africa, Europe and Asia. Yet considerable evidence suggests that this was not art in the sense of being 'for art's sake', but rather was connected with quasi-practical aims, to do perhaps with obtaining food, with hunting, sympathetic magic, ancestor worship and religion, even, as Durkheim believed, with the organization of society itself. Paintings depict animals, 'anthropomorphs', hunting scenes, often events connected with the life and living of the cave-dwellers. At a literal level, a scene of the hunt may be taken as a crude model, in the strict sense that an architect's plan is a model, though presumably offering, more than simply a plan for the study of hunting strategy, an occasion for a kind of enactment of the hunt, complete with its fears and dangers and excitements — all quite practical problems for the hunter, though not susceptible to the same kinds of study and planning as the manoeuvres of stalking, say. Questions of palaeolithic art fall far beyond the scope of this book (as well as its author's competence). Present observations should not be taken to suggest a belief that cave paintings were early visual aids — though it seems possible that this might have been at least partly the function of some of them — only to draw attention to one element in the role they may have filled, which, many anthropologists appear to agree, involves, beyond their face value, matters of the 'spirit', feelings and beliefs, fears, hopes, expectations. These are deep waters into which I have ventured even this far with more boldness than good sense. My point, I believe, is made. Perhaps the best way to learn about hunting is by doing it, as the best way to learn tennis is by playing it. Instruction from experienced hunters or 'textbooks' also have important roles in matters of technique and strategy. It is art, however, that is peculiarly fitted to provide the laboratory where feelings and experiences may be studied and refined, in forms approaching the ones in which they may occur in reality, yet, at least in Eliot's sense, 'in tranquillity' — at any rate, in safety. This, of course, is no more than the basis of a claim for a role for art; it should not be taken as a suggestion that art's aims are restricted to functional objectives, as if its cathartic qualities were its only justification.

On the basis of the conclusions we have reached, one might approach the practical problem of building an art machine from either of two directions. On the one hand, it might be argued that significant art could only come from a machine that incorporated about as much structure as a human artist, since a much weaker device would be unable to *conceive* of art and so could never set out purposefully to produce it. This would imply that the 'best' art machine would take the form of a simulation of a human artist. Similar reasoning underlies the choice of approach in a number of problem-solving procedures, such as most chess-playing programs for instance, which prefer to incorporate human chess masters' heuristics, rather than build up their own from scratch; or financial investment programs that set out to simulate the activity of investment managers, rather than seek wholly novel patters of share price movements and market indicators to guide them. Turning to simulation reflects a tacit admission of the difficulties and slowness of order extraction, a preference for taking over as much as possible of order already extracted sooner than attempting to generate it anew, and going further in accepting that, without exploiting the humanly acquired structures that already exist, many procedures simply will not be got to work. But human simulations achieve their successes only by largely sacrificing the goal of novelty. They search for solutions to their problems only those parts of the tree which have been searched before, because it is to those parts that human mimicry leads them. It seems probable that solutions from unfamiliar parts of the tree would be incomprehensible, and would therefore fail to be recognized as solutions by the human programmers, even if they were to discover them. In any case, sufficient reason has been shown for supposing, on theoretical grounds, that art of too novel a character would be rejected by its audience, a view art's history, at least to very recent times, amply supports. So this is another reason for setting out to simulate the human artist. Chess, however, is a limited activity, art a broad one. For a machine to play chess it is unnecessary for it to be able to conceive of playing it. The problem with the argument that led us to decide on simulation is that it is self-defeating: a true art machine must be capable of producing art; and to do so would have to incorporate much of the apparatus of human intelligence with which at present we should be unable to furnish it.

The alternative approach is more modest, and promises correspondingly less in the realm of art, though perhaps more for the art machine. It entails making the most of available devices, aiming to produce them with heuristics that will lead in the direction we want. We have already come across devices that in various ways model their worlds and their problems. Chapter 8 in particular dealt with examples that had the appearance of being of the kind that might extend to meet the needs of an art machine. Winston's program constructed simple concepts and Winograd's robot incorporated an arrangement resembling in some respects what we have called the 'symbiotic' relationship between W (in

this case statements in English), and its internal representation of *W, W**, represented by PLANNER. The robot's statements do not have the characteristics of true *W*s because they do not, once made, then assist the PLANNER language. The incorporation of a facility whereby the robot's statements were recorded, not merely as references for future statements, but as references that might advance PLANNER deductions as well, would remove this defect. But this would still permit production of only very simple and limited kinds of *W*s. Greater complexity would demand not merely more output but also a more complex world than the 'blocks world' of the make-believe robot. The tower a child builds out of wooden blocks is the product of, among other things, an embryonic creativity. The environment of real blocks is vastly richer than that of Winograd's CRS robot. Indeed, the robot's blocks *have* no environment; they *are* the environment. Yet it is not too difficult to envisage, as a next phase in this development, a robot whose constructions not merely advanced its deductive capacities, but also initiated its next construction, a kind of 'play', limited, but of the same kind as the child's. In such a case, error, an inability to handle the blocks perfectly, would advance such a machine's conceptualizing, not hinder it. For we may suppose that aiming for a goal within not too easy reach might be the best way of keeping some or other constructional activity going. A real robot with both a constructional and a language facility, able to advance its internal world by both, and able to use both to initiate further statements and constructions, where statements might be about construction and constructions suggested by statements, would be well on the way to having characteristics necessary for an art machine. It might be called a child art machine, because it might be expected to have about the same kind of relation to its statements and constructions as a child might have to constructions it made. But to turn the machine into an adult would require it to have a further level of 'self-consciousness'. The machine would need not merely to be able to make block constructions and discuss them, but would require to be doing so as part of a wider project, entailing possibly some kind of model of its own internal system. A machine with these accomplishments could probably produce *W*s that, for its purposes – which we have defined as a sufficient criterion – might have the characteristics of *WOA*s; and we might expect it to show the same kind of attachment to them as we, the meta-observers of Chapter 3, might interpret as showing a belief in their aesthetic value. Even such a machine would represent an extensive, if conceivable, advance on anything at present available. But its *WOA*s would still be very limited. To extend their quality, breadth and complexity so as to make them acceptable to a human audience would call for enriched contact with an enriched world, an elaborate sensori-motor system and, in particular, a facility for acquiring socio-cultural experience. For either the machine must itself be able to have experiences for which it may attempt to produce simulation procedures, or it will have to be programmed with or acquire for itself – by order-extraction work – descriptions

of experiences. In this latter case, it would then face a task roughly the reverse of that of science. For while science attempts to describe what art may only be able to simulate, the machine would have to try to simulate what it had only been equipped to describe.

14.2 Prospects

Was Turing's (1950) prediction of a machine, by the turn of the century, that could succeed in his interrogation game too optimistic? More than half the period is over but no clear indication has yet emerged. It is not even obvious how impressed one should be by achievements to date. From one point of view, Winograd's conversations with his robot seem startling advances, from another, paltry; like Faustus, who must himself decide what to do with all Mephistopheles' devilish power, so the power of the computer remains the imaginative problem of its user. Computer size and speed are not alone enough to accomplish Turing's goal. And it is clear that evolving order within a machine is a problem not to be lightly brushed aside as something we may overcome by helping it along. In Ashby's warning, there is no getting selection for nothing; the Law of Requisite Variety will not be ignored. Perhaps the real shortcoming of Turing's argument is its failure to emphasize sufficiently a holistic view of the individual in his world. The individual is part of a total reactive system with a variety vastly greater than his personal variety. His receptor and response systems link him too intimately with his surroundings to allow total definitive importance to his own 10^{10} neurones. But the computer, locked securely in its cabinet, enjoys only the slenderest links with this world. Nor, until these outside links are greatly strengthened, does it seem likely that increases in computer storage capacities will go far towards compensating for their weakness. The problem is to estimate what point on the growth curve of artificial intelligence may have been reached. In the light of his analysis of animal intelligence, Sommerhof (1969) believes that 'we are compelled to the conclusion that true machine intelligence is still a long way off' (p. 20).

A view founded upon this belief must justify the wholly abstract nature of the undertaking here that is now concluded. No art machine was ever seriously envisaged as a true possibility at present. The machine was proposed simply as an exercize by which to clarify certain aspects of art theory and to close, within the single frame of organization, art along with all other enterprizes that call upon the resources of intelligence and mind. If we could make a machine capable of producing art, it would probably be able to produce it without need of special features. If we were to look for special features, they would probably have to resemble those Beckett mentions, which, through negligence or inefficiency, incline art towards the omissions of the duty of Habit, so opening for it 'a window on the real', for our machine, like the human artist, enlarging its world by increasing its responses to the world's conditions, even at the risk of its

own extinction. The alternative, the adequate performance of the duty of Habit, is the prescription for Boredom, with its own attendant risks: risks in which cybernetics, that takes its name from the helmsman, has a peculiar interest, remembering the unfortunate Palinurus,

> a skilful pilot of the ship of Aeneas [who] fell into the sea in his sleep, was three days exposed to the tempests and waves of the sea and at last came safe to the seashore near Velia, where the cruel inhabitants of the place murdered him to obtain his clothes: his body was left unburied on the seashore. (Lemprière, *Bibliotheca Classica*.)

The Story of the Cape

A woman came to Rabbi Israel, the maggid of Koznitz, and told him, with many tears, that she had been married a dozen years and still had not borne a son. 'What are you willing to do about it?' he asked her. She did not know what to say.

'My Mother,' so the maggid told her, 'was aging and still had no child. Then she heard that the holy Baal Shem was stopping over in Apt in the course of a journey. She hurried to his inn and begged him to pray she might bear a son. "What are you willing to do about it?" he asked. "My husband is a poor book-binder," she replied, "but I do have one fine thing that I shall give to the Rabbi." She went home as fast as she could and fetched her good cape, her "Katinka", which was carefully stowed away in a chest. But when she returned to the inn with it, she heard that the Baal Shem had already left for Mezbizh. She immed-iately set out after him and since she had no money to ride, she walked from town to town with her "Katinka" until she came to Mezbizh. The Baal Shem took the cape and hung it on the wall. "It is well," he said. My mother walked all the way back, from town to town, until she reached Apt. A year later, I was born.'

'I, too,' cried the woman, 'will bring you a good cape of mine so that I may get a son.'

'That won't work,' said the maggid. 'You heard the story. My mother had no story to go by.'

MARTIN BUBER *Tales of the Hasidim: Early Masters*

List of References

ACKOFF, R.L. and F. EMERY, (1972). *On Purposeful Systems*. London, Tavistock Publications Ltd.

ARNHEIM, R. (1967). *Art and Visual Perception, A Psychology of the Creative Eye.* London, Faber and Faber.

ARNHEIM, R. (1971). *Entropy and Art*. Berkeley, University of California Press.

ASHBY, W. ROSS (1962). *Principles of the Self-Organizing System*. In *Principles of the Self-Organizing System,* (eds. H. von Foerster and G.W. Zopf, Jnr.), pp. 259–278. London, Pergamon Press.

ASHBY, W. ROSS (1962a). *The Self-Reproducing System*. In *Aspects of the Theory of Artificial Intelligence,* (ed. C.A. Muses), pp. 9–18. New York, Plenum Press.

ASHBY, W. ROSS (1964). *An Introduction to Cybernetics*. London, Methuen and Co. Ltd.

ASHBY, W. ROSS (1965). *Design for a Brain*. London, Chapman and Hall.

ASHBY, W. ROSS (1967). *The Set Theory of Mechanism and Homeostasis*. In *Automaton Theory and Learning Systems,* (ed. D.J. Stewart), pp. 23–52. London, Academic Press Ltd.

ASHBY, W. ROSS (1972). *Systems and Their Informational Measures*. In *Trends in General Systems Theory,* (ed. J. Klir), pp. 78–97. New York, John Wiley and Sons, Inc.

AUDEN, W.H. (1977). *Psychology and Art Today*. In *The English Auden: Poems, Essays and Dramatic Writings 1927–1939,* (ed. Mendelson). New York, Random House.

BACON, Francis (1975). *Sunday Times* Colour Supplement, 26 March.

BECKETT, S. (1970). *Proust*. London, Calder and Boyars.

BEER, S. (1972) *Brain of the Firm*. Middlesex, Allen Lane.

BELL, E.T. (1937). *Men of Mathematics*. New York, Simon and Schuster.

BLIXEN, K. (1964). *Out of Africa*. London, Jonathan Cape Ltd.

BOWDEN, B.V. (1953). *Faster than Thought*. London, Sir Isaac Pitman and Sons Ltd.

BRADBURY, M. (1976). Dangerous Pilgrimages. *Encounter*. Vol. XLVII, No. 6, pp. 56–67.

BREMERMANN, H.J. (1962). *Optimization through Evolution and Recombination*. In *Self-Organizing Systems,* (eds. M.C. Yovitz, G.T. Jacobi and G.D. Goldstein), pp. 93–106. Washington DC, Spartan Books.

BRUNER, J.S., J.J. GOODNOW and G.A. AUSTIN, (1956). *A Study of Thinking*, New York. John Wiley and Sons, Inc.

BULLOUGH, E. (1957). *'Psychical Distance' as a Factor in Art and an Aesthetic Principle.* In *Aesthetics: Lectures and Essays by Edward Bullough,* (ed. E.M. Wilkinson). Cited by H. Osborne (ed.) (1972), *Aesthetics*. London, Oxford University Press.

BURROUGHS, W. (1970). *The Job*, Interview with William Burroughs by Daniel Odier. London, Jonathan Cape.

CIOFFI, F. (1963). Intention and Interpretation in Criticism. *Proc. Arist. Soc.* 1963–1964, 64, pp. 85–107.

CLARK, LORD K. (1970). *Civilization. A Personal View.* London, British Broadcasting Corporation and John Murray.

COLLINGWOOD, R.G. (1963). *The Principles of Art.* Oxford, Clarendon Press.

CONANT, R.C. (1969). The Information Transfer Required in Regulatory Processes. *IEEE Transactions on Systems Science.* SSC-5, 4.

CONNOLLY, C. (1961). *Enemies of Promise.* Middlesex, Penguin Books.

CRAIK, K. (1967). *The Nature of Explanation.* London, Cambridge University Press.

DEWEY, J. (1934). *Art as Experience.* New York, Minton, Balch and Co.

DEWEY, J. (1958). *Art as Experience.* New York, Capricorn Books, C.P. Putnam and Sons.

DESCARTES, R. (1949). *A Discourse on Method,* (translated by J. Veitch). London, J.M. Dent and Sons Ltd.

DI SAN LAZZARO, G. (1949). *Painting in France 1895 – 1949.* London, The Harvill Press Ltd.

ELIOT, T.S. (1950). *The Use of Poetry and the Use of Criticism.* London, Faber and Faber Ltd.

ELIOT, T.S. (1951). *The Metaphysical Poets.* In *Selected Essays,* (by T.S. Eliot), pp. 281–291. London, Faber and Faber Ltd.

ELIOT, T.S. (1951a). *Dante.* In *Selected Essays,* (by T.S. Eliot), pp. 237–286. London, Faber and Faber Ltd.

ELIOT, T.S. (1951b). *Hamlet.* In *Selected Essays,* (by T.S. Eliot), pp. 141–146. London, Faber and Faber Ltd.

ELIOT, T.S. (1951c). *Tradition and the Individual Talent.* In *Selected Essays,* (by T.S. Eliot), pp. 13–23. London, Faber and Faber Ltd.

ELIOT, T.S. (ed.) (1954). *The Literary Essays of Ezra Pound.* London, Faber and Faber Ltd.

ELLIOTT, R.K. (1972). *Aesthetic Theory and the Experience of Art.* In *Aesthetics,* (ed. H. Osborne), pp. 145–158. London, Oxford University Press.

ENGELS, F. (1935). *Herr Eugen Dühring's Revolution in Science (Anti-Dühring),* (translated by E. Burns). London, Lawrence and Wishart Ltd.

FOGEL, L.J., A.J. OWENS and M.J. WALSH, (1966). *Artificial Intelligence Through Simulated Evolution.* New York, John Wiley and Sons Inc.

FOWLER, H.W. (1926). *A Dictionary of Modern English Usage.* Oxford, Clarendon Press.

FREUD, S. (1933). *New Introductory Lectures on Psycho-Analysis,* (authorized translation by W.H.J. Sprott). London, The Hogarth Press.

FREUD, S. (1966). *Creative Writers and Day-Dreaming.* In *The Standard Edition of the Complete Psychological Works of Sigmund Freud,* (translated from the German under the general editorship of James Strachey in collaboration with Anna Freud, assisted by Alix Strachey and Alan Tyson), Vol. 9, pp. 141–155. London, The Hogarth Press.

FREUD, S. (1966a). *Civilization and Its Discontents.* In *The Standard Edition of the Complete Psychological Works of Sigmund Freud.* Vol. 21 pp. 59–246.

FRY, R. (1937). *Vision and Design.* Middlesex, Penguin Books Ltd.

GAGNÉ, R.M. (1962). The Acquisition of Knowledge. *Psychological Review,* 69, 4, pp. 355–365.

GAGNÉ, R.M. (1964). *Problem Solving.* In *Categories of Human Learning,* (ed. A.W. Melton), London, Academic Press Ltd.

GEORGE, F.H. (1965). *Cybernetics and Biology.* Edinburgh, Oliver and Boyd.

GEORGE, F.H. (1970). *Science and the Crisis in Society.* London, Wiley Interscience.

GREENBERG, C. (1947). The Present Prospects of American Painting and Sculpture. *Horizon,* (ed. C. Connolly), No. 93–94, pp. 20–30.

GUZMAN, A. (1968). Computer recognition of three-dimensional objects in a visual scene. *M.A.C. Technical Report 59,* Project MAC. Cambridge, Mass.: M.I.T.

HARMON, L.D. and K.C. KNOWLTON, (1968). *Computer Generated Pictures.* In *Cybernetic Serendipity (the computer and the arts),* (ed. Jasia Reichardt), pp. 86–87. London, Studio International.

HARTLEY, A. (ed.) (1970) *Mallarmé.* Middlesex, Penguin Books Ltd.

HEWITT, C. (1969). PLANNER: A Language for Proving Theorems in Robots. *Proceedings of the International Joint Conference on Artificial Intelligence 9,* pp. 295–301. Bedford, Mass., Mitre Corp.

HONOUR, H, (1968). *Neo-Classicism.* Middlesex, Penguin Books Ltd.

HONOUR, H. (1976). *The European Vision of America.* National Gallery Washington; Cleveland Museum of Art.

HUXLEY, A. (1956). *Liberty, Quality, Machinery.* In *Adonis and the Alphabet.* Chatto and Windus, London.

JEFFERSON, G. (1949). The Mind of Mechanical Man. Lister Oration for 1949. *Brit. Med. Jnl.* vol. i, pp. 1105–1121.

KANT, E. (1934). *Critique of Pure Reason,* (translated by J.M.D. Meikeljohn) London, J.M. Dent and Sons Ltd.

KENNER, H. (1975). *The Pound Era,* London, Faber and Faber.

KEPES, G. (ed.) (1965). *Structure in Art and Science.* London, Studio Vista.

KLIR, J. and M. VALACH, (1965). *Cybernetic Modelling,* (translated by P. Dolan). London, Iliffe Books Ltd.

KRISTOL, I. (1979). The Adversary Culture of Intellectuals. *Encounter.* Vol. LIII, No. 4, pp. 5–15.

LAKE, C. and R. MAILLARD, (1956). *A Dictionary of Modern Painting.* London, Methuen and Co. Ltd.

LANGER, S. (1953). *Feeling and Form: a Theory of Art.* New York, Scribner.

LEAVIS, F.R. (1967). *Thought and Significance in a Great Creative Work.* In *Anna Karenina and Other Essays,* (by F.R. Leavis). pp. 9–32. London, Chatto and Windus Ltd.

LETTVIN, J.Y., H.R. MATURANA, W.S. McCULLOCH and W.H. PITTS, (1965). *What the Frog's Eye Tells the Frog's Brain.* In *The Embodiments of Mind,* (ed. W.S. McCulloch), pp. 230–256. Cambridge, MIT Press.

LEVEY, M. (1966). *Rococo to Revolution. Major Trends in Eighteenth Century Painting.* London, Thames and Hudson.

LINDSAY, A.D. (Translator) (1954). *Plato's Republic.* London, J.M. Dent and Sons Ltd.

LÖFGREN, L. (1967). *Recognition of Order and Evolutionary Systems.* In *Computer and Information Sciences,* Vol. II. (ed. J. Tou), pp. 165–175. New York, Academic Press.

LÖFGREN, L. (1969). Relative Recursiveness of Randomization and Law Recognition. *Notices of the American Mathematical Society,* 16, 4, p. 685.

LÖFGREN, L. (1972). *The Relative Explanation of Systems.* In *Trends in General Systems Theory* (ed. J. Klir), pp. 340–406. New York, John Wiley and Sons Inc.

LORENTZ, K. (1976). *On Aggression,* (translated by M. Latzke). Methuen and Co. Ltd. London.

LORENTZ, K. (1977). *Behind the Mirror: a Search for a Natural History of Human Knowledge,* (translated by R. Taylor). Methuen and Co. Ltd., London.

MANDELSTAM, N. (1971). *Hope Against Hope. A Memoir.* London, Collins and Harvill Press.

MAYER, R. (1969). *A Dictionary of Art Terms and Techniques.* London, Adam and Charles Black.

McCARTHY, J. (1958). *Programs with Common Sense.* In *The Mechanization of Thought Processes,* Vol. I, National Physical Laboratory, Symposium No. 10, pp. 75–84. London, Her Majesty's Stationery Office.

McCULLOCH, W.S. (1965). *The Embodiments of Mind.* Cambridge, MIT Press.

MEDAWAR, P.B. (1969). *Hypothesis and Imagination.* In *The Art of the Soluble: Creativity and Originality in Science,* (by P.B. Medawar). Middlesex, Penguin Books Ltd.

MEDAWAR, P.B. (1972). *The Hope of Progress.* London, Methuen and Co. Ltd.

MINSKY, M. (1958). *Some Methods of Artificial Intelligence and Heuristic Programming.* In *The Mechanization of Thought Processes.* Vol. I, National Physical Laboratory Symposium No. 10, pp. 3–27. London, Her Majesty's Stationery Office.

MINSKY, M. (1965). Matter, Mind and Models. *Proc. IFIP Congress,* 1, pp. 45–51, Washington DC, Spartan Books.

MINSKY, M. (1972). *Computation: Finite and Infinite Machines.* London, Prentice Hall International, Inc.

MINSKY, M. and S. PAPERT, (1969). *Perceptrons.* Cambridge, MIT Press.

MINSKY, M. and S. PAPERT, (1972). *Artificial Intelligence,* Memo No. 252. Cambridge, MIT Press.

MOLES, A. (1966). *Information Theory and Esthetic Perception,* (translated by J. Cohen), Urbana, University of Illinois Press.

MONOD, J. (1974). *Chance and Necessity,* (translated by A. Wainhouse). Glasgow, William Collins Sons and Co. Ltd., Fontana Books.

NEWELL, A. (1962). *Some Problems of Basic Organization in Problem-Solving Programs.* In *Self-Organizing Systems,* (ed. M.C. Yovitz, G.T. Jacobi and G.D. Goldstein), Washington DC, Spartan Books.

NEWELL, A. and H.A. SIMON, (1956). The Logic Theory Machine. *IRE Transactions on Information Theory,* IT–2, No. 3.

NEWELL, A., J.C. SHAW and H.A. SIMON, (1958). *The Processes of Creative Thinking.* Rand Corp. Memo. P. 1320.

NEWELL, A., J.C. SHAW and H.A. SIMON, (1963). *G.P.S. A Program that Simulates Human Thought.* In *Computers and Thought,* (eds. E.A. Feigenbaum and J. Feldman). pp. 279–297. McCraw-Hill Books Co. Inc.

OGDEN, C.K. and I.A. RICHARDS (1923). *The Meaning of Meaning.* Routledge and Kegan Paul, Ltd., London.

OSBORNE, H. (1965). *Theory of Beauty.* London, Oxford University Press.

OSBORNE, H. (ed.) (1972). *Aesthetics.* London, Oxford University Press.

PALINURUS (C. Connolly) (1961). *The Unquiet Grave.* London, Arrow Books Ltd.

PASK, A.G.S. (1968). *An Approach to Cybernetics.* London, Hutchinson and Co. (Publishers) *of Thought Processes,* Vol. II, National Physical Laboratory Symposium, No. 10, pp. 877–922. London, Her Majesty's Stationery Office.

PASK, A.G.S. (1968). *An Approach to Cybernetics.* London, Hutchinson and Co. (Publishers) Ltd.

PASK, A.G.S. (1969). The Computer-Simulated Development of Populations of Automata. *Mathematical Biosciences,* 4, pp. 101–127.

PASK, A.G.S. (1974). Analogy. In *Cybernetics of Cybernetics,* (compiled by H. von Foerster). Urbana, University of Illinois, Biological Computer Laboratory Report, No. 73.38.

PASK, A.G.S. (1975). *Conversation, Cognition and Learning.* Amsterdam, Elsevier Scientific Publishing Co.

PASK, A.G.S. and B.C.E. Scott, (1973). CASTE: A System for Exhibiting Learning Strategies and Regulating Uncertainties. *Int. J. Man-Machine Studies,* 5, pp. 17–52.

PASK, A.G.S., B.C.E. Scott and D. Kalliakourdis, (1973). A Theory of Conversations and Individuals. *Int. J. Man-Machine Studies,* 5, pp. 443–566.

PENFIELD, W. (1958). *The Role of the Temporal Cortex in Recall of Past Experience and Interpretation of the Present.* In *The Neurological Basis of Behaviour* (eds. G.E.W. Wolstenholme and C.M. O'Connor), A CIBA Foundation Symposium, pp. 149–174.

London, J. and A. Churchill Ltd.

PITTENDRIGH, C.S. (1958) Perspectives in the Study of Biological Clocks. *Perspectives in Marine Biology*. La Jolla. (Scripps Institute of Oceanography).

POLYA, G. (1948). *How to Solve It*. New Jersey, Princeton University Press.

POPPER, K.R. (1959). *The Logic of Scientific Discovery*. London, Hutchison and Co. (Publishers) Ltd.

POPPER, K.R. (1963). *Conjectures and Refutations*. London, Routledge and Kegan Paul Ltd.

POPPER, K.R. (1972). *Objective Knowledge*. London, Oxford University Press.

POUND, E. (1914). Vorticism. *The Fortnightly Review*, 46, No. 573. New Series.

POUND, E. (1960). *Gaudier-Brzeska: a Memoir*. London, Faber and Faber Ltd.

PROUST, M. (1957). *Remembrance of Things Past*, (translated by C.K. Scott-Moncrieff). London, Chatto and Windus Ltd.

REICHENBACH, H. (1968). *The Rise of Scientific Philosophy*. Los Angeles, University of California Press.

ROSENBLATT, F. (1958). *Two Theorems of Statistical Separability in the Perceptron*. In *The Mechanization of Thought Processes*. National Physical Laboratory, Symposium No. 10, pp. 419–456. London, Her Majesty's Stationery Office.

RUDOFSKY, B. (ed.) (1965). *Architecture Without Architects*. New York, The Museum of Modern Art.

RUSSELL, B. (1948). *Human Knowledge: Its Scope and Limits*. London, George Allen and Unwin Ltd.

SCHRODINGER, E. (1947). *What is Life?* New York, MacMillan.

SHANNON, E. and W. WEAVER, (1949). *The Mathematical Theory of Communication*. Urbana, University of Illinois Press.

SKINNER, B.F. (1981). *Notebooks*. Prentice Hall.

SOLOMONOFF, R.J. (1964). A Formal Theory of Inductive Inference. Part I. *Information and Control*, 7, pp. 1–22.

SOMMERHOF, G. (1969). *The Abstract Characteristics of Living Systems*. In *Thinking Systems*. (ed. F.E. Emery) Middlesex, Penguin Books Ltd.

SPENCER-BROWN, G. (1969). *Laws of Form*. London, George Allen and Unwin Ltd.

STEINER, G. (1972). *Of Nuance and Scruple*. In *Extraterritorial. Papers on Literature and the Language Revolution*, (by G. Steiner). pp. 12–21. London, Faber and Faber Ltd.

STEINER, G. (1976). Dante Now. *Encounter*, Vol. XLVI, No. 1, pp. 36–47.

SUTHERLAND, N.S. and MACKINTOSH, N.J. (1971). *Mechanisms of Animal Discrimination*. New York, Academic Press Inc.

TAYLOR, J.G. (1962). *A Behavioural Basis of Perception*. New Haven, Yale University Press.

TOLSTOY, L. (1929). *What is Art?* (translated by A. Maude). London, Oxford University Press.

TRILLING, L. (1950). *The Liberal Imagination*. In *Freud and Literature*. Charles Scribner's Sons.

TURING, A.M. (1937). On Computable Numbers with an Application to the *Enscheidungsproblem*. *Proc. London Math. Soc.* (2) 42, pp. 230–265.

TURING, A.M. (1950). Computing Machinery and Intelligence, *Mind*, 51, 236, pp. 433–460.

UHR, L. (ed.) (1966). *Pattern Recognition*. New York, John Wiley and Sons Inc.

VON FOERSTER, H. (1960). *On Self-Organizing Systems and Their Environments*. In *Self-Organizing Systems*, (eds. M. Yovits and S. Cameron), pp. 31–50. London, Pergamon Press.

VON FOERSTER, H. (1972). The Perception of the Future and the Future of Perception. *Instructional Science*, 1, No. 1.

VON MISES, R. (1951). *Positivism*. New York, Dover Publications Inc.

WAIN, J. (1975). The Breaking of Forms. *Encounter*, 45, No. 2, pp. 49–56.

WHITEHEAD, A.N. (1975). *Science and the Modern World*. Fontana Books.

WHYTE, L.L. (ed.) (1951). *Aspects of Form*. London, Lund Humphries and Co. Ltd.

WILLIAMS, R. (1961). *The Long Revolution*. Middlesex, Penguin Books.

WINOGRAD, T. (1972) *Understanding Natural Language*. Edinburgh, University of Edinburgh Press.

WINSTON, P.H. (1970). Learning Structural descriptions from examples. *A.I. Technical Report 231*, Artificial Intelligence Laboratory. Cambridge, Mass.: MIT.

WITTGENSTEIN, L. (1966). *Lectures and Conversations*, (ed. C. Barrett). London, Oxford University Press.

WOLFE, T. (1976). The Painted Word. *Harper and Queen*, Feb., pp. 70–81. National Magazine Co. Ltd.

WOOLF, V. (1950). *Mr Bennett and Mrs Brown*. In *The Captain's Deathbed*. London, The Hogarth Press.

ZADEH, L.A. (1965). Fuzzy Sets. *Information and Control*, 8, pp. 338–353.

Index

Printed and bound by CPI Group (UK) Ltd, Croydon, CR0 4YY

18/10/2024

01776242-0004